# Artists Making Landscapes in Post-war Britain

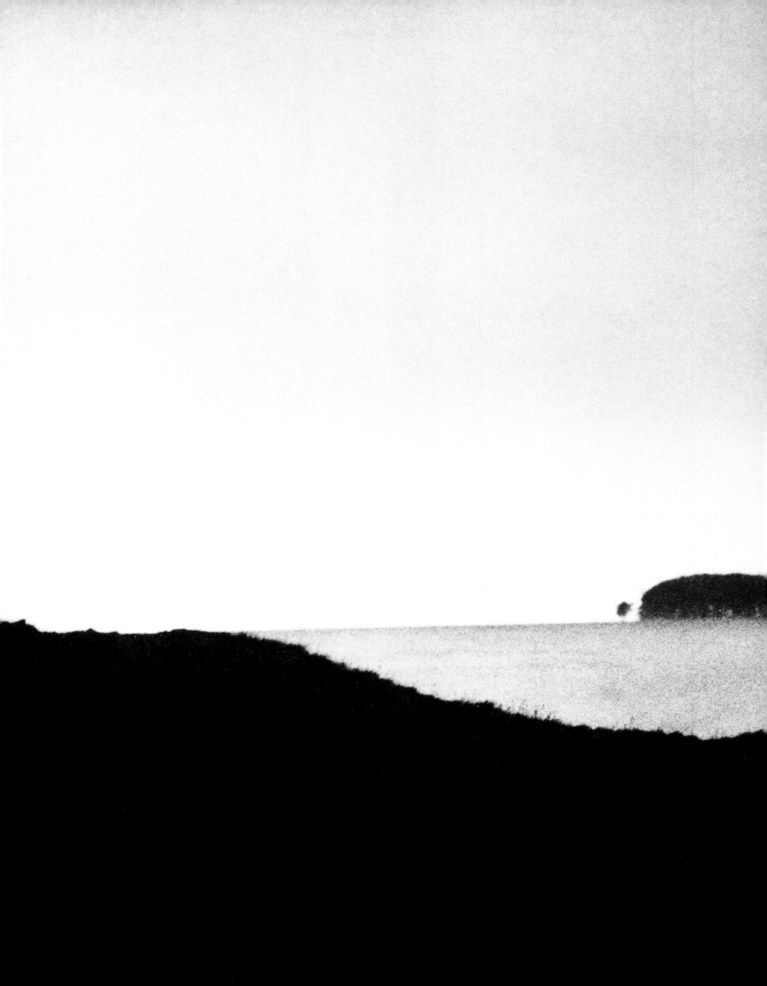

# Artists Making Landscapes in Post-war Britain

MARGARET GARLAKE

MODERN ART PRESS

First published in Great Britain in 2021 by

Modern Art Press
37 Bury Street
London
SW1Y 6AU

A catalogue record for this book is available from the British Library
Library of Congress Control Number: 2021932635
ISBN 978-1-9163474-0-3

Edited by Toby Treves
Designed by Gillian Malpass
Typeset in Avenir Light and Gill Sans
Colour reproduction by Flavio Milani
Printed in Italy by Printer Trento on Gardapat Bianka

Distributed for Modern Art Press by Yale University Press, New Haven and London

Cover illustration: Victor Pasmore, *Square Motif, Blue and Gold: The Eclipse*, 1950 (detail of fig. 19)

Quotation on back cover from Maurice Merlau-Ponty (Colin Smith trans.), *Phenomenology of Perception*, Routledge & Kegan Paul, London & New York, 1962, p. xviii

Pages ii and iii: Bill Brandt, *Barbary Castle, Marlborough Downs, Wiltshire*, 1948 (detail of fig. 39)

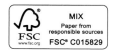

For my daughters, Teresa and Francesca,
and in memory of my son, Richard

# Contents

# Preface

This book has grown out of my long-term interest in and enjoyment of landscape painting as it developed in Britain after the Second World War. It investigates the diverse ways in which British artists, their followers and, on occasion, those with little specific interest in visual art represented, saw, understood and inhabited landscape after the war, at a time when an entire society was being reformulated. Although the genre occupied a small niche at that time, it reveals a great deal about a generation of artists, their practices and the extraordinary variety that they brought to and found within their subject. While there are numerous monographs on individual artists of the period and various broader accounts of twentieth-century British art, there has been a lack of focus on the post-war landscape, as though it had ceased to be of interest to painters by the mid-century. Nevertheless, those who made it their subject developed an extremely broad body of work. Seeking to render it coherent, I have focused largely on those who sought to build on and extend the aesthetic modernism of the interwar period, though I have also discussed one distinctive group of academically inclined painters. While I have written primarily about the representation of landscape, I have also discussed the ways in which it changed in the short term and, especially in urban contexts, was entirely reconstructed, at least on canvas, by the many artists who developed experimental practices that challenged older, more conservative approaches.

Although the book is predominantly about painting, I have also referred to drawing, printmaking and photography, alternative media through which artists were able to extend and reinterpret their subjects. In the context of urban landscapes, I have taken into account the role of sculpture, predominantly in architectural contexts, where it made a significant contribution to constructing the identities of rebuilt urban spaces. Finally, architecture itself has a part in this text as the major informing factor, with planning, of the urban landscape. Evidently, I have omitted far more than I have

included: numerous admirable artists have been passed over in order to focus on a small number and thus attempt to avoid a scatter-gun approach. The work of artists and architects offers a potent record of the many aspects of the landscape and their relationships with it. My title acknowledges that arbitrariness, which is demonstrated in the diversity of artists' work.

Many people have helped to produce this book; to any whom I have failed to acknowledge, I apologise. I am most grateful to Toby Treves for his enthusiasm, expertise and patience. Not for the first time, I should like to thank Professor Christopher Green, who read the manuscript and gave invaluable comments and advice. I am also most grateful to Professor Gareth Roberts for his reading and responses. I have had the pleasure and the privilege of meeting many of the artists about whom I have written, as well as their families. Sadly, many of them are no longer with us but I should like to record my gratitude to the late Sheila Lanyon, for her generosity and hospitality over many years; also, to the late Prunella Clough, Terry Frost, William Gear, Adrian Heath, Patrick Heron and Victor Pasmore. I thank Andrew and Martin Lanyon for help, hospitality and moments of hilarity. Not least, I am deeply indebted to my family, Teresa, Francesca and Richard Garlake, for their interest and encouragement; they played an invaluable part in the production of the book by ensuring that I reached the end. It would not exist without them.

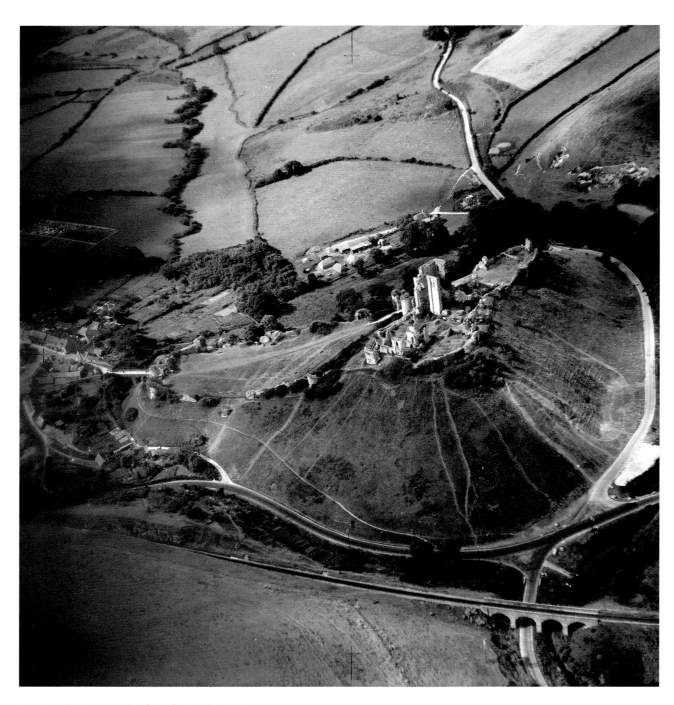

1   Aerial photograph of Corfe Castle, 1947

# Introduction

This book is about the development of landscape art in Britain in the years following the Second World War, a period defined by the need to recover from conflict and to reformulate societies as well as individual lives. It was a complex, difficult and, for artists, creative time, when innumerable practices and assumptions were challenged and reassessed. Landscape painting was one such practice. Its extent is partly determined by what are understood to be physical landscapes. Here I define them as predominantly urban or rural, with the former generally compact, defined by streets, buildings and occasional works of art, and the latter often extending across wide stretches of country with great variations in scale and usually, though not always, distinguished by natural features. Rural landscapes may include villages, churches, grand houses or an occasional castle, as well as woods and fields that are visually differentiated by their crops, all of which contribute to a more diverse totality than the urban equivalent (fig. 1). To these two typological divisions of physical landscape, I add a third, namely 'edgelands'.[1] These are normally industrial areas near or at the edge of towns, which seem to be, or in fact are, exempt from the aesthetic standards that civic planning departments generally demand. Although such places have rarely been celebrated by artists in Britain or elsewhere, there were notable exceptions in the period discussed in this book. Despite such differences, the urban, rural and edgeland landscape share fundamental qualities; perhaps most obviously they contain different individual places defined in ways that range from the personal ('where we first met') to innumerable public and ceremonial sites, from the gasworks and local bus stop to London's Mall. Such qualities hint at the richness of the phenomenon and the genre that is referred to by the seemingly simple term 'landscape'.

During the two decades that followed the war much of Britain's land was transformed by the need to rebuild shattered cities and return the countryside from

military to civilian use. This far from simple task was initially sustained by the Labour government's drive to establish a functional modern society by re-fashioning lives and social structures through education, housing and welfare. Gradually, in a manner that may have seemed – and perhaps was – haphazard, bomb-damaged cities were reconstructed, the transport network was redeveloped and widespread military installations, from airfields to pillboxes, were converted or demolished. As land was released from military use the life of the countryside was reasserted but, however much it may have seemed that an old order was being restored, landscape was, and remains, inherently dynamic and some years later, when conventional agricultural practices were converted to new agribusinesses, it radically changed again. The post-war transformation of farming, when relatively small fields bounded by hedges and worked by horse-drawn contraptions gave way to great open tracts, dug, sewn and harvested by a single man perched on a vast machine, constituted an ontological shift. At the same time, coal mining, which had an immense, long-term physical impact above and below ground, asserted an ideological significance that is almost unimaginable today. The nationalisation of the industry in 1947 was recognised as a profoundly important demonstration of democracy in action. Consequently, the physical sites of mining, which extend beyond coal, provided potent subject matter for artists and represent the modern landscape no less definitively than new patterns of agriculture.

One of the most urgent post-war priorities was to re-establish and develop the industries that had been in abeyance for the duration of the conflict. This process, which demanded land, infrastructure and buildings, seldom received the aesthetic attention that might have been more readily forthcoming in less pressurised circumstances. A significant result was 'a perceived confrontation with the alienating forces of industrialisation and the portrayal of inner and outer "waste-lands"', a situation that has been understood as 'crucial to the definition of mod-ernity'.[2] 'Waste land', a phrase that suggests an unproductive territory of dubious usage, lacking evident aesthetic qualities, is widely assumed to be a peri-urban

2    Prunella Clough, canal and gasworks, 1950s

phenomenon closely associated with industrial installations and remote from the interests of artists. It was, nevertheless, adopted as a personal territory by the painter Prunella Clough, who found in it some of the outstanding landscape imagery of the late twentieth century (fig. 2).

The wider, social modernity of early post-war Britain depended on the willingness of legislators to address the unfamiliar, even the unknowable, in order to enhance human existence. Overall, the modernity of early post-war society – that is, the factors that differentiated it from the world of 1939 – was almost entirely a product of the war. The new social order evolved from what has become known as the post-war settlement: the state's unprecedented undertakings on the provision of social security, education, healthcare and housing, all sustained by an assumption of full

employment. R. A. Butler's 1944 Education Act stipulated universal compulsory education supplied by the state until the age of fifteen, while the 1946 National Insurance Act, which did much to dispel long-standing, widespread fears of destitution, was the foundation of the Welfare State. Early social legislation culminated in the establishment of the National Health Service in 1948, bringing an assurance that the maimed and deformed figures famously portrayed by L. S. Lowry would no longer haunt the streets. The egalitarian thrust of these innovations was succinctly expressed in the Arts Council's catchphrase, 'The best for the most', which encapsulated the wider ideology of the period.

That the responsibility of the enlarged state extended to provision for the arts was a potent indication of the development of an inclusive social democracy and a radical innovation, albeit one in line with other western European democracies. Founded in 1946 with an extremely limited budget, the purpose of the Arts Council was, as its first director-designate, John Maynard Keynes, explained: 'to create an environment to breed a spirit, to cultivate an opinion, to offer a stimulus to such purpose that the artist and the public can each sustain and live on the other in that union which has occasionally existed in the past at the great ages of a communal civilised life'.[3] Keynes's aspirations were to be fulfilled insofar as participation in the arts grew steadily, though visual art never reached the level of popularity of drama, dance and music.

Modernity, which generally refers to what is new and up to date, is temporal; its dominant form may change radically even within a period as brief as the one covered in this book. Recent commentators have emphasised the hybridity of early post-war modernity, noting the diversity of its modes of expression and 'the extraordinarily contradictory impulses towards the modern' that manifested between 1945 and the early 1960s, especially in the context of architecture and housing.[4]

After the war architecture was the most visible product of the modernising aesthetic. In the aftermath of the Blitz, when much of the urban environment required extensive reconstruction (see fig. 77), physical manifestations of modernity were to be found

3　Kenneth Rowntree, mural at Barclay School, Stevenage, 1949

in the new housing and schools that incidentally provided abundant opportunities for innovation. Despite the limitations imposed by an acute shortage of materials and bearing in mind that much new building was utilitarian and undistinguished, the post-war period had, at its best, a distinctive architectural identity imparted by concrete, horizontality, extensive glazing and a lack of external ornament. Internally many schools were embellished with murals, painted or constructed with decorative tiles (see fig. 3).[5] The Hertfordshire school building programme, predicated on an

immediate increase in the demand for places, was run by Stirrat Johnson-Marshall. An enthusiast for prefabrication, he introduced a modular system involving pre-cast concrete panels and extensive glazing in steel frames. Elain Harwood has commented: 'The Hertfordshire schools embodied the post-war aesthetic, an evaluation from first principles that extended to every component.'[6] Widely imitated, they established a model to aid the delivery of child-centred education across the country.

Conversely, shops, offices and factories were seldom celebrated in the architectural press despite the urgent need for industrial expansion. The single, notable exception was the Brynmawr rubber factory (1946–51; fig. 4) designed by the Architects' Co-Partnership with the engineer Ove Arup.[7] Structurally and visually distinguished by the nine huge concrete shell domes that formed its roof, it was a shrine to aesthetic idealism, intended to bring prosperity to a struggling area of south Wales. It closed in 1982, a victim of unfavourable economic circumstances and a 'haphazard management style'.[8] In general, the slow process of re-establishing an infrastructure of housing, commerce, industry and transport was manifested by unremarkable, if functional buildings. As money and materials became more readily available during the 1950s, developer-led architecture proliferated in the form of shoddy, even dangerous, structures designed and erected solely for short-term profit without social or aesthetic consideration.[9]

By 1960 major cities from London to Liverpool had recovered from war damage sufficiently to become the sites of a glamorous youth culture, a shift vigorously celebrated by artists. A significant corollary was the commissioning of works of art, often by young sculptors, to embellish housing estates, schools and other new buildings. This resulted in the creation of numerous small but highly individuated landscapes that followed the model of the 1951 South Bank Exhibition of the Festival of Britain.[10] That exhibition's intensely urban landscape was formed of innovative pavilions designed by leading architects and lavishly embellished with sculpture, fountains and murals. The dynamic modernity of the site consciously echoed that of the Great Exhibition a century earlier. Received by the public with

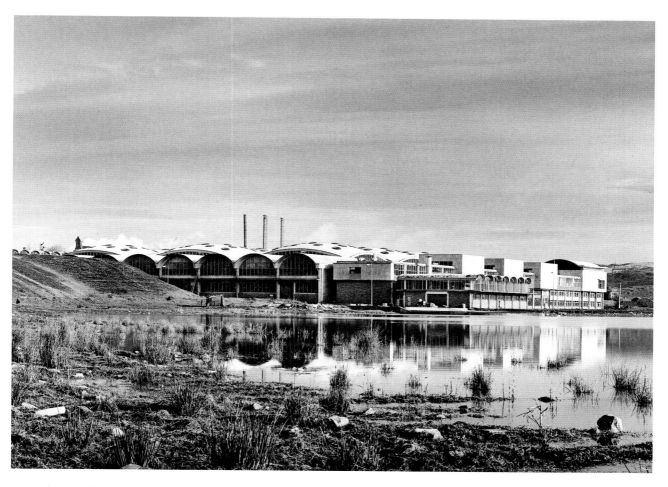

4 Architects' Co-Partnership with Ove Arup, factory for Brynmawr Rubber Company, 1946–51, photographed in 1951

enormous enthusiasm, the South Bank Exhibition was a source of both pleasure and self-improvement, a dual impetus that would also have been readily acknowledged in 1851.

As the economy stabilised, the parameters of modernity expanded from necessity to leisure, including travel, with its attendant material culture of cars, accommodation and guidebooks, as well as new destinations and pastimes. The many forms of post-war cultural landscape included prominent destinations for relaxation, tourism and sport, among which Snowdonia and the Lake District were magnets for walkers, climbers and, albeit less frequently, artists. Outdoor pursuits flourished, with popular enthusiasm, especially for the natural world and historic sites, acknowledged by a steady increase in the number of attractions. A significant by-product of domestic tourism was the growth of photography as an attractive, novel pastime. By the early 1960s, the camera, which twenty years earlier had been an esoteric technology restricted to the well-to-do, was rapidly becoming the attribute of every tourist.

These were some of the diverse elements that comprised the hybridity of post-war social modernity. When referring to art I have used 'modernity' and 'modern' to distinguish innovatory from earlier and more conventional practices. The term 'modernism', however, I understand to mean the modern intellectual and physical processes through which a work of art evolves. In pre-war Britain it was exemplified by Ben Nicholson's paintings and white reliefs, and the distinctive abstract sculpture of Barbara Hepworth and Henry Moore. Such work created a situation in which the physical form of a work of art, whether a piece of polished stone or geometric shapes painted on canvas, might constitute its meaning.

For the visual arts in general, the conditions of modernity offered a release from precise representation that in turn brought about the gradual recognition of abstraction as a viable mode of communication, albeit one partially dependent on empathy. The acceptance of abstraction was a slow process, hardly complete within the period covered by this book, though its evident impact on Pop Art, in terms

of non-referential colour and the frequent occurrence of flat planes of pure colour, indicates a considerable conceptual advance by the early 1960s. Landscape painting in general displayed a combination of diverse aesthetic approaches, many of which incorporated the gestural marks, rich colour and non-literal view of subject matter that characterise post-war practice. Abstraction raises the question of what it can tell us about landscape that is not found in more literal imagery; primarily, it requires us to ask what is the particular language of marks made by a painter? Bearing this in mind, I have attempted to investigate the relationship between the physical landscapes of post-war Britain and the ways in which artists with diverse interests and priorities depicted them.

Across the range of visual media in the post-war era, it was the fluidity of the not-quite-abstract style that was most fruitful for – and was most frequently adopted by – innovatory artists, among them many of the landscape painters discussed in this book, who rejected the model offered by the pioneers of the 1930s in favour of a more intellectually open approach that acknowledged the entire formal range from realism to abstraction. In this respect post-war British art was indebted to developments pioneered by exemplars and colleagues in continental Europe, primarily Pablo Picasso, Nicolas de Staël, Jean Dubuffet, Alberto Giacometti and Pierre Soulages. Exposure to contemporary American painting in the mid and late 1950s was to provide further models for abstract work that had a profound impact on British artists. More recently, the late Michael Harrison's work on the painter Alan Reynolds suggests that the sources of aesthetic renewal explored by British artists were, for some, considerably wider than the conventional Paris–New York axis, indicating that the post-war narrative is still under construction.[11]

In order to render a sprawling subject manageable, I have partly approached post-war landscape art through the responses of a small number of artists to places with which they were familiar, considering the impact of social and physical modernisation on such places. Among them, Peter Lanyon, Edward Bawden, John Piper and Joan Eardley have been closely identified with specific places and areas,

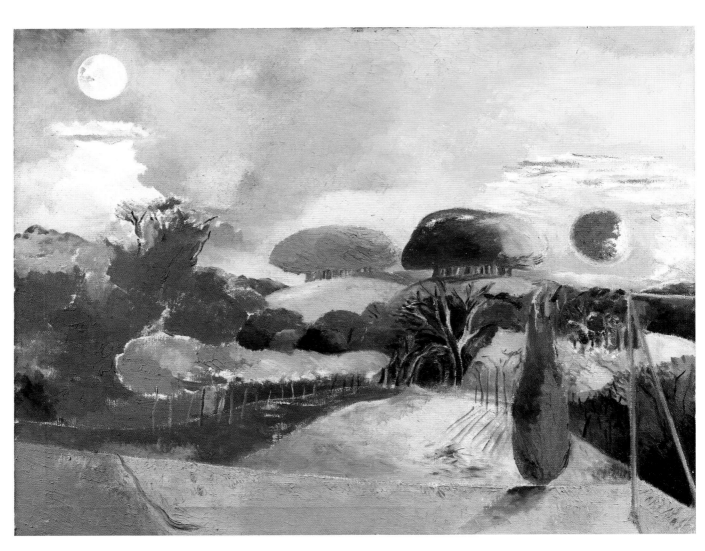

5   Paul Nash, *Landscape of the Vernal Equinox*, 1943

respectively Cornwall, Great Bardfield, North Wales and Catterline in Scotland; and I have focused on those artists, for example Moore, who developed new thematic and formal approaches to their subject that exemplify a modern aesthetic, if not modernism in a strict sense. In adopting this emphasis, I argue that the impulse to modernity was a potent driver for social and aesthetic renewal throughout the early post-war period.

Chronologically, the book opens with Paul Nash's *Landscape of the Vernal Equinox* (1943) and ends with Richard Long's *A Line Made by Walking* (1967). I have occasionally referred to works a few years outside these dates for comparative purposes. Nash has been an enduring example of a painter who formulated an intensely individual concept of landscape in which every element might be animated. His *Landscape of the Vernal Equinox* (fig. 5) summarises his career even as it looks forward in ways that he could not have envisaged.[12] Details such as the frame on the right of the canvas, the receding trees, the tunnel of branches, the quality of the paint – simultaneously thin and taut and thick and luscious, with the implausible drama and delicacy of the colour – recall earlier works, places and motifs, brought together with incomparable grace. The painting has been aptly interpreted as an image of 'reconciliation', with its pairings 'of the sun and the moon, life and death', female and male, made as the course of the war was starting to turn.[13] Its central motif is the pair of rounded, tree-topped hills near Oxford called the Wittenham Clumps. Nash drew them in 1912 and they were still central to his work in the 1940s. He wrote: 'Ever since I remember them the Clumps had meant something to me. I felt their importance long before I knew their history. They eclipsed the impression of all the early landscapes I knew . . . They were the Pyramids of my small world'.[14] Like many of the generation who followed him, Nash had a repertoire of familiar, emotionally significant, frequently painted places, which included Iver Heath in Buckinghamshire, the Romney Marsh coast at Dymchurch and prehistoric Avebury, with the chalk and flint country that surrounds it.

At the other end of the period is Long's *A Line Made by Walking* (fig. 6), the most well-known of his early physical interventions into landscape.[15] Initiating a practice

to which walking has been central and has resulted in the temporary reformulation of landscapes across the world, Long created his line by repeatedly walking up and down a narrow strip of an unidentified field in the outskirts of south London. Thus, in treating landscape as medium and subject, Long's walks, whose concomitant works included photography and concrete poetry, extended the processes of such pioneering painters as Lanyon and Eardley, who also experienced their subject through intense physical engagement.

The book starts with an overview of the status of landscape art in the early post-war years. In subsequent chapters I discuss the place of landscape painting in the wider context of the art world; the reactions of artists and visitors to large-scale physical changes in landscapes across the country; landscapes that were specifically devoted to leisure and, in contrast, those formed by new urban architecture and sculpture, all of which stimulated fresh imagery and conceptual approaches. I discuss artists' reactions to the development of agriculture, industry, transport infrastructures, tourism and the emergence of the edgelands, many years before they were named and described.[16] While such themes address various forms of physical landscape in general terms, their corollary is the intensity of the relationships that certain artists maintained with personally significant places, resulting in a sense of phenomenological immersion in and identification with locations that ranged in scale from a large garden to an entire county. Phenomenology, together with the related concepts of space and place, is a helpful way to understand the work of certain artists, though it demands qualification by consideration of the wider culture and physical landscapes. There were as many and varied responses to landscape as there were landscape artists; the complexity of the processes through which they balanced emotional reactions, filtered visual stimuli or recalled a fleeting, extraordinary sight, all of which might connect tangentially with visiting a farm or a slag heap, ensures that the historian's understanding and reconstruction can be a long way from what the artist saw.

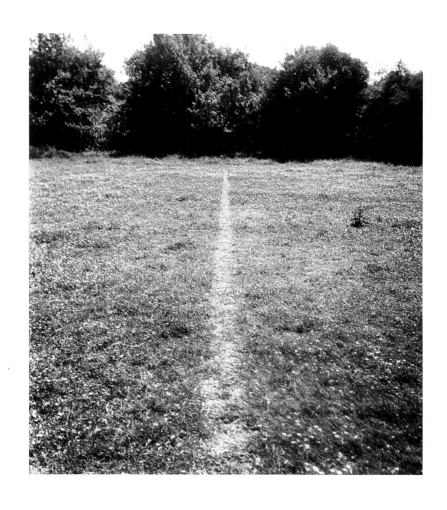

A LINE MADE BY WALKING

ENGLAND 1967

6   Richard Long, *A Line Made by Walking*, 1967

Many more artists responded to the post-war environment than can be discussed in a single book. The selection in this book has been guided by my interest in modernist rather than academic artists, though I have not entirely excluded the latter. Some painters found that their work changed markedly in response to the experience of a new place. As a result, certain names recur in diverse contexts; for instance, Terry Frost worked in both St Ives and Yorkshire, making sharply differentiated groups of work in response to the distinctive topographies of those places. Eardley began her career painting children on the streets of Glasgow before she turned to the drama of the sea and weather on the east coast of Scotland. During the period covered by this book, Prunella Clough was much engaged with various groups of specialised workers, from fishermen in East Anglia to women in Peek Frean's biscuit factory, before she became enthused by industrial landscapes across the country.

Just as there are many approaches to painting, there is a huge variety of physical landscapes. Even the apparently fundamental distinction between urban and rural is qualified: allotments and cottage gardens flourish in cities; urban parks shelter sizeable wild areas, and foxes and seabirds have expanded their natural habitats to cities. Urban landscapes extend from the formal public space, sometimes identified by a monument, to the texture of a decrepit wall. The diversity of their rural counterparts is immense; they may be defined by a mountain range or the presence of a rare plant and they are mediated in ways that include leisure, farming and industry. Whereas landscape painting is conventionally perceived in relation to the actual landscape, a significant minority of artists, among them Nash and David Jones, developed imagined or ephemeral versions of their subjects that were inspired variously by religion, politics and utopian ideals, which I discuss in the final chapter.

My earlier book, *New Art New World: British Art in Post-war Society*, included a chapter on landscape, offering a very limited approach to a complex subject, which focused on the relationships between four artists and their painting territories. Its subject was the primary, essential connection that exists between a given stretch

of land and an artist's sense of it as a personal place with an individual character and mythology. I proposed that the historic centrality of landscape art in the British tradition had brought about a situation in which 'the relationship between conceptual constructions of the countryside and its appearance, between theorised space and visual perception, between contemporary and historical readings of landscape remain central to any discussion of its development within modernism'.[17] While I would now replace the aesthetically specific 'modernism' with 'modernity', this book has evolved from that chapter and has retained its focus on the artist–place relationship.

In considering the significance of, for instance, St Just in south-west Cornwall, Great Bardfield in Essex, Aspatria in Cumbria, Catterline in Scotland and the various ways in which places may be approached, analysed and described, I have – perhaps recklessly given the hazards of cross-disciplinarity – turned to the work of cultural geographers. I was prompted by a long-standing shortcoming in discussions about post-war British art, namely a reluctance to situate it in wider contexts. Cultural geographers provide such a context and an opportunity to extend the historical account, though I remain aware of the strong possibility of having made thin and superficial readings of rich and complex conceptual thinking.

The cultural landscape exists in parallel with the personal landscapes of artists, which are linked to space and place, as well as to their diverse perceptions of the English countryside. Scholars who study prehistoric societies dismiss the possibility of separating nature and culture because people shape their own environments and, equally, are moulded by them: our food, shelters and health hazards are all products of such shaping.[18] On the other hand, an archaeologist's explanation of the origins of a circle of standing stones does not account for its cultural prominence today. Why do we value menhirs, the remnants of ancient agriculture, mediaeval cathedrals and nineteenth-century railway viaducts? This is the territory of cultural geography, which encompasses the innumerable faces of landscape, its ideology and human relations and extends to landscape painting. In Britain, small and densely populated,

there remains no wilderness and no place untouched by human culture: 'Every islet and mountain-top, every secret valley or woodland, has been visited, dwelled in, worked, or marked at some point in the past five millennia. The human and the wild cannot be partitioned'.[19] In other words, the entire countryside has been formed by human intervention, which has resulted in innumerable cultural landscapes that extend from the parks surrounding great houses to small domestic gardens; from ancient battlefields of dubious location to centres of industry; from motorways and their service stations to hilltops and beaches. Even sites as ancient as Stonehenge belong to the present, in that they are subject to constant reinterpretation by those who study and visit them.

In exploring the themes that link artists to landscapes, cultural geography elucidates the relationships between individuals and their environments: 'Geographical experience . . . refers to the entire realm of feelings, acts and experiences of individuals in which they apprehend themselves in a distinct relationship with their environment'.[20] As regards geographers, there are those who believe that all landscape is a theoretical construction and, conversely, the empiricists, for whom it is what lies underfoot. I tend to follow the more pragmatic cultural geographers, whose every case study is plausible if not indisputable. Ultimately, I am interested in why a given work of art looks as it does and how to decipher the artist's marks, given that every work needs to be related to its subject through a more sophisticated conceptual framework than style or resemblance. In order to address complex works, both visually and in terms of what has been written about them, particularly by their makers, I have adopted a pluralist methodology; if it looks like a toolset that is because one size never fits all. I have, however, tried to find the right tools for various aspects of the job.

Geographers, archaeologists and anthropologists have interpreted landscape in ways that range from an artificial, social construct to a 'natural', given phenomenon that implicitly includes the work of artists. Denis Cosgrove has argued that all landscape carries 'symbolic meaning', brought about by human activity.[21] The

precincts of war memorials, children's playgrounds, shopping centres, walkers' trails (in 'natural' countryside) and the pub garden all function according to strict, generally unwritten protocols. The equivalent for the art historian is the work of art and its not always obvious relationship to a physical territory. To decode symbolic landscapes requires a concentrated, detailed interpretation of the place itself and the way that it is understood and used, often according to internalised rules.

David Matless has discussed the activities, perceptions and beliefs governing the ways in which individuals relate to and inhabit landscapes, describing hugely diverse practices as 'cultures of landscape'.[22] Analysing landscape's centrality to the formation of a renewed national identity in the 1920s and '30s, Matless identified a range of innovatory practices. They included field archaeology (with the associated eccentricity of ley lines), hiking, map-reading (which had class status), the Woodcraft Folk, 'nature mysticism' and, not least, the ideological significance of the healthy body, to be achieved by vigorous outdoor pursuits.[23] Painting is among the many factors that contribute to and define individual landscape cultures. Just as landscapes are formed through everyday physical activities within contexts as disparate as agriculture, mining and tourism, they are also produced by artists.[24]

This book contains no examination of landscape art in relation to tradition and national identity, which has been a significant theme in recent years, not only for Matless but also notably for Stephen Daniels, Brian Foss, Catherine Jolivette, and Will Vaughan. Instead I have sought to address the diversity that is implied by landscape as a cultural construct and physical phenomenon; the way that landscapes both contain and become places; how physical features may be reconciled with the cultural landscape and, not least, the significance of post-war land use and the emotional and social charges conveyed by these factors. The relationship between the physical landscape and an artist's interpretation of it is central to this book. It involves the uncertainty of representing or reaching a coherent reading of landscape, while also demanding an acknowledgement of the contradiction be-tween the old and romantic and the innovatory and functional. The difficulties of

establishing an authoritative interpretation of any physical territory is delightfully illustrated by a hypothetical scenario which proposes that a 'royal castle originating in fears of insurgency would doubtless be visited by the monarch and royal retinue – and this would constitute a demand for the institution of a Forest and for the conversion of land devoted to peasant agriculture into deer parks. There is no apparent link between insurgency and deer parks, but the royal castle provides a bridge'.[25]

Landscape's inherent instability (we may surmise that the Forest was felled to provide timber for Nelson's ships while the deer park survived only as a record in old maps and the castle as a grass-covered mound) explains why so much emphasis is placed on its symbolic content, sidestepping the physical presence which, for artists, is irreducible. Though I touch on symbolic content in the final chapter, I have been primarily interested in investigating the ways in which artists inhabited and depicted landscapes and how their work was perceived. This involves the social significance of landscape in post-war Britain and the immense changes brought to bear at that time on both country and city. In this context, David Meinig's well-known demonstration of the plurality of landscape is apposite. He argued that the same stretch of land seen by ten people would evoke as many different readings: as nature, habitat, artefact, system, problem, wealth, ideology, history, place or aesthetic.[26] The list may be expanded and, indeed, extends far beyond the individual to a point where landscape acts as 'a vast mnemonic system for the retention of group history and ideals', from the village to nationwide scale.[27]

Artists' interpretations may be added to the system. Nash's transformation of his personally significant places rendered them uncanny, conceptual, symbolic; sites of passion, despair, death or, as in the *Landscape of the Vernal Equinox*, a revelation of the complexity, the ambiguity, the diversity and difficulty of defining landscape. In its display of oddly conjoined realities, this work is a fitting prelude to post-war landscape painting in general and to a book that investigates the ways in which, during a short period, a small number of artists evolved a wide range of practices,

often in recognition of specific places, if also with frequent, wilful disregard of their topography. It has been astutely remarked of Nash's paintings that 'there is a sense of something additional out of sight that was determining his vision'.[28] If Nash's sense of an inexplicit otherness is incomparable, to a certain degree 'something additional' can be said to characterise the work of most of the artists whom I discuss. Nash, like Jones, created mythic landscapes from real places, finding in the Wittenham Clumps a character that superseded rationality and incorporated the theme of 'a body within the landscape, and with it . . . the recurring generations of birth and death that echo the recurring seasons'.[29] The body in or as landscape was to be a significant, even primary theme for many artists who followed Nash.

The years between *The Landscape of the Vernal Equinox* and Long's *A Line Made by Walking* saw a radical revision of the concept, use and depiction of landscape. In so far as the visual arts contribute to expressions of national identity, landscape painting rates highly, being recognised as central to a tradition already well established by the mid-nineteenth century. The pedigree of the genre ensured that its adoption and transformation by modern painters would be controversial; they were widely – and incorrectly – understood to be engaged in a rejection of tradition, which contributed to their marginalisation. Very few critics or dealers were prepared to promote radically new art in the early 1950s, a situation that drove some artists to desperation. A further displacement occurred a decade later, when Pop Art threatened to eclipse landscape painting. The gradual acknowledgement of landscape painting is a demonstration of its belated success, though its rise to prominence has not always been accompanied by adequate recognition of its content.

To grasp the range of landscape representation – and the ways in which it is sensed and understood – it is only necessary to imagine a virtual gallery of landscape art. Even if it were restricted to post-Enlightenment European painting, it would be possible to travel from the terrifying sublime of Philip de Loutherbourg's Swiss Alps to the domestic calm of Golding Constable's kitchen garden; from the minute

Ruskinian observation of the pre-Raphaelites to Paul Cézanne's intense individual scrutiny; from the polite recordings of rural scenery that are a leitmotif of early twentieth-century English painting to the highly charged semi-abstraction of the post-war years and, finally, to the conceptual art of the 1960s. Such journeys reveal landscape's multiple identities set out as individual visions. It has been aptly written of landscape that it is 'an academic open sesame', so numerous and diverse are the interpretations put upon it.[30] Alternatively, as the critic Geoffrey Grigson remarked: 'Landscape may exist, rock and tree and red earth, and the shine of water. But it is a very personal affair, the affair of one man and the world'.[31]

I suggest that there is a reciprocity between the cultural landscapes that were specific to post-war Britain and the work of those artists who were stimulated equally by aesthetic modernity and discontent with the remnants of a time-expired pre-war culture. That culture is conventionally represented by Sir Alfred Munnings, President of the Royal Academy (1944–9) and a renowned equine painter who had no traction for the modernists of the late 1940s. The landscapes that they painted resulted from internalised impulses, though they echoed diverse realities. Landscapes may articulate space, power, politics, time, gender, hierarchy; they are constructed physically by megalith builders, farmers, miners, gardeners and the proprietors of theme parks and symbolically by those who see, inhabit, depict and write about them. As a result, the sense of any landscape will depend to a considerable extent on the individual circumstances of those who interpret it.

The ways in which artists inhabit, work in and move around a given area calls its identity into question. Defined at one extreme as wilderness and at the other as anonymous urban space, landscape remains rural by convention. This understanding was challenged by the emergence of the 'townscape' as the basis for planning the South Bank Exhibition site and the early New Towns. Further questions of identity are raised by, for instance, the route of the Aldermaston marches of the late 1950s and early 1960s. A physical site of impassioned political protest, it retains no permanent trace of that activity though it was extensively recorded by photographers. Walked

over, inhabited, incorporated into the national psyche through codes of speech, body language, social rituals and behaviour, such landscapes structure and identify the individuality of a culture no less than those that are protected, painted and recorded in literature. The insubstantial nature of political landscapes such as the route between London and Aldermaston, which survive in memory, sustains Grigson's perception of landscape as intensely personal. Out of long-standing interest, I have located this book within the social context of the early post-war period. If the narrative of that context sometimes appears to have assumed a character of eccentric utopianism, that reflects the unpredictable process of history.

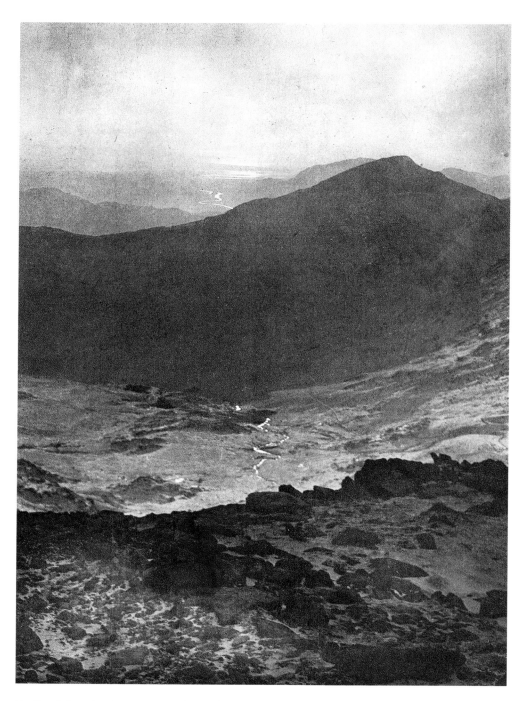

7   Frank Smythe, *Nearing Sundown: from Lliwedd*, 1940

# 1    Landscape Painting in Post-war Culture

In December 1940, during a brief break in North Wales, the photographer and mountaineer Frank Smythe took a picture that he titled *Nearing Sundown: from Lliwedd* (fig. 7). Five years later he described what he had seen: 'In the cwm at my feet a stream flashed and glittered. Beyond was the steadier gleam of the Glaslyn threading woods and meadows on its way to the sea, and further still the sea splendid in the declining sun. This was life as it should be. This was Peace. A few days before I had heard the wail of sirens and shriek of bombs.'[1] The landscape that Smythe described was both enduring and normal but, in the context of those times, its promise of a life untouched by conflict had a significance far beyond the image itself. To address the future in 1945 was to recognise the inevitability of coming to terms with the war and its aftermath and the need to reconcile them with older perceptions of society, landscape and art.

As Smythe implicitly acknowledged, landscape's cultural centrality is fundamental. If the primary distinction was between rural and urban landscapes, their topography, use and history were also important. In a context of destruction, fantasised landscapes of refuge expressed an emotional truth, while regional distinctions and fundamental divisions such as those between the cultivated and the wild, or the territories of home and the unfamiliar, contributed to the diversity of art practices across the country, from London to Edinburgh, Essex to Cornwall. These were in turn extended by a post-war version of modernism which developed under the impact of contemporary French and American art.

In the early post-war period artists received little support beyond that provided by a handful of commercial galleries and the new Arts Council, which was established in 1946 with abundant goodwill but minimal funding, and the British Council. The latter, which had acted effectively as a cultural arm of the Foreign Office, emerged from the war re-energised to undertake the promotion of new art and artists, principally

in western European countries, and was helped in this regard by Herbert Read, who had vigorously supported the modernist artists of the 1930s, and continued to offer the British Council his expertise after the war. Likewise, Kenneth Clark, the former director of the National Gallery, Slade Professor and Director of the Arts Council (1953–60), was an enthusiastic patron of some modern artists, especially Paul Nash and Graham Sutherland, whose work, with that of their younger Neo-Romantic colleagues, provided the dominant imagery of the immediate post-war years.[2]

During the war, Nash was one of seven artists appointed to the Air Ministry by the War Artists' Advisory Committee run by Clark, though his employment ended soon after Air Commodore Harald Peake took violent exception to his representation of the Sunderland bomber in an anthropomorphised form.[3] At the same time, Graham Sutherland revealed the physical context of the Home Front as a mythic place where mangled machinery metamorphosed into fabulous beasts. Commissioned by the War Artists' Advisory Committee in 1940 to record bomb damage in South Wales and later in the City of London, Sutherland worked as an official war artist almost throughout the conflict, spending periods in Cornish tin mines and Yorkshire coal pits, while also acting as *chef d'école* to the younger Neo-Romantic artists.

While the identity of the central figures of Neo-Romanticism[4] varies from one writer to another, the central figures, with Nash and Sutherland, are widely agreed to have been Michael Ayrton, Robert Colquhoun, John Craxton, John Minton, Keith Vaughan, and by some estimates Prunella Clough and John Piper.[5] The distinctive character of the style has been defined by the cultural historian Kitty Hauser as primarily a tendency towards an 'indigenous frame of reference' mixed with an acknowledgement of formal innovation, enabling artists to combine an essentially English subject with the conceptual freedom of Surrealism.[6] As the work of Nash and Sutherland demonstrates, this potent approach to the realities and fantasies of wartime Britain emerged in practice as a combination of deep, rich colour with intimations of hybridity and metamorphosis.

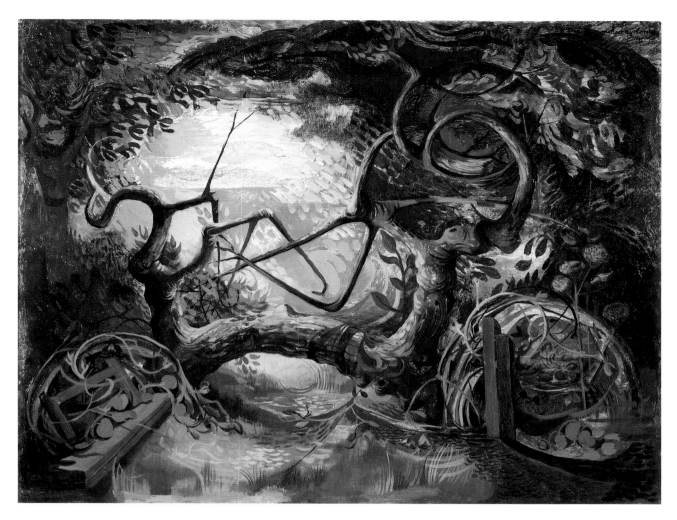

8   Michael Ayrton, *Entrance to a Wood*, 1945

Throughout the war landscape carried an intense emotional charge. A common perception of an idealised rural scene as a metaphor for a world free from conflict bound the Neo-Romantics together at a time of constant insecurity. A prime example is Ayrton's *Entrance to a Wood* (1945; fig. 8), one of the defining images of Neo-Romantic painting, which suggests a state of refuge and unattainable arcadian bliss. The pathway that might offer a route to distant, bright hills, were it not blocked by an unidentifiable menace, constitutes a statement of yearning and loss, a metaphor for the theme of flight from the wartime reality of unspecified terror.

Even before wartime destruction became reality, the mutability of landscape had been demonstrated when swathes of the countryside were quickly converted to military use under the 1940 Government Building Programme. This enabled the 'construction for direct war purposes of airfields, camps, training establishments, defence works, storage depots and all kinds of military installations . . . industrial premises, with . . . hostels and housing, roads and streets, and public utilities, to feed the Forces with munitions on an unprecedented scale'.[7] As parks and private gardens were converted to food production and sheep grazed in Hyde Park, arable land across the country increased by nearly seven million acres, a transformation that no doubt contributed to nostalgia for Ayrton's ideal landscape.

Although the power of Neo-Romanticism inevitably diminished when the war ended, the term remained a widely used critical concept and the style continued to provide a formal model for painters into the following decade, despite Robert Medley's description of its final phase as a 'prison'.[8] In 1948 Nash's unfinished autobiography, *Outline*, was published, with a foreword by Read, who pointed out that the last full chapter was called 'End of a World' while the notes for those to follow were titled 'Making a New World'.[9] A positive sense of a 'new world' runs through the art of the late 1940s, in parallel with Nash's understanding of landscape as a vital force. He expressed his perception through the concept of the *genius loci*, or the 'spirit of a place', which he identified with a childhood memory of his father's garden, writing of 'the first place which expressed for me something more than its natural features seemed to contain, something which the ancients spoke of as *genius loci* – the spirit of a place'.[10] And though today it may sometimes be considered a quaint period theme, the *genius loci* has an equivalent in the perception, shared by many artists, of a personal, physical identity with certain places. If the attraction of the concept as a driving force died with Nash, an understanding that places may be imbued with specific, communicable meaning was to inspire many of those who followed him.[11]

Meanwhile, in the early post-war years some of the Arts Council's touring exhibitions promoted a more conventional perception of landscape. They were directed at a

domestic public for whom landscape was a familiar and favoured subject. *The Artist and the Countryside*, *The Art of the Countryman: The Pen Drawings of Thomas Hennell*, *The Art of Landscape: An Exhibition of Reproductions*, *Cornish Painters*, *The East Anglian Scene* and *A Prospect of Wales – Kenneth Rowntree* were characteristic of those circulated outside London in 1948. At a time when habits of making and displaying art were being re-assessed, categorisation by geographical areas offered a means of assembling exhibitions that could highlight local artists.

## 'Making a New World'

In 1949 Kenneth Clark's *Landscape into Art* was published, a book that elucidates the status of the landscape genre in the late 1940s and the manner in which it was scrutinised and understood. In it, Clark examined the landscape tradition under such broad thematic headings as 'symbolic', 'factual', 'ideal' and 'natural'. Almost incidentally and with reference to the fifteenth-century artist Albrecht Dürer, he identified a theme that was to be of obsessive interest to contemporary painters, writing of 'a new sense of space' as characteristic of modern landscape art.[12] Though Clark expressed reservations about majority taste ('naturalism tends to vulgarity. It is the popular style'), his book remains highly informative.[13] As a prophet of the modern he faltered only when contemplating abstraction: 'we cannot seriously consider the more austere forms of abstract art as a possible basis for landscape painting'.[14] Though it seems unlikely that Clark would have come to terms with Richard Long's work, it is significant that throughout the book he emphasised that landscape was a shifting phenomenon, constantly responding to wider cultural changes. In this respect he revealed himself to be well ahead of his time.

Idealistic, politically sophisticated and aware of the need to grasp what they recognised as an unprecedented opportunity for cultural renewal, many artists returned to their studios after 1945 intolerant of old conventions. The works of Moore, Nicholson and Hepworth were powerful models for practices that brought together old and new, the strange and the familiar. The semi-abstract forms particular to Moore's large-scale sculptures, such as the Stevenage *Family Group*

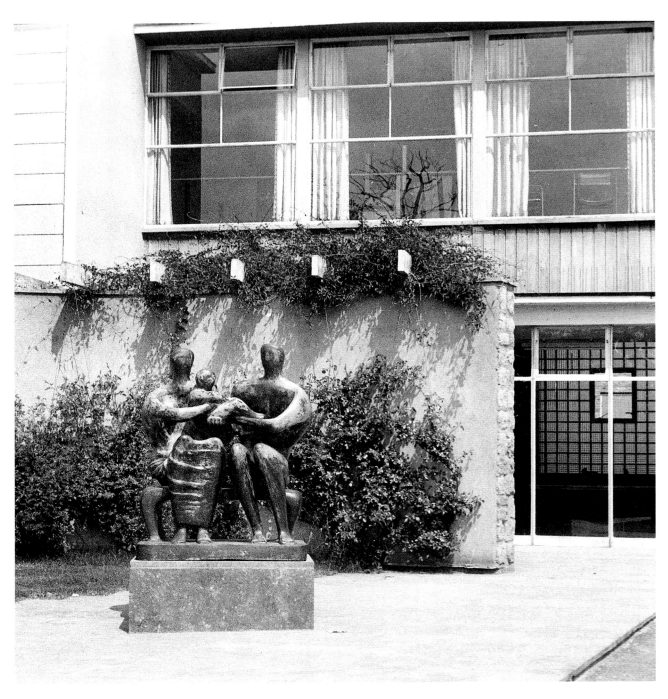

9 Henry Moore, *Family Group*, 1948–9, shown installed at Barclay School, Stevenage, in 1949

(1948–9; fig. 9) provided important models for a type of practice that was formally inventive while leaving no doubt as to the subject.[15] The openness of this approach enabled artists to develop personal vocabularies of eloquent, descriptive marks and forms that reveal empathetic interpretations of their subjects that bypass literal renderings. For such painters, colour became expressive rather than imitative, while paint textures ranged from translucent washes to viscous clumps that were scored, scratched or slapped on with a knife. Such techniques were integral to the fresh visions that would be revealed in works as different as those of Frank Auerbach and Peter Lanyon.

Although earlier social transformations had nurtured associated art practices, such as Soviet Constructivism and the Dutch De Stijl, in Britain it was left to individuals to map out their own courses, sometimes under extreme stress. Yet in his book *Places of the Mind*, the poet and critic Geoffrey Grigson was optimistic about post-war British landscape painting, recognising that contemporary painters had taken 'hold of the bone and substance, shape, and reality of landscape, in a near view. Painted or in a poem, an authentic landscape is no longer an illusion of a landscape in nature . . . A pictured landscape has become a thing, formalised, selective . . . an autonomous reality'.[16] Published in the same year as Clark's *Landscape into Art*, *Places of the Mind*, which coincided with Grigson's abrupt dismissal of Neo-Romanticism, was effectively an acknowledgement of the dynamic of modernism. Grigson's perception of landscape's cultural status was wide-reaching and up to date; he applauded a reciprocity between the work of contemporary artists and that of naturalists and ecologists in designating protected landscapes. Less perceptively, he deplored the 'preservation spirit' of the National Trust, believing that its 'museum spirit' would detract from the pleasures of individual discovery.[17] In the long term, his fears, no doubt stimulated by the frustrations of wartime restrictions, were shown to be groundless.

In the late 1940s the National Trust was developing a new policy with regard to country houses that their owners could no longer afford to maintain. James

Lees-Milne, Secretary to the Trust's Country Houses Committee (1936–44) and subsequently to its Historic Buildings Committee (1945–51), strongly favoured the case for central government support, which the Trust was reluctant to accept. In 1948 Lees-Milne recorded that the Treasury intended to establish a committee 'to deal with the problem of large country houses with collections'. He 'urged very strongly that the Trust ought to come to terms with the Government and indeed ask for, and accept, Government subvention, in spite of our hitherto having set our faces against the risk of state interference'.[18] The Trust had a long-standing commitment to 'nature conservation' which appeared to be incompatible with the new focus on historic houses, while the question of important gardens presented further complications.[19] The previous year the Royal Horticultural Society had proposed that a joint committee be formed 'to administer a small number of the best gardens in England'.[20] Hidcote House was the first property acquired by the National Trust primarily for its garden, shortly followed by Stourhead and Cotehele. To have shifted the Trust's focus entirely to buildings would have demanded a realignment of its thinking and purpose, as Lees-Milne acknowledged when he concluded: 'the dwindling countryside and the coastline of Great Britain cry aloud for immediate protection' and 'I sense that the Council of the Trust is of the opinion that the acquisition of country houses has had its day'.[21]

Land acquisition was encouraged by the foundation in 1949 of the Nature Conservancy as an agency for research and the protection of vulnerable areas. Following Beatrix Potter's bequest of 4,000 acres in the Lake District in 1943, the National Trust acquired Penrhyn Castle in North Wales with an estate of 42,000 acres that incorporated the Carneddau at the head of Nant Ffrancon Pass, the Glyders, Tryfan and Cwm Idwal, all major landscape features of Snowdonia.[22] A corresponding focus of interest for the Trust was marked by the foundation of the Neptune Coastline Campaign in 1965 to aid the acquisition of outstanding coastal areas. The Trust already owned 4,000 acres of north Cornwall and had added a further fourteen coastal sites by the end of the decade.[23] Its post-war shifts in emphasis

are of particular interest as indicators of the cultural value placed on certain kinds of landscape, especially those that might be considered 'wild', a construct that conveyed implications of unblemished nature, free from human presence.

In parallel, the huge extent of post-war reconstruction in cities encouraged the potentially controversial genre of urban landscape painting. It tends to have a lower status than images of the rural, suggesting that the city has conventionally been acknowledged as tainted in the way that was peerlessly defined by Hogarth. And if Hogarth is not the equal of Constable in popular affection, the disparity may be connected with perceptions of the city as essentially opposed to rural purity. The urban landscape has represented change, renewal and progress, whereas the rural has carried the weight of its past, of places that defy modernity because they must not change lest an idyll collapse. While the realist painters of the 1950s produced desolate images of urban domestic life, the fundamental changes to the post-war city were manifested in its architecture and associated public art. At the same time, the limitations of conventional urban landscape painting were challenged by Frank Auerbach's unprecedented building site series which he made between 1952 and 1963, of which *Shell Building Site from the Thames* (1959; see fig. 80) is an example.[24] Gripped by the immense depth and extent of the foundation excavations required for London's Shell Building (Easton & Robertson, Preston, Cusdin & Smith, 1957–62; see fig. 79), Auerbach compared the 'mountainous landscape' of its construction site with the Grand Canyon.[25]

## Tradition and Innovation

In the two decades following 1945 the practice of landscape art shifted from straightforward representation to an analytic process that involved considerations of place, topography and history, which were often conveyed through an abstract or semi-abstract format. In summary, the new post-war landscape painting may be understood as having evolved from views 'of' places to ideas 'about' them, while the rigid hierarchical scale that had elevated painting and sculpture over drawing and

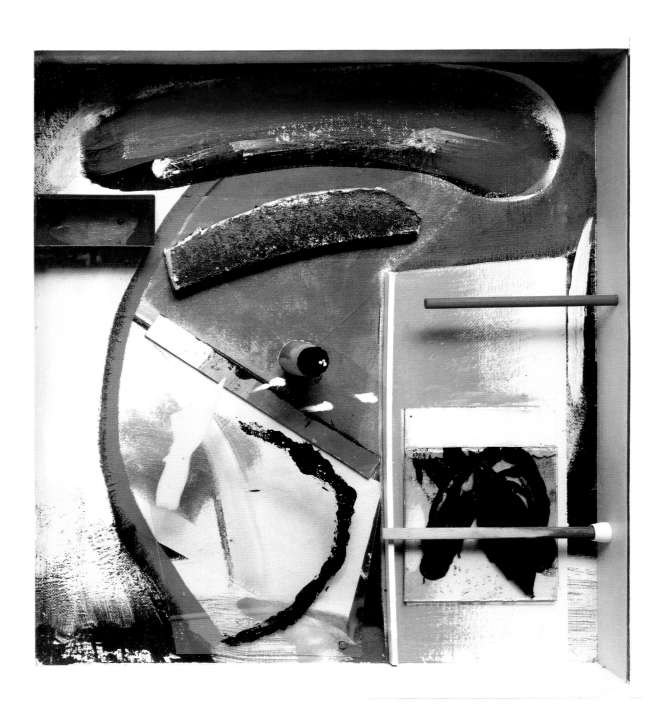

10   Peter Lanyon, *Turnaround*, 1963–4

print media gradually relaxed – though pockets of resistance persisted, particularly to the relatively new medium of photography. Nevertheless, over a period of less than twenty years critics were to acknowledge the progress made by artists from working within strictly classified conventions to a situation in which materials such as scraps of metal, Styrofoam, plastic, wood and glass had become routine constituents of works of such compelling complexity as Lanyon's *Turnaround* (1963–4; fig. 10).

In the spring of 1945 old divisions between innovators and traditionalists were reasserted when the painter-critic Michael Ayrton denounced Picasso's work as a destructive and 'vampire art, founded, not on the limitless gifts of nature, but on the dead body of the past'.[26] What he meant was that, for all his acknowledged brilliance, Picasso – whom he deemed to be uninterested in nature as a source for his work – was a nihilist whose sole aim was to uproot all the traditions of art, leaving nothing for his successors to build upon. Some months later when he visited *Picasso and Matisse*, the first major post-war exhibition from Paris, which opened at the Victoria and Albert Museum in December 1945, Ayrton was shocked to discover that, in his recent work, 'Picasso, giant that he is or was, has reduced himself *ad absurdum* to a caricature of "modernistic" art'.[27] Though Matisse's work was bypassed by most commentators, the paintings that Picasso had made during the Occupation of Paris, predominantly near-monochrome still lifes featuring animal skulls and candles, had a profound impact on many artists. Ayrton's comments initiated a controversy that ran through the decade and became conflated with a protracted, acrimonious debate over the validity of abstraction, although the terms of the disputes were clearly distinct from one another.[28] Whereas abstraction was condemned as immoral or deranged because it was held to cast doubt on the identity of the subject, objections to Picasso's work were prompted as much by his manner of painting as by his imagery. Bold, unmodulated brush marks, heavy outlines and flat colour, with prominent greys and blacks, found little favour with British commentators. The process of assimilation lasted until the mid-1950s, with artists well ahead of all but a handful of critics.

Many artists were desperate to regain their common European culture and to see the work of colleagues, especially those in Paris. A few institutions, among them the Central School of Arts and Crafts, the Institute of Contemporary Arts and the Artists' International Association, contributed substantially to the exchange of ideas and information, as did certain commercial dealerships, notably Gimpel Fils and the Redfern and Hanover galleries.[29] Nevertheless, the complex thrust to a modern aesthetic, stimulated primarily by Picasso's wartime work, first required the demolition of the cultural barriers that had become established by six years of conflict and isolation.

For William Gear this process began in 1946 when he decided to stay in Paris, remaining until 1950. He exhibited in Paris and London, as well as in the COBRA Group's *International Exhibition of Experimental Art* at the Stedelijk Museum, Amsterdam, in November 1949.[30] Gear did not share COBRA's international, Marxist ethos, nor did his paintings – typically constructed as blocks or *taches* (a patch or dab) of colour within intricate black frameworks – resemble those made by the COBRA artists, but while COBRA had little direct impact on British landscape painting, Gear's contact with the group enabled him to develop an idiosyncratic, aesthetically up-to-date visual identity that he sustained throughout a long career.[31] Gear was primarily interested in colour and though his canvases often indicate generalised landscape affinities, they make no reference to specific locations. An example of his approach is *Summer Garden* (1951; fig. 11), which has a characteristic structure of jagged black forms with dynamic flashes of brighter colours. Gear attributed this imagery to childhood memories of the Forth Bridge, as well as the Scottish landscape in which he grew up, where the pithead machinery of the coal-mining area made a deep impression.[32]

While his work was formed by his years in Paris, it brought him little immediate benefit when he returned to an England still bound by pre-war visual conventions. Although a modern aesthetic might occasionally be construed as patriotic, as it was in connection with the architecture of the South Bank Exhibition, Gear's *Autumn*

11   William Gear, *Summer Garden*, 1951

*Landscape* (1950), commissioned for the Arts Council's Festival of Britain touring exhibition, *60 Paintings for '51*, was condemned as scandalous when it won a government-sponsored purchase prize.[33] Because its title implicitly referred to the colours rather than the forms of landscape, it was understood to be fully abstract and therefore an inappropriate recipient of a major award. But widespread condemnation brought widespread publicity: Gear exhibited energetically and sold steadily, though he has not been sufficiently credited for his contribution to the evolution of informal, semi-abstract landscape painting.

His return to Britain in 1950 coincided with an intense debate on the competing merits of abstract and representational painting.[34] Polarised as on the one hand a matter of personal aesthetic choice and on the other as the product of sinister left-wing thinking, the debate was subtler than its extremes suggest, though it vigorously misrepresented a situation far more nuanced, confused and creative than a straightforward head-to-head. The American painter-critic Elaine de Kooning was to identify a concurrent situation in New York in 1956. Writing from a position of privileged knowledge of abstract art and artists, she remarked: 'There is . . . still a prevalent belief that abstract art is, per se, revolutionary; that representational art is, per se, reactionary'.[35] It is easy to overlook the extent to which artists communicate with each other to create situations in which apparently distinct conceptual approaches become inextricably mingled. Though the abstract/realist dichotomy remained an obsession for certain critics, fading away only when Clement Greenberg lost his dominant position, in practice, in artists' studios, as James Hyman has remarked, 'Realism was no more monolithic than abstraction'.[36]

When, in 1949, Lanyon told his mentor Naum Gabo that his painting was 'in the sense of landscape', he was caught in an acute personal dilemma, reluctant to explain to Gabo, whom he deeply respected, that he felt unable to follow him into pure abstraction.[37] Lanyon's understanding of landscape demanded a form of figuration, albeit one characterised by deliberate visual imprecision. It was to be articulated principally through colour deployed in marks that alluded to, rather

than represented the subject, an attitude to imagery that would increasingly be adopted by other painters as an alternative to literal recording or, conversely, pure abstraction. Lanyon's phrase, 'the sense of landscape', opens a space for the many strands of thought that contribute to the identity of places and landscapes and, incidentally, reflect the difficulty of translating them into visual form. Despite his admiration for Gabo's three-dimensional constructions, Lanyon was obliged to accept that his personal priority was landscape painting. The problem was to devise an approach that acknowledged the history, culture and character of a place while also alluding to its appearance. In practice this amounted to a new genre of painting, though Lanyon was not primarily inspired by aesthetic radicalism and insisted on the traditional nature of his practice. Many colleagues shared his reluctance to abandon representation. The semi-abstract painting that emerged from their struggles was hard-won; a radical, creative solution in a culture that resolutely shunned philosophical or theoretical thinking, especially in connection with the visual arts.[38]

## The Character of Places: Nikolaus Pevsner

In parallel with the profound and extensive changes to rural and urban landscapes that took place during and after the war, artists and historians have sought to reconstruct them visually and theoretically. A central figure among those who formulated perceptions of British art and, especially, architecture in the post-war period was the German émigré art historian Nikolaus Pevsner, best known for his immense architectural survey, *The Buildings of England*. He enjoyed a long, mutually beneficial association with the *Architectural Review*, initially as a frequent contributor from the mid-1930s, then as acting editor between 1943 and 1945 and thereafter as a member of the editorial board. In the context of early post-war architectural practice and critical thinking, a series of articles on the eighteenth-century Picturesque was among his most significant contributions. The Picturesque had first been defined in 1794 by Uvedale Price, in his *Essay on the Picturesque as Compared with the Sublime and the Beautiful*.[39] Pevsner's articles, which reasserted the significance

of the Picturesque for modern Britain, were commissioned by the proprietor of the *Architectural Review*, Hubert de Cronin Hastings, who had published his own initiatory essay on the subject, 'EXTERIOR FURNISHING or Sharawaggi: The Art of Making Urban Landscape', as an editorial in January 1944.[40] Hastings understood the Picturesque as the 'ideal urban landscape style, taken from eighteenth century landscape planners [who] delighted in variety, contrast and irregularity'.[41]

Pevsner set out his historically grounded theoretical position on the subject in his Reith lectures, broadcast in 1955 and subsequently published as *The Englishness of English Art*.[42] The epitome of 'Englishness' as he understood it, was the 'asymmetrical, informal, varied' picturesque landscape garden, first established by Alexander Pope at Syon Park and Lord Burlington at Chiswick House, both 'begun', Pevsner noted, 'about 1718'.[43] Central to the character of such a garden were the 'winding path' and the 'serpentine lake', which introduced 'such elements as surprise', which was echoed in the internal architecture of the houses.[44] The natural condition of a landscape was equally important, whether it was identified by untrimmed trees or rough rocks and waterfalls. Pevsner offered no comment on the ideology of the Picturesque, though Price had placed considerable emphasis on the picturesque garden because of its association with freedom: 'A good landscape is that in which all the parts are free and unconstrained, but in which, though some are prominent and highly illuminated, and others in shade and retirement; some rough, and others more smooth and polished, yet they are all necessary to the beauty, energy, effect, and harmony of the whole. I do not see how a good government can be more exactly defined; and as this definition suits every style of landscape . . . it equally suits all free governments, and only excludes anarchy and despotism'.[45] The point was evidently as apposite to post-war Britain as to the late eighteenth century, as would be demonstrated by the aesthetic of the modern Picturesque that distinguished the planning and architecture of the 1951 South Bank Exhibition, the primary site of the Festival of Britain (see Chapter 5).[46]

•

## St Ives: An Artists' Centre

A former fishing village, St Ives experienced a heyday as an artists' centre early in the twentieth century when the fishing industry was in decline; effectively, the cultural shift that was to establish tourism as the town's economic rationale was already starting. It has been emphasised that most of the modernist artists in St Ives were 'immigrants' and that the Cornish painting centres at St Ives and Newlyn, near Penzance, were effectively artists' colonies.[47] Cornwall had been immensely popular with artists since the late nineteenth century, when it 'became the most painted region of Britain outside London'.[48] Its appeal to predominantly metropolitan patrons was inseparable from its physical distance from the capital and the commensurate gulf between fishing villages and sophisticated urban life. Maritime villages with fishermen and boats were subjects with a near boundless appeal for urbanites, as was 'the realistic rural art that engaged directly with the locality and culture of the time'.[49] For the most part, early twentieth-century artists visited, painted and left again in a manner that might today be understood as exploitative, though it was insignificant compared with the long economic pillage of Cornwall by mine owners and associated industrialists. The tin and copper mining industries had begun to fail by the 1870s, resulting in large-scale emigration and a traumatised population, and which left the county with a rich inheritance of industrial archaeology and one of the most impoverished local economies in Britain.[50]

In the late summer of 1939 Hepworth, Nicholson and Gabo had moved to St Ives to avoid the bombing that was expected to annihilate London. Unequivocal modernists and leading participants in the Hampstead avant-garde of the 1930s, they had close contacts with continental European artists and had contributed to *Circle: International Survey of Constructive Art*, published in July 1937.[51] Edited by Nicholson and Gabo with the architect Leslie Martin, the book set out an idealistic, if not utopian, vision for the future. In Cornwall the trio not only kept alive the ethos of the Circle group but were able, through their contacts in London, to bring its influence to bear on forward planning for the post-war era.[52] Moving to Cornwall

was not without problems: the newcomers entered an established community with a conservative aesthetic identity and though they mentored younger artists and helped to establish the Penwith Society in 1948 as a prestigious local exhibiting organisation, internal tensions soon emerged. The distinction was no longer between sophisticated urbanites and picturesque fisher folk but between generations and between modernist and traditional painters. A further distinction emerged later between those who were content to exhibit locally and others who sought to show in Paris, Venice and New York and to associate with their peers in parallel artistic cultures.

Local divisions became evident in September 1946 when Sven Berlin, Lanyon, the printer Guido Morris, John Wells and Bryan Wynter, acknowledged collectively as the Crypt Group, showed their recent work in the first of a series of three exhibitions in the crypt of the deconsecrated Mariners' Chapel.[53] Though the Crypt Group exhibitions were subsequently celebrated as early manifestations of post-war aesthetic modernity, the first was vigorously attacked in the local press by the artist and illustrator Harry Rountree (1878–1950). His letters, which may even have encouraged attendance, stimulated a chorus of support from colleagues and contemporaries of the exhibiting artists, including the potter Bernard Leach and the maritime painter Robert Borlase Smart. That the participating artists had invited Smart to open their exhibition as a highly respected local figure indicates that the distinctions between practices that seem so clear today were a great deal more ambiguous in 1946.

At this time Cornwall was still remote, with poor road and rail connections (as late as 1970 Prunella Clough dismally recorded, '[London] w' P Heron in car 9¼ hrs').[54] Nevertheless, numerous colleagues made their way to the far south-west, some for brief visits, others for longer periods. Francis Bacon and the 'two Roberts', Colquhoun and MacBryde, found Cornwall invigorating and enjoyable for brief holidays, while Terry Frost and Roger Hilton tried it out for several years before settling there permanently. Wells and Lanyon, who had spent most of their lives in

the area, were set apart by their personal sense of affinity with it. Clough first visited in August 1948, noting the third Crypt Group exhibition in her diary. Publicity for the event had no doubt encouraged this restless, lively minded woman, who like so many others was desperate for new ideas, to travel to Penzance. Though Cornwall found no obvious resonance in her work she returned several times and had many friends in the area. On a visit in 1961 when she seems to have stayed with Heron and his family, she noted: 'Space flight film . . . next door house etc . . . St Ives 1-3 . . . St Just, Cape Cornwall . . . sup[per] Bryan Wynter . . . talk non-fig[urative]'.[55] For Clough, as for many artists, 'non-fig' (or abstraction) was a subject of compelling and enduring interest.

Her experience raises the question of the extent to which artists may be defined by their association with a certain area. Andrew Causey discussed this with reference to Lanyon, whose determination to develop a practice that was both demonstrably modern and rooted in Cornwall defined his work and consequently helped to establish his status as the leading landscape painter of the early post-war period. Successful regionalism, exemplified by his career, emerged from local cultures that drew on and developed from both national and international sources, 'setting up the creative tension between centre and periphery'.[56] Causey concluded that for Lanyon 'art was modern or it was nothing: there was no specific English variant of modernism'.[57] Yet this approach was not unproblematic in the context of the conservative mindset of the late 1940s when recent memory acknowledged the 'English countryside' as a primary reason for fighting the war.[58]

The question of regional priority was overtaken by the international aesthetic reputation that St Ives had acquired by 1959, when the town attracted the art critic Clement Greenberg and the painter Mark Rothko as visitors from the United States. Writing in 1977, Heron recalled that the 'sensational' annual exhibitions mounted by the Penwith Society had lured from New York to Cornwall such eminent dealers as Martha Jackson, Bertha Schaeffer, Catherine Viviano and Eleanor Ward.[59]

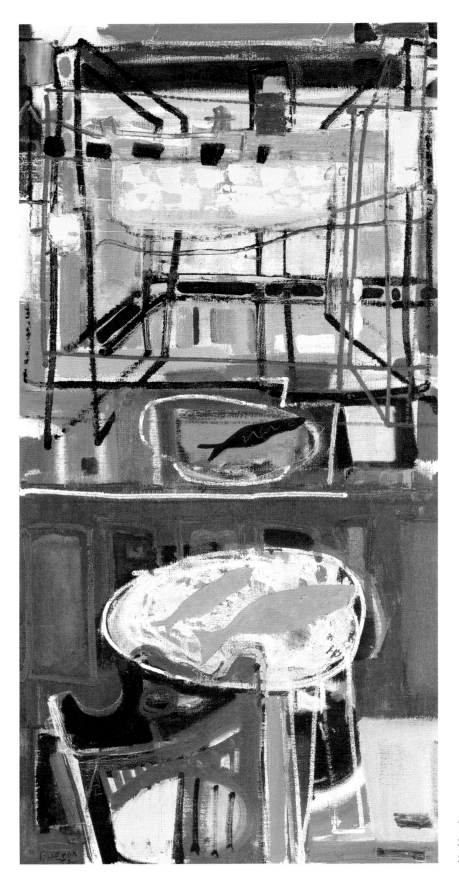

12   Patrick Heron,
*St Ives Window with
Sand Bar*, 1952

Because St Ives had previously been a refuge for certain pre-war Hampstead artists, it has also been understood as the seat of a dispossessed avant-garde. Yet Michael Bird notes that Hepworth and Nicholson had considered returning to London after the war and maintains that, had they done so, 'St Ives's temporary incarnation as an avant-garde outpost would have come to a natural close'.[60] Gabo left for the United States in 1946; Nicholson remained in Cornwall a decade longer before moving to Switzerland where he found more stimulating international contacts and opportunities. Only Hepworth stayed on in the centre of the town, an increasingly renowned international figure but one who had little contact with fellow artists other than her assistants.

Although St Ives has often been identified as having been the epicentre of English landscape painting in the mid-twentieth century, the post-war generation developed remarkably complex perspectives on subject matter in which they were as likely to merge body, still life and landscape in a single image as to distinguish between them. Heron's *St Ives Window with Sand Bar* (1952; fig. 12) combines a still life with a distant view of Smeaton's Pier on the seaward side of the harbour, the distance between them denoted by a scarlet window frame. In the early 1950s William Scott and Hilton briefly developed parallel approaches to painting in sparse, linear, black-and-white images that updated the old theme of metamorphosis between body and landscape in which both are implicit but neither is dominant, as is evident in Scott's *Figure into Landscape* (1954; see fig. 29).

Scott and Hilton were not primarily landscape painters but those who were found that the picturesque qualities that made St Ives so attractive to visitors rendered it problematic to artists interested in developing an expression of reality more complex and up to date than the traditional 'view'. This dilemma was at the core of Lanyon's thinking in 1949 when he was struggling with the need to devise a fresh formal and thematic approach to landscape painting. His solution was to develop a visual shorthand that enabled him to present places in the form of painted equivalents of collage, with disparate viewpoints set side by side and prominent features moved

13   Peter Lanyon,
*Porthleven*, 1951

or omitted. *Porthleven* (1951; fig. 13) is neither abstract nor vaguely generalised, though its links with the small, south-coast fishing port are not immediately obvious. Lanyon's painting shows a plan view of the sheltered entrance to the harbour and its two basins, with the prominent clock tower at the top.[61] Certain places, to which he returned over years, including Porthleven, stimulated large groups of work in various media, one of which, based on the harbour at Portreath on the north coast, ran virtually throughout his career. Frost similarly made a group of works in diverse media related to his *Walk Along the Quay* (1950; see fig. 45) which developed in a comparable way but with fewer overt references to the original site (see Chapter 3). Both painters were fundamentally concerned with place, with which they took enormous liberties, recalling Nash's habit of combining different locations on a single canvas, in contrast with the strong sense of the priority of topography that was shared by the group of artists who lived and worked in Great Bardfield in Essex.

## Great Bardfield

Set in flat agricultural land, the small town of Great Bardfield first became a focus for artists in 1925 when Eric Ravilious and Edward Bawden rented rooms in the Brick House in the town centre. Bawden later bought this distinctive building which was to become a symbol of the circle of artists associated with him. By 1940 they included Eric Ravilious (who died over Iceland in 1941), his wife, Tirzah Garwood, John Aldridge – whose painting *Builders at Work, Brick House, Great Bardfield* (1946; fig. 14) was an early indication of the building's significance – Michael Rothenstein and Kenneth Rowntree. After the war John Nash lived nearby and joined the group. Identified by their allegiance to high-quality, quasi-academic painting, these artists embraced a range of local subject matter.

The Essex artists were adamant that they were not a formal group and did not have a common visual approach. They did, however, share an obsession in the late 1940s with agricultural subject matter, demonstrated in paintings of ancient, decrepit farm

14   John Aldridge, *Builders at Work, Brick House, Great Bardfield*, 1946

machinery. Michael Rothenstein's *Untitled (Farm Scene)* (1945; fig. 15) suggests an awareness of living in a moment of change when a familiar, unspectacular landscape would vanish, together with the ancient rural crafts that it had nurtured. The threats to survival stimulated a flurry of books that sought to record places, people and their skills. Aldridge illustrated Henry Warren's *Adam was a Ploughman* (1947), while Noel Carrington's *Life in an English Village* (1949) was devised and illustrated by Bawden.[62] The latter was published in the King Penguin series, which Pevsner co-edited from 1942.

As others discovered, place attachment alone did not provide a living; London offered the primary market where artists' work could be seen by critics and colleagues, while the stimulating conditions and complexity of the city encouraged experiment. In addition to paintings, Bawden produced a large quantity of murals and graphic work, from book illustration to poster designs, as well as several series of

15   Michael Rothenstein, *Untitled (Farm Scene)*, 1945

very large linocuts which depicted common features of the urban landscape such as monuments and markets. His full *oeuvre* reveals an eclectic interest in architecture, from flint-knapped Essex churches to Victorian cast-iron structures, and a powerful ability to convey the spirit of his subject as well as its appearance. The unspectacular Essex landscape that proved so fruitful for Bawden and his colleagues does not appear to have been a site for engagement with local people and their modern farming economy.[63] Artists and farmers lived, it seems, parallel lives, yet the artists' belief in the need to retain and record the character of the place to which they were so deeply attached is one of the features that most clearly distinguishes Great Bardfield from St Ives. For all the modernity of Bawden's graphic work, it seems that the Essex artists remained largely embedded in a past imbued with nostalgia, whereas their colleagues in Cornwall were oriented to the future.

•

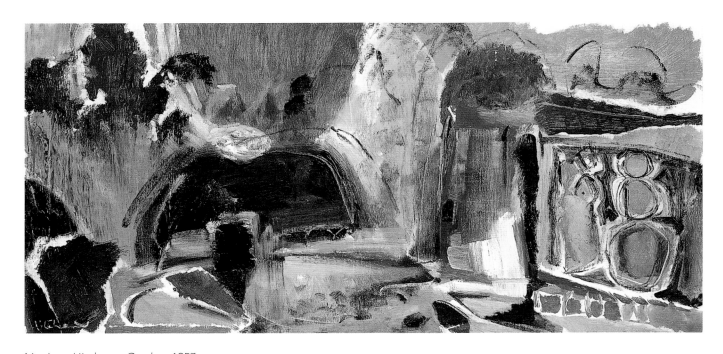

16   Ivon Hitchens, *Garden*, 1957

## The Cultivated and the Wild

Like Nash, Ivon Hitchens was both a modern and a romantic artist, who moved with his family from London to Lavington Common in Sussex in 1940 when his studio was bombed. He bought a six-acre plot on the Common where he built first a studio then a house, which was set in a very large garden, while his wider territory embraced the considerable extent of the surrounding countryside. *Garden* (1957; fig. 16), arranged in Hitchens's wide, horizontal format, is loosely divided into three spatially distinct segments. On the right a balustrade suggests a terrace adjacent to the house while the centre is occupied by a pool which merges into a dark, recessive thicket of foliage on the left. In 1944–5 Hitchens had adopted the same format for a group of nineteen canvases known as the *Terwick Mill* series, which focused on the watermill on the River Rother near Midhurst. The series, with its distinctive format, not only established Hitchens's dominant aesthetic for a lifetime but provided an early, authoritative example of a mode of semi-abstract painting that combined natural colour with bold, sweeping brushmarks.

While Hitchens's paintings of his garden and its environs epitomise the joy of domestic cultivation, other artists were attracted to the harsh territory of Snowdonia. Numerous painters have visited North Wales since at least the eighteenth century when Richard Wilson depicted his home territory in a classicising mode. J. W. M. Turner made sketching trips to Wales in 1798 and 1799, followed by numerous painters, printmakers, draughtsmen and photographers. The dramatic scenery of Snowdonia, a relatively compact region, inspired in Turner and others the spirit of the Sublime that Uvedale Price defined as being 'founded on principles of awe and terror'. It was this, a concept that David Fraser Jenkins suggests 'he probably thought of quite consciously in the eighteenth-century sense of the word',[64] that John Piper seems to have experienced there.

Piper first visited Snowdonia in 1943 when the War Artists' Advisory Committee invited him to paint the interior of the Manod caves, where part of the nation's art collection was being stored for safety. Unfortunately, the darkness inside the caves made painting impossible, but he took the opportunity to familiarise himself with

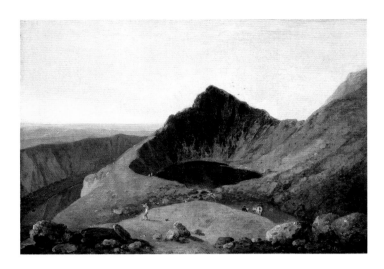

17   Richard Wilson, *Cader Idris, Llyn-y-Cau, c. 1765–7*

the area, walking and cycling extensively. Returning a year later, he started a group of works in various media that David Fraser Jenkins has suggested were inspired by the pictorial formula of Wilson's painting *Cader Idris, Llyn-y-Cau* (*c*. 1765–7; fig. 17) in which a lake is partially surrounded by hills that are reflected in the water.[65] If Piper searched for the exact view that Wilson had painted he must have been disappointed for, as David Solkin has pointed out, Wilson had invented the extensive rocky foreground and even the shape of the lake, to present 'a type of gentleman's utopia . . . where he can devote his energies to discerning the wilds of nature . . . a pastoral paradise, redolent of ancient and modern liberty and inhabited by primitive but contented rustics'.[66] Not for the last time, Wales was rendered fictional, a place apt for pictorial and ideological construction.

By contrast, Piper, who regularly visited Wales from the mid-1940s to the mid-1950s, made only small alterations to the scenes before him. He recorded geological formations and made detailed notes on the shifting colours of rocks and clouds, though he rejected the possibility of drawing 'naturalistically' because 'the result looks nothing like the real thing. The scale is gone; the colour is vague and impersonal . . . and the rocks are shapeless'.[67] He explained: 'Against mountain grass or scree, against peaty patches near tarns, on convex slopes, in dark cwms, – the same kind of rock can look utterly different: and changes equally violently in colour according to the light and time of year. The rocks are often mirrors for the sky, sometimes

18   John Piper, *Llyn Du'r Arddu – A Lake under Snowdon*, 1946–7

antagonistic to the sky's colour; they can react to a shower of rain like dried pebbles with the wash of a rising tide on them.'[68]

For basic information he turned to old guidebooks, reading Thomas Pennant's *Journey to Snowdon* (1781) and visiting the places described, while his antiquarian instincts also led him to Edward Pugh's *Cambria Depicta* (1816), illustrated with seventy hand-coloured aquatints.[69] Some of the most dramatic landscapes in North Wales referred to in such books are the north-facing cliffs, beloved of rock climbers, that rise bare, dark and sheer at the heads of valleys. The dramatic, 600-feet-high face of Clogwyn Du'r Arddu – 'a concertina of blank vertical walls' – on the north flank of Mount Snowdon has been described as 'the most formally beautiful and architectonic of British cliffs'.[70] Piper painted *Llyn Du'r Arddu – A Lake under Snowdon* (1946–7; fig. 18), its deep green lake coloured by copper deposits, from

a position on Maen Du'r Arddu, a small moraine immediately north of the lake. He delineated the fissures and clefts of the rock face, altering only the positions of some of the boulders at its foot; lightened the tone of the all but sunless rock face; and painted the lake almost black.

Such attention to the physical reality of the landscape was part of Piper's romantic vision. For him, romanticism was the motor of British art and William Blake was 'the true romantic', citing his insistence on imagination, definition and detail.[71] Piper, who has been widely identified – and perhaps identified himself – as a romantic artist, began his book, *British Romantic Artists*, by describing the genre as 'something that for a moment seems to contain the whole world; and, when the moment is past, carries over some comment on life or experience besides the comment on appearances'.[72] It was in this tradition, informed by an historical perspective, detailed geographical knowledge of the area and technical expertise, that he rendered Wales.

## Dialogues and Exchanges

As ever, there was constant traffic between periphery and centre. Just as Bawden travelled to London from Great Bardfield to make pictures of the city, many of the artist-visitors to St Ives were London-based, among them a number of constructive artists.[73] In 1950 Ben Nicholson invited Victor Pasmore to Cornwall, where Pasmore made drawings of the waves on Porthmeor Beach, as did Adrian Heath, who visited at about the same time. Both developed their drawings into paintings, but, whereas Heath's were unequivocally abstract, Pasmore, who at this point was unable to abandon representation, produced an extremely accomplished group of paintings based on spirals and wave forms which he exhibited at the Redfern Gallery in the winter of 1951–2. They included *Square Motif, Blue and Gold: The Eclipse* (1950; fig. 19), which, despite the band of small, Klee-like geometric shapes, retains the basic format of a landscape, with sky, sun or moon, clouds and horizon line.

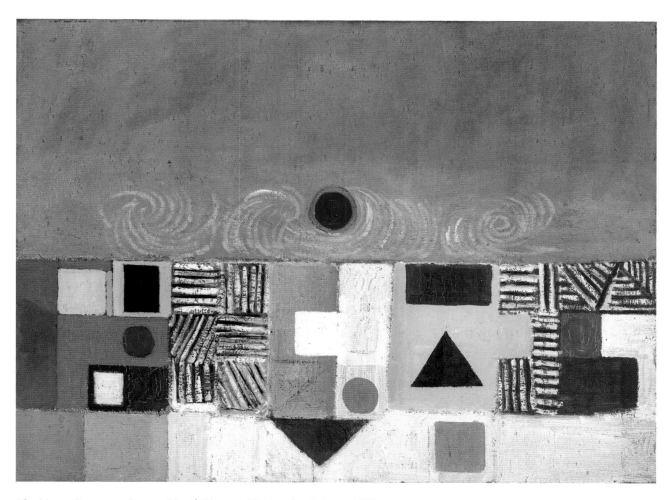

19   Victor Pasmore, *Square Motif, Blue and Gold: The Eclipse*, 1950

Subsequently, a diverse group of artists associated with St Ives was invited to take part in three exhibitions held in London in Heath's Fitzroy Street studio during weekends in 1952 and 1953.[74] Though these occasions have since acquired near-mythic status, very few contemporaries were aware that they were happening. Photographs of the exhibitions show works by, among others, Nicholson, who took the opportunity to reinvent still life in an up-to-date form, often dismissing the conventional domestic setting for an indeterminate, landscape-related context.[75] His *December 1951 (St Ives – Oval and Steeple)* (see fig. 109) shows a distant view of the town in which the steeple of the Catholic church is the most prominent feature.

It doubles as a bottle at the centre of an elaborate still life, through which the harbour may be seen in the distance.[76] Both Nicholson and Pasmore adopted still life as a default mode when they were trying to devise a visually satisfactory form of abstraction, perhaps because it was open to formal experiment.[77]

Such exchanges and dialogues were also international. Metropolitan bias allied to the problems of inadequate roads, slow trains and ancient cars ensured that nearly all important early post-war exhibitions took place in London. As early as December 1945 London was host to the first of a succession of international exhibitions of painting by pioneers of modernism. *Picasso and Matisse* (1945) initiated the resumption of international cultural exchanges, followed by *Paul Klee* (1945–6), *Braque and Rouault* (1946), *Vincent Van Gogh, 1853–1890: An Exhibition of Paintings and Drawings* (1947) and *Fernand Léger: An Exhibition of Paintings, Drawings and Book Illustration* (1950).[78]

These exhibitions, which introduced some of the leading painters of the century to an immensely enthusiastic public, also contributed significantly to the development of a new aesthetic as artists responded to their examples. The Klee memorial exhibition, for example, which was so popular that it led to several new books on Klee's work and the publication in English of his own text *On Modern Art*, had a considerable impact on such artists as Pasmore, who responded to the unpredictability of Klee's small forms and the individuality of his unsettling vision. Another artist for whom Klee was especially important was Alan Reynolds. Serving in the army of occupation in Hanover in 1946, Reynolds discovered in the Landesmuseum not only paintings by Klee and members of the early twentieth-century Die Brücke and Blaue Reiter groups, but also more recent abstract works by Friedrich Vordemberge-Gildewart and Kurt Schwitters. From these artists he absorbed the way that they constructed an abstract image from geometric forms: a triangle, a circle, a line, 'piece by piece'.[79] This process demanded a way of thinking totally unlike the more usual English manner of converting a visual experience into semi-abstract form by omitting detail or adding non-specific shapes. It took Reynolds some years to put into practice

what he had discovered in Hanover. After demobilisation he studied at Woolwich Polytechnic School of Art and the Royal College and launched into an astonishingly successful early career as a landscape painter. Klee's example, Sutherland's early post-war work and the omnipresent Nash led Reynolds to construct his images as, typically, a band of buildings across the centre of the canvas, punctuated by spiky, static foreground plants. He would habitually go into the Kentish landscape and make notes, then return to his studio and 'compose from his imagination'.[80] Gradually the buildings disappeared, leaving only plants and geometric shapes, but at the moment when Reynolds seemed poised to leap into constructed abstract art, he embarked on a group of colourful, superficially conventional landscape paintings. They include *Kent Summer* (1953; fig. 20) in which the close-up foliage, reminiscent of a late Neo-Romantic flourish, was the beginning of a new approach. The centre of the canvas is filled with a structured pattern of green and yellow triangles indicating, with hindsight, Reynolds's future as a constructive artist. For him, as for Pasmore, landscape appears to have been a vehicle through which he could develop an individual pictorial form.

Unsurprisingly, the rising generation of post-war European artists who became role models for aspirational British counterparts were those whose work diverged most obviously from the conventions of British painting. Hans Hartung, Jean Dubuffet, Nicolas de Staël, Pierre Soulages, Antoni Tàpies and members of the COBRA group were among the most significant continental European painters for the post-war generation, though the routes by which their British contemporaries learned about, processed and made use of their work were far from straightforward. British landscape painters devised sophisticated syntheses of their subjects with French formal models. Scott and Heron, for example, on occasion followed Braque closely and adopted de Staël's distinctive marks, laid down in voluptuously thick oil paint.

De Staël's solo exhibition at the Matthiesen Gallery in London in February 1952 caused a sensation in the studios. Even Berger, not known for his admiration of abstract painting, found 'the quality of the paint and the . . . relationship of colours

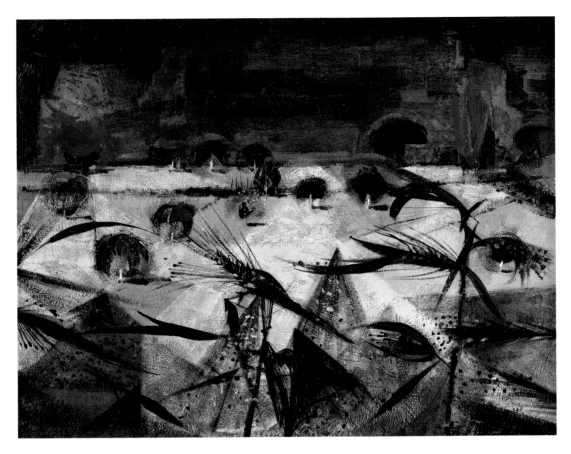

20   Alan Reynolds, *Kent Summer*, 1953

and shapes' exciting.[81] John Russell for the *Sunday Times* considered de Staël 'the most interesting new painter of the last four or five years' and his canvases 'not pictures of something, but autonomous objects existing in their own right'.[82] Autonomy was a critical buzzword for an abstract work that appeared to have no subject; de Staël evoked it because he embedded his subjects in the texture of his paint, a practice that was to be adopted by Feiler and Scott. A regular visitor to Cornwall since 1950, Feiler settled in the county in 1953. His *Black Rocks with Blue Harbour* (1953; fig. 21) echoes de Staël's work, notably in the solidity of marks that appear almost to be carved in pigment. Yet Feiler's paintings remain distinctive, especially for their muted colour, often grey and cream tones set out in characteristic rectangular blocks.[83]

21   Paul Feiler, *Black Rocks with Blue Harbour*, 1953

22   Jean Dubuffet, *Table de forme indécise*, 1951

If de Staël provided a readily appropriated formal model for imagery and surfaces, Dubuffet's work was more complex. It had developed in response to the problems of the post-war era, a deeply divided terrain that was discussed as penetratingly by philosophers and critics as by artists. Few, if any, English painters had encountered Existentialism or Dubuffet's source material, which encompassed prehistoric and non-European art, that of children and psychiatric patients, as well as the anonymous stains, scrawls and graffiti recorded in Paris by the photographer Brassaï. Dismissing the long French tradition of *la belle peinture*, with its evident rationality and aesthetic skill, Dubuffet maintained that a painting should demonstrate the artist's struggle to achieve a desired image and that it should be physically formed by pigment itself, smeared, scratched and heaped in the thick masses known as *hautes pâtes*.

Throughout the 1950s Dubuffet consistently showed his latest work in New York as well as Paris, where it was seen by Paolozzi, Turnbull, Freud and Bacon, who may have encouraged the ICA to exhibit it the spring of 1955. Its most significant feature was seen to be a surface texture in which scored and battered pigment was rendered almost sculptural (see fig. 22).[84] Commenting on the artist's text in the catalogue of his 1954 New York exhibition, in which he related human flesh to the textures of earth, rock and bark, Frances Morris wrote, 'The impression these images gave of the "body-as-landscape" was intentional'.[85] It was a far more brutal, shocking rendering of the body-as-landscape than the equivalence between human contours and hills favoured by British artists.

Artists often mentioned Pierre Soulages as a significant role model. Heron commented on the single, untitled canvas shown in 1952 in *Young Painters of l'École de Paris* as 'the finest in this whole exhibition' (1951; fig. 23).[86] At that time Soulages was exploring what J. J. Sweeney described as effects of dark and light: his signature black lines, either straight or curved, were thin and closely grouped to create an illusion of bright, coloured light appearing from behind them. This technique produced markedly spatial canvases with strongly textured, scraped and stippled surfaces. By 1955, when Soulages first showed at Gimpel Fils in London, he was

23   Pierre Soulages, *Untitled*, 1951

laying paint down in broad palette-knifed strokes with squared-off sides that are almost sculptural in their solidity. If Soulages's work was not directly imitated to the same extent as de Staël's, it seems to have been widely experienced as a compelling demonstration of rendering light and space, in which respect it made an important contribution to British abstraction.

Less well-known than these artists are the German émigré and refugee artists, mainly sculptors, who made a significant contribution to the public spaces of post-war Britain.[87] Siegfried Charoux, Georg Ehrlich, Franta Belsky, Heinz Henghis and Peter Peri, all of whom had been trained to make public art, were among those who formed a strong presence in the South Bank Exhibition and subsequently played an enduring part in the reconstruction of London and other cities, often through sculpture commissioned by local authorities. Peri's singular contribution took the form of reliefs and idiosyncratic free-standing works (see fig. 24), many of which he made for the Leicestershire Education Authority in response to the scheme run by its Director of Education, Stuart Mason, to place art in its numerous buildings.[88]

## A Definitive Shift

Early in 1956, when the painter and critic Andrew Forge was arranging *10 Years of English Landscape Painting 1945–1955* for the ICA, he recognised a change in the status of landscape art. He commented that it was no longer 'a prime mover'; that rather than being a marker of national identity as it had been during the war, it had become, as Clark had recognised, a medium for individual expression.[89] If Forge found this loss of status distressing, it might be argued that it was an inevitable by-product of the economic recovery, since in that context national identity depended on a demonstrably renewed, re-industrialised society that might be more cogently expressed by realist painting and sculpture.

There is no identifiable point at which confrontation with the unfamiliar became acceptance, but by the mid-1950s a definitive shift had taken place in attitude and practice. The privations and restrictions of the immediate post-war period were

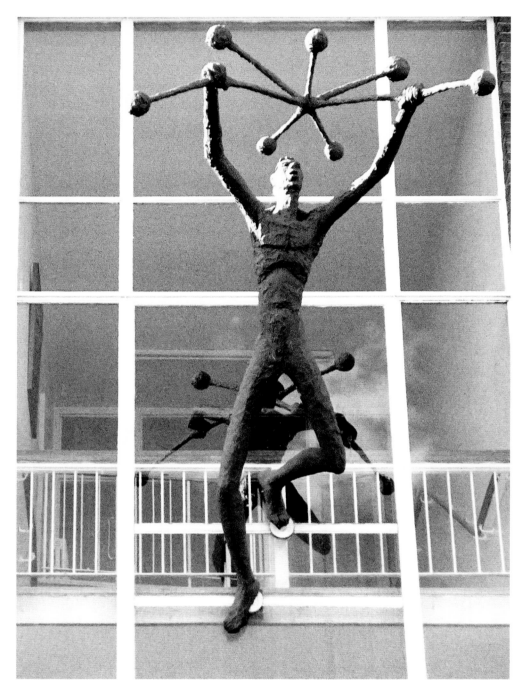

24  Peter Peri, *Man's Mastery of the Atom = Self Mastery*, 1957, sited at Longslade
Community College, Leicestershire

over: the promise of modernity, manifested by full employment, car ownership, domestic machinery and entertainment delivered by television into every living room was sufficiently widespread for artists and lay-people alike to exploit and extend its possibilities. Early in 1956 *Modern Art in the United States* opened at the Tate after a lengthy tour of western European capitals, with a small selection of Abstract Expressionist paintings including work by Jackson Pollock, Willem de Kooning, Robert Motherwell and Mark Rothko, which underlined messages already received from Paris.[90] By 1956 British art was to be seen in Venice and Saõ Paulo and in galleries across Europe and North America; the Royal College of Art was poised to become a hothouse of invention, while increasing international travel offered unprecedented opportunities for aesthetic dialogue, interaction and commerce. As the infrastructure of the art world developed, landscape art mutated, developing new forms in reaction to external stimuli as well as to domestic social developments.

25   Jackson Pollock, *One: Number 31*, 1950

26   Jean-Paul Riopelle, *Le Printemps*, 1952

# 2   Landscape in the Post-war Art World

After the war, the complex system known as the art world, which combines commerce, educators, critics and artists, was reconstructed as thoroughly as the shattered streets and buildings. It was highly centralised, with the art market situated firmly in London, as were most independent dealers. The rest of the country, widely referred to in contemporaneous accounts as 'the provinces', was largely dependent on municipal galleries for aesthetic stimulus. Many of them had excellent collections that focused predominantly on the period when they were established in the late nineteenth century, taking little account of more recent developments. There was not, in summary, a great deal to engage innovatory contemporary artists.

In 1953 two exhibitions in London concentrated on the way some painters disregarded conventional subject matter in favour of abstract mark-making. The first, *Opposing Forces*, which was visited by relatively few people, was held at the ICA. Devised by the French critic Michel Tapié, it was a variant of his *Véhémences confrontées* exhibition that had opened in Paris in March 1951. Although *Opposing Forces* has since become memorable as the first occasion on which a major work by Jackson Pollock, *One: Number 31* (1950; fig. 25), was exhibited in Britain, the painting in fact attracted virtually no comment at the time. Indeed, it would be another three years before British critics recognized the power of Pollock's work or that of his American colleagues. Of far greater immediate consequence were the works in the exhibition by such contemporaries as Georges Mathieu, Sam Francis, Henri Michaux and Jean-Paul Riopelle (see fig. 26). Of particular significance was the individual mark or *tache* that some British artists adopted as an important element of their own work, notably Gear and Heron as discussed in the previous chapter.

The second exhibition, which opened at the Hanover Gallery in July 1953, was *Space in Colour*, curated by Patrick Heron. Its purpose was to demonstrate Heron's long-held conviction that the most important aspect of any painting was the artist's

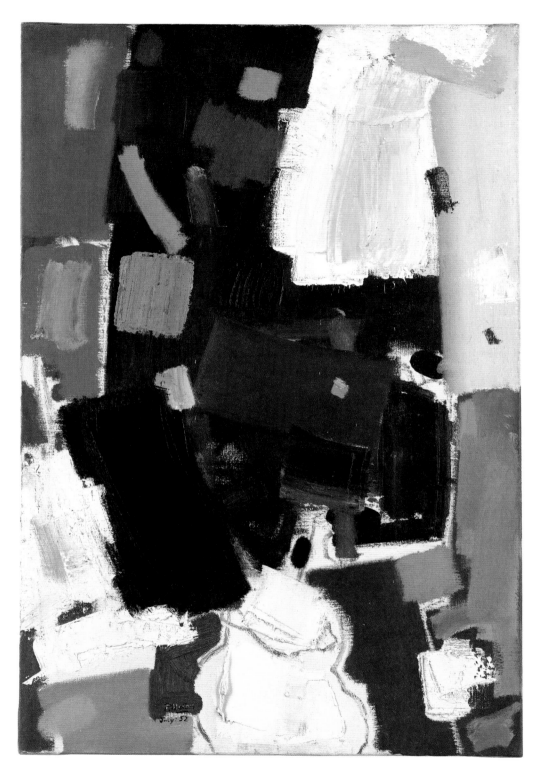

27   Patrick Heron, *Square Leaves (Abstract): July 1952*, 1952

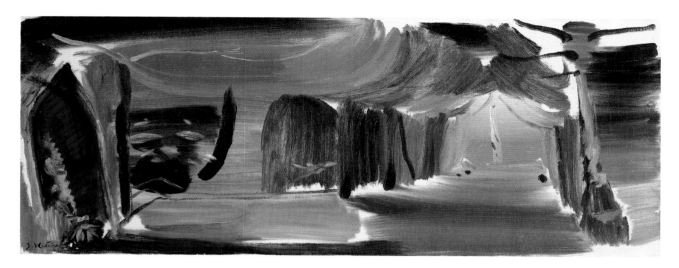

28   Ivon Hitchens, *Winter Walk 3*, 1948

ability to use colour to evoke a sense of space behind and in front of the surface. He maintained that the quality of spatial illusion – which he considered to be the primary purpose of all worthwhile painting – could only be achieved through a sophisticated use of colour.[1] At its simplest, spatial illusion in painting relies on the way that light, bright colours appear to advance in front of the canvas while darker tones recede; just as dark trees against a pale sky create a sense of great distance in an eighteenth-century painting, bright colours 'float' off the surface of a canvas. It was a far from a new idea, but no other writer or curator had applied it with such conviction to contemporary painting.

Among the landscape paintings that Heron selected to demonstrate the inseparability of space and colour were four of his own works, one of which, *Square Leaves (Abstract): July 1952* (fig. 27), is an indubitably spatial image in heavy impasto and an homage to de Staël.

He also chose landscapes by Hitchens, William Johnstone and Lanyon. Hitchens's *Winter Walk 3* (1948; fig. 28) is a persuasive demonstration of Heron's argument. It is a panoramic, winter-brown landscape, in which the tunnel of trees on the right is the focus of Hitchens's experiments with colour. It appears as a receding, light green space in strong contrast with the dominant warm tones. Rudimentary marks reveal with some precision vertical dark brown tree trunks in a landscape of red-brown

horizontals, confirming that in Hitchens's work 'the identification between object and painted mark is complete'.[2] Effectively Hitchens devised an abstract process, albeit one that depended on a clear differentiation of coloured marks that could equally well have found their place in a figurative painting.

While Hitchens painted more or less what he saw, from 'a single viewpoint', Lanyon habitually brought together diverse 'viewpoints, including aerial ones', as he did in *St Just* (1951–3; see fig. 55), which was first exhibited in *Space in Colour*.[3] A large, complex image, it amounts to a visual exploration of various places and spaces in and near the small Cornish town of the title, though to grasp the connections between the frontal view of the black mineshaft that runs up its centre and the bird's-eye views of houses and fields around the sides requires knowledge of Lanyon's numerous comments on the painting in jottings and letters. Why he felt impelled to depict the place in this way is revealed in a letter he wrote to Terry Frost two years later in which he commented, 'Abstract Art has let us see & relate ourselves freshly to experience. It has given us new space & new tools but we must now use it'.[4]

In a bold, inventive decision, Heron also selected several monochrome works by Victor Pasmore, each catalogued as *Black and White Motif (Photostat Collage)* (1953).[5] The medium was unprecedented at a time when collage was adventurously modern, photographic techniques were sharply distinguished from 'fine' art, and the photostat was associated principally with office work. Pasmore's process was both playful and complex: he would 'make a photostat of a collage, then cut up part of this or another collage or photostat and use it to alter the composition, from which he then made another photostat . . . and so on, until he was satisfied that the design was complete'.[6] Heron explained his selection, asserting that 'blacks, whites and greys' were as capable of demonstrating pictorial space as full colour: 'it is a physical impossibility to paint shapes on a surface, using different colours in a variety of tones, and avoid the illusion of the recession of parts of that surface'.[7] Though Pasmore's photostat collages were not landscape-inspired, their spatial properties set them in close relation to landscapes both real and depicted, especially in photographic form.

Heron was a powerful critic, respected by artists because he was himself a painter. In the early 1950s his criticism lay between two distinct positions: the philosophically inclined writing of Herbert Read and the modernism associated with Clement Greenberg, which only began to be absorbed by British artists later in the decade. Greenberg maintained that a painting's purpose was to explore its own physical properties such as colour, surface, edges and – centrally – flatness, thus obviating illusion. Heron's exhibition was an investigation and demonstration of his near-obsessive engagement with the spatial implications of colour. In defining optical space as a product of colour, he also drew attention to the distinctions that might be made between various kinds of pictorial and physical space. An important result of the debate that he stimulated was the recognition that painterly space contributed significantly to understanding the physical, geographical spaces represented in such non-realist images as Lanyon's *St Just*. Today, in retrospect, *Space in Colour* is recognised as a definitive exposition of a central theme in post-war British painting.

If *Opposing Forces* and *Space in Colour* made significant contributions to artists' working practices in 1953, *Nine Abstract Artists* was no less important in 1955. The exhibition, which was held at the Redfern Gallery in January, was accompanied by a book titled *Nine Abstract Artists: Their Work and Theory*, edited by Lawrence Alloway at the artists' invitation.[8] Echoing Heron's preoccupations, Alloway's quest was to identify a form of painting in which pigment itself was the subject, evidently a position towards which painters had been moving for some years. Frost, Hilton and Scott were among the participants.[9] Scott showed *Figure into Landscape* (1954; fig 29), with a group of sparse paintings, in which the motif simultaneously reads as a rudimentary still life and a seated figure. Hilton, painting in blocks of solid colour on light grounds, had made some of the most abstract and intensely spatial paintings of the early 1950s, in which he approached Heron's position on space and colour through the example of Piet Mondrian rather than Heron's preferred French models.

29　William Scott, *Figure into Landscape*, 1954

The primacy of European modernism for British artists received a sharp corrective in January 1956 when the exhibition *Modern Art in the United States* opened at the Tate Gallery. Arriving at the end of an extensive tour of western Europe during which the Americans were hailed as the progenitors of a new art, the single room that included works by Rothko, Pollock, de Kooning, Motherwell and Franz Kline enthralled British artists, who were well prepared for innovative demonstrations of pure colour and gestural marks by earlier encounters with French art. As a result, the American exhibition tended to be acknowledged as a confidence-boosting

confirmation of work in progress. Grafted on to British practices already steeped in current French painting, its rapid appropriation portended not so much a change of direction as a confirmation that British painters were in line with their international colleagues. Lanyon's gliding paintings, Heron's garden series and his interpretations of Rothko were to be among the results of the fusion. *Modern Art in the United States* had produced a context within which ambitious landscape painting such as Lanyon's and Heron's might be understood and critically acknowledged. Consequently, whereas in 1956 landscape had been pronounced a genre without a future, by the end of the decade its status was well on the way to being transformed.

## Re-making the Urban Landscape

Landscape's renewal, as subject and concept, was to take place in both urban and rural contexts since it was clear by 1956 that the critical perception of landscape had, like the painter's, fully incorporated urban territories. This was also a moment when any ambitious architect was obliged to adopt a position vis-à-vis Alison and Peter Smithson, who had designed the pioneering Smithdon High School at Hunstanton in Norfolk (1950–4). In December 1952 *The Times* carried a comment complaining of Hunstanton's 'brutal realism',[10] though the phrase 'the New Brutalism' was only to appear in print a year later.[11] Nikolaus Pevsner was to describe it some years later as 'a ruthlessly spare building conceived as a steel frame completely glazed, or nearly so . . . the forerunner of the Brutalist movement in British architecture'.[12] Early in 1955 the Smithsons published a statement on the architectural principles manifested at Hunstanton. They asserted that Brutalism's central feature was respect for building materials: in the case of the Smithdon School this was raw concrete (béton brut), as used by Le Corbusier and contemporary Japanese architects.[13] Le Corbusier combined concrete and brick in his much-discussed Jaoul houses (1955), of which it was remarked three decades later that they 'can still shock with the extreme roughness of the brickwork, the bold exposure of plywood facings, the rough surfaces of the concrete both inside and out. And yet . . . these are

eminently "desirable" homes, as well as great architecture.'[14] Some months after the Smithsons' statement, the architectural historian Reyner Banham published an article that proposed Brutalism as a counterbalance to the aesthetic of the neo-Picturesque, itself an updated interpretation of the planning of grand eighteenth-century parks and gardens, that had informed the design and planning of the South Bank Exhibition (see Chapter 5).[15] The New Brutalism is to be understood as marking a shift away from the aesthetics and ethos of 1951; as an indicator of a society emerging from post-war trauma to address and assimilate a newly inventive, confident, international culture.

The intensive renewal of the fabric, appearance and use of urban landscapes that took place through the 1950s was to inspire diverse responses, from the photography of Roger Mayne to mural-scale abstract paintings by Robyn Denny. Mayne's eloquent images of Southam Street in Paddington in the late 1950s (see fig. 43) are evidence of his ability to identify significant places within apparently desolate urban landscapes. Towards the end of the decade Denny was commissioned by the London County Council to make a mosaic mural for Boxgrove Primary School in Abbey Wood, London. Installed in the glazed entrance porch, the colourful jumble of letters and numerals that form its imagery define a specific place and underline its vitality.

Denny's mural was one of many artworks commissioned by the LCC that greatly contributed to the modern urban landscapes created by the construction of new housing estates and schools.[16] During the same period Denny made several very large paintings, including *Untitled* (1956–7; fig. 30), that incorporate diverse topical interests and sources of imagery. For several years text, in the form of painted and stencilled letters and numerals, was prominent in his paintings and commissioned murals.[17] Their urban nature lies in their affinity with the casual accumulation of graffiti, fly-posting and inconsequential marks that is the fate of anonymous city walls, ubiquitous surfaces that are constituents of urban space and incidental markers of overlooked places.[18]

30   Robyn Denny, *Untitled*, 1956–7

In 1958 Denny was invited by the film director John Schlesinger to collaborate with Richard Smith on a proposal for a film on the relationship between art and the urban environment. No subject could have been more apposite, though their submission, which was not what Schlesinger had envisaged, never became a film. Instead it was published in *Ark*, the house journal of the Royal College of Art, as a four-page pull-out, with reproductions of the authors' work and a typewritten text with diverse collaged images that included speeding traffic in a townscape of lights and signs (fig. 31). The text contained a statement of the authors' identity as urban artists: 'Because we are painters, living in a world, an urban world, that's not as old as the hills . . . our viewpoint is angled . . . [The city is] a frame of reference a climate rather than a place, relating a private (painter) situation to a public scale.'[19] In formulating a response to the physical realities of the city, Denny and Smith

31   Robyn Denny and Richard Smith, *Ev'ry-Which-Way*, published 1959

32   Claude Monet, *Nymphéas*, after 1916

intuitively developed a counterpart to Heron's narrower view of abstract painting, while incidentally dismissing the convention that had for so long linked urban art with realism.

## Allusive Abstraction

A development that was arguably as significant for landscape painters as the advent of Abstract Expressionism was the renewal of interest towards the end of the 1950s in the late paintings of Claude Monet. A retrospective exhibition, organised by the Arts Council for the 1957 Edinburgh Festival and also shown at the Tate, demonstrated a shift in perceptions of Monet's contemporary significance. It was such works as the Rouen cathedral series and the *Nymphéas* paintings (fig. 32) that were the focus of interest; the exhibition included four images of the Cathedral and eight of the water garden at Giverny. The selector, Douglas Cooper, singled out Monet's large, bold marks and the range of his colour as direct predecessors of abstract painting.[20] He

did not dwell on Monet's perception of space, though he emphasised the absence of a horizon line to locate the surface of the water. Conventional landscape painting insisted on a horizon to provide a sense of distance from a fixed viewpoint, but Monet indicated the surface only by the reflections of clouds. Since many of the *Nymphéas* paintings contain neither a horizon nor a definable viewpoint, the water's depth can only be suggested by the hue and thickness of the paint. Monet's repertoire of marks was vast. Superimposed, juxtaposed and never precisely repeated, they produced extraordinary images of aqueous depth and space.

By the end of 1957 the thrust to align British art with its counterparts in Paris and New York had become unstoppable. Introducing an ambitious survey exhibition titled *Dimensions: British Abstract Art 1949–1957*, Alloway maintained that abstraction had become 'one of the dominant tendencies of British art'.[21] It was a large claim and largely true. Equally significant was his acknowledgement of the prominence of landscape painting and a related, new category that he described as 'allusive abstraction'. It referred to paintings that appeared to be abstract but, through their forms and colours evoked a strong sense of the natural world, as was the case with Gear's *Autumn Landscape*.[22]

Whereas links with French artists were restored soon after the war's end, a further decade passed before British practitioners were to become familiar with recent Italian and Spanish painting. Since the first post-war Venice Biennale in 1948, the event had been one of the primary means for artists to exchange information and ideas and, as travel became easier, they flocked to it. Alloway, who visited the Biennale for the first time in 1958, subsequently identified a far from obvious connection between the Argentinian-Italian Lucio Fontana, the German artist known as Wols and the American Mark Rothko, all of whom he recognised as representatives of 'the Informel-Abstract Expressionist-l'Art autré [*sic*] cluster'.[23] On this occasion, Antoni Tàpies showed in the Spanish pavilion, while two years later the work of Alberto Burri and Emilio Vedova occupied individual rooms in the extensive Italian pavilion.[24] All were to be significant exemplars for British artists. If Tàpies and Burri

33　Emilio Vedova, *Dal ciclo della protesta '53 – 6*, 1953

were remarkable for the texture of their surfaces, built up with pigment, clay and –
in Burri's case – sacking, Vedova was no doubt singled out for the spatial qualities
of his work. The abstract paintings he made in the Scuola di San Rocco in Venice
in the 1950s, of which *Dal ciclo della protesta '53 – 6* (1953; fig. 33) is an example,
echo the extraordinary illusions achieved on the building's walls and ceilings by
Jacopo Robusti (Tintoretto) in the sixteenth century. These illusions were to become,
effectively, Vedova's principal subject.

Writing a decade after the event, Alloway was to identify Spanish art as a 'success
story' of the 1958 Biennale, with Tàpies 'the sole substantial Spanish painter'.[25] In
the late 1950s Prunella Clough was one of a group of three friends who bought
and circulated among themselves six lithographs by Tàpies.[26] During a brief visit to

34    Prunella Clough, *Brown Wall*, 1964

Paris in 1961, she twice visited an exhibition of his work. Frances Spalding suggests that Clough's painting, *Brown Wall* (1964; fig. 34) may have been 'at some level, an homage to Tàpies', a name that is also the Catalan word for 'wall'.[27] Though the surface of the painting bears little resemblance to the artist's habitually thick

impasto, the structure that Clough saw and reproduced on canvas was evidently old, battered and much replastered: her image amounts to a visual testimony to the common interests of the two artists.

In 1958 a ground-breaking exhibition called *Abstract Impressionism* confirmed that, for many artists, the shift into abstraction was a natural progression.[28] Organised, with Alloway, by the painter Harold Cohen, it offered, as had numerous works in *Space in Colour*, a means of combining a modern emphasis on abstract marks with the desire to incorporate references to the natural world; that is, to adopt 'allusive abstraction'.[29] The American painter-critic Elaine de Kooning had already acknowledged Abstract Impressionism as a distinctive aesthetic approach.[30] Writing in 1956 she reproduced paintings by Josef Albers, Rothko and Kline, maintaining that their work was so familiar that it had already 'become part of "nature" or the general cultural environment'.[31] More specifically she commented on the close relationship with Impressionism that she found in the work of Miriam Schapiro and Joan Mitchell, noting 'the quiet, uniform pattern of strokes that spread over the canvas without climax or emphasis'.[32] Alloway followed de Kooning in acknowledging Impressionism as a model for British artists. At the same time, he somewhat belatedly identified 'space' as 'a key word in post-war art' and as a 'substance', selecting an aerial painting by Lanyon in which the density of cloud and water vapour indicated what he meant by 'substance'.[33] Alloway cited Louis Finkelstein, an artist–critic who, writing shortly after de Kooning, had reiterated the links with Impressionism that had recently led American painters to devise a new form of abstraction that emphasised 'light, space and air' in place of the Abstract Expressionist focus on surface and texture.[34] In Finkelstein's opinion, it was 'the sense that space . . . constitutes the primary reality of our understanding which gives this movement its unity and conceptual basis'. This emphasis on space aligned Abstract Impressionism with the current practices of British landscape artists.[35]

●

### '...a city is as strange as a tree'

While Alloway was primarily interested in the impact of Abstract Impressionism on artists working in London and Cornwall, the concept opened a way of reassessing landscape painting in general. Alloway quoted Joan Mitchell, who made no distinction between the 'natural' and the 'man-made'. Her catchy phrase, 'a city is as strange as a tree' underlines the disparate thinking of British and American urban artists.[36] Mitchell's paintings demonstrated the link between the first-generation Abstract Expressionists, whom she admired, and the approach defined by the *Abstract Impressionism* exhibition, in which *Hudson River Day Line* (1955; fig. 35) was included. Acknowledged in Britain as an abstract landscape painter, she lived 'on the fourth floor of a lower East Side walk-up' in New York and painted 'from

35   Joan Mitchell, *Hudson River Day Line*, 1955

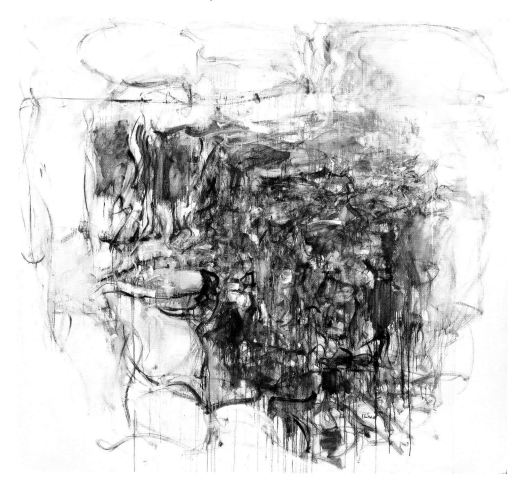

remembered landscapes that I carry with me'.[37] Irving Sandler described her working process: she would make a charcoal sketch and then apply paint to the 'chalked areas with housepainters' and artists' brushes, her fingers and, occasionally, rags'.[38] Her work emphasised two areas of consuming interest to British painters in the late 1950s: a sense of space and a way of achieving it through marks that, while they avoided the drama of Action Painting, still echoed the movements of the body and could be made with any tool, including fingers. Abstract Impressionism and the associated contributions of New York writers had demonstrated that the content of a landscape painting was open to choice. An artist might paint a place, a space or a memory, provided that the paint surface was lively and expressive.

*The New American Painting* exhibition, which opened at the Tate Gallery early in 1959, presented recent abstract work as New York's dominant art movement.[39] The show introduced six artists new to the British public, among them Barnett Newman and Clyfford Still. Primarily, it demonstrated the possibility of working on a hitherto inconceivably large scale, while it also offered precedents for a city-oriented art. In this context, *Abstract Impressionism* should also be acknowledged, not least for its contribution to the thinking of the artists who devised *Situation: An Exhibition of Abstract Painting*, which opened at the RBA Galleries in 1960. Organised by a committee of artists, *Situation* was a response to the American exhibition, setting the parameters for a post-American approach that has been aptly described as coming 'from first principles, from thinking "what if?"'.[40] Predominantly London-based, the participating artists were intent on developing large-scale abstract painting in images that ranged from vibrant tachiste canvases to enormous collages.[41] Disavowing any interest in allusions to the natural world, the participating artists displaced the conventional, physical landscape with contradictory, sensually confusing urban space, which they presented as an alluring enigma. They emphasised visual instability and processes of perception that tested the limits of comprehension; in effect the practical and visual processes adopted by the *Situation* artists amounted to a constant interrogation of habitual modes of seeing.

In contributing to the catalogue, the painter and curator Roger Coleman was aware of describing a pioneering event, even if he did not recognise that it would subsequently be perceived as having marked a definitive shift in the way that artists thought about and made their work. Acknowledging the American precedent for radical change, Coleman set out to define the basis of a new painting and, implicitly, what constituted a contemporary work of art. Firstly, he asserted that space was understood in an entirely new way; it might appear in a painting to be unstable and flickering or, as it did on a CinemaScope screen, oceanic and enveloping. Coleman noted that if a very large canvas was hung in a domestic room, the painted space would assume the character of a self-sufficient object, with no representational function. As a result, it could only be discussed within the wilfully solipsistic terms of abstract painting. *Situation* nevertheless made an impact that extended well beyond those who took part in it. It presented a visual identity that rapidly became closely associated with popular culture, not least film, as well as design and style in architecture, advertising, graphic production and fashion. Paradoxically, given the organisers' stipulation that the paintings should be large scale and abstract, 'without explicit reference to events outside the painting – landscape, boats, figures – hence the absence of the St Ives painters',[42] *Situation* had a considerable if indirect impact on landscape painting, through the scale of the pictures, their attention to space and the numerous reiterations of Heron's insistence on the spatial role of colour.

By the end of the 1950s landscape painting appeared to be a genre fully re-newed. It had incorporated new, abstract forms and moved into an upward spiral of development, expanding its scope in parallel with American painting and developments in other media. As a corollary of its lack of concern for representation, aesthetic imagination was released to consider new concepts such as the politicised 'atomic landscape' that emerged when the Campaign for Nuclear Disarmament was formally initiated in January 1958. In 1960 Lanyon acquired his glider pilot's licence, which stimulated him to devote himself to an unparalleled group of images, known

as the gliding paintings, that explored the visual and physical experiences of flight. Frost, working in Leeds, had also devised a distinctive approach to landscape imagery. Nicholson had already moved to Switzerland and thereafter was to travel extensively in western Europe, making groups of architectural drawings and prints which, based ultimately on cubist collage, took the reinvention of space as their central, if unacknowledged, theme. All these approaches were indebted to abstraction which, by the turn of the decade, had become naturalised; an unproblematic set of tools to be picked up, used and put aside. Representation, filtered through the artist's eye, had become a hybrid quality, primarily allusive rather than factual and made up of both abstract and realist components.

## Sculpture

Among the enduring innovations of the post-war years was what has since become known as public art. Given the priorities of the period, it was slow to develop, though it was encouraged by local authorities and occasionally by local residents.[43] Its most significant boost may have been the various 'percent for art' arrangements, through which a fraction of the total construction cost of a new building might be set aside for art.[44] Public art was in principle demotic, non-monumental, secular and modern, in that it embraced new or recent work in forms that ranged from strict realism to occasional abstraction. Moore's sculpture was favoured as being highly prestigious, though the public often found it difficult, preferring such pieces as a small bronze donkey, no bigger than a child's toy, made by Willi Soukop and first cast in 1935 (fig. 36). The emergence of public art in streets, housing estates, hospitals, parks and gardens did much to transform communal spaces in London and other cities where, as well as bringing visual pleasure, it had an important secondary role as a place-maker. A distinctive sculpture such as Reg Butler's *Birdcage* (1951), now in the grounds of Kenwood House, not only identifies and acts as a mnemonic for the wider area in which it stands, but also serves as a navigation point and a meeting place.

36   Willi Soukop, *Donkey*, shown sited at Harlow in 1955

From the late 1950s, unprecedented forms of new sculpture emerged from St Martin's School of Art.[45] They had developed following an in-depth reappraisal of the nature of the medium that took place within the Advanced Course devised by Frank Martin, the long-serving head of the Sculpture Department.[46] Very early, in 1953, he invited Anthony Caro, who had previously been an assistant to Moore,

to teach two days a week. Caro also ran evening classes which included a popular combination of architecture and sculpture that attracted young architects. Tim Scott enrolled as a student straight from the Architectural Association in 1956, as did Philip King a year later. These developments were indicative of the widespread relaxation of rigid categories that had hitherto enforced the separation of media and genres. On this point Alloway had presciently remarked in 1955: 'Now that sculpture is not associated principally with carving, it no longer appears to possess an absolute difference from painting'.[47]

Caro returned from his first visit to the United States in 1959 with a new approach to teaching, which he envisaged as a shared process of discovery. It involved instructing students to 'go out into Soho and pick up some materials that you've never seen used in sculpture before, and come back and we will make a sculpture of them'.[48] This method was to instigate a rolling revolution: the rule book had been torn up to ensure a new orthodoxy of richly coloured abstract sculpture, predominantly in metal or plastic. Displayed, as was the work of the same generation of painters, in Bryan Robertson's *New Generation* exhibitions in the early 1960s (see fig. 37), it offered an immediate challenge not only to the identity of sculpture but to conventional perceptions of the type of art appropriate for public spaces. Commemorative statues of national and local worthies, architectural decoration and conventional fountain figures were all rendered liable for reassessment or replacement.

Caro left St Martin's in 1965, and thereafter Peter Kardia, a dedicated teacher, ran the Advanced Course until 1969.[49] More concerned with process than end products, Kardia insisted on the centrality of conceptual thinking, demanding that students take part in discussion groups and read philosophical texts. His particular interest, developed at the Slade, was phenomenology; he focused on the writing of Edmund Husserl and on Maurice Merleau-Ponty's appreciation that 'what we perceive visually is bonded to a bodily sense of physicality, weight and touch'.[50]

The St Martin's course of the late 1960s called into question the philosophical and physical nature of sculpture and the conventional categorisations of sculptural media.

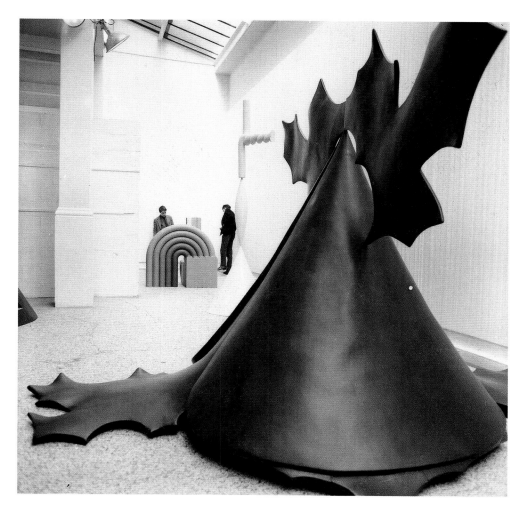

37   Installation shot of *The New Generation: 1965* exhibition at the Whitechapel Gallery, 1965, with Phillip King's sculpture *Genghis Khan* (1963) in the foreground

It required students to examine the purpose and nature of their work and to devise new ways of expressing themselves. As a result, Richard Long and his contemporaries were as much concerned with their own identities as British artists as with that of their sculpture. This radical rethinking took place at a time when art in Britain was politicised as it had not been since the Napoleonic Wars; when performance was

38   Installation shot of Richard Long's exhibition at Konrad Fischer Galerie, 1968

routinely assimilated into conventional practice, and there were unprecedented opportunities to exhibit in both continental Europe and North America. In this respect, Long benefited considerably from the presence in the student body of the Dutch artist Jan Dibbets, who was able to offer contacts with continental European gallery directors.[51] As a result, Long's first solo show, in 1968, took place at Konrad Fischer's gallery in Düsseldorf, where he was invited to exhibit while he was still a student (see fig. 38).[52] A year later he was invited to show photographs at the Gibson Gallery in New York, an early career trajectory that was in astonishing contrast with the situation a decade earlier, when British artists began to exhibit in New York only in their forties. Long's early practice fell naturally into a relationship with Minimalism, Arte Povera and the nascent environmental movement, leaving the isolation of the early post-war years as no more than a bitter memory for an earlier generation.

## Photography

Photography is surely the only art form of which the invention can be precisely dated. Its singularity is to have emerged as a technology seeking a purpose and an identity, both of which were slow to develop. Early photographers sought to establish their medium in relation to fine art subjects, particularly landscape, which was suited to the extremely long exposure times then required. Consequently, though landscape photography was developing as a genre as early as the 1850s, its format and subject matter remained firmly tied to painting, which it faithfully copied.[53] The link between the media mirrored that between painting and engraving. Whereas painters had long been accustomed to distributing prints of their work in order to make it more widely known, the refined tonal gradation of eighteenth- and nineteenth-century print technology set an aspirational standard for early photographers. While painting offered a range of subject matter for imitation, only print techniques could reveal the huge aesthetic potential of a monochrome technology.[54] Graphic media were able to achieve a range of textures and tonal contrasts that converted into spatial planes as dramatic and convincing as any painted equivalent.

Moreover, photography's documentary capacity was sufficiently convincing to suggest that photographic images would be received in a different way from paintings of the same subject. Belief would not be suspended for a photograph of a mountain as it might be for a painting of a 'sublime' experience of alpine scenery; in other words, photography was 'truthful' in a way that painting is not. Indeed, there was a vigorous debate among early post-war photographers over artificial 'retouching': the pre-digital process of manually enhancing the appearance of an image. Frank Smythe deeply disapproved of the practice though he conceded that it was 'delicate and debatable ground'.[55] Some photographers chose to emulate painters by 'eliminating the unessential and adding details', whereas Smythe considered that they should 'seek to present a landscape as truthfully as possible despite the handicap of having to reduce colour to monotones'.[56] To do otherwise was to deny photography's status as an independent art form.

To begin with, photography was a laborious practice confined to professionals, but when George Eastman – founder of Kodak – patented roll film in 1884, and the Box Brownie appeared on the market two years later, it started to attract amateurs. Immediately recognised as offering a practical alternative to cumbersome glass plate cameras, 100,000 Box Brownies were sold in 1896. While they were not yet sufficiently cheap to be universal accessories, they enabled middle-class enthusiasts, among them many women, to adopt photography as a pastime.[57] By the 1920s Kodak was selling photographic equipment worldwide, and in 1925 Leica produced the first successful 35mm camera.[58] Its portability and the quality of the photographs it could take enthused amateurs and professionals alike. Concentrating on everyday objects and activities, amateur photographers proliferated, leading Lucia Moholy to reflect in the late 1930s: 'It has been the great merit of amateur photography to have opened the eyes of many to objects which may be of little sentimental value, but have been everyone's everyday experiences in the twentieth century'.[59] While photography's ability to record banality may have rendered it critically suspect, its versatility and convenience brought photojournalism, which in turn opened up a strenuous debate in the early post-war period on the comparative merits of 'journalistic' and 'art' photographers. Incidentally, photojournalism also introduced a term of vivid abuse to fine art criticism by identifying a terrain – 'photographic realism' – into which serious painting might not venture. This perception was an indicator of photography's lowly position in the art hierarchy at that time.

Photography's progress from a minority enthusiasm associated with the well-to-do to a near-universal pastime was complete by the mid-1960s.[60] Import controls allowed the British camera industry to flourish after 1945; if the Leica remained the goal of serious photographers, cheaper, British-made imitations were soon introduced alongside other small models. By the late 1950s popular photography was inseparable from the steadily expanding tourist industry, itself promoted by advertising that was indebted to recent improvements in colour film technology. The final boost to the medium's mass appeal, before the introduction of the mobile

phone camera, came with the introduction of the Kodak Instamatic early in 1963. Cheap, infallibly easy to operate and loaded with colour or black and white film in a cartridge format, 50 million were sold by the end of the decade.[61]

The search for high quality colour took longer than the popularisation of the medium. By 1946 Eastman Kodak was producing colour negative film from which it was possible to make prints and by the end of the decade transparencies in the form of rudimentary colour slides were being used by magazines such as the *National Geographic*. Advertising, fashion shoots and specialist publishing, not least of art books, encouraged the refinement of colour technology, but as late as the mid-1950s many serious amateurs and professionals still considered colour suspect, partly on the grounds that it was commercially rather than aesthetically desirable. For them colour remained as contentious in principle as it had been in 1945 when L. A. Mannheim wrote in *Amateur Photographer*: 'Most of the colour photographs one sees nowadays . . . emphasise that it is colour and ignore the question of what it is for . . . too much colour distracts from the value of the idea'.[62] Thus art photographers preferred monochrome film, which could be processed at home, whereas colour was almost impossibly complex. As a result, colour only began to be widely demanded for its 'reality effect' in the 1960s, when it was hugely encouraged by Cinemascope and rendered universally available by the Instamatic.[63]

## Landscape Photography

Between 1941 and 1944, Bill Brandt was commissioned by the National Buildings Record to photograph cathedrals and churches at risk from bombing in Canterbury, Chichester and Rochester. At a time when photography was still considered a documentary rather than an artistic medium, Brandt combined both approaches, subverting the rigours of documentation by using camera angles and lighting for purely aesthetic reasons.[64] When *Picture Post* commissioned him to photograph Hadrian's Wall in 1943, he took the opportunity to engage seriously with landscape. After the war he again focused on landscape subjects as he gathered the images

39    Bill Brandt, *Barbary Castle, Marlborough Downs, Wiltshire*, 1948

that were to be published in 1951 as *Literary Britain*. Haworth, Stonehenge, Avebury and other sites of literary pilgrimage were rendered memorable by Brandt's extraordinary tonal contrasts, which he sometimes allowed to obscure large areas of his subject. His photograph of Barbary Castle (1948; fig. 39) shows two clumps of trees on the horizon, which runs across the centre of the plate. Most of the lower half of the image is densely black while the sky is almost undifferentiated in tone. In this respect Brandt's technique brings to mind Prunella Clough's paintings of slag heaps and mine dumps, which she presented as very simple shapes set down without detail, in a comparably limited tonal range.

In the mid-century, landscape photography was identified as an independent genre distinct from fine art though, like painting, it embraced both rural and urban subjects. Brandt developed his singular vision of the British landscape between 1945 and 1950, seeking artifice and drama as vigorously as others rejected them. He cropped, retouched and experimented with light to produce 'veiled chiaroscuro tones',[65] through which, it has been argued, he and other photographers 'propagated a Neo-Romantic aesthetic to a broad audience'.[66] While Brandt was assembling his literary landscapes between 1945 and 1950, he was also engaged on the project that would be published as *Perspective of Nudes* (1961). For this he acquired a deliberately archaic camera that enabled him to develop a view of the world quite unlike conventional vision. The Kodak Wide Angle, first manufactured in 1931, had an exceptional lens: 'a 110° angle. Anything four feet or more from the camera was in focus'.[67] With this camera Brandt could photograph models in extreme close-up, as though they were themselves elements of the landscape (see fig. 40). The affinity between Brandt's nudes and Moore's reclining figures has often been asserted; the photographs are startlingly close to the large elmwood carvings of 1939 and 1945–6. Both artists, in different ways, drew on surrealist affinities to convert the body into a human–landscape hybrid.

If Brandt sought revelation through strangeness, other landscape photographers adopted more literal approaches to their subjects. Frank Smythe, who died in

40   Bill Brandt, *Nude, East Sussex Coast,* 1959

1949, was a mountaineer, well known from Wales to the Himalayas; a prolific writer of books on climbing, and a serious photographer. Smythe had a clear perception of the comparative status of photography and fine art: 'photography is no mere technical process; it is redeemed by composition, and I would go so far as to say that this is of even greater importance in photography than in painting. It is the choice and composing of a subject that raises photography to the level of an art, and an art distinct from any other art'.[68] He disdained 'picture postcard photography' which he characterised as 'the lake with Snowdon in the background', perhaps unaware of Richard Wilson's origination of the theme.[69]

Smythe gave copious advice to readers, whom he assumed to be making photographic records of their holidays, on how to devise original compositions. He particularly objected to the use of 'very deep yellow or red filters' to brighten up dull landscapes, as they encouraged what he considered to be overly dramatic results.[70] His work extended the style adopted by landscape photographers in the 1920s, when they began to emphasise the detail that could be expressed through the tonal gradations of monochrome.[71] The nuances of terrain and rock surfaces that Smythe was able to reveal are evident in *Cynicht from the South-West* (fig. 41) and could not have been achieved in colour when he took the photograph in 1945.[72]

Towards the end of the 1950s, when camera ownership was becoming widespread, William Poucher, who has been described as the pre-eminent mountain photographer in terms of popularity and output, became a role model for amateur landscape photographers and a populariser of upland areas throughout the country.[73] Though he worked for 30 years as chief parfumier at Yardley,[74] he also contributed regularly as a photographer to *Country Life* and to various climbers' and walkers' magazines. Poucher produced many collections of photographs, the first of which was *Lakeland Through the Lens* (fig. 42).[75] In *Escape to the Hills*, his first book for *Country Life*, he sought to demonstrate his preference for 'the hills, dales and lakes of Britain', focusing on the Lake District, the Scottish Highlands and Snowdonia.[76] A descriptive gazetteer, *Escape to the Hills* was directed towards holidaymakers,

41   Frank Smythe, *Cynicht from the South-West*, 1945

42   W. A. Poucher, *Lakeland Through the Lens*, 1940, cover

offering 'schemes' for visiting specific areas. Poucher extolled the Lake District, as would Alfred Wainwright a few years later. Like Wainwright, Poucher emphasised the pleasures of solitude and promoted walking as opposed to climbing, recommending 'ridge wandering – a pleasant, safe and easy form of mountaineering'.[77]

Poucher's books, like Smythe's and Brandt's, were enthusiastically collected during the 1950s and '60s, when they featured as regularly on Christmas gift lists as do celebrity cookbooks today. Intimately linked with walking and rock climbing as

leisure pursuits, the books were both specialised souvenirs and gateways to new experiences. By the 1960s photographic books had, if incidentally, become markers of the status of the medium. If collections of photographs of much-loved landscapes lacked the intellectual content or the campaigning vigour of Gordon Cullen's and Ian Nairn's conjunctions of text and image (see Chapter 5), they had a huge appeal to the sector of the middle classes that supported 'preservationist' causes and freedom of access to the countryside. Poucher expressed the hope, no doubt echoed by many of his readers, that the National Trust would acquire areas of hill country 'so that they may be preserved in their natural state and offer greater facilities to all who wish to visit them'.[78]

Poucher's books contain advice on mountain photography supported by information on his personal equipment. His use of a Leica was still sufficiently novel for a reviewer to find 'something tremendously encouraging to the average photographer' in that all but four of the illustrations in *The North-Western Highlands* (1954) had been 'taken with the camera in the hand'.[79] Poucher seems to have had no aspirations to be identified as an artist, though he was acknowledged as an excellent professional photographer whose work appealed equally to serious mountaineers and to visitors seeking attractive souvenirs. It is possible that he envisaged an instructive series under the general title *Climbing with a Camera*, of which only a volume covering the Lake District was published.[80] He observed that though 'almost everyone carried a camera . . . they seemed unaware of the grandeur of the surrounding scenery . . . only taking pictures of their friends'. He therefore wished to 'indicate those routes of ascent that will yield the best opportunities of taking good pictures'.[81] *Climbing with a Camera* was the first of his books to contain colour plates, an acknowledgement of the progress made in colour reproduction. When Poucher died in 1988, his popular reputation was confirmed by the man most widely associated with the Lake District. Wainwright wrote that Poucher had 'been a hero of mine since his *Lakeland Through the Lens* . . . a future without a new Poucher is a bleak prospect for me and countless others'.[82]

While Smythe's and Poucher's numerous publications confirm their professional status, their early post-war landscape images were characteristic of 'Pictorial' photographers, a description often applied to serious amateurs who took part in exhibitions and occasionally published their work. The Pictorial approach had originated in the early years of the medium when photographers aligned themselves with painters. Pictorialists sought dramatic effects; many were initially keen to use the filters that Smythe condemned and went to great lengths to achieve satisfactory compositions, while some went so far as to exclude all traces of modern developments from their picturesque 'view' photographs. As cameras and equipment improved, it became evident that certain photographic techniques, such as tonal variation, might be used with dramatic lighting, reflection and surface textures to suggest circumstances such as implicit danger in a way that paint all too easily renders banal. Photography's unresolved relationship with paint was an ever-present problem until the technology of colour film evolved sufficiently for it to become aesthetically acceptable.

## Photography and the City

Before the late 1950s the only art institution in Britain to acknowledge photography on equal terms with older media was the ICA, where photographic practice was addressed analytically and experimentally. Roger Mayne, a generation younger than Brandt, frequented the Institute in the early 1950s.[83] A scientist by training but an artist by inclination, he took up photography as a hobby and started to read *Photography*, the most 'influential' magazine on the subject.[84] Subsequently, he joined camera clubs and became fascinated by technique. Mayne was then living in London's Holland Park, not far from Southam Street in Paddington where, between 1955 and 1961, he took approximately 1400 photographs, mostly of children, all on the street. He recorded twenty-seven visits to Southam Street, resulting in eighty-eight published images taken with a Zeiss Super Ikonta. Writing in 1957 about this drawn-out undertaking, Mayne commented on the lack of self-consciousness

shown by the children and their eagerness to be photographed, as well as his attraction to 'the shapes of peeling walls, of children's scribblings, and the textures of the roads' (fig. 43).[85]

If Southam Street was not Mayne's home territory – it was a slum, declared unfit for human habitation and demolished in 1968–9 as part of an LCC improvement scheme – it was a place that he knew intimately.[86] Through his photographs he gave it an identity and historical status that it would not otherwise have had. Southam Street's children became Mayne's friends, a cast present throughout the series. His conceptual approach was complicated: though his work was informed by a left-wing political position, it was far from polemical. In 1961 an issue of *Uppercase*, an occasional publication edited by the architect Theo Crosby, was devoted to Mayne's Southam Street images. Under the title 'The realist position', Mayne wrote: 'I photograph Southam St because it is beautiful and because the people have great vitality, especially the children . . . Southam St is too extraordinary to be typical – the photographs are a dramatisation rather than a portrayal of a slum street'.[87] Much the same could be said of Joan Eardley's paintings of children and their graffiti in Glasgow's slums (see Chapter 3).

Mayne's concept of realism clearly involved a considerable degree of selection, emphasis and interpretation, suggesting an affinity with painting as well as photography. It has been convincingly suggested that Mayne 'transformed' conventional documentary photography by moving it in a more consciously 'aesthetic and equivocal' direction.[88] He associated with painters and was familiar with their work; he visited St Ives, knew Hilton and Heron and bought a painting by Frost as early as 1953. Some of Mayne's images suggest that Southam Street would have appealed to Clough, whose *Brown Wall* (see fig. 34) is remarkably close to the anonymous structures that form backdrops to many of his photographs. One of the walls that Mayne photographed even carries an unidentifiable diamond shape comparable to the one in Clough's painting. Like it, Mayne's photographs of Southam Street reveal structures that have been ruined, repaired and damaged yet again, incidentally

43   Roger Mayne, *Footballer and Shadow*, 1956

proclaiming their modernity more strongly than any documentary identity. While Southam Street presented a combination of deprivation, vitality, occasional brutality and the beauty of dereliction that was so familiar to Clough, the most extraordinary aspect of Mayne's experiences is arguably the freedom that was accorded to him to befriend its children, a reminder that in the 1950s photography claimed total liberty in its choice of subject matter.

There is no doubt that Mayne was well aware of the status of his own work and that of his photographer colleagues as works of art. He was active in the mid-1950s in organising photographic exhibitions, lamenting 'the difficulty of getting the

big galleries'. Later he was quoted as commenting that: 'In the Fifties there was no real interest in photography by the art establishment'.[89] In May 1955 he was pleased to inform John Piper of a possibility that photographs might be exhibited at the Tate Gallery and that, if they were, the editor of *Photography* would publish an article on the event.[90] Mayne had also written to Sir Leigh Ashton, Director of the Victoria and Albert Museum between 1945 and 1955, to enquire about the possibility of a group photographic exhibition at the museum. Ashton responded to the effect that photography was not an art: the museum would neither exhibit nor collect it.[91]

It was, perhaps, photography's ubiquity that slowed down its recognition as an art form worthy of being exhibited as widely as painting. Mayne's hoped-for exhibition at the Tate failed to materialise and for a considerable time the gallery's relationship with photography was confined to rare historical displays such as *Paul Nash's Photographs: Document and Image* (1973). Fortunately, since Ashton's retirement in 1955, photography has been not only accommodated but enthusiastically celebrated at the Victoria and Albert Museum, which in 1958 hosted the first museum exhibition of the Royal Photographic Society. Conversely, photography had always been central to the experimental ethos of the ICA, where it was not only accorded the same status as any other art form but was imaginatively exploited, its possibilities explored and extended in the context of exhibition design and format to an extent unmatched by any other fine art organisation. Mayne himself was to have a solo exhibition at the ICA in 1956 but, as early as 1949, photography – as an art of record – had been appropriated to provide substitutes for objects not available for loan in the Institute's pioneering exhibition, *40,000 Years of Modern Art*.

Mayne was a regular, if infrequent, contributor to *Amateur Photographer*, in which he promoted his views with great lucidity. In 1956, under the title 'Pictorialism at a Dead End', he used a review of the prestigious annual exhibitions of the London Salon of Photography and the Royal Photographic Society to promote the cause of modernity in photographic imagery. Pictorialist photography, which had flourished

until the early twentieth century, had aligned photography with painting: tonal effects were central, as were themes that closely echoed paintings, with subjects, such as the 'Lady of Shalott', often posed and dressed in character. By the mid-twentieth century, however, Pictorialism was in its final stages, though it remained an intense irritant to photographers like Mayne who were acutely aware of recent developments across the entire field of the visual arts and wished to demonstrate the strength of photography's status as an autonomous medium. In his review, he was adamant that the organisers of the leading annual photographic exhibitions had failed to demonstrate 'the slightest understanding of contemporary art'; he castigated Pictorialist photographers for seeking to be artists while failing to recognise 'the nature and function' of their medium. Photography, Mayne argued, had appropriated the recording role that had formerly been the remit of certain kinds of painting, but Pictorialists were not content to 'let the camera be objective'. He recommended that photographers start by making 'snapshots': 'the best photographs artistically . . . the super-snap (Cartier Bresson tradition) or the super-record (the Edward Weston tradition)'.[92] Four years later, in 1960, the art editor of *Amateur Photographer* adopted a cautiously centrist attitude to the problems of Pictorialism. He felt that it might have reached a turning point, detecting a tendency to 'more vital subject matter, more story value and more realism . . . no longer can the journalistic school scoff at exhibitions as old-fashioned, conventional or monotonous, but it would be a pity if . . . traditional work was forced out altogether'.[93]

As so often, the artist was well ahead of the critics; only a year after his attack on Pictorialism, Mayne found himself in a far more satisfactory situation. Reviewing the Combined Societies' Exhibition in 1957 he commented on the singularity of its concentration on contemporary or modern photography, and added: 'The lack of showing of this kind of work is, we feel, responsible for photography's lack of status as an art medium or as a profession'.[94] The Combined Societies' annual exhibition was initiated in 1945, in order to encourage art photography; to underline their good faith, the 1957 selectors included work by John Rothenstein, Director of the Tate

Gallery and the sculptor Lynn Chadwick. The exhibition travelled around the country before being shown in the United States, where it was only the third exhibition of 'contemporary European photography' to have taken place.[95]

Mayne and Brandt were primarily urban photographers who made strong visual statements about specific places, just as, in very different ways, did Smythe and Poucher. Between 1945 and the mid-1960s landscape photography was principally understood to indicate images of the rural and scenic; it occupied a specific, popular position at a considerable distance from modern painting. It identified places that were distinguished by their beauty and remoteness as well as those that had become democratised, open to anyone able to walk. Through their work, Smythe, Poucher and their colleagues made notable contributions to the physical and conceptual reformulations of landscape that characterise the post-war era. Their books provided practical advice for walkers and climbers and contributed considerably to the appreciation of upland landscapes by large numbers of people. If today the books appear to present a somewhat anachronistic vision, their authors may nevertheless be celebrated both for the quality of their photographs as records of a certain kind of landscape and for their contribution to the rapidly increasing popularity of the medium as an attribute of a democratic society.

In summary, as the art world adapted to the realities of post-war Britain, the public and commercial galleries of London were dominant. Of those galleries, a handful exhibited and encouraged the most innovatory art being made in Britain, wider Europe and America, and in so doing greatly contributed to the artistic developments that allowed the range of the landscape genre to expand from the rural to the urban, from the physical appearance of a tract of land to a highly sophisticated, personal understanding of a place as a space and an experience. With the development of non-monumental, secular public art, there were also opportunities for art, mainly sculpture, to contribute directly to the communal spaces of Britain's reconstructed urban landscapes. At the same time, sculpture itself was beginning to change as St Martin's School of Art attracted a new generation of influential teachers and

students – among them Richard Long – who privileged process over physical product and, in Long's case, opened up a new area for landscape art.

While the public was ignorant of the developments at St Martin's, photography, which was treated with suspicion and even disdain by large parts of the art world, was hugely popular as a pastime and a medium of record. It had been associated with landscape from its birth and remained so in the post-war period. The books of Frank Smythe and William Poucher, both Pictorial mountain photographers, sold in vast quantities and greatly contributed to preservationist causes and the popularity of such outdoor pursuits as rock climbing and Lakeland walking. Less well-known but more acceptable to a small sector of the art world were such photographers as Bill Brandt and Roger Mayne, who broke with the Pictorial aesthetic in their photographs of rural and urban Britain. Thus, in this period the relatively new medium of photography was acknowledged and slowly began to be incorporated into the wider art world, with immeasurable benefits for the visual arts in general.

44　Philip de Loutherbourg, *An Avalanche in the Alps* (detail), 1803

# 3 Engaging with Landscape: Phenomenology, Place and Space

Tiny figures – heads thrown back, arms spread wide – stand precariously on a glacier, surrounded by falling rocks, gazing in awe and terror at a vast mountain landscape. The confrontation of human frailty and the power of Nature was a popular subject for such painters as Philip de Loutherbourg, whose *An Avalanche in the Alps* (1803; fig. 44) depicts the reaction of individuals to a 'sublime' landscape. Such a terrain is wild, vast and beyond human control; the writer Robert MacFarlane notes that it may encompass 'oceans, ice-caps, forests, deserts and, above all, mountains'.[1] Macfarlane maintains that the pursuit of pleasurable fear shifted the emphasis of eighteenth-century tourists from the classical to the Sublime, as they went 'tripping from cliff-top to glacier to volcano'.[2] If the Sublime is primarily identified with the late eighteenth century, it was still powerful 150 years later. Recording his physical and emotional reactions to the scale of the Yorkshire Dales, Terry Frost brought the Sublime succinctly up to date: 'I feel space is a bloody big thing looking at titchy me'.[3]

Frost's acute sense of personal identification with a certain place and landscape was far from unique; indeed, it was the primary factor that drove the work of all the artists discussed in this chapter, though their individual experiences, revealed in their paintings, were diverse. While John Piper was initially attracted to Snowdonia by historical accounts of the area, Josef Herman, always drawn to people rather than scenery, experienced an 'epiphany' when he first encountered a group of miners walking through Ystradgynlais in South Wales. He recalled: 'The image of the miners on the bridge . . . became the source of my work for many years to come'.[4] For Herman, the people constituted the place. Others, notably Frost, Peter Lanyon, Sheila Fell and Joan Eardley, revealed deep phenomenological attachments to their personal landscapes. In reading artists' accounts of their reactions to the places where they

worked, it is important to remember that they were written by painters, rather than philosophers or psychologists. Their words, as much as the marks that they made on canvas, emerged from the long and often painful process of developing new approaches to making works of art. Their trial-and-error experiments were central both to reaching a deeper understanding of familiar places and to evolving forms of visual expression commensurate with the personal significance that those places held for them.

## Terry Frost and St Ives

During the four years that Frost spent as a prisoner of war in the 1940s, he was encouraged by a fellow captive, the artist Adrian Heath, to paint portraits of the inmates. He recalled that 'It was a very good training'.[5] As Frost was determined to become a professional artist, Heath advised him to go to St Ives, in view of its long-standing status as an artists' centre. Consequently, in 1946 Frost moved from the Midlands to the Cornish fishing village, rented a flat near the harbour, worked in a local guesthouse and attended St Ives School of Art. This was a prelude to three years of study at Camberwell School of Art, made possible by an ex-serviceman's grant. Frost's tutors at Camberwell included Victor Pasmore, whose teaching and advice became hugely important to him. During his vacations in Cornwall between 1947 and 1950, Frost made paintings that combined his acute sensibility to the local landscape with the principles of abstract constructive art that Pasmore had taught him.

Throughout his years in St Ives Frost habitually walked along Smeaton's Pier, which almost closes the seaward side of the town's harbour.[6] He recalled:

If you walk along the quay, in fact, it is a hard under-foot experience. Things were happening to my right and beneath – my feet felt and saw all the shapes of boats tied up and either preparing to go out or unloading. The strange feeling of looking on top of boats at high tide and at the same boats tied up and resting

45   Terry Frost, *Walk Along the Quay*, 1950

on their support posts when the tide's out. It is a difference so great, like a silence and a bomb.[7]

Before he attempted to paint this alien experience, Frost spent two years making drawings. Eventually in 1950 he made *Walk Along the Quay* (fig. 45), the first of a dozen such works. The tall, narrow painting reveals the quasi-geometric, constructive origins of his imagery, which he set out predominantly as squares, semi-circles and rectangles defined by colour. At the base of the image is the sandy harbour beach with the semi-circular shape of a boat's hull left stranded by an ebb tide. To the right is water with a boat lying alongside the stone-paved quay; towards the top are further boat-like shapes and a junction of sea and sky that suggests the open water beyond the harbour. It is further complicated by combining several different viewpoints, showing the subject simultaneously from above, from the side and full-face. The result is an image that implies the viewer's movement along the quay using an abstract language learned from Pasmore.

While Frost acknowledged his debt to Pasmore, it seems that he was already conscious of an incompatibility between constructive principles and the expression of subjectivity. As well as working out how to paint the harbour in a modern manner, he seems to have been exploring a way of thinking about himself in relation to painting. And though the format of *Walk Along the Quay* was predetermined, as Frost owned the stretcher and frame before he began work on the painting, it happened that the tall thin canvas replicated his own tall, thin physique, leading to his well-known comment: 'I managed to paint up the canvas or along the canvas, like I walked along the quay, in fact I just walked up the canvas in paint'.[8]

## Phenomenology: A Philosophy of Consciousness

As he walked, both literally and 'in paint', Frost was so acutely aware of his body in a particular place and time that he made no distinction between actually walking 'hard under-foot' and making a painting about the walk. What he described was a phenomenological experience; a concept that refers to a consciousness of a

place or event so deeply felt that it causes a strong physical reaction, even though nothing momentous appears to have taken place. Many people are aware of such a sensation after having woken abruptly in the night, convinced that the house has been broken into, when all that happened was that a car door was slammed in the street. Conversely, many phenomenological experiences are pleasant: we react intensely and physically to the sounds, scents and sensations of a flower-filled garden on a hot summer day. Centrally, phenomenology maintains that we experience the world through our bodies, of which our minds are an integral part.[9] It insists that since we exist in the world (or in nature), we are inseparable from it; consequently our understanding and empathy are fully engaged with whatever we are thinking about, seeing or doing.[10] Just as children completely inhabit the imaginary places of their games (world war in a suburban street, a moon landing under a garden shrub, an operating theatre behind the sofa), artists live intuitively in the territory of their paintings. This kind of insight, also called perception, is gained through our senses, especially vision and touch. It is the means by which we are able to understand or come to terms with our environment and our existence within it.

In the early 1950s British artists were not yet aware of the *Phenomenology of Perception*, the book in which Maurice Merleau-Ponty expounded the origins and significance of phenomenology. Published in Paris in 1945, it only became available in English translation in 1962.[11] Consequently Frost, Lanyon and their colleagues had no text that might help them to understand the direction that their work was taking. Their task was made all the more difficult because they were trying simultaneously to make sense of their own reactions to what they perceived and to devise a new language of painting as an appropriate form of expression. This developed slowly, even painfully, predominantly taking an abstract form. While Frost and Lanyon both arrived at what are now recognised as phenomenological paintings, Lanyon developed his singular way of experiencing landscape unaided, albeit at great emotional cost. He conveyed some of his information to Frost, who described how Lanyon would tell him to lie down, look up into trees, walk 'over the hills and the high ground so that you knew what was above and below you . . . and all the while

you're feeling those forms all through, you're travelling through the landscape'.[12] Though every such experience was unique, they were commonly accompanied by acute anxiety and self-doubt. In Roger Hilton's words, the kind of artist whom both he and Frost aspired to be was 'like a man swinging out into the void; his only props his colours, his shapes and their space-creating powers' – and no knowledge of where the ground might be.[13]

Hilton's anxiety was prompted by an intense feeling of solitude: of being engaged, as were his colleagues, in a venture for which there was neither precedent nor rulebook. Lanyon and Frost both recognised a physical identification between their bodies and their environment, a sense of being so intensely bound into a landscape that in Lanyon's case it became the driving force of his painting. Seeking to describe the bond, he explained: 'I have to project myself as it were with my feet where I am, and my head may be fifty miles away'.[14] His vivid, discomforting words suggest that he recognised a situation in which landscape can only be fully experienced from 'a particular point of view *within* the world – not a gaze from without'.[15] In other words, rather than something that could be comfortably observed from a distance, landscape was integral to his existence. Merleau-Ponty's explanation of this constant interrelationship was to maintain that 'the world is what we perceive'.[16]

Other writers before and since Merleau-Ponty, including anthropologists and geographers, have offered important insights into phenomenology. The German philosopher Martin Heidegger reflected on 'dwelling', which involves relationships parallel to those experienced by Lanyon and his colleagues.[17] He interpreted dwelling as an ancient, rural way of life that continued unchanged over generations, resulting in a landscape and patterns of work so habitual that they were never questioned.[18] More recently dwelling has been compared with making use of the world,[19] an insight that has been extended to everyday activities such as walking, and has been illuminatingly aligned with the behaviour of animals, whose experience of local weather and terrain amounts to geographical knowledge, which they are able to turn to their advantage.[20] Tim Ingold, an anthropologist, acknowledged these insights in his description of landscape as a constantly evolving record of the

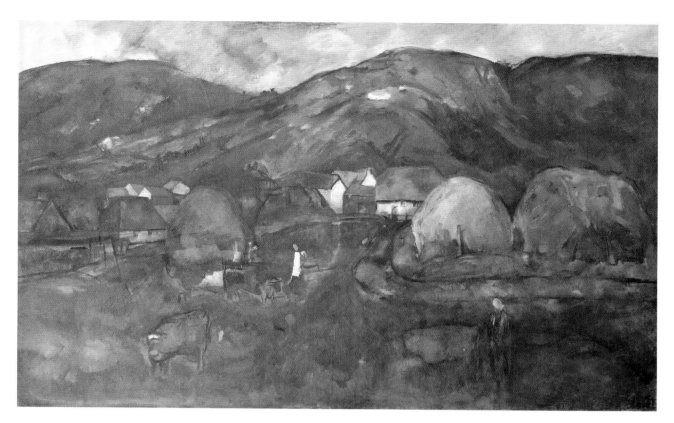

46   Sheila Fell, *Cumberland*, 1959–60

generations of people who have lived and worked on it.[21] In his insistence on the complementary nature of landscape and body, comparable to figure and ground, Ingold approaches Lanyon's notion of perception being integral to the landscape.[22] He proposes that rather than being a natural phenomenon distinct from humanity, landscape is an evolving, reciprocal process in which all human activities take place, an insight that Lanyon would surely have acknowledged.[23]

The reciprocity between body and landscape is recognised by artists who intuitively understand the deep connection with the land developed by generations of people living close to the 'folds, nicks, flats, glades, crags, screes, crests, and gaps' of their personal terrain.[24] The paintings that Sheila Fell made in and near Aspatria in Cumbria, where her family is said to have farmed for centuries, demonstrate her grasp of the unconsidered stance and movements of farm workers and animals. Her Cumbrian paintings, of which *Cumberland* (1959–60; fig. 46) is an

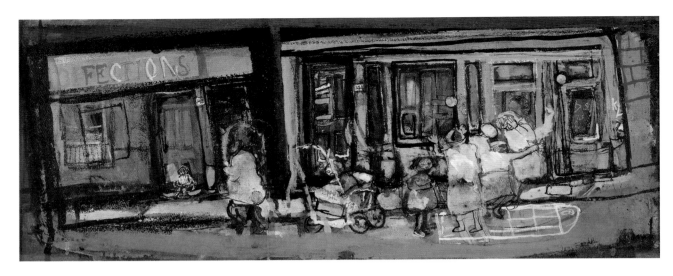

47   Joan Eardley, *Glasgow Street, Rottenrow, c.* 1955–6

example, acknowledge landscape-as-dwelling, implying a way of living grounded in an unspoken, habitual knowledge of the local terrain and weather shared by people and animals profoundly familiar with them.

The Scottish painter Joan Eardley was similarly bound by a strong phenomenological attachment. She began her career living and working in Glasgow, where she befriended and painted children from the slums near her studio. *Glasgow Street, Rottenrow* (c. 1955–6; fig. 47) records a derelict place, its shops boarded up and heavily adorned with graffiti. In preparation for making it, Eardley asked a photographer friend to record the graffiti on buildings in Glasgow, which she then incorporated into her paintings of inner-city children and their habitat.[25] Vividly documenting poverty and resistance, Eardley's images of children occupy common ground with Roger Mayne's Southam Street photographs. Her preference was to live and work in Catterline, a small coastal village south of Aberdeen which she discovered by chance in 1951. Four years later she bought what has been described as 'the most exposed cottage in the whole village', a remote, vulnerable building set at the end of a row of houses running along a flat-topped hill.[26] She lived there for a further four years in extreme discomfort, a condition that may have been integral to her sense of belonging to Catterline, where she developed an identity as an open-air painter, responding to its sky, sea and weather rather than to its people.

Eardley's paint surfaces suggest an awareness of Dubuffet's work. Just as he gouged and scarred the thickly impasted surfaces of his images of the human body, she piled pigment onto such paintings of the sea as *Flood Tide* (1962; fig. 48) to emphasise its immense power. Fiona Pearson has described Eardley's habitual process of working on board with conventional pigments, to which she added 'boat paint, with newspaper, sand and grasses embedded in the mixture. She used a palette knife to create texture, dribbled paint down the foreground, and used the end of her brush to draw into the wet surface'.[27] Eardley had an affinity with expressive painting: she greatly admired the work of Chaim Soutine, which she may have encountered in Benno Schotz's exhibition of Jewish art in Glasgow in 1942, and the paintings of Wassily Kandinsky, which she travelled to London to see in 1958 when the Solomon R. Guggenheim Museum sent an exhibition of its Kandinsky collection to the Tate

48    Joan Eardley, *Flood Tide*, 1962

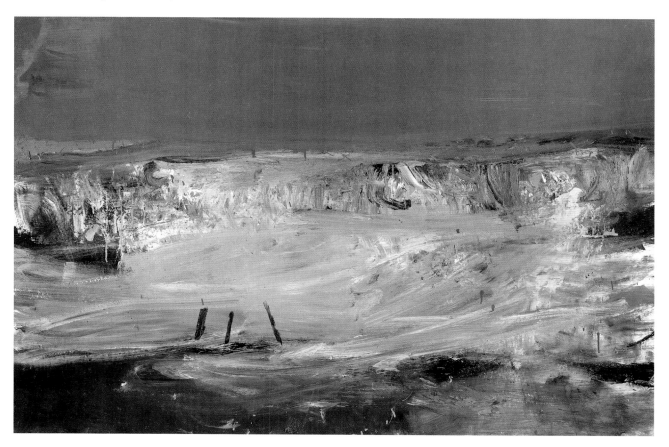

Gallery. She was also an enthusiast for the work of Hans Hartung, Pierre Soulages and Nicolas de Staël.

At Glasgow School of Art Eardley had been taught by Hugh Adam Crawford, who encouraged his students 'to feel their painting in their bodies'.[28] Evidently, she was receptive to this approach; at Catterline her paintings became larger, as if in acknowledgement of the huge expanse of sea and sky visible from her door. She commented: 'When I'm painting in the north-east – I hardly ever move out of the village. I hardly ever move from one spot . . . I think I am painting what I feel about scenery . . . it's just a vast waste, vast seas, vast areas of cliff.'[29] The many marine paintings that she made between 1950 and her death in 1963 convey this scale, as well as her love of storms and heavy seas. Her comments in letters on the 'visual grandeur of storms' echo a local friend's description of being in Catterline as 'like living in a Turner painting'.[30] Just as Turner's vortices evoke the sensation of being thrown around in a small boat caught in a gale, Eardley's paintings reflect her position, balanced on a shooting stick as she worked, facing an incoming tide. *Flood Tide* conveys the solidity of a grey wall of water on the point of breaking, its mass relieved only by flashes of light set down with short, vertical marks in blue, yellow, pink, black and gleaming white. Whereas the complex surfaces of Eardley's marine paintings record brief, dramatic incidents within air and water, the intensity of her reactions to natural phenomena in general suggests that her underlying subject was entropy, or transformation from order to disorder within a system.

Between 1954 and 1957 Terry Frost spent two years as a Gregory Fellow at the University of Leeds, followed by a year during which he taught at Leeds College of Art.[31] The paintings that he made during this time are markedly different from his earlier work. He told Lawrence Alloway that Yorkshire had changed his visual relationship with places: 'I'm not on the same wavelength as I was when in Cornwall. There the visual experience was important, nowadays its [*sic*] practically gone'.[32] It seems that in the Yorkshire Dales he found the extent of the landscape revelatory; he was overwhelmed by the scale and drama of the geology of Gordale and

49   Terry Frost, *Blue Winter*, 1956

Giggleswick Scars. Gordale lies in an area characterised by 'rocky gorges with steep or even precipitous sides . . . Mountain Limestones occur in thick beds . . . The beds, moreover, are often tilted and bent into great folds'.[33] This is immediately evident inside Gordale Scar, probably a long, ancient cave in which the roof collapsed to leave steep overhanging walls. Giggleswick Scar, a short distance to the west, is a scarp with a long, rounded top and vertical, limestone cliffs that run beside the road between Settle and Ingleton. Frost made several paintings which translate this dramatic geology into paint including *Blue Winter* (1956; fig. 49), which represents both the cold, hard light of a northern winter and the tumultuously broken, folded landscape, threaded with pillars of rock. The thin lines that run from top to bottom of the canvas emphasise the scale of the landscape and evoke the dry-stone walls that criss-cross the Dales as they meander in great loops or run, it seems, vertically uphill.

Frost gave a splendidly theatrical, much-quoted explanation of the impetus to his work in Yorkshire, which involved a walk near Herbert Read's house at Stonegrave: 'I looked up and saw the white sun spinning on the top of a copse . . . I thought I saw a Naples yellow blinding circle spinning on top of black verticals'.[34] At about this time the pentagon and hexagon became frequent motifs in his work, devices to focus and enliven an image with a slightly ragged 'spinning' shape. Years later Frost recalled: 'the dales were huge and the escarpments were fantastic and so I started better to appreciate the flatness of the surface'.[35]

During this period William Scott was absorbed by the idea of a shared identity of body and landscape. He explored it through a group of near-abstract images, occasionally in bright monochrome but more often in greyish white articulated by rough black lines. Scott gave the title *Figure into Landscape* to two paintings made a year apart. The earlier, 1953 version (fig. 50) is sparse, smooth and tidy, the other is made up of ragged black lines on a heavily scumbled ground (see fig. 29).[36] Their common title is a prompt to read them both as schematic bodies and field patterns. The ambiguity of these paintings puts them among the many examples of artists exploring deeply rooted feelings about landscape and their personal connection with it. While Scott's images address an aspect of phenomenological engagement that was of primary importance to some of his colleagues, notably Lanyon, they do so at a remove that indicates a more generalised, anonymous relationship to landscape.

Evidently the diverse attachments of artists to landscapes are reflections of ancient relationships; Ingold sets them in a biological past so distant that it took place when human beings were not yet distinct from the rest of the natural world.[37] Today, a sense of the reciprocity between body and landscape permeates cultural geography, landscape studies and archaeology, though it is most vividly conveyed by visual artists. The interrelationship between landscape and body has been described as folding one part into another in a continuous process of 'intertwining'.[38] It was, however, Merleau-Ponty who most eloquently summarised the visceral sense of a

50   William Scott, *Figure into Landscape*, 1953

figure/ground dualism, when he referred poetically (if not with blinding clarity) to the flesh of the body and 'the flesh of the world'.[39]

## Embodiment

Embodiment, which is fundamental to the work of certain artists, is a way of explaining relationships between the individual and the external world. It involves ideas or knowledge so deeply assimilated that they have become intuitive. A dramatic example of embodied activity was the successful emergency landing made by an Airbus A320 on the Hudson River early in 2009, following a collision with a

flock of geese shortly after take-off from LaGuardia. The flight, which lasted only five minutes, incurred no loss of life solely because of the actions taken by the pilot, Chesley Sullenberger. He was unable fully to explain them to the crash investigators, but it has been persuasively argued that they were embodied actions arising from the fact that Sullenberger 'did not sit in airplanes so much as put them on. He flew them in a profoundly integrated way, as an expression of himself. He lived through them. He knew their souls . . . this is not speculation. It is a reality for thousands of working pilots who feel deeply at home in the sky'.[40]

Lanyon intuitively identified embodiment when he maintained that if one of his landscape paintings extended 'at a terrific rate up one side it is simply because I felt that in my own side, in fact, I'm painting what's happened like my knee right up to my armpit'.[41] His description evokes the 'as-if' approach to painting that artists began to explore in their private notes and letters in the 1950s, when they were trying to come to terms with an unnamed area of sensibility that evoked a powerful, if lonely, personal reality. The 'as-if' is the territory of many artists, a means to explain how the world works, even if the explanation amounts to no more than 'a fuzzy area of defective knowledge'.[42] It is evident from the first-hand accounts of some artists' working practices that the body is always at the centre of their encounters with space or place. Equally, certain places and events are so deeply embedded in their consciousness and carry so strong an emotional charge that they provoke involuntary reactions.

Just as Sullenberger's response to the goose strike appears to have been as involuntary as breathing, such unremarkable activities as 'walking, looking, driving, cycling, climbing and gardening' are also recognised as embodied, that is, as actions routinely carried out with little or no conscious thought.[43] If an artist's habitual practice takes place in landscape and extends to painting on the ground, arranging stones or walking a predetermined route within a set of self-imposed rules, it may be similarly understood. When the geographer John Wylie undertook a 200-mile walk along the South West Coast Path, it was a consciously formulated event, though one

that was probably less rigorously predetermined than a walk made by Richard Long. Wylie has described his own concentration on 'moments, movements, events' and concludes, fortuitously echoing many artists, that rather than seeking to allocate meaning to landscape, it should be understood in the same way it is experienced, that is, through bodies and minds, from an appreciation of its colours, scents and sounds to thirst and sore feet.[44]

A different, if comparable, account of the centrality of the body is provided by Deanna Petherbridge's description of drawn marks as 'spontaneous, unpremeditated traces of the body'. She notes the long history of admiration for unfinished works and specifically links the incomplete state with modernity and an emphasis on the individual.[45] In post-war Britain, spontaneity was among the most highly prized qualities of contemporary art, as Patrick Heron emphasised when he identified a particular form of painting: 'Post-war non-figurative painting makes its point through the medium of a free movement of brush or knife: this is the essential quality of painterly "scribble" common to Rembrandt and Velasquez; Michelangelo and Rubens; Titian and Piero della Francesca; Cézanne and Delacroix.'[46] Painterly scribble was central to various post-war artists including Piper, Lanyon and Bob Law. The irregular white line that dominates Piper's drawing *Nant Ffrancon Pass* (1947; fig. 51) appears to stand free of the paper, the result of hand movements that mark out the twisting Ogwen River as an event in pigment that intuitively records the artist's encounter. It would be as implausible to describe Piper's white marks as premeditated as to suppose that he planned the river's course. His white line is an empathetic, visually convincing equivalent to its passage through the rough terrain.

It is difficult to understand why Bob Law is less well-known than other artists discussed in this book except that he found it difficult to cope with the isolation imposed by creativity and tended to sabotage his relationships with dealers and critics. His career began when in 1957, on a whim, he moved to St Ives, where he stayed for three years before returning to London. Between 1959 and 1963 he made hundreds of rudimentary drawings, known as the Field Drawings, since they were

51   John Piper, *Nant Ffrancon Pass*, 1947

loosely related to the small fields of Penwith.[47] The early Field Drawings, of which *Drawing 25.5.59* (1959; fig. 52) is an example, were made in pencil on sheets of paper approximately 25 × 35 cm, set within rectangular freehand borders drawn not quite square on the sheet. They recall Merleau-Ponty's comment, 'the world is what we perceive'. Discontinuous lines of rudimentary trees, punctuated with chevrons and stars, run round the outer edges of the sheets while the central space is typically occupied by the sun, a cloud or a dividing line. Law's Field Drawings, which are ostensibly 'about lying down in a large open space', may represent acts of self-location.[48] Interviewed by Richard Cork in the 1970s, Law stated: 'The early Field Drawings were about the position of myself on the face of the earth and the

52   Bob Law, *Drawing 25.5.59*, 1959

environmental conditions around me: the position of the sun, the moon and the stars, the direction of the wind, the way in which the trees grew, an awareness of nature's elements, an awareness of nature itself and my position in nature on earth in a particular position in time. I was finding myself, and the map that went with myself.'[49] The 'map', on which Law is present though not visible, may be elucidated through Merleau-Ponty's perception that the observer's/artist's/writer's body is always implicitly present in images where there is an ambiguity between figure and ground.[50] In this respect, Law's Field Drawings may be compared with Scott's *Figure into Landscape* paintings of 1953 and 1954 (see figs 50 and 29), which demonstrate a similar uncertainty regarding identity.

## Space and Place

The Field Drawings suggest that Law was seeking the type of orientation that is experienced through the body. This has been called 'somatic' space: 'a space of habitual and unselfconscious action'.[51] It provides the sense of back and front, right and left, vertical and horizontal; aspects of spatial understanding without which it would be impossible to cross a road, let alone reach a destination. A temporal extension identifies time and direction, which may be expressed as "'here is now', or 'there is then'".[52]

While somatic space is individual and informal, other types of space are active, creative or social. Existential space is distinctive; it provides 'reference points and planes of emotional orientation for human attachment and involvement'.[53] Linked to buildings or prominent features, such as a cathedral close, a market square or a vista across a landscape, to which people may react or feel attached, it applies equally to rural and urban locations. Places within existential space are those with specific significance or purpose which, though they may appear simply to be gardens, racecourses or quaysides, are likely also to constitute individual 'centres of meaning'.[54]

Space, place and landscape are so deeply interwoven that in practice place and space appear to be inseparable, in that 'places *constitute* space as centres of human meaning'.[55] At its simplest, space articulates the relationships between places, indicating the distance between objects, buildings and people. Nevertheless, dancers, mountaineers, toddlers and housing officers occupy and understand space in very different ways, while its innumerable formal and informal uses merge through habit into dedicated places: beaches, shopping centres and designated routes for walkers all demand specific modes of behaviour.[56]

The obverse of identifiable places is the 'wilderness or barren spaces "outside" of civilised realm' and exemplified by the recently acknowledged category of edgelands.[57] Associated with urban peripheries, the edgelands are populated with landfill, sewage works, business parks and a range of flora and fauna that has

brought them to the attention of naturalists and geographers.[58] Certain areas of the edgelands, notably landfill sites, were a source of fascination to Prunella Clough, who developed an evocative, if typically non-specific, imagery in response to them. A painting with thick scabs of brown paint, surrounded by grey pigment, fringed with lines is characteristic of the work that she made in response to industrial sites and detritus. The scale is unreadable; the marks suggest makeshift fencing, discarded lumps of building material and unidentifiable decay. In these ruined remnants, Clough identified and depicted in such paintings as *Rockery* (1963; fig. 53) an indeterminate place that is implicitly part of a much larger area.

53   Prunella Clough,
*Rockery*, 1963

In the early 1950s pictorial 'space' – as opposed to actual lived space – was frequently and intensively discussed, particularly with reference to abstraction. As discussed in the previous chapter, Heron, for example, considered it to be an indispensable component of good painting. He described such space as flexible, a quality that 'is compressed or attenuated, massed or drawn out, according to the picture's needs'.[59] Referring specifically to Scott's heavily textured *Table Still Life* (1951; fig. 54) Heron wrote that: 'it creates space directly from its own surfaces, not so much by any reference to extraneous objects, as by a reference to space itself. Space is the object it portrays'.[60] If Heron was single-minded in his focus on pictorial space, the difficulty of distinguishing space from place was pinpointed many years later by Sean Scully, who was probably describing the experience of many artists when he wrote: 'The notion of place in abstract painting is free. It is indistinct. One doesn't know quite where it is, and one has to find it for oneself within the painting'.[61] Evidently, the notion of a place in an abstract image is paradoxical and subjective. It might most readily be conveyed through a variation in the colour and texture of paint which might in turn be unpremeditated. Scully's point also illustrates the difficulty of identifying place as an abstract construct. It may be discussed in terms of social relations: 'home, work, school, church, and so on, form nodes around which human activities circulate and which *in toto* can create a sense of place, both geographically and socially' or, equally, as a visceral physical quality.[62] Describing her father's relationship with a one-acre plot of land, Madeleine Bunting, daughter of the sculptor John Bunting, wrote that the 'sense of place is not just a product of imagination and memory, it is also physical; the elements of the land, its rocks, earth and water, are measured in our bones. It's hard, perhaps even impossible, to abandon our own geography of memory.'[63] Her final evocative phrase highlights the compelling nature of the relationship between memory, physical presence and place, which is fundamental to many artists. Generally, their responses to space and place are reminders of the flexibility of both terms and the extent to which they are inseparable.

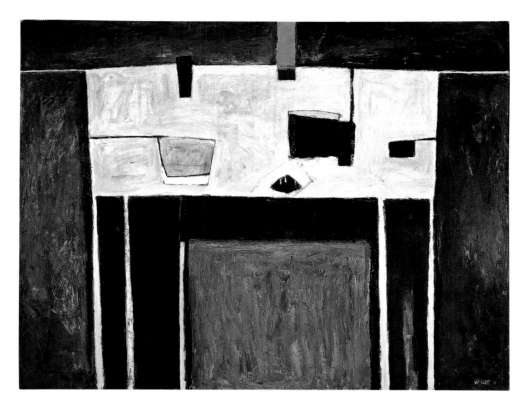

54   William Scott, *Table Still Life*, 1951

The awareness of being in and responding to a specific place has, no doubt, as many manifestations as there are artists. Barbara Hepworth was acutely conscious of the topography, textures and colours of the Cornish landscape. She had a clear perception of her embodied relationship with it, believing that she could stand aside from the sculpture that she was making, either to look at it or, as Herbert Read acknowledged, to become the sculpture itself.[64] She eloquently described this sense of her extended identity: 'I became the object. I was the figure in the landscape and every sculpture contained to a greater or lesser degree the ever-changing forms and contours embodying my own response to a given position in that landscape'.[65] Her comment 'I rarely draw what I see – I draw what I feel in my body', suggests

that for Hepworth drawing and sculpture were aspects of a single process.[66] Her words imply a binding identity between the work of art, the artist's body and the place established by their presence. Hepworth habitually photographed her work in carefully selected settings, for example *Pendour* (1947) – which she identified with the coastal landscape – in front of St Ives Bay.[67] This sculpture curls inside its outer skin like a wave about to break, while comparable pieces are tunnelled through the wood to disclose cave-like internal spaces that might equally well correspond to the hollows and cavities of the human body.

In the 1970s Edward Relph noted there had been 'almost no detailed discussion' by geographers of 'the phenomenon of place' in relation to day-to-day experience.[68] Emphasising the distinction between the identity *of* a place and a personal sense of identity *with* a place, Relph categorised individual relationships, designating degrees of belonging or alienation in terms of 'insideness' or 'outsideness'.[69] An outsider's (or visitor's) perception of a Cornish farmyard heaped high with tractor tyres and smelling strongly of bovine urine is unlikely to extend the vision promoted by the tourist board, although to an insider or local person it indicates a working farm, a livelihood, and a home. The farmer, living and working in the landscape, converts it to a significant place while the visitor, for whom landscape is an aesthetic feature, remains essentially detached from it. Hepworth's carved and painted sculpture might be understood as a manifestation of her 'insider' status, expressing her identification with Penwith, her home territory. Relph identifies 'existential insideness' as 'the deep and complete identity with a place that is the very foundation of the place concept'.[70] At its most familiar and visceral, place represents home: 'the territorial core' that signals security and provides a locus for individual expression.[71]

For some, home may consist of a street or a neighbourhood, while others – like Hepworth – claim a wider territory. Across the entire *Terwick Mill* group (see Chapter 1), Hitchens concentrated on the pond and its surroundings in different lights, weathers and seasons; an intense, prolonged scrutiny suggesting that he identified with the mill as closely as with his home. His working process is illuminated by Scully's

recognition of the need to find a place within a painting; if Terwick Mill was primarily a place constructed in paint, it also had a physical identity as Hitchens's home territory.

For Lanyon, home was the whole of Cornwall, including its airspace. His relationship with it was intense, recalling Relph's definition of 'existential insideness – the unselfconscious and authentic experience of place as central to existence'.[72] Moving around on foot, on a bicycle or in a car, he put into practice his advice to Frost regarding the primacy of physical engagement with landscape. As a result, space, place and phenomenological experience are conjoined in his work. Neil Lewis argues that the sensual manner in which people confront the world defines their understanding of its reality.[73] Lanyon's engagement with landscape was multi-sensual, an approach that has been described in another context as 'the total embodied awareness of a body in an environment'.[74]

*St Just* (1951–3; fig. 55) relates to the small, eponymous town near Land's End, which is set in a flat, almost treeless landscape punctuated by copious remnants of the mining industry that once dominated the district. Lanyon's painting refers to an accident described in the local press as 'a tragedy far more serious, and more awful in the poignancy of its sorrow than any event in the history of Cornish mining'.[75] On 20 October 1919, in the Levant Mine, the 'man-engine' – a crude device for transporting miners up and down the shaft – shattered, with appalling consequences. Said to be the only such machine 'remaining in the world', it consisted of forty-five wooden beams, each 40 feet long, joined end to end to a total length of 1,800 feet.[76] Steps were attached at 12 feet intervals to correspond with small platforms fixed to the wall of the shaft. As the entire beam rose and fell 12 feet on every stroke of the steam engine that drove it, a man could move slowly up or down by repeatedly stepping off onto a platform and back onto the beam as it rose or descended. It is likely that as many as 150 miners were on the machine at the time of the accident, which killed thirty-one men and injured nineteen. It took five days to retrieve the bodies. Lanyon made the painting when the accident was still within living memory, suggesting that it could have been informed by first-hand accounts. Whether or not

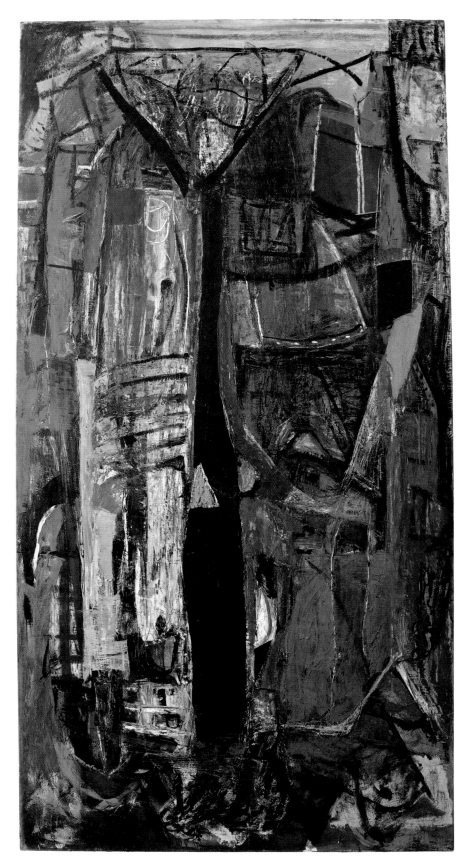

55   Peter Lanyon,
*St Just*, 1951–3

this is so, it is evident that throughout his eighteen-month struggle to complete *St Just*, which involved painting over an earlier version, he remained acutely aware of the plight of the men and boys who died without solace; in terror, pain and darkness.

The black shaft, which is slightly off-centre and was laid down towards the end of the painting process, is the core of the imagery and meaning of *St Just*. Various points on and below ground level are shown round the sides of the canvas: the sea can be seen at the top, as if from the Levant Mine, and also at the bottom, where the stopes ran out below the water for a mile and a half. Though Lanyon identified certain features of the town, notably the church and chapel, overall *St Just* expresses his perception of various existential spaces rather than identifiable locations. The right-hand, predominantly green side contains numerous lines that suggest an open topography of fields, rocks, paths and tracks. Conversely, the heavily worked left side suggests the interior of the shaft: a dark, tightly confined, rough-walled space. Close scrutiny of both sides reveals small areas of bright yellow, pink and crimson pigment that were applied at a late stage, perhaps to emphasise the dominant, sombre colours.

Lanyon's relationship with St Just and his compulsion to make a painting associated with it were inextricably bound up with his family's mining interests in Cornwall, which presented him with an acute personal and ideological dilemma. He referred to 'the shame that I feel for instance when going along the coast and seeing these ruined tin mines', a reaction that was inseparable from his complex relationship with the industry in general.[77] The intensity of Lanyon's engagement with Cornwall sets him apart from many of his contemporaries.

Whereas Lanyon was a prime example of an 'insider', David Haughton, who moved to the area in the late 1940s, remained a perceptive outsider. He discovered St Just by chance and became deeply attached to it, writing:

The turning point in my life occurred when I first discovered the town of St. Just. What happened to me on that Spring day was inexplicable . . . I have no idea what caused it, whether it really was the divine and transcendent visitation that it so

56   David Haughton, *Queen Street*, 1960

clearly seemed to be or merely a freak of one's chemistry. But I do know that it was all important and unutterably beautiful, a trance that went beyond logic but never against it, and that I was at home and everything was mine, loving and tender, the landscape and houses a living thing.[78]

Over a long period Haughton made numerous paintings and etchings connected with the town, among them *Queen Street* (1960; fig. 56). He showed the street lined with near-identical small stone houses, each with a tiny plot at the front, indistinguishable from other streets or, indeed, from other small Cornish towns. There can be no doubt about the strength of Haughton's feelings for St Just, which he consistently depicted as a dour, impoverished place, identified primarily by church and chapel.

Lanyon returned to the history of mining in Cornwall when he painted *Wheal Owles* (1958; fig. 57). Like *St Just* it refers to a mine accident: 'In the 1850s eight steam engines were working here to keep the mine free of water, but in 1893 the water won and drowned twenty-nine miners, whose bodies were never recovered, and so heavy was the sense of doom at the failure to give them a Christian burial that the mine and its victims were abandoned'.[79] Lanyon painted an imagined bird's-eye view of the flooded mine, its shafts indicated by black crosses, its centre filled with the rushing water that carried away men, machinery and fittings, while the surrounding land was stained red by copper oxide. Many mines were flooded, often with terrible loss of life but, in striking contrast to the Levant accident, the one at Wheal Owles was a result of human error rather than negligence.[80] While the scale of the events was comparable, *Wheal Owles* lacks the sombre quality of *St Just*, though the fate of the miners had evinced no less respect for their humanity than did the 1919 disaster. Lanyon, however, seems to have viewed the two events differently and in the 1958 painting appears not to have situated himself within the psychological space of the mine. On the contrary, his treatment of *Wheal Owles* implies an external, aerial viewpoint and an existential space in which he was able to distance himself from the drowned men. In this respect, there may be a link with his experience of flight, specifically gliding, which he took up in the late 1950s. When he commented that gliding enabled him 'to experience my county from outside returning to the land rather than emerging from inside', he revealed the distance between his airborne and his terrestrial self.[81] The point is underlined by the distinction between the dark, heavily painted,

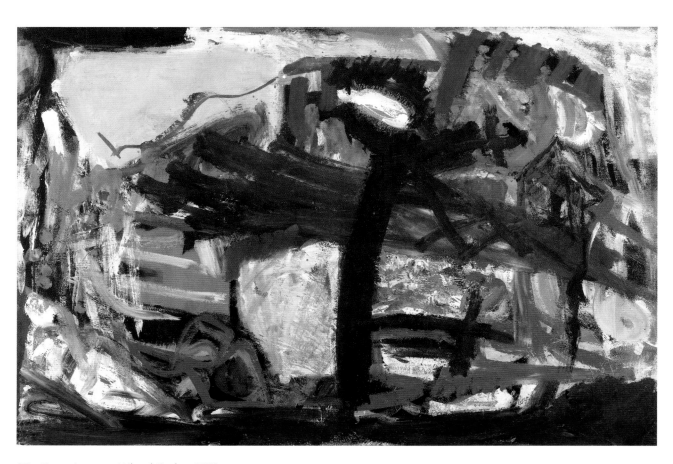

57   Peter Lanyon, *Wheal Owles*, 1958

enclosed spaces of *St Just* and the light, bright openness that characterises the gliding series.

Lanyon's passion for gliding was deeply phenomenological and set him in a distinguished historical lineage: 'I go gliding myself – to get actually into the air itself to get a further sense of depth and space into yourself, as it were, into your own body, and then carry it through into a painting. I think this is a further extension of what Turner was doing'.[82] His comment suggests that the central location of every gliding painting is the implicit presence of the artist/pilot's body in the glider, just as in actual flight aircraft and pilot are inseparable: 'In the air, in a cockpit tailored to fit, [the pilot] feels part of his aircraft. The one-man-one-glider urge is strong'.[83] The gliding paintings are bound up with the technical processes of flight, which are in turn inextricably linked to weather conditions: 'No other sport is so interwoven with the ways of the weather', a point borne out in numerous canvases.[84]

The gliding paintings were products of a skill that brought Lanyon fulfilment as well as considerable insight into his primary subject, the landscape of Cornwall. In making this group of paintings he combined his knowledge of the area and its weather conditions with a hitherto unfamiliar aerial viewpoint and a new set of sensory impressions, stimulated by the experience of flight. It has been emphasised that 'Lanyon is the only artist of note to have taken the pilot's experience of gliding as a significant subject for art'.[85] His constant, implicit, physical presence in his work is the distinguishing feature of the gliding paintings. They demonstrate, as many of their titles indicate, the stages of learning to fly, the techniques of flight and diverse meteorological conditions. Flight processes are central to the narrative of this group of paintings; whereas only one of Lanyon's logbooks survives, his work offers a parallel account of his progress through the skies, from the initial, wavering *Solo Flight* of 1960, to *North East* (1963; fig. 58): a confident overhead view, three years later, of the Cornish Gliding Club, overlaid by curving lines that probably mark out the progress of a glider from its launch to its upward spiralling progress through a thermal.[86] Not least, the gliding paintings proclaim a profound sense of identity, in that 'the glider

58   Peter Lanyon, *North East*, 1963

59   Peter Lanyon, *Airscape*, 1961

itself is an extension of the pilot's sensate body – its fuselage a torso, its wings arms, its wingtips fingers, with which to feel and search the air'.[87] It would be difficult to devise a stronger statement of phenomenological identification. Lanyon's constant, implicit and always mobile presence is the central, distinguishing feature of the gliding paintings, in which he transposed into paint his entire emotional range.

If his presence on the canvas is a constant factor, it is not the most obvious feature of every gliding painting. Those that are concerned with weather or topography may also contain a narrative. Lanyon described the tripartite *Airscape* (1961; fig. 59) in such terms, with 'a spiral current on the left, quiet air in the middle, and stormy weather conditions – an approaching rainstorm – on the right', implying a left-to-right course for both the glider and the viewer.[88] Aerial weather conditions are articulated

by a great diversity of marks: the 'spiral current' was expressed by turning a loaded brush tightly in a single sweep, a feature of Lanyon's later work which he seems to have relished. At the base of the painting the spiral fragments into a mass of thin, wiry lines that lead into the quieter central section where the marks are broader and horizontal. As the colours become warmer towards the right, the storm advances, establishing a metaphor for a situation never far from Lanyon's consciousness, in which 'the encounter of rough and calm air could be related to the physical and emotional encounter of two people'.[89]

No doubt Hitchens was as closely attached to the small area of Sussex where he and his family lived as Lanyon was to Cornwall. Their correspondence reveals that for some years they took a close interest in one another's work, though they were very different artists and personalities. Hitchens's approach to his local area – a long process of recording the nuances of shifting light, colour and atmosphere – was self-effacing; evidently, he did not consider himself to be present in his paintings as Lanyon did, though he did share his preoccupation with place and the means by which it might be identified. Haughton, obsessed with St Just in a way that he was unable to articulate verbally, was an outsider, an artist as recorder, rather than one who refashioned his subject, as Lanyon did, to express a personal mythology. Hitchens occupied a middle ground between them, adopting local subjects for which he devised a semi-abstract style combined with natural colour. He was, perhaps, the most informative of the three as regards the appearance of the places that he painted, while he was the most reticent as regards his own state of mind.

For mid-twentieth-century British artists during the war, engagement with landscape – whether it was distantly recalled or close to hand – was emotional and visceral, that is, phenomenological. The experience endured and may now be acknowledged as a significant factor in forming the identity of the post-war generation of painters. For the most part, they were marked out by their willingness – or desire – to express their personal, emotional reactions to their subjects. This demanded a new approach to painting as a physical activity, one that was facilitated by modernism and may be

elucidated through phenomenology, though artists were exploring its possibilities before they found texts to guide them. While artists adopted diverse routes to a point where they felt able to investigate the links between a landscape and an individual perception of it, ultimately it was phenomenology that gripped them most firmly. It took them into the orbit of what is now known as embodiment: a physical reaction to a sight, a place or an event so intense as to preclude conscious thought. As they reached out towards abstraction and the freedom of practice that it offered both visually and conceptually, the phenomenological process encouraged a fresh understanding of space and place that in turn introduced previously unconsidered subject matter. The early 1950s was a period of intense rethinking, when the experience of individual artists was made visible, as both the subject and the *raison d'être* of their work. This was a profound, if unpremeditated, shift that drew on and contributed to the concurrent development of abstraction and, more broadly, an innovative approach to visual art in general.

60   Bryan Wynter, *Cornish Farm*, 1948

# 4   Reshaping Rural Britain

During and after the war the 'landscape of peace' so eloquently described by Frank Smythe was transformed to an extent unmatched since the eighteenth century. The social, economic and political innovations that define post-war Britain had a huge impact on the rural landscape, bearing out Edward Relph's contention that 'landscape is not merely an aesthetic background to life, rather it is the setting that both expresses and conditions cultural attitudes and activities, and significant modifications to landscape are not possible without major changes in social attitudes'.[1] The British public, having recognised the inevitability of war, accepted unprecedented changes to much-loved, familiar landscapes in order to facilitate the logistics of conflict. The end of the war signalled a lengthy, somewhat haphazard process of readjustment to the many innovations as the landscape was 'reshaped' both physically, on the ground, and imaginatively, by artists in their studios.

If the visible landscape of 1945 was very different from that of 1939, especially in the south and the cities, it was to be further transformed over the next two decades by road building, New Towns, vast domestic and commercial construction programmes, the restoration of an industrial infrastructure, and a shift to large-scale farming. In the tally of what had to be done to re-establish peacetime practices, the visual arts scarcely registered, but the work of artists nevertheless constitutes a rich and eloquent commentary on the processes of change. Among those who interpreted and constructed the post-war identities of rural places, some welcomed renewal while others bitterly resisted it. Bryan Wynter's *Cornish Farm* (1948; fig. 60) and Richard Hamilton's *Trainsition IIII* (1954; fig. 61) represent divergent perceptions during the early period of transformation. Wynter's farm building resembles many in Penwith: a lichen-covered stone structure surrounded with wind-blasted vegetation. Conforming to an anti-modern impetus widespread in the late 1940s, Wynter established his subject as old, picturesque, crumbling and defiant of the new. It

61   Richard Hamilton, *Trainsition IIII*, 1954

was perhaps an attitude of desperation: ancient rural England, home to 80 per cent of the population until the late eighteenth century, had scarcely survived into the twentieth. By the early 1930s, the rural population was only 20 per cent of the total.

Hamilton, who taught in Newcastle from 1953 to 1966 and routinely made the journey to and from London by train, became fascinated with the modifications of vision brought about by high speed, a relatively novel phenomenon. He painted

the four works in the *Trainsition* group when he was researching Marcel Duchamp's representations of movement. Specifically, Hamilton wished to investigate what could be seen from a moving train while trying to focus on a fixed object, such as a tree.[2] He concluded that 'everything between train and tree appears to move from left to right (the opposite direction to the movement of the train), while everything behind the tree appears to move from right to left'; the direction being indicated by Klee-like arrows. The roman numerals in the title *Trainsition IIII* are 'a pun on the structure of railway lines, which rest on sleepers'.[3] Nostalgia and modernity go head-to-head in Wynter's and Hamilton's images, though nostalgia was to be the loser in this instance when the car announced its primacy.

## 'Things in Fields'

The 1947 Town and Country Planning Act introduced stringent controls on land use, though the local authorities moved so slowly that the bulk of early planning proposals were only approved in the late 1950s. In 1947 planning was based on rational assumptions that disregarded the arbitrariness of events. For example, it was assumed that the population would not increase significantly, and that there would be no housing shortage once war damage had been repaired. Similarly, it was expected that urban expansion and population densities would be rigorously controlled, and suburban sprawl and town centres would be transformed into 'architectural show-pieces'.[4] Given that Britain was soon to experience unexpected economic growth that contributed to an unforeseen degree of urbanisation and a building frenzy, it is surprising that the planners were as effective as they were. Nevertheless, despite their efforts, by the mid-1960s urban expansion presented the menacing prospect of 'a virtually unbroken stretch of metropolitan areas . . . from Sussex to North Lancashire'.[5]

Though much of the land given over to military installations had reverted to civilian use by the 1960s and had in many cases retained a dual identity as farmland, informed observers found that change was frustratingly slow, and often arbitrary

and unsightly. Among them was Ian Nairn, who, in 1955 and 1956, edited 'Outrage' and 'Counter-Attack', two well-known issues of the *Architectural Review* that addressed an imminent crisis in which it seemed town and country would shortly evolve into the formless sprawl he called 'Subtopia' (fig. 62). He described this new landscape as being 'neither town nor country' and as one characterised by 'abandoned aerodromes and fake rusticity, wire fences, traffic roundabouts, gratuitous noticeboards, car-parks and Things in Fields'.[6]

Nairn's concerns were shared by the landscape historian W. G. Hoskins, who lamented that 'the immemorial landscape of the English countryside' had become the 'Barbaric England of the scientists, the military men, and the politicians'.[7] In his book *The Making of the English Landscape*, Hoskins argued for the old, the familiar and the rural against the encroachments of industry, infrastructure, mechanisation and modernity in a text that is in many respects an equivalent to such late manifestations of Neo-Romanticism as Wynter's *Cornish Farm*.

Hoskins's rural Britain survived only through efficient state intervention.[8] It is difficult now to over-emphasise either the unreality of his dream or the extent to which his beloved countryside has been transformed. The push–pull of modernity and its opponents echoes through the story of twentieth-century agriculture. In his study of constructions of the English landscape in the first half of the twentieth century, David Matless maintains that within early 'preservationist' movements, headed by the Council for the Preservation of Rural England, 'the dominant voices were those committed to planning and designing a new England'.[9] Nevertheless, the counterview was powerful: Hoskins, with John Betjeman and John Piper, was among those who rejected planning and whose thinking remained grounded in melancholy. A well-understood post-war trope but an intellectual cul-de-sac, their attitude was identified with the nostalgia exemplified by Neo-Romantic painting.[10] Evidently it is a long-established mindset. When searching for early nineteenth-century paintings that demonstrated awareness of recent enclosure and new agricultural practices, Hugh Prince was disappointed. He attributed the lack of evidence to 'artistic fashions . . . patrons' preferences and . . . widespread feelings of nostalgia'.[11]

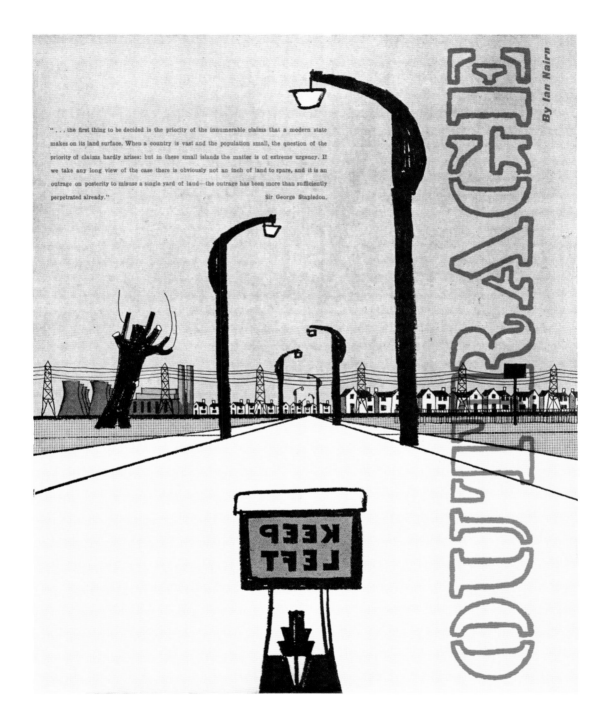

62   Gordon Cullen, cover illustration of 'Outrage', by Ian Nairn, *Architectural Review*, 1955

## 'Ag & Fish'

The phrase 'Ag & Fish', indicating the control of food supplies, was prominent in early post-war consciousness. The Ministry of Agriculture and Fisheries had been established in 1919 from the former Board of Agriculture and Fisheries (1889); food was added in 1955 and the Ministry was dissolved in 2002. Between the wars a collapse in farm prices was followed by an agricultural slump that brought the price of wheat to its lowest level since records began in the mid-seventeenth century, establishing in a situation in which 'rural life was synonymous with depression' until the 1930s.[12] A slow change began in the early 1930s, when the Milk Marketing Board was founded and the first subsidies were introduced, but full recovery was only achieved through the stringent controls imposed by the wartime economy. This resulted in a situation in which the total arable acreage had returned almost to the level 'in the 1860s, the heyday of British agriculture, before the invasion of cheap corn from the New World had set arable farming into retreat'.[13] As a result, by 1945 Britain was producing 80 per cent of its food.[14] Since the hazards of war and the war economy enforced a considerable reduction in imports, including animal fodder, livestock numbers were reduced, while the acreage of ploughed land increased by 50 per cent.

Wartime agriculture, with its hugely increased crop production, was a success story that laid the ground for later prosperity. Grants and subsidies ensured the long-term cooperation of farmers, who were able to buy land for investment, maintaining large labour forces well into the post-war period.[15] Whereas most farmers prospered and labourers benefited from a statutory wage, they still worked longer hours for less money than their counterparts in manufacturing industries. Moreover, in 1943 fewer than half the farms in England and Wales had piped water and only a quarter had electricity.[16] This situation is implicit in Sheila Fell's paintings, many of which poignantly record the lives of hill farmers in Cumbria, of whom Peter Hennessy remarked that 'even' they 'flourished during the war', though they remained poor compared with the prosperity of the south and east.[17]

The agricultural landscape resonated forcefully in 1947 when Britain, virtually bankrupt and perilously short of food, laid secret plans for conscripted labour on

the land.[18] Fortunately Marshall Aid intervened in the nick of time and the scheme was abandoned. The necessity of sustaining production resulted in grants for new farm buildings and land converted to tillage, with subsidies for artificial fertilisers.[19] Improvements to farming techniques were stipulated in the 1947 Agriculture Act, the complement to the Town and Country Planning Act. Whereas the latter provided statutory protection for agricultural land, the Agriculture Act determined how it should be used. Guaranteed prices and markets, modernisation grants, and a central, scientific advice service combined to bring about a resounding success for both economic and production levels.[20] Yet as early as 1955 Nairn acknowledged the price of mechanisation, writing of a 'countryside which is under sentence to machine agriculture'.[21] Fifty years later the evidence was plain to see: 'we turned the landscape into American-style prairie . . . and turned some of the biggest farms in Europe into giant, fertiliser-gobbling, pesticide-spraying, manufactured-seed-using monocultures', a situation poignantly acknowledged in Burra's *English Countryside* (1965–7; fig. 63) which shows featureless swathes of implicitly monocultural land abutting a smaller, remnant area of trees and woods.[22]

The centrality of agriculture in post-war culture and consciousness is illustrated by its long-lived by-product, *The Archers*, first nationally broadcast by the BBC on 1 January 1951. Intended to provide advice to farmers and to familiarise the urban population with rural problems, its success far outstripped expectation – an outcome that has been attributed to nostalgia, a conclusion that accords with the programme's centre-right ideology.[23] A broadcast titled *The Politics of the Archers*, which aired shortly before the programme's 60th anniversary, described how Godfrey Baseley, the original script writer, had defined the principal characters, establishing their politics (conservative) and religion (Church of England).[24] In contrast with calls from the Left in 1939 for the nationalisation of land, the early days of the programme might be recognised as a relic of that 'Other Eden', visually constructed by Neo-Romantic painters and available for re-enactment through a gently dramatic storyline.[25]

Nonetheless, the future of farming was to be technological and planned, driven by the efficient use of machinery, crop-spraying, intensive production of meat and

63   Edward Burra, *English Countryside*, 1965-7

eggs, and a minimal workforce. A creative corollary of mechanisation would focus on wild places, animals, birds and plants, with the formation of nature reserves, Sites of Special Scientific Interest and, in 1949, the Nature Conservancy. The natural world, birdwatching and specialised photography were to become staples of a democratised leisure industry.[26] This later extended to a new sensitivity to the fragility of ancient relic landscapes, from the neolithic settlement of Skara Brae on Orkney to the tiny Bronze Age fields of West Penwith. Protected by legislation and planning, specialised micro-landscapes were established and dovetailed into the burgeoning tourist industry. It was not until Rachel Carson published *Silent Spring* in 1963, an exposé of the effects of the widespread use of pesticides on American farming, that doubt was cast on the principles of the new agriculture and, by extension, much of the post-war planning for the countryside.

But that was in the future and the agricultural landscape of the late 1940s was not yet imbued with modernity. Though the number of tractors had increased fourfold by the end of the war and, as a result of Lend-Lease, that of combine harvesters had doubled to almost 2,000, horses remained the principal source of power on farms. Many ancient, horse-drawn devices stood alongside the new milking machines and combines.[27] The strangeness of agricultural practices and equipment appears to have had a near-surreal impact on town dwellers. It was encapsulated in a Ministry of Information pamphlet that read: 'Teeth of the Gyrotiller. Cut of the Plough. Rake of the Harrow. Press of the Roller. Drill of the Planter. Arms of the Reaper'.[28] Richard Hamilton's *Reaper* prints are the visual equivalent of these oddly poetic words. The seventeen plates that he made when he was still a student in 1949 were exhibited at Gimpel Fils the following year as 'Variations on the theme of a reaper'.[29] Each of the plates, all but one in monochrome, is a fanciful variation on the complex mechanism of a reaping machine. The essential rotating blades, driver's seat, brake, wheel and baseboard can all be identified, though only the final image, *Reaper (p)* (fig. 64), which is set in a field crop, much resembles an actual machine.[30]

1/20

R. Hamilton

64   Richard Hamilton, *Reaper (p)*, 1949

65   Diagram of a nineteenth-century reaper from Sigfried Giedion's *Mechanization Takes Command*, 1948

While Hamilton devised the prints in the context of a long-running debate at the ICA on a much-desired *rapprochement* between art and science, the origin of the imagery lay in Sigfried Giedion's idiosyncratic book, *Mechanization Takes Command*, an investigation of technologically grounded modernity written, as its author explained, in an effort to understand the effect of mechanisation on humanity.[31] In a section on agriculture Giedion examined the development of reapers, with four detailed illustrations of machines made between 1831 and 1875 (fig. 65). But whereas his plates were factual demonstrations of technological development, Hamilton's etchings on the same theme are explorations of imagery and print techniques produced during a year spent largely in the Slade's print room, 'investigating [its] technical resources'.[32]

Whereas Hamilton's prints propose an evolving technology, Michael Rothenstein's *Untitled (Farm Scene)* (1945; see fig. 15) suggests that his imagination was fired by the archaic quality of a malfunctioning machine. A dynamic wreck, it can be understood as defiant of technological improvement. Rothenstein had moved in 1941 to Great Bardfield and remained in the area for twenty years, drawing his subject matter

from the surrounding landscape. Comparable rural places in Sussex and Dorset had provided the wartime experiences of John Stewart Collis, who had enlisted as a labourer in the predominantly female Land Army. Collis described his first encounter with a harrow (used for levelling and breaking up soil): 'I had continually come across strange-looking instruments at odd corners. Useless things thrown away, they seemed, old rusty chains and spikes with grass growing over them. They reminded me, somehow, of those awful crocodile-teeth traps that used to lie concealed in woods against poachers . . . But I found that these creatures were by no means dead. They were harrows . . . I would go up to one of these rusty abandoned instruments, connect it with the horse-traces and bring it to life'.[33] Collis's 'by no means dead' machine finds a close counterpart in Rothenstein's painting.

The recognition of modernity's potential for transformation extended far beyond machinery and industry. Sheila Fell, one of the diverse realist painters who exhibited at Helen Lessore's Beaux Arts Gallery, grew up in Aspatria, a village set in flat agricultural land beyond the Lake District. In 1949 she left for St Martin's School of Art in London. Though she never lived in the north again, it was her home territory, fundamental to her well-being, to which she returned regularly for holidays and intensive work.[34] She wrote: 'I have no interest in any painting which does not have its roots in reality . . . The closeness of my relationship with Cumberland enables me to use it as a cross section of life. All the landscape is lived in, modulated, worked on and used by man', a point underlined by her work.[35]

Among Fell's images of Aspatria is one painted from a garden behind Queen Street where her parents had their small house (fig. 66). She constructed the painting to emphasise the light emerging behind a hill in the background which was a bold pictorial invention that she incorporated into several paintings of the town. Returning from a school trip to the Netherlands in 1946 she had been astonished by the bulk of the Westmorland mountains: 'black and hostile . . . like a gigantic frightening wall . . . although I'd lived among them for years, it was the first time I ever saw them'.[36] Her reaction was to permeate her subsequent work. The flat countryside surrounding

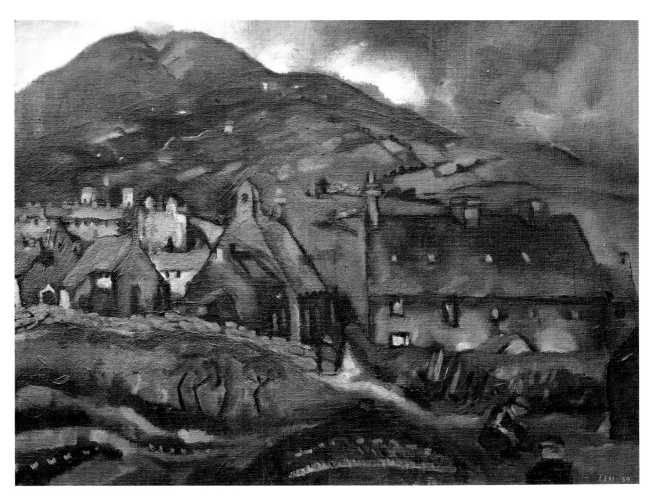

66  Sheila Fell, *Aspatria*, 1959

Aspatria is made up of fields divided by hedges, quite unlike the dry-stone walls of
the Lake District. Its hills are at some distance, on the horizon; it is there that the
one painted by Fell belongs, rather than in the neat little town with its long, uniform
streets of brick and pebble-dash houses. Fell believed that 'it takes years to get to
know a place well enough to paint it'.[37] She wrote later of having 'mostly drawn and
painted in Cumbria, Yorkshire and Wales so the chief influence has been that of the
country and the different activities which take place on the land i.e. Farming, Mining,
Harvesting etc. The Prescence [*sic*] of the mountains moors sea and the effect of the
changing light in relation to the earth'.[38]

Fell produced many drawings formed of bold black marks that recall the work of Frank Auerbach.[39] Largely for financial reasons, she limited her palette to earth colours for many years, though the darkness of her work probably had as much to do with her northern upbringing as with her impecunious state.[40] Her depictions of unpicturesque poverty, her restricted colour range and clotted surfaces amount to statements of aesthetic modernity, as they did for other Beaux Arts Gallery painters. Reviewing Fell's 1965 exhibition in Kendal, John Russell Taylor wrote: 'clearly the grim semi-industrial landscape of Aspatria shaped her view of life . . . there is never anything in the slightest picturesque about Sheila Fell's Cumbria though sublime, maybe'.[41]

Much of her work focused on agricultural workers in the vicinity of Aspatria, an area that she found harsh, 'almost drab . . . with its basic workaday activities'.[42] Her skies are huge, the fields vast expanses in which tiny figures, indistinguishable as individuals, toil in a morass of mud. Gripped by the back-breaking task of potato picking, these labouring figures are all but absorbed in the thick paint that replicates the texture of heavy, wet soil. Nevertheless, she was well aware of recording an anachronism, writing to friends in 1966 that the pickers had been replaced by machines.[43] If Fell began her career as a social realist in the lineage of Lowry and Herman, she ended it as a landscape painter, her modernity apparent in simplified imagery where a dab of white paint might denote a house on a hillside. She was much attracted to Skiddaw, one of the Lake District's highest peaks, showing it towering over a group of tiny buildings at its foot in such a painting as *Skiddaw, Summer* (1963–4; fig. 67). The tonality of the image reveals her acute sensibility to the light that illuminates slopes and rises. Fell's painting also records changes in vegetation, from a lush meadow at the foot of the mountain to the thin growth on the rocky slopes below the summit. Lower down, centrally placed in the band of buildings, is a patch of thick, intense colour, including turquoise and a high, bright mauve, which reappears in a long streak down the mountainside. They lighten and destabilise the image, as do the clouds.

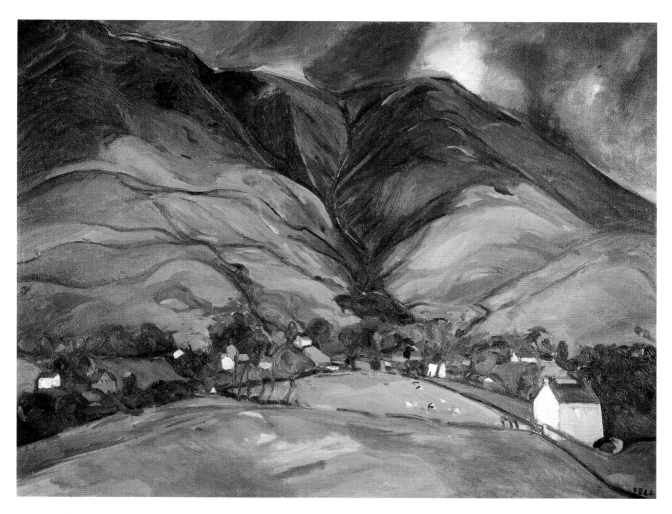

67   Sheila Fell, *Skiddaw, Summer*, 1963–4

While 'Ag' engaged many artists, 'Fish' was less popular, though no less topical. Burra's *The Harbour, Hastings* (1947; fig. 68) is an almost conventional view of a harbour with fishermen surrounded by boats, baskets, nets and fish boxes. Only the abrupt transition from towering boats in the closed-in foreground to tiny buildings below distant white cliffs indicates the unease in this busy scene. Early in the same

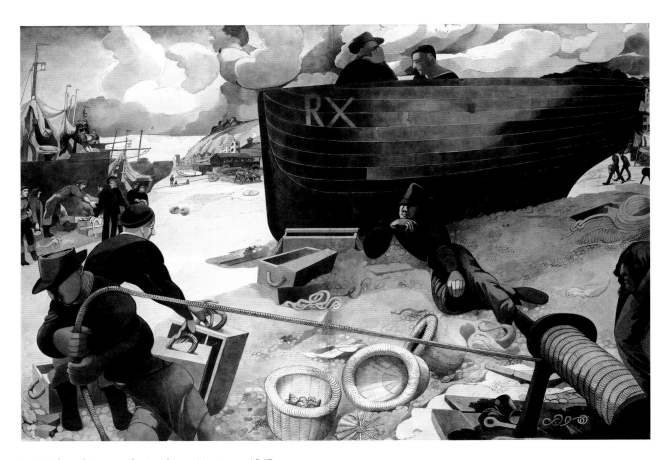

68　Edward Burra, *The Harbour, Hastings*, 1947

year Clough recorded in her diary entries an obsessive interest in the details of the stern of a beached boat.[44] Her preoccupation culminated, at the turn of the decade, in a celebrated group of paintings of Lowestoft fishermen with their nets, baskets and fish. The industry was already in decline though Lowestoft remained a significant fishing port until the early 1960s, with roughly 100 trawlers and a fleet of 25 herring drifters.[45] If Clough, always focused on the defining detail, bypassed the wider landscape of fishing, it is present as a vignette in the top right-hand corner of *Lowestoft Harbour* (1951; fig. 69).

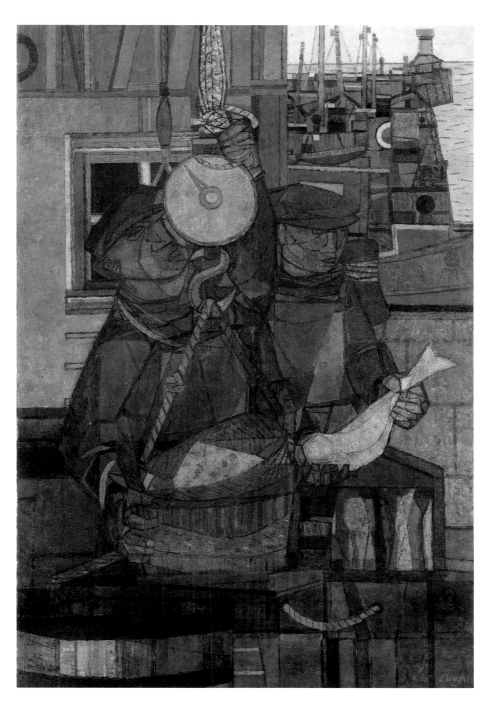

69   Prunella Clough, *Lowestoft Harbour*, 1951

70   William Scott, *The Harbour*, 1952

During the interwar years Newlyn and St Ives were the most popular centres for artists seeking picturesque maritime subjects, but when they regrouped in Cornwall in the late 1940s the fishing fleets were giving way to tourism as the major local industry. Newlyn had been the centre of the Cornish fishing industry in the early twentieth century and remains so today, though the fleet is greatly reduced.[46] The industry's most visible legacy is the many picturesque small harbours, including Mousehole and Porthleven, which have also been notable painting sites.

Between 1945 and 1952 William Scott found a fruitful subject in Cornish harbours. He developed a group of paintings, each one progressively more abstract, to which he brought a destabilising absence of symmetry and a restricted colour range. He named only one canvas for its location, suggesting that place was not his primary

concern. The most prominent feature of *The Harbour* (1952; fig. 70) is the long, black, tongue-like jetty that thrusts across the canvas with 'animal vigour', as Patrick Heron remarked.[47] Though the painting is predominantly greyish in tone it also contains flashes of bright pink and creamy, off-white pigment. Both its luxuriously thick paint and the arrangement of thin black lines relate *The Harbour* to *Figure into Landscape* (1954; see fig. 29), underlining Heron's prim implication of sexual content. Scott painted relatively few landscapes, preferring still life and the body as subjects and favouring ambiguity: 'figure-as-landscape, landscape-as-still-life, still-life-as-figure'.[48] Briefly in 1953–4 his schematic, black on white, hybrid images coincided with very similar works by Roger Hilton, who was a 'close rival' in painting what Andrew Lambirth has aptly described as the 'figured landscape'.[49] If this was a mode that demanded less intensive personal identification than Lanyon's more visceral approach, it was both new and a direction in which Scott may have seen a route to abstraction.

## The Industrial Landscape

In 1956 *The Studio* published an article called 'Painting Industrial Britain', a commentary on the results of a competition set up to promote interest in a relatively unfamiliar subject.[50] The illustrations indicate that, despite the prominence of industry as an economic imperative, relatively few artists engaged with it or its landscapes. When they did, it was predominantly with reference to mining. Pre-war coal mining had been in a worse condition than any other industry, only improving when the war enforced dependence on British production. By 1945, coal 'met over 90 per cent of the nation's fuel requirements' and was to remain at the core of the industrial economy until the late 1950s.[51] Its nationalisation, on 1 January 1947, was a significant symbolic moment, marking 'the first and most joyous of Labour's major transfers of ownership'.[52] Coal played a prominent part in the 'Minerals of the Island' pavilion in the South Bank Exhibition, its ideological and emotional significance lyrically celebrated in the official guide: 'Coal is put to work to serve us in a myriad

71   Prunella Clough, *Sunset in Mining Area*, 1959

ways. Coal for ships, for locomotives, for power stations, for gas; for by-products pouring out in plenty – chemicals, nylon, aspirin, saccharin, plastics . . . coke for the blast furnaces and for the marriage with iron, whose issue is steel.'[53]

Coal mining produced its own, vast landscape: 'coke ovens, brickworks, farms and row upon row of tied housing – those distinctive redbrick, soot-blackened terraces of the classic pit village . . . hugely run down thanks to the war and decades of under investment'.[54] Clough's *Sunset in Mining Area* (1959; fig. 71) offers a dramatic if generalised version of such a landscape, with a fiery sun setting through smog and a suggestion of burning on blackened land. It echoes the 'industrial sublime' that

preoccupied nineteenth-century painters who found themselves caught between a celebration of international commerce and 'a hell's brew of polluted industrial chaos'.[55] With its associated railways, harbours and canals, mining had transformed the geography and appearance of places where it was the dominant industry, from the north and the Midlands to the far south-west. Artists who worked in mining areas in the 1940s and '50s saw places and working conditions that are no longer recognisable following the closure of the pits; today the south-west is associated with tourism, surfing and artists, its mines having been converted to picturesque relics to divert visitors.

George Chapman, a former graphic designer from Great Bardfield, found himself by chance in the Rhondda valley in 1953. He felt an immediate empathy with the area, which was to provide subject matter for the rest of his career. He made many sparse but atmospheric realist paintings and prints, recording the changes to the two valleys that constitute the area Rhondda Fawr and Rhondda Fach (large and small Rhondda). His *Rhondda Suite* of seven etchings, printed by John Brunsden in 1960, was commissioned and published by Robert Erskine for St George's Gallery Prints.[56] Technically unorthodox and given to experiment, Chapman worked on copper plates treated with heat-fused bitumen dust, which he combined variously with sugar lift and aquatint, charcoal, and 'Goddard's glove polish with whiting'.[57]

He wrote a description of Rhondda Fawr to accompany the suite of prints:

Eleven miles of narrow valley from Trehafod to Treherbert. 17 villages joining together from beginning to end, the row upon row of terrace houses winding their way through the valley . . . one hundred and six thousand human beings, six thousand of them working bravely below with the rats and mice in coal blackness . . . A valley of strength and courage, sometimes sad with tragedy, but always intensely alive.[58]

Chapman's *The Valley Gets Deeper* (*c.* 1959; fig. 72) shows a road leading to the workplace: a mass of pithead machinery delicately drawn against the bulk of a dark

72   George Chapman, *The Valley Gets Deeper, c.* 1959

mountain. The landscape had been formed by the discovery in the mid-nineteenth century of accessible, good-quality coal, which was to bring about a vast increase in the local population, which peaked in 1921 at over 162, 000. The Rhondda's long decline began in the 1930s and, though it slowed during the war, it was far advanced when Chapman arrived. He left a record of a community whose people were defined by their labour, and a place identified by its blackened terraces, small houses and great masses of machinery.[59]

Josef Herman is the most prominent of the realist painters for whom miners were as much a cause as a subject. Among a wide circle of artist friends, he included Clough, Fell and Lowry. Born to an impoverished Jewish family in Warsaw in 1911, Herman – who commented, 'Whether religious or not, the Warsaw Jew was a political man' – exhibited with a group of socialist artists intent on representing 'the reality of the world of work' through narrative art.[60] In 1938 Herman left Poland for Brussels, never to return; his destination determined by his attachment to the expressionist work of Vincent van Gogh and Constant Permeke, a painter of fishermen, peasants and their landscapes. In May 1940 Herman found himself a refugee in Glasgow, where he rapidly became involved with the local Jewish community, which included the painter Jankel Adler and Benno Schotz, then head of sculpture at Glasgow School of Art.[61] With so many newcomers offering a hugely diverse knowledge of continental European modernism, Glasgow's wartime art world was possibly more cosmopolitan than London's. In 1942 Schotz organised an exhibition of Jewish art that included work by David Bomberg, Marc Chagall, Amedeo Modigliani, Chaim Soutine and Ossip Zadkine; the work of Georges Rouault followed in 1945, while *Picasso–Matisse* reached Glasgow a year later.

In 1944, following a brief period in London, Herman and his wife moved to a small mining town in south Wales, Ystradgynlais (its name refers to an estate and 'a local ruler who became a saint').[62] Here Herman recorded having found 'ALL that I required'.[63] Among the miners of the Welsh valleys he encountered the archetypal labourer who had been celebrated by the realist painters he admired: Gustave

73   Josef Herman, *Evening, Ystradgynlais*, 1948

Courbet, Käthe Kollwitz, François Millet and Rouault. Monica Bohm-Duchen concludes that in Wales Herman discovered people comparable to those with whom he had passed his childhood, drawn together in a community of poverty, suffering and the imminence of death, through which they faced down the world.[64] During his years in Ystradgynlais Herman's principal subject was the miners and their families, though he would include fragments of landscape in a way that illuminates the concept of what has been described as the 'dwelling perspective': the process of interaction between a place and those who live and work in it.[65] In *Evening, Ystradgynlais* (1948; fig. 73) Herman depicted a street, buildings, the river and a bridge. The painting

records his arrival in the town on a hot, still afternoon when 'a copper-coloured sky . . . reddened the stone walls of the cottages and the outline of the stark trees'. Herman recounted that a group of miners suddenly crossed the bridge, 'almost black' against the sun.[66] The four figures define the space and scale of both street and canvas; as monumental as the telegraph poles beside the road, they provide a rationale for an otherwise anonymous place. Herman's image constructs a place without surplus, with no reason for its existence but labour.

From the early 1950s Herman spent increasingly long periods in London before moving in 1962 to Suffolk where he adopted fishermen as his principal subject. In London Herman met and encouraged Fell while she was a homesick student at St Martin's School of Art. Herman became important to her because she also painted miners, representing them as she did agricultural labourers, as small, hunched figures overwhelmed by slagheaps and machinery. Fell was intimately connected not only with the poverty of miners but with their harsh lives and ill-health, as her maternal grandfather had been a miner, as was her father until he was laid off when the pits at Aspatria began to close in 1932.[67] She commented: 'I do not want to be thought of purely as a landscape painter. I hope that the nearby community is always implicit in my landscapes'.[68] Lowry was to make a similar point about his industrial paintings: 'A street is not a street without people . . . It had to be a combination of the two – the mills and the people – and the composition was incidental to the people. I intend the railways, the factories, the mills to be a background'.[69]

Fell and Lowry met at his request after he bought two paintings from her exhibition at the Beaux Arts Gallery in November 1955. He became her mentor, encouraging her to draw and to find new subjects. He also bought many of her early works and provided crucial financial support, as he did for other young artists. Their interactions generally took place in Cumbria during the summers, when Lowry would hire a car with a driver and travel to Aspatria to stay in the Fell household. Neither artist yielded an inch on their preferences concerning subject matter: the priority of a significant place. Fell would paint the landscape while Lowry would

look on or draw, 'and once', she recounted, 'when we had worked all day, sitting facing Skiddaw, I looked to see what he had done: it was an industrial landscape'.[70] Their deep aesthetic engagement with one another is far from obvious, though it emerges in their parallel depictions of small, anonymous workers, their bodies shaped by labour – Fell's characteristically in agricultural settings and Lowry's in crowded towns.

Towards the end of the 1950s Lowry was introduced by a friend, Monty Bloom, to south Wales, where he painted enthusiastically though, it seems, with less emotional engagement than in Lancashire. Barring an occasional slagheap, Lowry tended to avoid the rural landscape as a subject, though from time to time he painted seascapes. He had long been familiar with Maryport, a small town on the southern side of the Solway Firth to which he introduced Fell and for which she developed a great fondness. A few miles south-east of Aspatria, close to Allonby Bay where she often worked, Maryport lies on the edge of the West Cumberland coalfield. In the eighteenth century the small fishing village was transformed into a Georgian urban landscape, laid out on a grid plan by a local landowner, Humphrey Senhouse (1705–1770).[71] It developed into a hub of local industry, serving quarries, forges and furnaces. Later it was connected to the Carlisle railway and a considerable ship-building industry developed, though the town's principal feature was the deep-water harbour constructed to carry steel, cast iron and coal to Ireland from local collieries, including one at Aspatria. Maryport prospered until the industries closed down in 1927, leaving it with little purpose except to shelter a few fishing boats, visiting yachts and an overflow of tourists from the Lake District.

Though Fell's paintings of the town vary in tone and atmosphere, all show it from virtually the same position, looking across the harbour and sea towards Scotland. Her viewpoint was in the grounds of the Maryport Educational Settlement, facing a footbridge across the River Ellen.[72] *Maryport* (1964; fig. 74) emphasises a prominent local landmark, Christ Church, which Fell darkened dramatically. In other respects, she showed the town much as it is today, its many transformations absorbed back

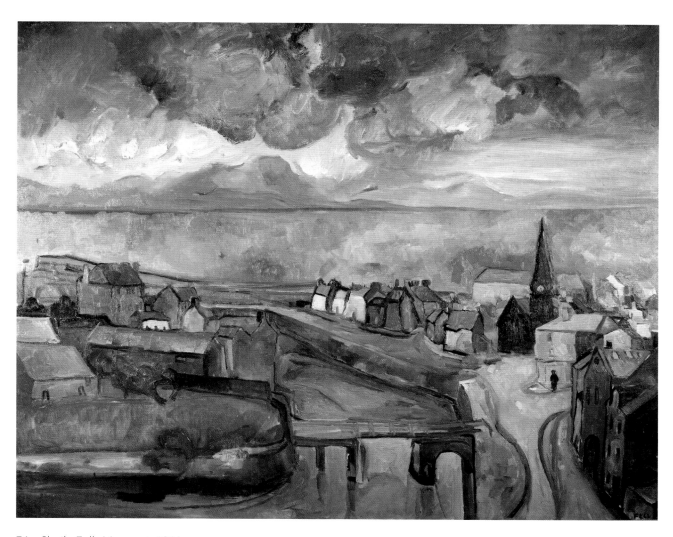

74   Sheila Fell, *Maryport*, 1964

winto a place of uncertain identity. In contrast with the realism with which Fell represented Maryport, at nearby Allonby she 'focused on transience – the sea and the ever-changing sky', which provided an infinite range of colours and weather conditions.[73] She painted seawater and snow in a similar manner, as if to underline the way that the density and weight of ice and water act on the land. Fell made at least four paintings at Allonby in 1965, all emphasising the curve of the bay with a fast-running sea sweeping onshore, with the ceaseless movement of water and clouds and ever-changing colours.

One of Lowry's closest artist friends was David Carr. They met in 1944 when Carr bought one of Lowry's paintings; subsequently they visited each other's homes, corresponded and exchanged works. Writing to Lowry, Carr acknowledged their common interest in industrial landscapes: 'For the last few years I have been working on the same style of landscape as yourself and . . . have had good opportunity for exploring the so-called hideous parts of London, Ipswich and Bristol, concentrating almost entirely on the dock areas of those towns. But unlike you, I try to express my feelings through the buildings alone; the boats, the cranes, the railway trucks are the monsters who live in my world and people it'.[74] After a brief early stint in the Peek Frean biscuit factory in Bermondsey, which was owned by his family, Carr refused to engage with the business, though it may have stimulated his fascination for mechanical imagery. He was to remain gripped by a relationship in which 'the machine has become part of the man, and the man part of the machine', a theme that he explored throughout his career.[75]

From 1947 Carr and Clough, who became close friends, corresponded frequently and prolifically, incidentally creating a vivid record of art world gossip intertwined with their own lives and work. At this time, Lowry, Clough, Carr and Fell, who were all connected with one another,[76] all took working people as their primary theme, in contrast with the strictly realistic industrial paintings reproduced in *The Studio* in 1956. For most of the decade Clough's subject matter came from various industrial environments. Her workers tend to resemble one another, with Cubist-inspired

features, though they are sharply differentiated by their tools, equipment and settings, which amount to specialised, miniature landscapes. Identified solely by their work, they are, as Frances Spalding notes, 'trapped by machines and restricted in movement by the repetitive nature of their labour'.[77] Lowry emphasised that working people were the rationale for all his urban paintings, though they tend to act as anonymous space definers, rather than as individuals. In contrast, Fell believed the body of the labourer to be inseparable from the task; the physicality of the working body is always implicit in her work.

Other than a few early paintings of hedges and greenhouses in East Anglia, Clough avoided the rural, though, like Lowry, she enjoyed visiting the countryside and kept a house and studio in Southwold, where she had passed much of her childhood. Almost throughout her career she sought out factories, slag heaps, canals, gravel pits and the detritus that litters wastelands, finding in them nuances of colour, shape and visual significance unrecognised by her contemporaries. She defined the post-war industrial landscape through her painting, though – given her uncompromising subject matter – her early success would be extraordinary had she not been understood to express the ethos of a society engaged in reconstruction and to recognise the humanity of those engaged in the concomitant physical labour.

Clough's figures are predominantly male, generally stocky, and always engrossed in the tasks by which they are defined. The printer, driver and telephone engineer fit into their workshops, cabs and holes in the road like snails into their shells: their work and their being are indivisible. Much the same might have been said of Clough herself. A large part of her subject matter was gathered in the course of lengthy walks around London. Wapping, Battersea, Rotherhithe, Wandsworth and Bow were areas that she explored on foot and appropriated as subject matter. She was, as she put it to Bryan Robertson, 'an "eye" person'.[78] Everything that she painted was grounded in a refined, idiosyncratic vision informed by wide reading, a large circle of acquaintances, and energetic travel throughout the country. She made a group of pictures of the cranes that then still dominated the London docks.

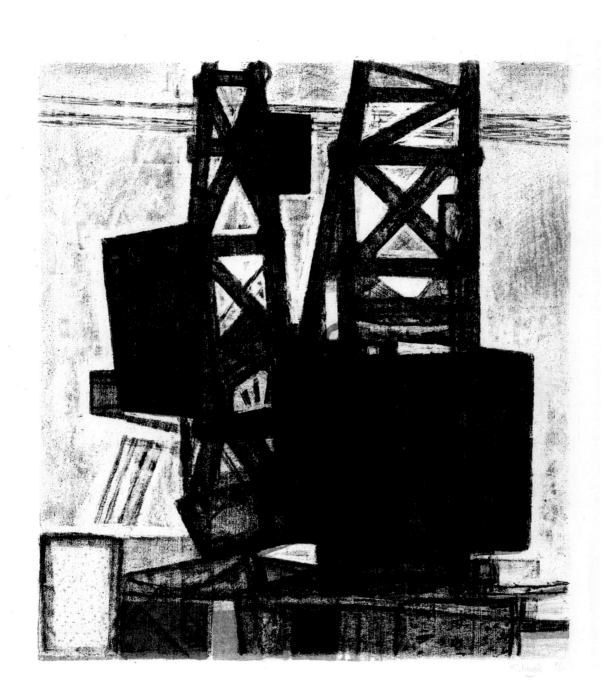

75   Prunella Clough, *Cranes*, 1952

*Cranes* (1952; fig. 75) suggests that her interest lay as much in the intricacies of the mechanisms as in the drama of the long arms reaching into the sky. Certainly, she was sufficiently gripped by machinery in general to note in her diary the *Mechanical Handling* exhibition in June 1952.[79] Like all her work at this time, the crane pictures were based on observation, initially recorded *in situ* in tiny black and white photographs. Clough's images of the docklands set out the visual facts and atmosphere of a specialised landscape defined by water, shipping and heavy machinery. The cranes occupied much of her time during the early 1950s, after which she turned to other subjects, though she retained her fascination with dockyards, visiting an unidentified marine engineering and welding works in September 1953 and other urban yards at home and abroad when she found the opportunity.[80]

Conventionally attractive landscapes held no interest for Clough; dismissing 'fields and woods' but attracted by the interactions of people with various kinds of industrial plant, she stated a firm preference for 'the urban or industrial scene or any unconsidered piece of ground'.[81] She was fascinated by slag and scrap heaps which she photographed and painted repeatedly, noting, in the vicinity of Wigan in 1958: 'Walk on slag heap by coal dump'.[82] *Slag Heap* (1958; fig. 76) indicates a history of industrial spoliation of a once-rural place. Clough's image presents it in isolation, dominant and unmodulated by detail other than a heavily textured surface in the characteristic 'deep red-brown colour of rust'. Clough's slag heap is emphatically not rendered as an identifiable place, suggesting, rather, a generalised condition of dereliction over an undefined area. Since her industrial landscapes lack obvious boundaries, their scale is ambiguous, suggesting that they reveal and dwell on close-up details while being of limitless extent.

Many of Clough's industrial landscape paintings engage with the peri-urban spaces that have been identified as edgelands, thereby incidentally establishing a new category of landscape.[83] The antithesis of a clean, controlled Corbusian aesthetic, edgelands are equally central to formulations of modernity and landscape. Enthusiasts for these ambivalent areas maintain that they have no marker 'truer or

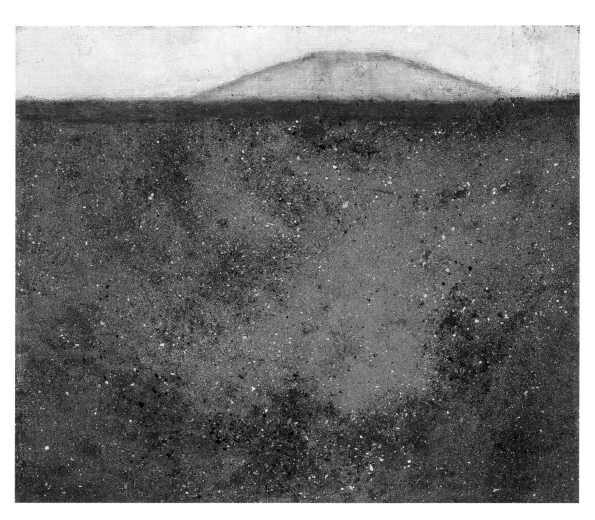

76    Prunella Clough, *Slag Heap*, 1958

more emphatic than the sight of cooling towers in the distance' and that 'there is nothing objectively more beautiful about a community forest than a derelict industrial site'.[84] The edgelands have been described as

> places where an overlooked England truly exists, places where ruderals familiar here since the last ice sheets retreated have found a way to live with each

successive wave of new arrivals, places where the city's dirty secrets are laid bare, and successive human utilities scar the earth or stand cheek by jowl with one another; complicated, unexamined places that thrive on disregard, if only we could put aside our nostalgia for places we've never really known and see them afresh.[85]

This was Clough's territory: the litter-strewn, weed-covered spaces which – overlooked by planners and colonised by sewage works, land fill, gravel pits, scrap yards and similar socially marginal sites – have been acknowledged as 'the lowest grade of landscape in UK landscape conservation terms'.[86]

If, as *The Studio* article of 1956 suggested, relatively few artists engaged with industrial subject matter, Carr's and Clough's enthusiasm was unusual, particularly as most of those who approached industry did so, like Herman, for emotional rather than visual reasons. Whereas Herman experienced an epiphany on reaching Ystradgynlais, Fell's devotion to old agricultural practices emerged from her deep attachment to her home territory and her reluctance to see it modernised. More often, though, as Hamilton demonstrated with his *Trainsition* paintings, transformation was brought about by the desire of artists to engage with the present, rather than with thatch and handicrafts. Hamilton was interested in modes of perception and Clough in an aesthetic of modernity. They were among those who not only evolved new ways of painting landscape but in doing so revealed previously unacknowledged aspects of their subjects. They were, however, not quite the first to recognise the potential of industrial subject matter. As early as 1949 Geoffrey Grigson remarked:

The one landscape which the Romantic discoverers did not know, and which it has taken a hundred and fifty years to perfect – is the landscape of the lunar beauty of industrial dereliction . . . the scarred, half-repaired landscape where industry has settled and decayed . . . the lunar, derelict landscape . . . is perhaps the authentic landscape of modern England and modern associations . . . disregarded, safe and uncontaminated for our enjoyment.[87]

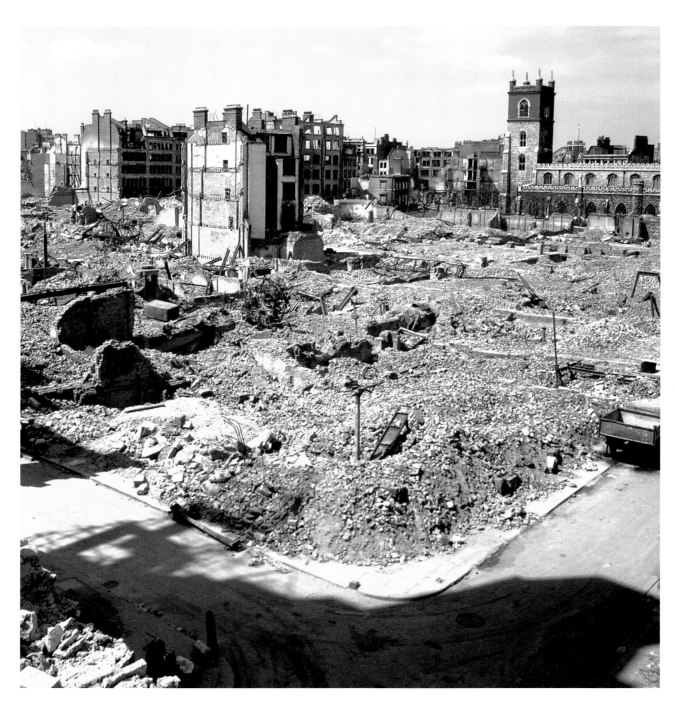

77   St Giles-without-Cripplegate, City of London, after bombing during the Blitz, December 1940

# 5  Cities Reimagined

Among the phrases that have been proposed to identify the urban equivalent to landscape, Gordon Cullen's 'cityscape' is the most succinct. The 'urban landscape', which I have adopted, is broader, in that it covers visual art as well as architecture. In 1945 the urban landscape included not only open spaces and parks but the sites of the most urgent post-war reconstruction. Housing was pre-eminent among the categories of construction that jostled for materials and manpower, the urgency of the problem underlined by frequent squatting in empty buildings.[1] In London, despite widely expressed preferences for houses, new provision predominantly took the form of flats, encouraged by subsidies offered to local authorities to build blocks of four or more storeys with lifts, which obviated the need for the older, much disliked access balconies. Early results of this policy were manifested by Woodberry Down, Hackney, designed by J. H. Forshaw for the LCC Architects' Department (1948), and the widely acclaimed Churchill Gardens by Philip Powell and Hidalgo Moya in Westminster (1946–52). The LCC's Lansbury Estate in Poplar, designed by various architects from 1949, was the first London estate to be laid out with mixed housing in discrete neighbourhoods, the design principle that had been initiated by Frederick Gibberd in Harlow New Town.

If architecture establishes the places and spaces within cities, their identity and character are often given, or at least enhanced, by works of art: Moore's *Family Group* (1948–9; see fig. 91), which proposes the harmony and stability of an exemplary family, identified not only the Barclay School in Stevenage, for which it was commissioned by Hertfordshire County Council, but the ethos of the town itself. Statues and memorials continued to play a part in place-definition though it was not until the 1980s that memorials related to the Second World War began to proliferate, since gifts of land or buildings for public use had been more highly favoured as forms of commemoration in the early post-war years. Between 1945 and

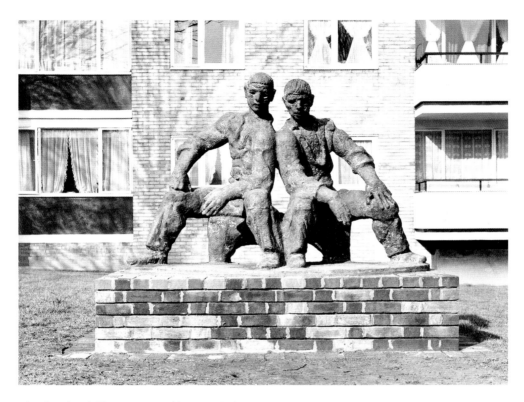

78   Siegfried Charoux, *Neighbours*, 1959

the 1970s, commissioning bodies and artists alike took advantage of new buildings which offered abundant space for secular, non-commemorative works of art. These generally took the form of sculpture in stone or metal though there were also successful, if less frequent, interventions in the form of tile and mosaic murals. The LCC provided a model for local authorities across the country with its commissioning scheme for contemporary works of art in association with new buildings.[2] Whereas some commissioned works were simply ornamental, many carried a social message: Siegfried Charoux's *Neighbours* (1959; fig. 78), sited in the grounds of Quadrant Estate in Highbury, suggests an ideal relationship between tenants. The chunky monumentality of the two men recalls the trope of the heroic Soviet worker carried

over into this portrayal of harmonious friendship, a reminder that Charoux had been an enthusiastic supporter of 'Red Vienna' in the 1920s and retained many of its values.

Reviewing the ethos of architecture in the post-war years, Alison Smithson commented:

> Unless a building outlasts its first users, we get no body of choice, that is, there's no pool of housing from which people can choose how to live where they want to live. And more important, you get no build up of a comparable body of quality. This was the situation we stepped into after the war – completely vandalised environment, of anything will do, make do.[3]

London bombed or – as the Modern Architectural Research Group (MARS Group) had proposed in an exhibition at the Burlington Galleries in 1938 – deliberately razed, had featured in the architectural imagination since the 1930s; it was a shocking reality by 1945 when 475,000 houses were uninhabitable, as were schools, offices and factories.[4] A brief utopian moment intervened, when wide-scale, planned renewal seemed possible, before economics, materials and builders manifested as near insoluble problems. During the negotiations that preceded construction, aspirations to a finer future were all too often abandoned, with planning delivered in isolated packets rather than as an overall vision.

## Painters and Builders

Among the artists who adopted bombsites as a subject, few were interested in the subsequent reconstruction process, but for the young Frank Auerbach and his friend Leon Kossoff, the extraordinary landscapes of building sites scattered across London offered a rich and unprecedented subject. These sites stimulated a body of work that has been described as 'a convincing synthesis between the concepts of British landscape tradition and a contemporary, concrete experience of reality'.[5] The two painters, who met at St Martin's School of Art in 1949, responded to the building sites brought into being by bomb-damage. The construction sites of the

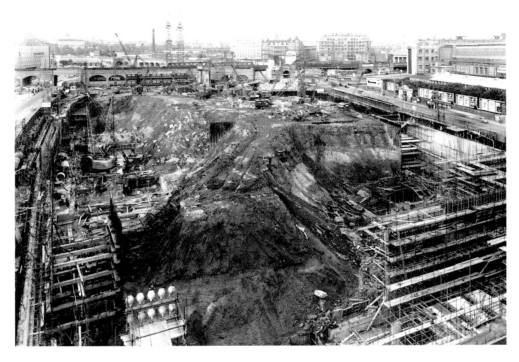

79    Construction site of the Shell Building, London, 1959

Royal Festival Hall and the Shell Building on the South Bank were among the places Kossoff painted in the 1950s, alongside Auerbach, who was fascinated by the drama and scale of the foundation excavations (fig. 79). His dramatic vision of deep pits and precipitous mounds of subsoil crossed by fragile walkways, of which *Shell Building Site from the Thames* (1959; fig. 80) is an example, has been aptly compared with the irrational spaces of Giovanni Battista Piranesi's *Carceri* prints. If Auerbach did not seek to convey the same cavernous claustrophobia as Piranesi's images, his paintings vividly convey a vertiginous sense of height.[6]

That Kossoff's renderings of buildings appear to be less abstracted than Auerbach's is a result of their different techniques and perceptions of the essential facts to be recorded. Auerbach painted, scraped back and obliterated, building up a great depth

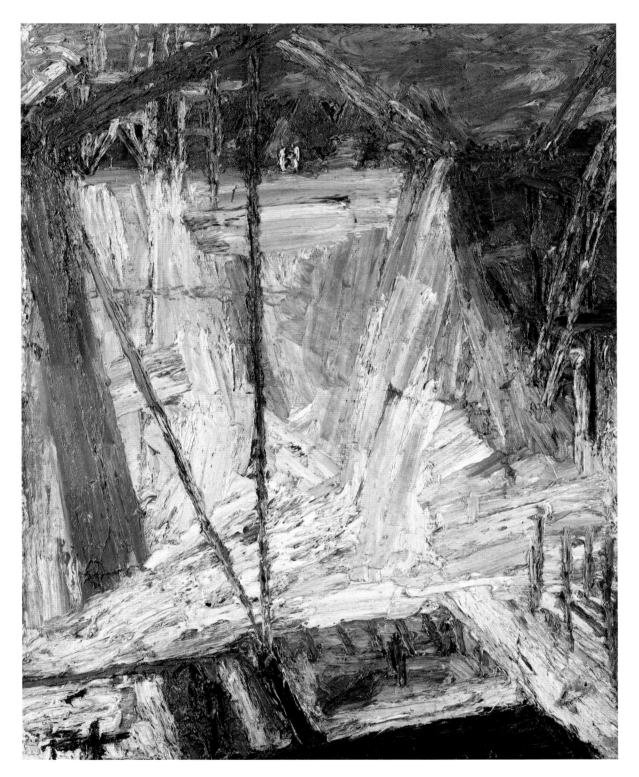

80   Frank Auerbach, *Shell Building Site from the Thames*, 1959

of pigment until a satisfactory image took its place on the canvas. His construction paintings, which focused on the material facts of building, revealed a strong sense of geometry and rational control, whereas Kossoff's buildings suggested events in a process of becoming rather than solid structures, a result of the directional fluidity of his paint marks. In this context Paul Moorhouse has written of Kossoff's need to find a structure within 'the visual chaos of the subject'.[7] Conversely, the working drawings of both artists are, in their different ways, rational and factual, showing proportions and the various sections of foundation excavations.

Kossoff and Auerbach revealed London at a moment of transformation from apocalyptic disaster to optimistic renewal, juxtaposing landscapes of despair with those of renascent capitalism. It is easy to forget that optimism was slow to take hold: that opposite the new office block there would be a bomb site which would serve as an *ad hoc* playground. In this regard, the most well-known site in London was St Paul's Cathedral. Long before the war's end, its survival had become a metaphor for the future of London itself. On the periphery of the City, in an area that suffered intensive bombing because of its proximity to the docks, St Paul's was often portrayed in wartime photographs surrounded by a wasteland of rubble. In 1955 Auerbach and Kossoff both painted and drew the east end of the cathedral. It abutted an area that was soon to be the epicentre of a building boom, which was exemplified by the undistinguished neo-Georgian façade of New Change House (Victor Heal & Smith, 1953–60). Curving around St Paul's, the building conveyed a faint attachment to the past and an uncertain vision of the future, while occupying one of the most aesthetically sensitive sites in London.

Housing and schools constituted the core of the reconstruction programme, with priority given to houses: 'first things must come first. The houses must go up and nothing must stand in their way'.[8] The most urgent need for accommodation was in the East End of London, of which it has often been said that the Luftwaffe completed the job of slum clearance, removing an old landscape of narrow streets and small, dark courtyards that had acted as light-wells to tenement buildings. Regrettably, the

81    Gollins, Melvin, Ward & Partners, Castrol House, Marylebone Road, 1957–60, shown nearing completion in 1959

best opportunity for architectural creativity since the Great Fire was passed up in favour of short-term profit. Until 1954 stringent controls ensured that labour, as well as meagre supplies of steel, wood and concrete, were directed to other priorities. As a result, would-be developers waited, taking the opportunity to amass what has been aptly described as 'cheaply acquired bomb sites of incredible potential'.[9] When, in November 1954, the conservative government enacted its 'bonfire of controls', office and commercial development took off, frequently with appalling results. The developer-led frenzy lasted almost exactly a decade, until the 'Brown Ban' enforced strict limits on office building in the south-east and major cities.[10] Sadly, during the subsequent property boom of the late 1950s and early 1960s the lure of a fast profit again overwhelmed other considerations, resulting in buildings that were widely condemned on aesthetic grounds.[11] Despite the appearance of occasional gems such as Castrol House (Gollins, Melvin, Ward & Partners, 1957–60; fig. 81), London's first response to New York's Lever House, most commercial

developments were, in the words of the former developer and poacher-turned-gamekeeper Jack Rose: 'nothing better than shoe boxes with glass in them . . . When I look at the streets of London and at the buildings that were put up in that era, I'd say we made a muck of it'.[12] It was not only cities that suffered from the aftermath of deregulation. A fundamental lack of vision, or perhaps of will, was lamented by Ian Nairn (see Chapter 4), who enumerated the categories of development released from planning control in 1950. Less apparent than city-centre projects, they included all buildings connected with forestry, water, gas, electricity and the National Coal Board; recreational land and refuse sites; street furniture, barriers, overhead wires and signs. The subsequent, appalling mess that Nairn documented (see fig. 62) resulted as much from a failure of imagination as from inadequate legislation.[13] At the same time, long-standing inner-city housing problems remained unresolved, with 'deprivation . . . unfit dwelling stock and environmental disadvantage' persisting into the 1960s.[14]

Most large-scale housing developments were designed by local authority architects and, in London, by those working for the LCC. Immediately after the war responsibility for housing was handed to the Valuer's Department, later succinctly described as 'totally dedicated to quantity'.[15] In 1950, when housing was returned to the Architects' Department, it immediately became evident that 'the new, exciting architecture was coming from the public sector and for any young aspiring architect, the LCC was the place to be'.[16]

The LCC estates which provided so much of London's housing produced a remarkable diversity of landscapes, their character often underlined by well sited sculpture. The Alton Estate in Roehampton (LCC Architects' Department, 1951–9) was a rare example of a new estate built on open land. It contains two areas of discrete architectural character that exploit the local topography and acknowledge 'the quality and scale of the landscape', with views over Richmond Park, as a central factor in determining design parameters.[17] Alton West (1959) contains eleven slab blocks of maisonettes and two groups of point blocks set on wide lawns with mature

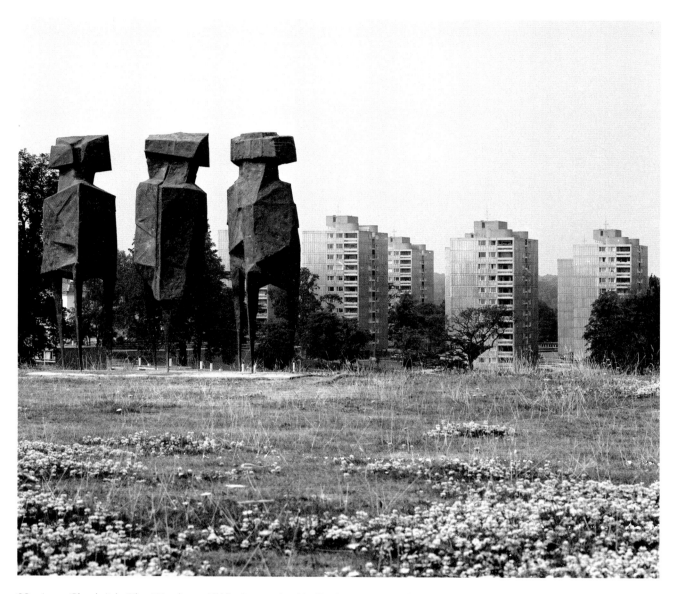

82  Lynn Chadwick, *The Watchers*, 1960, shown sited in Roehampton in 1963

trees. It was embellished by Robert Clatworthy's life-size bronze *Bull* (1957; installed 1961), while Lynn Chadwick's bronze group, *The Watchers* (1960, installed 1963; fig. 82) was poised theatrically at the top of a slope overlooking the estate, as if on guard.[18] Both pieces demonstrated picturesque qualities of surprise and reasserted the role of sculpture in a designed, if informal landscape.

83 (LEFT)   Bryan Kneale,
*Sculpture*, 1962, shown
sited in Lambeth in 1965

84   Trevor Tennant,
*Gulliver, c.* 1959

Inner-city estates inevitably had less available space and consequently a very different character. In 1962 Bryan Kneale was commissioned to make a sculpture for Fenwick Place in Lambeth, for which he produced a powerful piece in welded steel and slate on a high plinth. Wedged into a narrow site, Kneale's *Sculpture* (fig. 83) conveyed an intense sense of urban enclosure. Regrettably, it has long since vanished, its disappearance raising legitimate questions about the acceptability to tenants of such uncompromising works.[19] A more populist approach to modernity was widely publicised following the siting of Trevor Tennant's play sculpture, *Gulliver*

(c. 1959; fig. 84), in Dora Street, Limehouse. Though it was modelled on Moore's reclining figures, *Gulliver* was not conceived primarily as a work of art; constructed in concrete and set in a sand pit for children to scramble over, it was one of several comparable pieces installed in the new playgrounds of the early 1960s.[20] Years later it was raised on a brick plinth and surrounded by a railing. Nairn had prescient views on such alterations: 'If a monument is to live it mustn't be railed off, fenced around, beautified or even pampered. It must stay in the view on its own merits: otherwise "preservation" means obliteration'.[21]

## Townscape

The South Bank Exhibition, which was the centrepiece of the nationwide Festival of Britain in 1951, was described in the *Architectural Review* as 'the first modern townscape' (fig. 85).[22] The magazine's editors considered the greatest triumph of the exhibition to be its 'revolutionary', 'informal' planning, which they identified with the 'Picturesque theory of landscaping . . . now recognised as one of Britain's major contributions to European art'.[23] Dismissing the repetitive Beaux Arts format that had been associated with international exhibitions as late as the 1939 New York World's Fair, the planners and architects of 1951 conceived the entire exhibition site as a temporary town, in which individual structures were less significant than the presentation of a new model for urban planning.[24] Its progeny includes Harlow's 'Casbah' area, the Alton Estate and the central square of Lansbury, as well as many lesser contributions to urban landscaping – now taken for granted – such as planters, irregular ground surfaces and water features.[25] Ten years later Peter Cook concluded that the South Bank Exhibition 'did more to design in Britain than anything a decade before or since'.[26]

For many visitors the South Bank Exhibition may have been confusing, though it cannot have been other than stimulating. It was predominantly concerned with a new vision of life, while including occasional acknowledgements of older conventions, such as the embroidered mural made for the 'Homes and Gardens' pavilion by members of the Women's Institute.[27] The tone was set by Powell and Moya's *Skylon*, a gleaming, suspended structure of 'steel panels . . . covered with satin-finished aluminium louvres, standing almost 300ft high' and internally lit at night.[28] Too large and unprecedented to be acknowledged as sculpture, it was the centrepiece of the exhibition; a pure spectacle that proclaimed the future, demanding that it be recognised as the embodiment of a modern world without conceptual limitations. The *Skylon* was destroyed at the end of the exhibition; presumably the dream it offered was beyond the possibility of realisation.[29]

All the new buildings on the South Bank except the Royal Festival Hall were temporary, due to restrictions on materials. Maximising the use of screens and

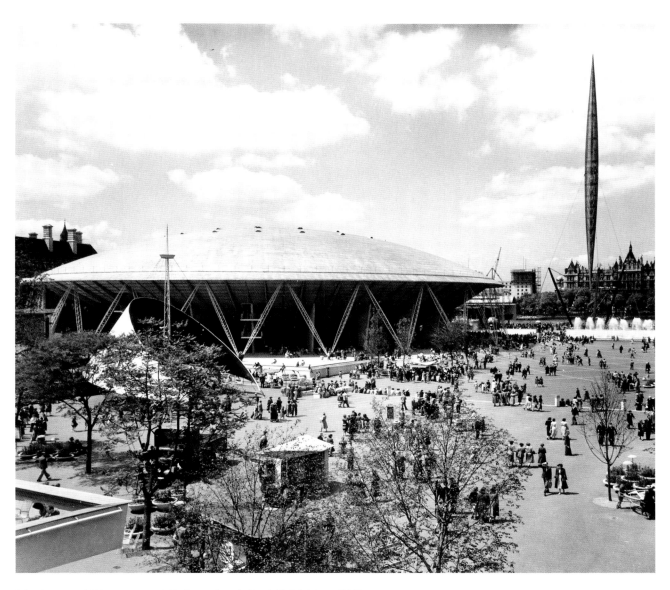

85   Dome of Discovery and Skylon – South Bank Exhibition, 1951

canvas, architects took the opportunity to design fanciful, eye-catching show-pieces distinguished by 'airiness and transparency'.[30] J. M. Richards found the sheer eccentricity of the Chicheley Street entrance, designed by the Architects' Co-Partnership, a welcome contrast with conventional buildings. Fully in accordance with the spirit of the South Bank it incorporated 'a semi-circle of management offices' and an upper floor that consisted of 'a series of glass-fronted boxes slung

from steel bipods'.[31] Across the site, the pavilions were individualised, with glass widely used as a space creator and a means of providing 'frequent panoramic views . . . to furnish unexpected but well-composed pictures of the bright outdoor world'.[32] The *Architectural Review* enthused over the detailing of the site. Patterning, on the skyline, the ground and wall surfaces, was praised for its 'intricacy' and favourably compared with the 1930s when 'simple geometry was admired for purity's sake'; it seems that after the severity of stripped-back wartime utility design, decorative complexity was welcome.[33]

Overall, the South Bank's architecture emphasised lightness of spirit and suggestion rather than precept. 'Hazards' – changes of level, pools of water, plant boxes and patches of grass – acted as space dividers, while walkways and screens articulated space without enclosing it. The ubiquitous 'nautical style', manifested by thin railings, struts and wire in a manner faintly reminiscent of a ship's rigging, provided a colourful finish to many corners. The planners' emphasis on the Thames was welcomed and hopes were expressed for the long-term retention of structures designed to interact with the river, especially those which offered opportunities to admire the view of the Palace of Westminster on the north bank.[34] Proclaimed 'the climax of the exhibition', the Palace and Whitehall Court were proposed as equivalents of the picturesque 'rock-strewn hill and the well-placed clump of trees'.[35] That the planning of the South Bank site was imbued with the spirit of the Picturesque, manifested in an updated form fully congruent with modernity, was enthusiastically acknowledged by the editors of the *Architectural Review*, who had played a central part in promoting and celebrating it. The central Festival site was also a rich repository of sculpture and murals, which incidentally amounted to a significant demonstration of the role and siting of public art.[36] Most of the murals were inside pavilions to protect them from the weather, which may have prevented them being as thoroughly recorded as the sculpture. Conversely, while some pieces of sculpture were thematically related to specific pavilions, the largest and most prominent pieces were placed on prime sites along the river and on circulation routes, where they provided visual punctuation points and navigational aids as well as aesthetic pleasure.

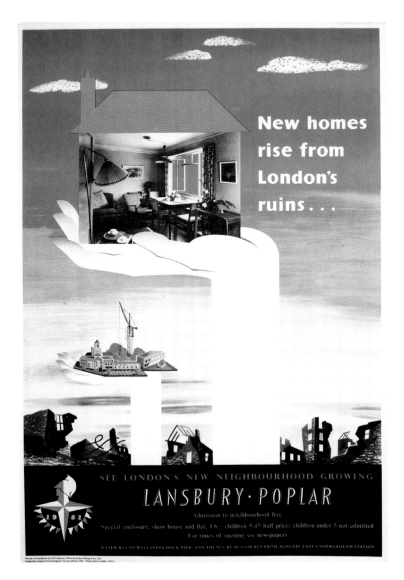

New homes rise from London's ruins . . .

SEE LONDON'S NEW NEIGHBOURHOOD GROWING
LANSBURY · POPLAR
Admission to neighbourhood free
Special enclosure, show house and flat, 1'6 – children 5-15 half price; children under 5 not admitted
For times of opening see newspapers
WATER BUS TO WEST INDIA DOCK PIER AND THENCE BY BUS OR BUS FROM ALDGATE EAST UNDERGROUND STATION

86  Poster advertising the Lansbury Estate, Poplar, as part of the *Living Architecture* exhibition

In contrast with the South Bank, the *Living Architecture* exhibition at Lansbury presented a handful of permanent buildings and a scheme for a new type of inner-city estate (fig. 86). It was completed later with mixed housing, shops, schools, churches and a town square with a clock tower and two pubs.[37] Frederick Gibberd, also the Chief Architect of Harlow New Town, laid out the exhibition in the form of

a neighbourhood unit, a basic planning component of the New Towns. Gibberd himself was responsible for Lansbury's main square and shopping centre, the first pedestrianised example of the neighbourhood unit that would be a feature of the New Towns, for which the diverse, low-rise Lansbury was an apt model. It was one of eleven areas to be rebuilt in Stepney and Poplar, though only the southern section had been started by the summer of 1951; a specimen flat and house were open for the Festival.[38] Overall, Lansbury, with its housing set in small open spaces or terraces with individual gardens, was 'bright, cheerful and human in scale'.[39]

## Sculptural Landscapes

Sculpture and memorials play a large, if under-acknowledged part in formulating conceptual images of cities, while they also constitute significant landmarks and convert urban spaces into places replete with symbolic content. The Cenotaph and Nelson's Column are obvious examples, while the totality of Trafalgar Square is a symbolic landscape that also forms one of London's principal nodes or 'conceptual anchor points'.[40] As Nairn presciently remarked: 'A monument can either be just simply the sum of its scarcity and historical importance, or a living part of the environment'.[41]

In 1948 the editors of the *Architectural Review* invited an international group of architects and theorists to discuss how the current, necessarily utilitarian approach to building might be extended through a consideration of the role of 'monumentality'.[42] Sigfried Giedion argued that people wanted buildings capable of expressing 'their social, ceremonial and community life. They want their buildings to be more than a functional fulfilment. They seek the expression of their aspirations for joy, for luxury and for excitement'.[43] Given the hazards of the national reconstruction process, his prescriptions were to be more readily fulfilled by public sculpture, which proliferated in the 1950s, than by buildings.

Of the many artists who made public works, it was Moore whose monumental sculpture responded most consistently to Giedion's call. In the 1960s the LCC bought

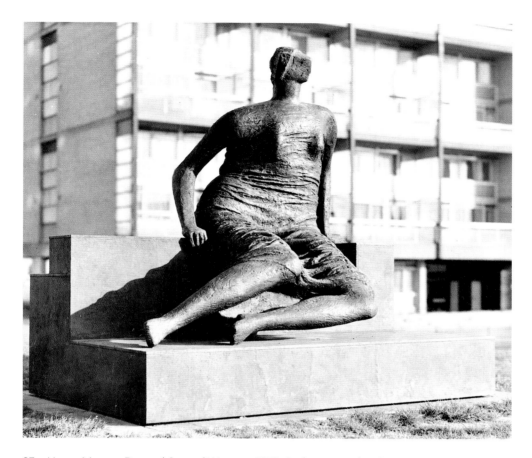

87　Henry Moore, *Draped Seated Woman*, 1957–8, shown sited in Stepney in 1962

a cast of *Draped Seated Woman* (1957–8; fig. 87), installing it in front of a slab block on the Stifford Estate in Stepney, where it became naturalised, establishing a social identity for an otherwise nondescript place. Rainwater formed a miniature cascade in the folds of the drapery; children played on the figure whose amplitude may have recalled their grandmothers; later Moore's sculpture became known locally as 'Old Flo', a familiar landmark in an area with few other attractions. Its removal, precipitated by the demolition of the estate in 1997, was controversial and much regretted by local people.[44]

88   Sydney Harpley, *The Dockers*, 1962

An even worse fate awaited Sydney Harpley's *The Dockers* (fig. 88), which was commissioned by the LCC and installed in front of Trinity Church on East India Dock Road in 1962. Its theme was both specific and apposite to the locality as most local men worked in the docks. They were badly paid, strongly unionised and reviled for calling their employers to account with frequent, crippling strikes. Harpley's life-size group in *ciment fondu* – a cheap, widely used material – was later vandalised by burning; its remnants were still to be seen in the 1980s but were subsequently removed.

By contrast, Edward Wyon's magnificent bronze memorial (1865–6; fig. 89) to Richard Green still contributes to the identity of its locality. Green was a builder, philanthropist and ship-owner, closely associated with the nearby Blackwall ship

89   Edward Wyon, *Richard Green*, 1865–6

repair yard, who died in 1863.[45] Set in front of the Poplar Baths, his memorial speaks of a culture of philanthropy grounded in trade, deep within London's docklands. Modern Poplar is split between affluent waterside conversions and unrestored housing largely occupied by immigrant communities. They have in turn established a new symbolic landscape of shops selling saris and djellabas, halal meats and exotic fruit; of flourishing mosques and specialist immigration lawyers. Such areas speak eloquently of successive acculturations and present hybridities. The Wyon memorial is scarcely a stone's throw from Lansbury's Clock Tower, a monument to 1951; neither is anomalous, suggesting that they are fully incorporated into the constant, unremarked process of urban transformation.

•

## New Towns

Thirty-two New Towns were built in the post-war years, eight of them in the vicinity of north London. Stevenage was designated first, late in 1946; Harlow followed a year later. Gibberd's masterplan for Harlow demonstrated the New Town model of land use: incorporating natural features such as streams and woodlands, the site was divided into neighbourhoods with equal populations, each with its shopping centre, landscaped open space, schools, churches and residential areas.[46] Harlow is not the only New Town that is well supplied with works of art, though it has significantly more than any other since its Chief Architect and his wife were enthusiasts for contemporary art and had a considerable collection of British works on paper by artists including Edward Bawden, John Nash and John Piper. In Harlow, as in Stevenage and Basildon, sculpture was deployed as a place maker, sited to underline the character and use of an area.[47]

Harlow Art Trust was established in 1953 by a local entrepreneur, Maurice Ash, who invited Philip Hendy, then Director of the National Gallery, to chair it. The Trustees, who included Gibberd and his wife-to-be, held their first meeting on 9 June 1953. From the start they decided to focus on sculpture, the preferred sites being informal public spaces such as the central Market Square. Mapped on to Gibberd's town plan is a sculptural landscape in which works of art demarcate routes and meeting places. The Water Gardens and the adjacent Civic Centre were identified as prime locations for works of art, as were certain housing areas. An early decision to commission Ralph Brown's *Meat Porters* (1960; fig. 90) for the central Market Square initiated a practice of favouring young artists.[48] Though it was an acclaimed work, the *Meat Porters* was not initially popular with local people. Much later, Brown said that he had chosen a controversial subject to counter the modernism of the square's architecture, which he disliked.[49] Set at the junction of the square with the pedestrian Broad Walk, the visibility of Brown's sculpture as the culmination of a significant vista was vigorously debated, the question being whether it was obscured by street furniture. Gibberd maintained that he had 'never envisaged the sculpture as being a focal point'; it

194    Artists Making Landscapes in Post-war Britain

90   Ralph Brown, *Meat Porters*, 1960

belonged, rather, to his design for the square.[50] The debate underlines the diversity of sculpture's practical roles in town planning and place-making. Brown's adverse reaction to the relatively upbeat architecture of central Harlow is, perhaps, evidence of a wider disjunction between the town's utopian modernity and the nostalgia inherent in its ideology of family, tradition and attachment to the rural.

An early commentator on Harlow, writing in 1956, recognised and welcomed the blossoming of a consumer society among a demographic that could never previously have aspired to prosperity.[51] Four decades later Michael Ricketts, exploring the town's many paradoxes, argued that its planners had ignored 'the complexity of modernity', so eloquently expressed on the South Bank site, in favour of an orderly environment that implied social control. Writing in the 1990s, after Harlow had 'been trashed', Ricketts dismissed its prominent green spaces as characteristic of the post-war 'fetishization of the rural'. At the same time, graffiti provided abundant evidence of dissent, while sculpture had been damaged and buildings, including the once much valued Playhouse, stood empty.[52]

The story of Moore's *Family Group* (1954–5; fig. 91) amounts to a metaphor for the rupture of the post-war utopian moment. Philip Hendy, an old friend of Moore, enabled Harlow Art Trust to commission the sculpture for the town. Moore inspected possible sites, settling for an open space off First Avenue. Installed on grass, amid trees, with no visual distractions, the monumentality of the sculpture was emphasised and its light Hoptonwood stone displayed to advantage. However, Moore's aesthetically ideal site left the work vulnerable to damage, while its status demanded a location in the town centre.[53] By April 1957 it had been vandalised, though it remained *in situ*. When it was damaged again the following year, the unfinished Civic Square was proposed as an alternative site. Moore resisted, but when the head of the child was broken off in July 1963 he restored it and agreed that the group should stand in the square, in front of the Civic Centre. Though this arrangement acknowledged the emblematic status of the work, it was far from satisfactory: the sculpture appeared diminished in size, isolated in the large, bleak,

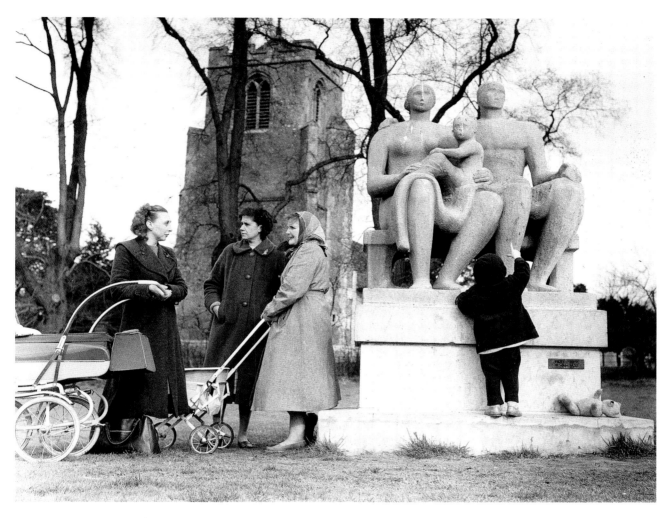

91  Henry Moore, *Family Group*, 1954–5

space where its pale-grey stone was almost indistinguishable from the surrounding concrete. In 2004 Moore's *Family Group* was moved once again, this time into a large glass bay inside the entrance to the Civic Centre, where it is protected from vandalism at the cost of having become an item on display rather than the potent emblem of the citizens of Harlow New Town that Moore conceived.

## Victor Pasmore and Peterlee

Peterlee, designated a New Town in 1948, lies within Easington District Council in County Durham. It was built to serve a depressed mining area and to alleviate the conditions of a scattered community of about 30,000 people who were entirely dependent on the economy of coal. In 1948 Berthold Lubetkin, the founder of the Tecton practice (1932–48), was appointed Chief Architect-Planner for Peterlee. A committed modernist and enthusiast for concrete, he was arguably not the most appropriate architect for the post. His concept for Peterlee was, unlike the park-like arrangement of other New Towns, a close-knit plan with the amenities of a small urban centre, which would bind the community together. Lubetkin resigned in March 1950 when it became clear that the preparation of a master plan and its subsequent development would be rendered impossible by the disorganisation of the National Coal Board and the Development Corporation.[54]

Five years later, following the construction of much undistinguished housing, A. V. Williams, the far-sighted General Manager of Peterlee, appointed Victor Pasmore as part-time consultant with a brief to bring his aesthetic sensibility to bear on housing design and planning.[55] Williams made the appointment after seeing Pasmore's recent relief constructions, in which he experimented with the spatial perceptions established by arrangements of glass planes, projecting fins of plastic and painted wood. Williams's recognition of their affinity with architecture was underlined a year later when Lawrence Alloway compared Pasmore's reliefs with the plans of Frank Lloyd Wright's prairie houses, noting also: 'the space-light reliefs of 1954–55 suggest the hovering, sharp-edged planes of Mies van der Rohe', the renowned German architect.[56]

Working with the architects Peter Daniel and Frank Dixon, Pasmore focused on the South-West Area, a new, 300-acre site where he realised his ideas in the small area called Sunny Blunts. Welcoming Pasmore's intervention, J. M. Richards condemned 'the social and architectural inadequacies' of much New Town housing, describing the conventionally planned central area of Peterlee as 'dreary in the extreme'.[57] Pasmore

92   Victor Pasmore, Apollo Pavilion, 1963, photographed in the 1970s

later defined the problem that confronted him as the requirement to construct a spatially determined, urban and therefore 'artificial landscape'.[58] Adopting a process comparable to designing a relief or painting, he began with a sketch plan and progressed to three-dimensional models, noting that as his paintings became 'fluid and linear', so did the plan for Sunny Blunts.[59] Intent on a demonstrably modern design, Pasmore stipulated flat roofs (which leaked and have been replaced) and timber cladding, with a garage and screened patio for each house. Constructed on a 5-foot module, they had 'white and black flint-brick walls, with grey or creosote-stained timber panels', neutral colours prominent in Pasmore's reliefs.[60] His most distinctive planning feature was a Corbusian separation of housing and pedestrians from roads and traffic.[61] Constrained by a design brief that stipulated 'low-cost and low-rise housing . . . arranged in units of single, semi-detached and terraced blocks', he set the houses in tight, pedestrianised clusters or long terraces separated from the meandering access roads.[62] Regrettably the houses were badly built, but Pasmore's translation of constructive art into housing design continues to distinguish the unique landscape of Sunny Blunts.

Its central feature is the Apollo Pavilion (fig. 92) which Pasmore conceived in 1963.[63] A walk-through, double storey, concrete construction completed in 1969, the pavilion offers a visual complement to the housing and road layout. It required the conversion of a stream into a small lake, so that the pavilion could be cantilevered across its head, with the upper storey forming a bridge and a roof over the footpath below. Its spatial complexity offers visual surprises in the form of painted murals, changes of level, contrasts of light and shade, open areas and secluded corners. Pasmore described it as 'an architecture and sculpture of purely abstract form through which to walk, in which to linger and on which to play, a free and anonymous monument'.[64] Had it been a component of the South Bank townscape it would have been understood and celebrated. Instead it was derided, covered with graffiti and threatened with demolition before being restored in 2007.[65]

•

## Redevelopment: Triumph and Disaster

The redevelopment thrust of the 1960s has been described as 'a slightly frenzied, uncoordinated boom', involving private sector interests on an unprecedented scale.[66] If the Economist Building (Alison and Peter Smithson, 1959–64) near St James's Palace in London was the high point of commercial development,[67] its aesthetic refinement – a statement of economic and political confidence – was seldom matched.[68] Unfortunately, the public sector fared no better. By the mid-1950s there was virtually full employment, an improving housing situation and an increasingly affordable supply of consumer goods.[69] Prosperity extended to local authorities, who embarked on ambitious rebuilding programmes, though too often with an inadequate grasp of acceptable design.

In two special issues of the *Architectural Review*, Nairn, as editor, drew up an impressive list of design disasters, attacking an insensitive, uncontrolled use of space that he observed throughout the country. 'Outrage' (June 1955; see fig. 62) revealed the extent of the problem, while 'Counter-Attack' (December 1956) offered solutions.[70] 'Outrage' took the form of a 'route book' from Southampton to Carlisle and on to the Highlands, the only large area not blighted by industry. Nairn's vitriol was primarily directed at the growth of 'subtopia . . . neither town nor country', which had been brought about by an impressive roster of failures that ranged from the abandonment of military installations to the lack of taste embodied in 'fake rusticity'.[71] He identified a compelling need to preserve the countryside, not least to enhance urban identity. As a corollary, inner-city population densities were to remain high to avoid a sprawl of new estates in peripheral areas. Crucially, Nairn argued that it was essential to separate urban from rural and 'to re-identify the human with the non-human, including the animal, world'.[72] Eighteen months later 'Counter-Attack' proposed place definition and differentiation to counteract the persistent threat of subtopia; 'wild, country, arcadia, town and metropolis' were proposed as model categories of place.[73] There should be no wasted space or 'clutter'; a place might be constructed from 'walls, railings, a bus shelter, a war memorial'. Equally,

there were to be no special cases: 'In a metropolis there is no question of preserving the environment intact: buildings must fend for themselves like the Wren City churches'.[74]

Both of Nairn's special issues were illustrated by Gordon Cullen, assistant editor of the *Architectural Review*. His book, *The Concise Townscape*, published in 1961, was an exploration of how the ideal, small-scale urban environment might be achieved. Arguing for the local and quirky against grand planning, Cullen's concept was picturesque, cross-period and spatial, involving variety expressed equally by monumental buildings and market barrows, with carefully placed trees and sculpture as grace notes. He was acutely aware of the avoidable design and planning disasters that had occurred since 1945, deploring both the speculator's emphasis on single buildings regardless of context and the low-density mass housing that he called 'prairie planning', believing that it acted against an integrated urban life.[75]

Outside London, local authorities were eager to rebuild, though in many cases aspirations formulated before 1945 were not realised until the 1960s. In the wave of development that swept across major cities, councils embarked on ambitious high-rise reconstruction programmes, asserting their identity through renewal and rebranding.[76] Town centres were updated with underpasses, flyovers, shopping centres, multistorey car parks, tower blocks and ring roads. Alongside uniformity, repetition and overbearing scale, they introduced the colour and style that characterised contemporary car design, plastic products, acrylic pigments and Mary Quant's clothing. Prominent regional cities were transformed by new housing and shopping centres. In Birmingham, one of the first cities 'to include an inner ring road as a key planning policy', the authorities established a situation that resulted in the construction of the Bull Ring Centre (fig. 93).[77] One of the largest shopping precincts in Europe, it became notoriously unpopular as it degraded. The northern cities shared London's need for new housing and were similarly restricted by Green Belt planning policies. The solution was seen to lie in pre-fabrication and high-rise; encouraged by grants and incentives, the strategy proved remarkably successful.

93    Birmingham City Architect's Department, Bull Ring shopping centre and market, 1961–4, photographed in 1969

Park Hill Estate in Sheffield (City Architects Department, 1959; fig. 94a and b) was designed by former students of the Smithsons as a cluster of giant, interlocking, irregular blocks. It aspired, as did Peterlee's South-West Area, to sustain a community and provide the conditions in which it might flourish.

•

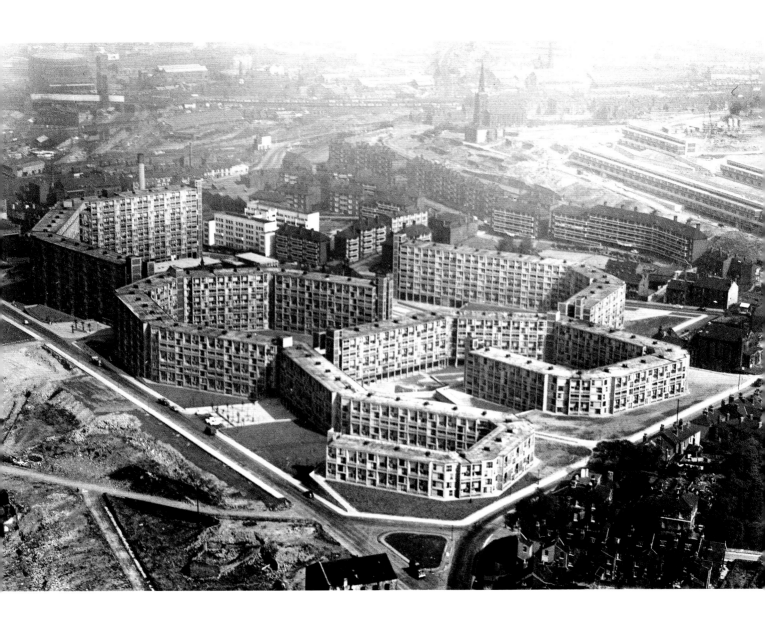

94a and b    Sheffield Corporation City Architect's Department, Park Hill Estate, Sheffield, 1957–61, photographed nearing completion in 1960

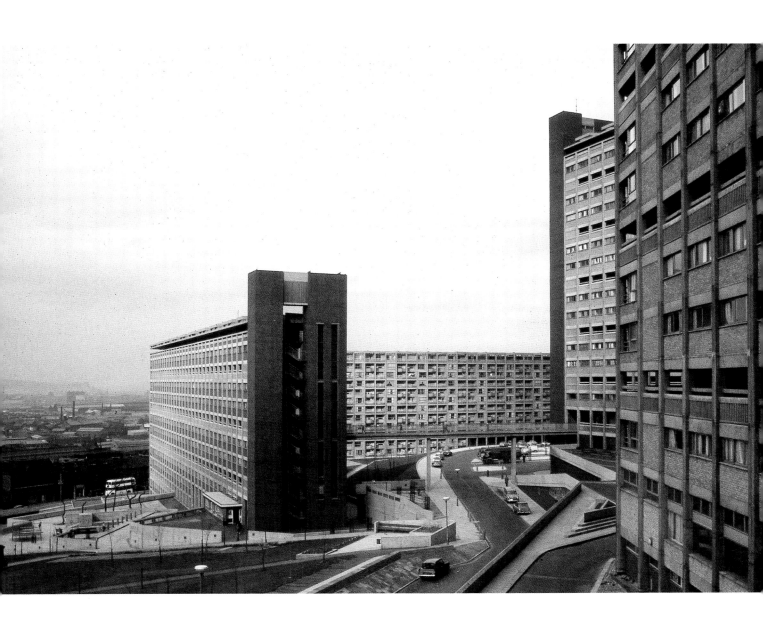

## Painting the Town

A triumphantly revisionist exhibition of L. S. Lowry's paintings at Tate Britain in 2013 revealed a startlingly different artist from the one presented in earlier accounts.[78] T. J. Clark argued that in devising a way to paint the culture of the working class north, Lowry had aligned himself more closely than any other British artist with the 'modern French tradition'.[79] Between 1950 and 1955 Lowry made five uncharacteristically large paintings, the last of which, *Industrial Landscape* (1955; fig. 95), incorporated his familiar combination of reality and fiction.[80] Perhaps informed by the frequency with which the River Irwell flooded in winter, it conveys a pre-war, pre-Beveridge sense of alienation that offers no hint of reconstruction or social renewal. Small, mean houses run across a foreground from which sightlines meander into a distance filled with smoking chimneys. The painting may be understood as a summary of Lowry's knowledge of the industrial north and its people, whose lives and pleasures and troubles were conjoined with his own considerable status. Despite the apparent arbitrariness of his urban imagery, Lowry's industrial paintings have come to be perceived as literal representations, constituting a 'place myth' that stands for the culture and life of northern England.[81] He was certainly familiar with poverty, sub-standard housing and ill-health, just as he acknowledged the conformity and social cohesion with which people confronted disadvantage. His reality emerges through the metaphor of his visual imagery, which T. J. Clark has admirably summarized as 'a long struggle to reconcile Engels's Manchester with George Formby's'.[82]

Lowry's panoramic images are as distant from the conventions of the sublime as from the landscape tradition in general.[83] He explained that he painted the ground in his paintings white because 'the interest in the picture was in the figures and you had got to do the background artificially light to throw the figures up. You had to keep it very white, almost chalky white . . . because the picture was worthless if the ground and the figures merged together'.[84] Lowry increasingly selected viewpoints that were outside and above his subjects, looking into imagined space characteristically defined by terraces of small houses. Further away, vast mill buildings, church spires

95   L. S. Lowry, *Industrial Landscape*, 1955

and vigorously smoking chimneys posit an industrial infinity. It is possible to find a route into Lowry's paintings, following streets, circumventing an artificial lake or a row of houses, to meander through a mass of chimneys to a far distant hillside beyond the smoke. The route is fictional, but Lowry's knowledge of smoke, dirt and poverty render his townscapes almost hyperreal.

   Artists who painted post-war London initially focused on buildings, industry and renewal, only later turning to urban space and traces of the human presence. Frank Auerbach remarked that the London he 'knew and saw hadn't really been painted,

partly because it was a new phenomenon because of the bombs' and 'partly because . . . the great efforts to paint London were made by people who came here for a relatively short time . . . very little seemed to have been done by people who actually lived here'.[85] Auerbach made his final building-site painting in 1962, the year that Helen Lessore gave him a contract which enabled him to buy bright pigments. Thereafter he was to concentrate on a tiny area of north London: the junction of Primrose Hill and Mornington Crescent at Camden High Street, close to George Adams's memorial to Richard Cobden (1867). When Auerbach painted this monument, he depicted his personal territory and, incidentally, underlined the role of monuments in establishing places.

Auerbach, a confirmed Londoner, who referred to the city as 'this raw thing . . . this higgledy-piggledy mess of a city',[86] also commented: 'you don't realise how much London changes. The Mornington Crescent paintings that I've done, in the road, with existing buildings, suddenly they take down a church spire or pull down a building. London is like a sort of heaving, bubbling cauldron with continual change'.[87] His paintings conveyed this perception of the city, which he expressed through a range of marks that he related to the work of Chaim Soutine and Willem de Kooning. Auerbach described the numerous preparatory drawings that he made for his landscape paintings as 'evoking "what it was like to draw there"'.[88] Such paintings as *The Origin of the Great Bear* (1967–8; fig. 96) convey a strong sense of being present in an actual place in specific conditions, in that instance near the Royal Free Hospital on Hampstead Heath amid the sounds, heat and quivering movement of summer.

Like Auerbach, Clough was a Londoner, but unlike him her subject matter was broadly industrial, focusing initially on workers in various trades and later on the places where they worked.[89] In the late 1940s Clough met the sculptor Gisha Koenig with whom she visited factories, including a print shop and papermill, an oil refinery, textiles mills and weavers, the latter requiring a lengthy journey to the Isles of Harris and Lewis. Clough described a less onerous trip to a chemical works at Redhill:

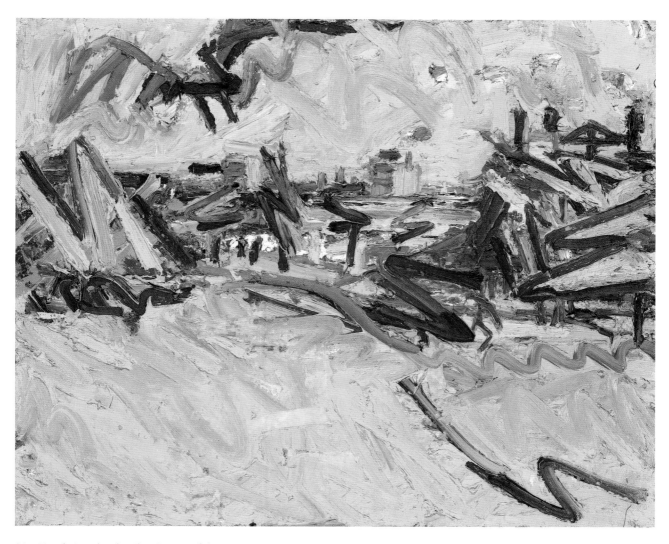

96　Frank Auerbach, *The Origin of the Great Bear*, 1967–8

'A bright day . . . carboys of acid gleaming milky in the sun and the limy waste streaked with sinister colours . . . Heavy Acids; hydrochloride and sulphuric; very new buildings with metals already corroding . . . they made "Toni Perms" . . . I preferred a mixing machine to kill the acid which was run by a Jamaican with a violent scarf (lime

white, rust, verdigris).'[90] These are among the colours that she interpolated as small, bright notes into her predominantly tonal paintings.

By the late 1950s Clough was increasingly focused on anonymous landscapes of urban neglect and industrial detritus. *Brown Wall* (see fig. 34) is a portrait of such a nameless urban fragment: a cracked surface, marked with graffiti and the outline of old advertisements or structures. Her brief diary entries of the late 1950s often refer to paintings of wire, and even several unspecific works from the '50s and '60s seem to illustrate the comment: 'The edgelands are a cross-hatch of wire', recalling Nairn's attack on the proliferation of wire that obliterated 'the pattern of the countryside'.[91] Clough and Nairn came from radically different positions: he determined to emphasise urban and rural distinctions, she absorbed in the ambivalence of the edgelands – an aspect of landscape that would remain unrecognised for at least another decade.

Among her industrial paintings, images of cooling towers imply the additional, unseen presence of the large stretches of land related to such complexes. These paintings echo the work of purist artists in interwar Paris, sharing the flat, unmodulated lighting of photographs of agricultural buildings in Le Corbusier's *Vers une Architecture* (1925). Her industrial paintings may equally be indebted to the even, subdued lighting of Pieter Saenredam's paintings of church interiors, which she admired, keeping a reproduction of one from the collection of the National Galleries of Scotland and recording a visit to the British Museum in 1957 to look at drawings by Saenredam and Jan van Ostade.[92] In keeping with her visual taste for austerity, Clough was enthused by a kind of architecture scarcely acknowledged in the early 1950s, when industrial buildings were repaired and rebuilt without the benefit of architects or regulation. Mindful of prejudice, she wrote in the mid-1950s: 'Went to Bradwell (Essex) . . . which they propose to "ruin" by building an atomic power station. (It seems very suitable to me and would look O.K. if they'd only let one get near)'.[93] If Clough's status as an artist set apart was her own choice, it was sustained by the singularity of her thinking and work.

Early post-war cities, especially those that had suffered bomb damage, offered unprecedented opportunities for architects and artists alike, particularly sculptors. As so often, London was dominant in this respect. The proliferation of sculpture in public spaces was, and remains, a significant success. Similarly, painters who were drawn to urban imagery developed it as a new genre after the war as they recorded the characters of their personal environments. If Lowry continued to portray the scarcely concealed desperation of ordinary people, Auerbach, Kossoff and Clough, all a generation younger, developed a new genre of urban painting in which the human presence, though implicit, was often replaced by their buildings. Pasmore's unique Peterlee pavilion, of which the sole function was to bring pleasure to those who saw and used it, is essentially a constructive work of art on an architectural scale. Despite their diversity, these artists and their work were united by a common subject, the contemporary city.

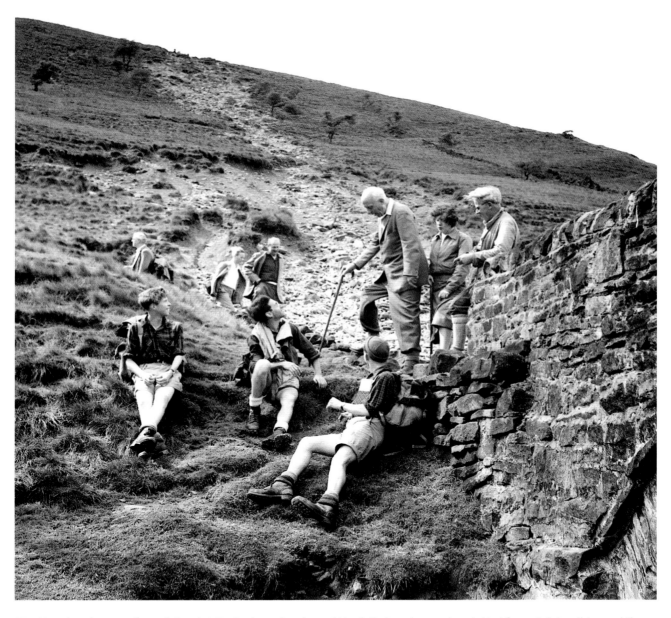

97    Tom Stephenson (far right) with MPs Barbara Castle and Hugh Dalton (second and third from right), talking to hikers on the Pennine Way, June 1952

# 6 Landscapes for People

As urban and rural landscapes changed physically in the mid-twentieth century, so did perceptions of their usage and ownership. Landscape as Arcadia had provided a fragile sense of security during the war, sustained by the Batsford publications (discussed in Chapter 7) on traditional places and buildings, the Recording Britain project and the various protective organisations that would later contribute to the conversion of Arcadia into a functional landscape for leisure and work.[1] One of the most significant was the National Trust, founded in 1895 with a remit that included the protection of nationally important monuments such as Stonehenge, often against the furious opposition of private landowners.[2] In the mid-1930s the Trust initiated a shift that, in the late 1940s, would see its efforts increasingly directed to the preservation of historic buildings. These became a still more pressing problem immediately after the war when a new generation of landowners, faced with un-precedented taxation and no staff, found themselves unable to maintain their properties.[3] As regards the landscape itself, both the Council for the Preservation of Rural England (established in 1926) and the new National Parks, of which the Peak District was the first to be designated in 1951, were initially identified with the middle classes and conservatism, though a strong working-class movement sought to establish open access to all land.[4]

The open access movement had been supported by various organisations in-cluding the Cycling Tourist Association (founded 1878), the Youth Hostels Asso-ciation (founded 1930), the Ramblers Association (founded 1935), the small but forceful Rock and Ice Club (founded 1951) and by such actions as the Kinder Scout mass trespass in 1932. Above all it was the campaign for the Pennine Way, initiated by the journalist Tom Stephenson in 1935 and supported by the foundation of the Pennine Way Association three years later, that really galvanised the movement (see fig. 97). By 1946 only 70 miles of footpaths were required to complete the route

of approximately 260 miles, but since the scheme continued to be opposed by landowners it was not until 24 April 1965 that the final section was declared open to the public. The gesture, momentous in its long-term effect, did not substantially change the appearance of the landscape but was important in formulating perceptions of individual liberty and social equality.

## Allotments and Gardens

During the war the small urban garden and the allotment flourished because of food shortages. The subject of such a painting as Roger de Grey's *Allotments*, (1947; fig. 98), allotments contributed to the genre of Home Front war. Allotments had first become prominent in the late eighteenth century when agricultural labourers were provided with a cottage and a patch of land 'to alleviate their poverty'.[5] A century later allotments became common in urban areas as a result of the migration of rural labourers seeking work. The 1887 Allotments Act enabled local 'sanitary authorities' to acquire land compulsorily, though it was only in 1918 that this socially progressive enterprise was ratified by the foundation of the National Union of Allotment Holders.[6]

In 1939 'Dig for Victory' exhibitions travelled the country while local authorities were given powers to appropriate land for allotments, for which the Ministry of Agriculture in turn issued advice on crops and growing techniques. By the end of the war it was calculated that approximately 1.5 million allotments were producing ten per cent of the nation's food, though as prosperity returned through the 1950s the number of enthusiasts declined rapidly and the allotment gradually developed into a form of urban garden.[7] Often eccentric or untidy, it is the antithesis of formal municipal planting, and belongs to a culture of work that separates it from the 'context of ownership, status and commodity'.[8] It has been said of allotments that they not only 'flaunt their functionality; the domestic garden with its hands dirty, busy and raddled with agriculture's business-like clutter',[9] but that they also 'signal that you are now passing through the edgelands as emphatically as a sewage works or a

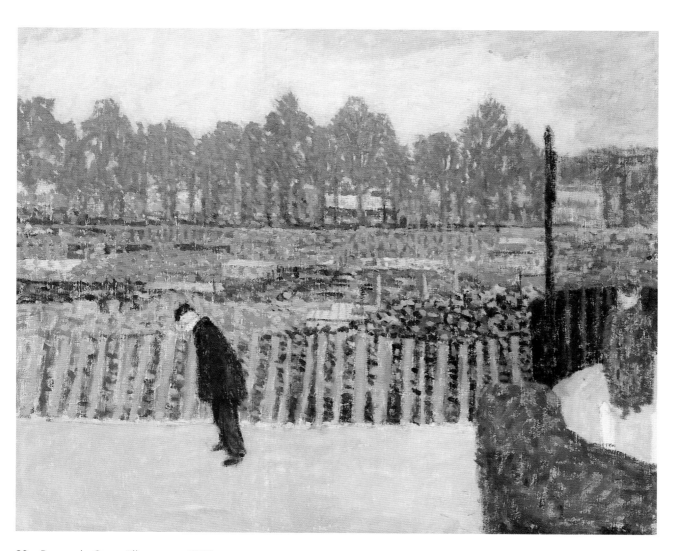

98    Roger de Grey, *Allotments*, 1947

power station. They thrive on the fringes, the in-between spaces . . . behind houses or factories, and in ribbons along the trackbeds of railways'.[10]

As allotments flourished, gardening became ever more popular as a serious pastime. The National Rose Society, founded in 1876, had huge success in the mid-twentieth century; the National Begonia Society was established in 1948, followed a year later by the British National Carnation Society.[11] The proliferation of garden centres sustained a nationwide, car-dependent industry and changed the nature of domestic gardening. Gardeners were supported by abundant horticultural advice: *Gardeners' Question Time* first aired on BBC radio in April 1947, broadcast from the Smallshaw Allotments Association, following possibly the worst winter in living memory. Available only in the north during its first decade, the programme was broadcast nationally from 1957. Percy Thrower's televised *Gardening Club* began on the BBC in 1951, mutating to *Gardeners' World* soon after the appearance of colour television in 1967.

At least since John Constable painted his father's flower and vegetable gardens in 1815, the domestic garden has been a subject for artists. With *Goose Run, Cookham Rise* (1949; fig. 99), Stanley Spencer selected a scene visible from his own windows: a private, casual space that was the antithesis of the productive allotment. Spencer provided a close view of an indeterminate area that has been aptly described as 'a shambolic bird pen'.[12] With its collapsed wooden hut, scattered tools, makeshift barriers of corrugated iron and chicken wire pervaded by slightly squalid decay, it is a familiar sight: a long-term *ad hoc* arrangement. Only the splendid magnolia that doubles as a goose perch is a reminder that Spencer was a prolific painter of landscapes and flower gardens. He had an uneasy relationship with his more conventional garden images, considering them principally as a means to earn money, but when the body of work associated with Cookham, his 'village in heaven', faltered commercially in the 1930s, his dealer, Dudley Tooth, insisted that Spencer produce a greater number of readily saleable pieces.[13] As a consequence, he agreed 'to concentrate on garden scenes, landscape and flower paintings during the spring

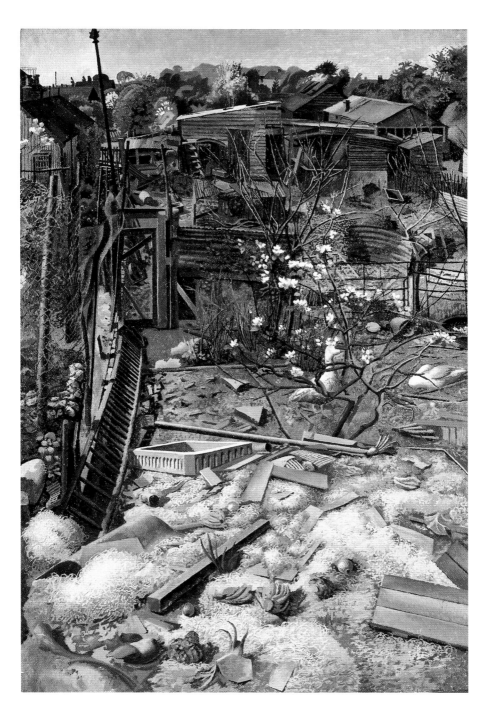

99   Stanley Spencer, *Goose Run, Cookham Rise*, 1949

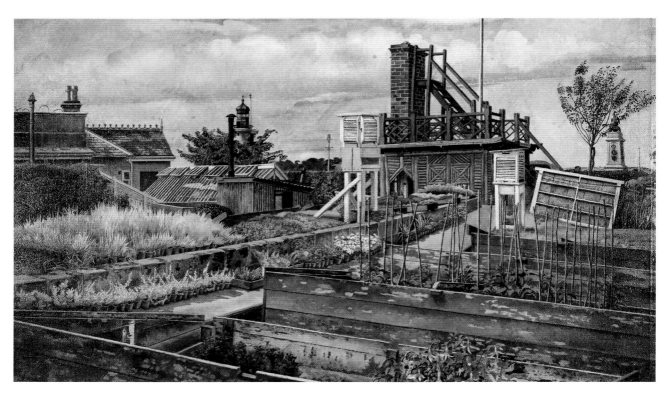

100  Stanley Spencer, *The Hoe Garden Nursery*, 1955

and summer'.[14] Spencer's *The Hoe Garden Nursery* (1955; fig. 100) was acquired by Plymouth City Art Gallery 'to celebrate the spirit of post-war reconstruction', the city having been severely bombed.[15] Ignoring the neat public garden, Spencer painted its nursery, setting out a working gardener's small landscape, with raised beds, neatly staked bedding plants in pots and slightly shabby cold frames. Though he acknowledged Plymouth's historical significance with a distant view of the monument to Sir Francis Drake on the Hoe, his painting amounts to a portrait of a workplace rather than an ornamental garden.

In the early 1950s, when 'landscaping' had made only a slight impression on architectural thinking, Peter Shepheard, architect, naturalist, devoted gardener,

president and long-term committee member of the Landscape Institute, was adamant that 'No theory of architecture is adequate which does not embrace landscape also; no rules are valid which both cannot use'.[16] Referring equally to municipal and domestic gardens and castigating 'the full ugliness of the great Victorian gardens in their heyday', he sought informality and simplicity in planting and landscape design, from the planning of New Towns to domestic housing. Shepheard, who called for the involvement of landscape architects in public projects down to the level of planting on verges, would have sympathised with Spencer's choice of subject and deplored the formal Hoe gardens.[17]

In painting as in planting, the garden lends itself to experiment; as modes of representation changed, the flower garden emerged as an uncontroversial subject through which to explore the formal possibilities of modernism. In Lavington Common Ivon Hitchens painted his 'wild, secluded garden'.[18] Encompassing woodland, cultivated land and ponds with a boathouse, it amounted to a contained landscape. Hitchens's *Garden* (1957; see fig. 16) shows a wall, perhaps a gazebo, a pool of water and tall trees, a harmonious arrangement of buildings and vegetation that recedes into a deep distance. Hitchens's use of colour as the prime means by which to create the illusion of space was close to Patrick Heron's own practice. In his catalogue essay for Hitchens's exhibition at the 1956 Venice Biennale, Heron related his paintings to an adaptation of cubist space, which had led him to lay them out in receding planes of colour.[19] Heron also noted that Hitchens's fondness for woodland allowed him to avoid a horizon line while providing a framework through which he might 'thread those slashing diagonals that resemble . . . the giant strokes of Hans Hartung'.[20] With the telling phrase, 'Hitchens is Hartung plus Sussex', Heron presented his colleague as both English and international.

William Gear often chose seasonal titles that corresponded to the dominant colours of a painting. *Autumn Landscape*, for example, is principally orange, yellow and brown, while blues, reds and drifts of white are the main colours in *Summer Garden* (1951). The strong structure of these works – with their crossing, truncated

101   Patrick Heron, *Camellia Garden: March 1956*, 1956

diagonals with almost no sense of recession – is characteristic of Gear's work in general. Despite his early connections with the COBRA artists, he retained the emphasis on structure that he had developed in Paris, modifying it by adopting a wide range of colours to replace the black armatures of his earlier paintings. Having opted unequivocally for a modern aesthetic, Gear developed an individual form of abstraction, modified only by allusive titles that may have made his work more saleable.

When Heron moved in 1956 to Eagle's Nest, his house overlooking Zennor in West Penwith, he began to paint its garden. Filled with azaleas and camellias, it was set among great rounded granite boulders. Heron cited Claude Monet, Pierre Soulages and Sam Francis as important to his first sequence of 'garden paintings', a distinctive group that no doubt developed concurrently with the garden itself.[21] The works that Heron made during his first year at Eagle's Nest contain a wide range of marks and colour. *Camellia Garden: March 1956* (fig. 101) demonstrates the characteristic shallow depth of the group, established by a loose grid of spidery lines overlying ragged red marks. Heron acknowledged his indebtedness to Monet's *Nymphéas* paintings both for this spatial arrangement and as a model for abstraction in general.[22] In later garden paintings Heron experimented with thin, watery pigment and drips, an occasional near-monochrome black-and-white palette and small dabs of paint. They are no closer to the reality of flowers and plants than Gear's garden images, nor did either artist share Hitchens's interest in the construction of place within pictorial space. Nevertheless, all three adopted an uncontroversial subject to formulate their individual approaches to modernism.

## Mobility: Transport and Travel

After the war, full employment and the enforcement of the 1938 Holidays with Pay Act, which ensured a one-week paid holiday for most working people, brought a small degree of leisure into many lives. At the same time, unprecedented prosperity offered access to hitherto inaccessible commodities. At the beginning of the 1950s

car ownership was at roughly the same level as it had been in 1939, but by the end of the decade it had doubled to about 5 million. Likewise, motorcycle ownership greatly increased over these years.[23] The roads were inadequate for such growth, resulting in appalling traffic jams, a situation of which Frank Smythe remarked: 'it can only be said about motoring that it is more satisfactory than flying which of all means of travel is scenically the dullest and most uninteresting except for a voyage in a submarine'.[24] Though a ten-year plan was announced in 1946 for the first 800 miles of motorway, and an overhaul of major routes, it was quickly abandoned for lack of resources, as was a large-scale scheme for ring and radial roads in Manchester.[25] It was only in 1955 that a schedule of improvements was announced that included bypasses and motorways. Developed by Ernest Marples, building entrepreneur and housing minister from 1951 to 1954, the plans acknowledged the growth of car ownership and the opportunities that it offered for unregimented travel. The extent to which cars and motorways gripped the public imagination is illustrated by Geoffrey Jellicoe's visionary scheme, published in 1961, for a new town, to be named 'Motopia' (fig. 102). Devised for a modest population of 30,000 people, it was envisaged as a gridiron system of terraces of housing enclosing large areas of open space. Cars were to be confined to elevated roads running along the roofs of the buildings, separate from the otherwise pedestrian landscape.

Motorways became reality in December 1958 with the completion of the Preston Bypass. Despite their slow start, 'motorways were a national symbol of virility', bound up with a long-term international obsession with speed that had gripped the Futurists and continued to permeate the later twentieth century.[26] The first 55-mile section of the M1 opened in 1959; three years later Marples announced plans (which were to be fulfilled) to build 1,000 miles of motorways in the following decade. Motorways evidently brought far greater changes to the landscape than the railways; beyond the displacement of buildings and agricultural land, they introduced unprecedented levels of pollution, as well as service stations, among which are to be found the most notorious 'non-places' outside airports.

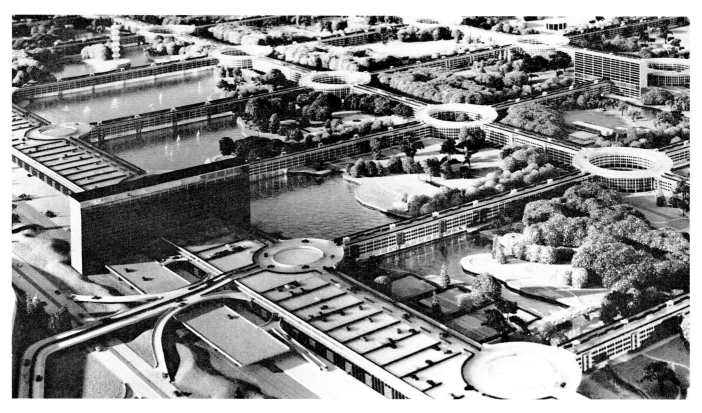

102   View of the model of the town centre of Geoffrey Jellicoe's Motopia, 1961

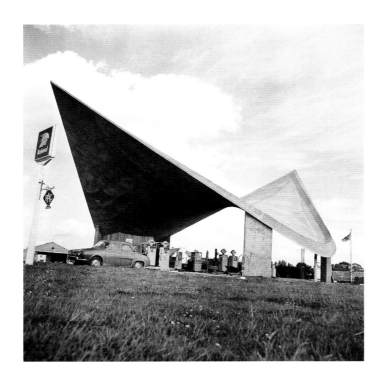

103 (LEFT) Hugh Segar Scorer, Markham Moor service station, 1960

104 John Carter, *On the Road*, 1964

The listing by English Heritage in 2012 of two forecourt canopies of the 1960s is a quirky reminder that car journeys and their local landscapes were for a brief time exciting, even glamorous. In 1964 Mobil commissioned an American architect, Eliot Noyes, to design the canopy for a petrol station at Birstall in Leicestershire. In a bold, stylish solution, he covered the area with six flat discs outlined in red. For the Markham Moor service station on the south-bound A1 near Retford, the Lincolnshire architect Hugh Segar (Sam) Scorer, worked with the structural engineer Dr K. Hajnal-Kónyi to design a swooping concrete shell roof in the form of a hyperbolic paraboloid to cover the petrol pumps (fig. 103). Both are eye-catching remnants of a former landscape of sophisticated motoring pleasure. Scorer designed several comparable roofs, subsequently listed, which include a showroom for the Lincolnshire Motor Company at Brayford Pool (1959) and the Church of St John the Baptist on Ermine Estate, Lincoln (1963).[27] 1963 was the year when the paraboloid roof of London's Commonwealth Institute (by Roger Cunliffe with James Sutherland) caused a sensation far beyond the architectural press.

Through the 1950s people experienced unprecedented mobility. Artists not only grasped opportunities to travel but adopted movement and speed as fitting subjects for expressions of contemporary life. *On the Road* (1964; fig. 104) is an early collage by John Carter, a well-known constructive artist, which he made after a year's travel that culminated in a term at the British School in Rome. While the source materials for this collage appear to be French, wider references to the speed and glamour of motoring – and possibly its dangers – were western or pan-European at a time when every young person aspired to own a car. Invitingly empty roads at the top of the image pass by way of a crash rendered in cartoon style through details of signs and road markings to a rush of scarlet and speeding tyres at the base. Carter's colour, clear and vivid, sets this piece in the 1960s as much as its subject.

Despite the appeal of motoring, the trains and railways that were prominent, long-established features of the British landscape continued to be more compelling subjects for artists than roads, perhaps because they provoked a greater sense of nostalgia than tarmac. Given Michael Rothenstein's pictures of ageing agricultural

machinery, it is no surprise that he also painted the railways. Many years after making the monotype *Guard and Lamp* (1950; fig. 105), he described the visual impact of the old-fashioned, manually adjusted signal lamp: 'I remember waiting at stations with the red and green eyes of signal lights at night . . . The signal gantries spanned the rail-tracks, spidery constructions drawing a lattice of angled lines cutting black silhouettes against the half-tone space of sky'.[28] Beyond the individual mindset that informed such images lay the nationwide programme of modernisation and reconfiguration of the railways that led to the 1963 Beeching Report and the consequent reduction of the network. Clearly the car contributed to the Beeching cuts: private spending on transport more than doubled between 1946 and 1969, largely as a result of car use.[29] By the early 1950s the rail system was already suffering competition from road and air transport, while labour and financial problems and the backlog of wartime maintenance delayed the switch from steam to electricity until the 1960s.[30] Seeking to make the rail network financially self-sustaining without much regard for the consequences, Beeching castigated the railway companies for having 'sacrificed the speed, reliability, and low cost of through-train operation' to 'a multiplicity of branch lines'.[31] Many such lines were to be closed, sparing only a few popular routes that were later elevated to 'heritage' status. Fulfilling many nostalgic yearnings, they were celebrated in 1951 by a television adaptation of E. Nesbit's book, *The Railway Children*. Two decades later, the eponymous film (1970) was shot on the Keighley and Worth Valley Railway, a five-mile-long branch line in Yorkshire.[32]

The widely ignored, actual landscape of railways, the antithesis of 'heritage' lines, was explored by Leon Kossoff, who addressed it as a vital system embedded in the fabric of London, a counterpart to the human bodies which he depicted with similar intensity.[33] Having always lived in London, which he chronicled as a living, breathing organism, Kossoff habitually painted the urban landscape adjacent to his studio. His *Railway Landscape near King's Cross, Summer* (1967; fig. 106) reveals a landscape gouged out of the inner city as if by an act of violence. Set out in thick, gleaming lines, it is constructed of dense layers of paint like geological strata. Kossoff's

105  Michael Rothenstein, *Guard and Lamp*, 1950

106   Leon Kossoff, *Railway Landscape near King's Cross, Summer*, 1967

multi-directional marks underline the layered topography and geometry of the area and emphasise the tracks that cut through a nondescript urban landscape as they wind into the train sheds. The image implicitly acknowledges the demolition of an earlier, small-scale, domestic environment and recognises that such destruction is inseparable from London's vitality and, indeed, all landscapes whether urban or rural. Kossoff's painting celebrates the apparently indomitable power of mechanisation presented in the form of the railway while it also incidentally recalls the famously hypnotic rhythms of Auden's 'Night Mail':

> Written on paper of every hue,
> The pink, the violet, the white and the blue,
> The chatty, the catty, the boring, the adoring,
> The cold and official and the heart's outpouring,
> Clever, stupid, short and long,
> The typed and the printed and the spelt all wrong.'[34]

## Tourism

'Holidays at home', a wartime mantra that lived on after 1945, was an exhortation to spare an impossibly overloaded transport system, to cause no disruption and to make no demands. In 1947 about half the population managed to have a week's holiday away from home, though very few went abroad. Shortly before Whitsun 1950 petrol rationing ceased, bringing to an end a decade of restrictions on private car use.[35] The following year Geoffrey Grigson, poet, historian and art critic, added travel writer to his portfolio with the publication of a series of guide books which he edited under the general title *About Britain*.

During the First World War, Harold Peake, honorary curator of Newbury Museum and a member of 'the Edwardian Bohemian intelligentsia', had organised several conferences to discuss the formal arrangement of England into provinces, 'corresponding to "regions" determined by vegetation, geology, industry, historical

settlement and so on'.[36] This pattern was replicated in Grigson's thirteen guide books. Published for the Festival of Britain Office, they covered not only history, scenery and monuments but geology, industry and new buildings. The first, *West Country*, includes photographs of Cheddar Gorge, the crossing of Wells Cathedral, Plymouth Lido, a derelict engine house at St Agnes and the china clay workings at St Austell. The latter was itself a reclaimed landscape, described by Grigson as 'one of the strangest . . . in Britain'.[37]

He was a generous editor, allowing the personal attachments of his authors to run through their texts. Whereas he chose to write *West Country* and *Wessex* in unabashedly romantic terms, R. H. Mottram's *East Anglia* was a plainer, only partially promotional text. W. J. Gruffydd wrote the two guides to Wales, north and south, in strongly nationalist terms: 100,000 jobs might benefit south Wales but would have an adverse effect on local craft, as immigration always diluted the receiving culture. On north Wales Gruffydd took a firm line: 'On the bridges and walls in North Wales you will find that nationalist slogans have been painted; you are not asked in this portrait either to sympathise or condemn, but it is vitally necessary for the stranger to know some of the background of this recent political movement . . . To many visitors the Welsh are enveloped in a fog of mystery, tinged with romance'.[38]

A brief introductory essay titled 'Using this book' prefaces each volume. Just as the Festival had demonstrated the British contribution to civilisation, 'the guidebooks as well celebrate a European country alert, ready for the future, and strengthened by a tradition which you can *see* in its remarkable monuments'. Predominantly illustrated with photographs, the books also contain strip maps, each of which opens with a pointing hand and the instruction: 'Start here' (fig. 107). They set out, in the form of itineraries, the way in which the country was to be explored and understood, as an area of varied and intense productivity, each region individuated by its geology, which was emphasised as the primary source of its diverse production.

Descriptions of local cultures punctuate the texts. Strongly differentiated and grounded in historical eccentricities, they range from 'The Londoner's character' to heavyweight wrestling in the Lake District 'which may have come down from the

## Tour **4**
Bath-
Weston-s-Mare-
Yeovil

**93 miles**

Entering Cheddar, visit St Andrew's Church for its coloured stone pulpit. Turn right in Cheddar for the cliffs and Gorge.

Wells. Look first at the West Front of the cathedral and inside at the inverted arches which support the tower. Modern embroidered hangings decorate the choir stalls and Bishop's Throne. Visit the Chapter House approached by a beautiful 14th-century staircase.

The route passes Midsomer Norton and the trim gardens of the mineworkers' cottages.

The centre of the Somerset coal-field is at Radstock.

START HERE

The route approaches Weston-super-Mare past the airport where you may take pleasure flights or the regular service to South Wales.

Banwell is the site of a prehistoric camp. There are caves here inhabited in palaeolithic times but not publicly shown.

At Sidcot is a well-known school run by the Society of Friends (Quakers).

A mile and a half from Wells is Wookey Hole. A charming approach past the paper mills and up a garden path leads to the mouth of the cavern in the limestone hills.

At Farington Gurney and its busy cattle market we return to the agricultural area.

Bath: Pulteney Bridge

Bath (see Gazetteer). The route climbs steeply out of Bath and travels over high ground with fine views into Somerset. The road mainly follows the Roman Fosse Way.

107    Strip map from *About Britain No. 1: West Country*, 1951

Norsemen'.[39] Grigson's familiarity with the visual arts resulted in each book carrying a title-page painting by one of the generation of artists who had contributed to the wartime 'Recording Britain' project.[40] James Fenton provided a portrait of cricket on a village green for the *Home Counties* while Kenneth Rowntree painted Stonehenge for *Wessex* (fig. 108) and Hadrian's Wall for *The Lakes to Tyneside*. The *About Britain* guidebooks offer succinct and detailed insights into a culture of landscape in which ancient and modern co-habit without friction though, in a persistent wartime spirit, its enjoyment by the tourist was to be firmly regulated by route maps that discouraged deviation from a stipulated path. The guides were, however, more generous in their presentations of diverse places, natural phenomena, history and economics. There was much for the new British tourist to encounter, just as there was in the new cultures of the arts.

In the late 1950s and 1960s domestic travel became easier and increasingly attractive to the predominantly middle-class, prosperous sector that enthusiastically adopted photography as an adjunct of tourism. The tourist and the camera became inseparably linked, aligned equally with nostalgic personal memory and commercial interests. When, in 1962, the landscape photographer William Poucher noted: 'At the present time most of our young people have ample funds available for holidays', he also commented on the extensive ownership of cameras.[41] Personal photographs were souvenirs and records, while attractive advertising imagery lured tourists to both new and familiar destinations. Nostalgia and discovery moved hand in hand, constantly demanding that records be made lest memory be lost.

Domestic tourism helped to inculcate and maintain specialist interests, some of which were encouraged by the formation of new organisations in the immediate post-war years. As early as August 1945 a Wild-Life Conservation Special Committee was established which proposed the formation of seventy-three National Nature Reserves. Four years later The Nature Conservancy was founded. These were enterprises for public benefit, promoted through publications like the *New Naturalist*. The primary visual medium of popular naturalism was to be photography, though

ABOUT BRITAIN NO. 2

# WESSEX

WITH A PORTRAIT BY
GEOFFREY GRIGSON

PUBLISHED FOR THE
FESTIVAL OF BRITAIN OFFICE
COLLINS
14 ST JAMES'S PLACE
LONDON

108    Kenneth Rowntree, title page of *About Britain No. 2: Wessex*, 1951

the sophistication of the equipment required to capture such images prevented it becoming a wide-spread pastime.[42]

## The Artist as Tourist

Tourism is a leisure pursuit, undertaken in places that provide experiences outside the norm. John Urry maintains that the tourist's experiences involve 'much greater sensitivity to visual elements of landscape or townscape than normally found in everyday life'.[43] This applies to artists as much as everyone else.

Prunella Clough was an enthusiastic motorist and an inveterate, specialised traveller throughout the length and breadth of Britain, though she showed strong preferences for East Anglia and the industrial north. On brief but intensive trips she combined the gathering of information in the form of notes and photographs with the pleasures of walking and visiting churches; much of her work was linked to journeys of discovery. She made a characteristically complicated excursion between 15 and 21 September 1954. Starting from Southwold she drove to 'Lincoln via King's Lynn var.[ious] churches Lincoln. Helmsley via York & Castle Howard (Scunthorpe iron) (C[astle] H[oward] Mausoleum) Helmsley Whitby Kirkham Abbey Firby Malton, Pickering? Whitby Staithes Whitby Middlesboro' Hartlepool back over moors to HELMSLEY Temple Newsam Leeds Gt. North Rd Peterborough through fens' to end at David Carr's home in Starston.[44] She also visited Paris frequently at certain periods and Holland occasionally; saw the famous Brussels Expo of 1958; spent some months in Rome a decade later as a tutor at the British School and travelled twice to the United States. Yet while all these journeys and their destinations no doubt contributed to her painting, it was only the British landscape that can be traced as a central feature of her work, albeit one that she transformed thoroughly, in her own idiom.

Ben Nicholson exemplified the artist as a serious, well-informed, specialised tourist. In 1939, soon after arriving in St Ives, he wrote: 'The country is incredibly lovely . . . It is very fierce & primitive & huge chunks of stone everywhere & the Atlantic & Carbis

109    Ben Nicholson, *December 1951 (St Ives – Oval and Steeple)*, 1951

Bay below . . . the sea is terrific . . . The Cornish are a very attractive race & it is all v. foreign here – & such a balmy climate, but now it has rained horizontally for a month & we're all rather fed up with it'.[45] Continuing to view Cornwall as peripheral, he sustained the intense consciousness of an outsider until he left nearly twenty years later.[46] His drawing, *December 1951 (St Ives – Oval and Steeple)* (fig. 109) shows a distant view of the harbour and a jumble of buildings, all seen through the complex still life that fills much of the sheet. The motif of the still life on the windowsill, which he may have developed as a way of indicating a deep external space, dated back to his work in the late 1930s. In this drawing, Nicholson replaced

the prominent, characteristically Cornish, square tower of St Ives church by the curvaceous 'steeple' of the title; in reality a bottle that was a frequently used studio prop. In substituting a mundane personal object for the well-known tower, he may be understood as claiming the town as a personal place, in some sense even a possession. This attitude is echoed in his paintings which, accomplished and visually sophisticated, are notably free from the visceral sensibility that permeates Lanyon's work.

When Nicholson travelled it was as an extension of his normal working practice; he carried his studio with him in the form of drawing equipment, seeking, perhaps, to retain a grasp on the domestic and familiar. Writing to Herbert Read, as he often did, in 1944 when the end of the war was in sight, Nicholson mentioned 'a lot of architectural drawings I want to make especially in Italy – & Greek temples in Greek landscape too'.[47] In 1949 he went to Brittany, seeking out remote churches and prehistoric megaliths; the following year he visited towns and villas in Tuscany and the Veneto, returning four times before he settled in Switzerland in 1958. He noted that fly–drive was 'a most convenient time saver & Italy anyhow much closer now to London than St Ives'.[48] Attracted by the complexity of great churches, he rated Siena Cathedral, the Pisa complex and Yorkshire's Rievaulx Abbey most highly. Visits to them were occasions for sustained drawing, despite the practical difficulties of working out-of-doors, among which he specified heat and 'small boys'.[49]

Nicholson would often select a single, prominent feature of a building to represent an entire complex, perhaps believing that a place might be more vividly defined by a fragment in a restricted space than by its situation in a wider landscape. Consequently, Olympia was summarised by a column base and Turkey by a sundial, both eloquent equivalents to sculptural fragments of the human body. 'It's interesting,' Nicholson wrote: 'that sections of an object, a landscape, a building or a ptg can often have far more potency than the whole'.[50] Nicholson's drawings are the products of a knowing outsider characterised by the detached mode of occupying a place that informed his aesthetic approach. It seems that drawing was his default medium; that

it represented the visual thought process through which he situated himself in the world and took it into his possession.

Nicholson visited Read from time to time at Stonegrave, his home near Rievaulx Abbey in Yorkshire.[51] Founded in 1132 in the heyday of Cistercian expansion, by the mid-twelfth century Rievaulx housed 140 monks and 500 lay brothers. Later it fell into ruin, to be reconstructed in a manner that emphasised 'the incomplete . . . inviting the visitor to envision a whole from its multiplied and often incoherent parts, and to construct a history from a vastly expanded exposure of its skeletal core'.[52] The restoration of the extensive building complex that we see today was initiated by Charles Peers (1868–1952), the first Chief Inspector of Ancient Monuments, who oversaw a massive clearance of the chaotic, overgrown, rubble-strewn site in the 1920s. In 1932 a five-bay section of the north-west corner of the cloister was reconstructed in order to satisfy Peers's desire 'to see at any rate one small bit of the great cloister arcade re-erected'.[53] An isolated fragment incorporating a short flight of steps, it is eloquent of human habitation and usage, albeit probably fictitious. To encourage the reconstruction Peers had pointed out: 'there are dozens of columns, capitals, and arch mouldings lying outside the hut museum': fragments available for re-use in much the same unfettered spirit that Nicholson would adopt as he shuffled features of the building around his drawings with a joyous disregard for architectural plausibility.[54]

The imaginative freedom offered by Rievaulx suggests that it might be understood as Nicholson's ideal destination, his drawings of the abbey offering a parallel to the process through which a formless ruin was rebuilt as the orderly property that is managed today by English Heritage. Nicholson drew various sections of it at least four times over fifteen years, making free with details of the structure, which he addressed as if he were devising a series of collages. Proposing ever more complex overlapping transparent forms, combinations and elisions of architectural features, he constructed an imaginative sequence of dramatic internal spaces which present a fractured, post-cubist, modern perception of the transformation of the Rievaulx

complex from a monastic foundation for lived religious ritual to a picturesque tourist delight.

Nicholson made two finished drawings facing in opposite directions along the nave, in which he carefully differentiated the precisely drawn architectural precinct from the rougher surrounding landscape, thus emphasising the two distinct conceptual areas separated by the boundary fence at the edge of the abbey grounds. At Rievaulx, as in Nicholson's reconstructions of other ancient buildings, the physical architectural remnants represent the 'here and now', whereas what lies outside the boundary, whether it is a village or agricultural land, is presented as an undifferentiated otherness of 'there and then', of 'them' rather than 'us'. The drawing *1969 (Rievaulx No. 1)* (fig. 110) shows a close view of the north-west corner of the transepts, facing east, according to ecclesiastical convention, over the countryside. In the centre of the sheet is a detail of a crossing pier and immediately to its right, two fragments that belong to buildings that are in reality some distance from the church and separated from it by the wide space of the cloister garden. One may be part of a three-light window in the refectory; the other is the entrance to the Chapter House, showing the distinctive square sockets for the roof beams that once covered the cloister walk. Nicholson's Rievaulx is, like many of the sites he drew, an amended place, which acknowledges a fluid identity open to reconstruction through memory and intuition.

When he moved to Ticino in Switzerland in 1958, Nicholson felt that he had arrived at the centre of a sophisticated creativity that he had not found in St Ives. He developed a rare enthusiasm for the local landscape: it was 'a knock-out' and though in summer it was 'overloaded with that thick shapeless green . . . in <u>winter it is breathtakingly lovely </u>& I go out & draw for the last 2 h[ou]rs before sunset'.[55] In his Ticino years Nicholson reverted to making reliefs, the format that he had first explored in the 1930s.[56] In the distinctive Swiss reliefs he replicated the shallow space of his pre-war works, though he adopted a markedly different mode of fabrication, carving them with razor blades from hardboard finished with paint, principally in

110   Ben Nicholson, *1969 (Rievaulx No. 1)*, 1969

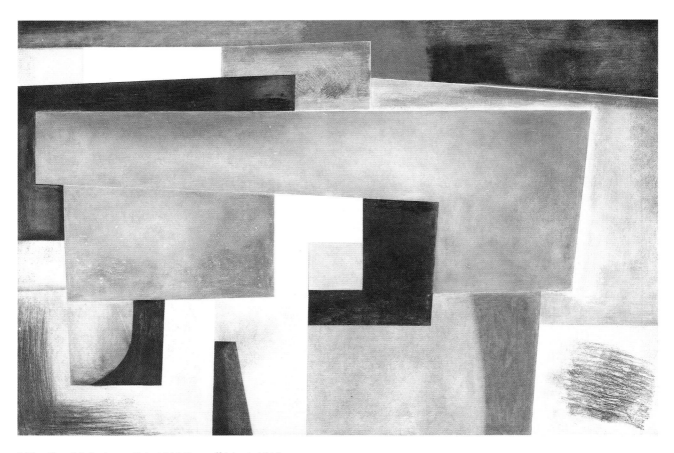

111    Ben Nicholson, *Feb 1960 (ice-off-blue)*, 1960

blues and browns. Peter Khoroche has aptly characterised these later reliefs as 'analogues or memory-traces of landscape'.[57] Nicholson connected them with his drawings as well as with the landscape, identifying the 'oil-wash line dwgs' as 'probably the idea & foil to the reliefs'.[58] The shallow curves and denials of horizontality in the large *Feb 1960 (ice-off-blue)* (fig. 111) are destabilising in a way that is comparable to the experience of seeing complex buildings and landscapes where parts overlap and obscure one another so that they are glimpsed incompletely, as fragments. The relationship that Nicholson recognised between his reliefs and a specific landscape, a point on which he was emphatic, is perhaps bound up with the sense of his own presence in that landscape. Yi-Fu Tuan suggests that while everyone has a 'primary place', which is usually their home, for some people home is conceptual, existing

principally in ideas or an occupation.[59] Given the physicality of the relationship that Nicholson described with his larger reliefs – 'You can find out a lot about a relief . . . if you crawl over it intelligently' – it may be that they were for a time his 'primary place'.[60]

## Walking

Walking as a creative activity rather than as a function of labour has been identified with a line of philosophers from Jean-Jacques Rousseau, who published *Reveries of a Solitary Walker* in 1782, to Immanuel Kant, Søren Kierkegaard and the Romantic poets of the early nineteenth century.[61] It assumed a further identity in interwar Britain as a democratised popular pastime. In this way it also became a political weapon in the class-based antagonism between walkers, or ramblers as they were widely known, and landowners, which culminated in the 1932 Kinder Scout mass trespass. Today walking is a widespread, if often self-conscious, leisure activity that involves extensive equipment, guidebooks and 'trails' or historically determined routes. Beyond its material demands, it has been identified as an activity that stimulates self-awareness and an increased consciousness of fleeting sights and sensations, chance events and the unknown.[62]

These were qualities that Alfred Wainwright expected of those who used his guidebooks to the Lakeland fells, which have done much to foster a specialised culture of walking. In 1952 he began his 'labour of love', the series of guidebooks that was to occupy him for thirteen years.[63] After first visiting the Lake District in 1930, Wainwright decided to live close to the fells. He took a job in the Borough Treasurer's office in Kendal and started to walk the hills, searching for such forgotten features as 'drove roads and neglected packhorse trails, the ruins of abandoned industries, the adits and levels and shafts of the old mines and quarries, the wild gullies and ravines'.[64] Intensely romantic, Wainwright disdained cultivated land, concentrating on the higher, rough areas populated only by sheep, whose grazing had done much to form his beloved landscape.

112   Alfred Wainwright, *Bowfell from Lingmoor Fell*

His initial project was to write seven illustrated guides for hill walkers, corresponding to the seven groups of fells. They were published between 1955 and 1966, the texts printed as cursive to emphasise the personal nature of the enterprise. The books were copiously illustrated with Wainwright's own drawings which were diagrammatic rather than aesthetic (fig. 112). Much clearer than his rather smudgy photographs, they function as specialised maps, directed to the activity of walking. While

evidently not works of art, they possess a strong visual identity which is inseparable from Wainwright's perception of the Lake District as a personal landscape; in his introduction to the first group of books he described his undertaking as 'one man's way of expressing his devotion to Lakeland's friendly hills . . . It is, in very truth, a love letter'.[65]

His prose conveys intimations of the Sublime: 'Mountains rose all round us, silent and brooding, and we were innocents in their midst, with nobody to assure us of our safety . . . alone in a strange new world except for a few grazing sheep who seemed not at all concerned by the awful loneliness of their surroundings'.[66] Though he considered Helvellyn as 'a very friendly giant', he could be briskly realistic: 'I regarded the rougher mountains with awe and respect and a little fear'; consequently he never attempted to climb.[67] Wainwright's walking has been understood, in parallel with the relationship between certain painters and their chosen landscapes, as an experiential, emotional undertaking, through which he formulated his intense, if selective, attachment to place (he detested marshy land and coniferous forests).[68] Though his guides sometimes suggest that the fells are immutable, it is clear that Wainwright sought to resist a process of change that he recognised as inevitable, that was indeed encouraged by walking and acknowledged by every walker: 'The well-seasoned hiker or pilgrim knows the landscape both as an individual, and as part of a community . . . as a landscape that is constantly undergoing a process of transformation through time, and through the process by which it is traversed, and used'.[69]

Wainwright demanded that his readers experience hillwalking as he did himself, proceeding silently and preferably alone or at least in single file. The experience was to be private and individual, unlike the communal pleasures promoted by the Youth Hostel Association and ramblers' clubs.[70] In an echo of Hoskins's famous lament for the 'immemorial landscape of the English countryside', Wainwright complained: 'discordant notes have crept into the symphony. The coming of the motor car heralded a slow decline . . . people are completely out of tune with the surroundings'.[71]

His attitude stands in acute contrast to Grigson whose own guidebooks were wide-reaching and predicated on car use. Not least, Wainwright's books are of interest for his idiosyncratic perception of the landscape. Ideally uncultivated, unforested and uninhabited, his preference was a powerful counterview to the democratically open, productive, visibly inhabited countryside promoted by popular culture. Nevertheless – and most significantly – Wainwright has enabled innumerable people to walk across and delight in his personal landscape.

For Richard Long, walking is both a practice and an art form: he works by walking, disregarding the historical status of his activity. His cultural references include detailed conventional maps, which are essential to his work; a concrete poetry of place names; hiking equipment for various terrains and the ecology of the natural world, which was becoming increasingly prominent at the start of his career in the 1960s. Long, who enrolled at St Martins School of Art in 1966 and joined Peter Kardia's course analysing the nature of sculpture, had come to London from the West of England College of Art where, two years earlier, he had pushed a snowball across Bristol Downs to leave a ragged track, or 'ground-drawing' in the thin snow. It initiated a practice of making distinctive physical objects that either self-destructed or were capable of being readily dismantled.

Because of the transient nature of his work, photography was at the core of Long's practice from the beginning, an activity that he undertook as a means of recording a journey or a set of actions rather than as an aesthetic aspiration. He made his first characteristic work in 1967 in a field south-west of London. By repeatedly walking up and down the same part of the field he created *A Line Made by Walking*, which he recorded in a black and white photograph (see fig. 6).[72] In common with other works that he made about the same time, it demonstrated that in Long's novel practice 'the landscape itself became the art object'.[73] This first line was the precursor of many that he walked, painted, marked out in stone, turf, sticks, clay or water, all ephemeral, all photographed to record his meticulously planned journeys across the world's landscapes. Bypassing romantic allusions and cultural references to early

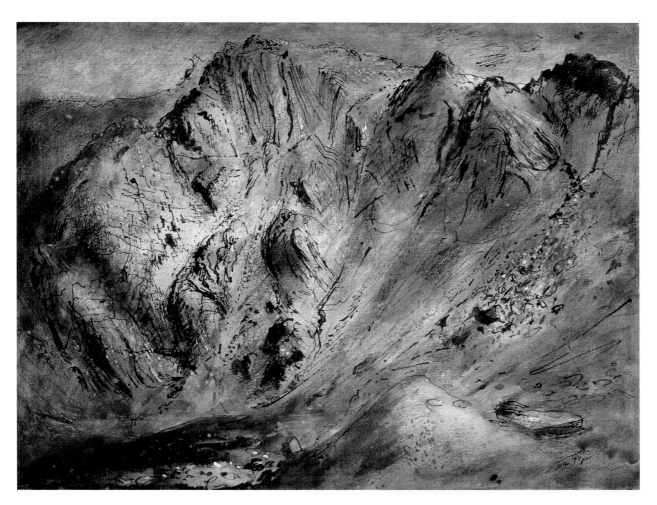

113    John Piper, *Slopes of Glyder Fawr, Llyn Idwal*, 1947

nineteenth-century walkers, his practice 'puts at the foreground the constant fluidity of the landscape and the walker as they entwine and shape each other'.[74]

## Climbing

While rock climbing is more closely associated with photography than with painting, the drawings and paintings that John Piper made in Snowdonia in the 1940s often, albeit fortuitously, focused on popular climbing sites. His watercolour, *Slopes of Glyder Fawr, Llyn Idwal*, (1947; fig. 113) shows, for instance, one of the most popular climbing sites in north Wales, a semicircle of rock faces at the head

of a valley overlooking a small lake. While Piper may or may not have been aware of the attraction that fear holds for mountaineers, there is no doubt that he was extremely well-informed on the Sublime and the associated recognition of terror as an appropriate physiological response to mountain landscapes.

Developing from certain mindsets and environments, the Sublime and the 'landscape of fear' are most potent and dramatic in mountain landscapes.[75] As for the intrepid eighteenth-century traveller, there is for the climber seeking fresh experiences a real possibility of death. One who had narrowly avoided an accident wrote: 'how much pleasure the fear had brought afterwards. And . . . how strange it is to risk yourself for a mountain, but how central to the experience is that risk and the fear it brings with it'.[76] Fear is at the core of 'free climbing', that is, climbing without ropes. It has been argued that while the associated risks may involve confrontations with death, they also raise important questions about 'dominant notions of what it is to be a human subject in Western society', with its extreme aversion to physical risk.[77] The 'climbing body' has been identified as the primary instrument for free climbing, led by the hand, which provides essential 'tactile navigation' in situations where touch is more informative than vision. The multi-sensual engagement of the whole body with a slab of rock or ice – 'the total embodied awareness of a body in an environment' – was, no doubt, familiar to Peter Lanyon as a glider pilot.[78]

The desire and need for mountaineers to record their largely unseen achievements has forged a link between climbing and photography. The *Alpine Journal* carried its first photograph in 1885,[79] and by the 1890s 'hand cameras' were being promoted as a means for climbers to record one another in action and to plan their routes.[80] On both counts they were early devotees of small, portable photographic apparatus, though the 'ice-axes that doubled as tripods' were among the less plausible of Victorian inventions.[81] It has been suggested that, beyond its practical benefits, photography was a medium through which climbers might offer a version of the Sublime consonant with twentieth-century visual modernity, a plausible speculation given the routinely dramatic nature of photographs of climbers in action.[82]

Few of the artists discussed in this chapter are to be understood as record-makers. That they may inadvertently have made significant contributions to recording the ways in which landscapes were perceived, altered and used in the latter half of the twentieth century is fortuitous. Yet nothing could replace the depth and range of their perceptions, from de Grey's *Allotments* to Long's *Line Made by Walking*, in formulating an aesthetic chronicle of a culture in flux. Today, the prominence of landscape in general culture is largely unquestioned, as is the recognition that 'landscapes are not static but always contested, always changing, constantly negotiated and culturally constituted'.[83] If this amounts to a dismissal of Hoskins's attachment to an unspecified past, it establishes a particular place for practices such as Long's which make no permanent interventions but propose radical alternatives to a current situation. This is a role for all the arts, especially in social contexts.

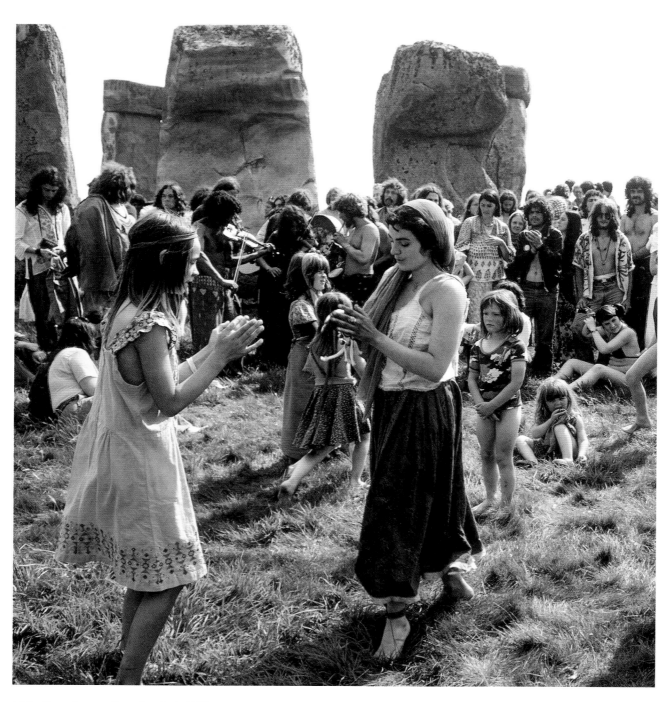

114   Stonehenge Free Festival, 1970s

# 7  Places of the Mind

The title of this chapter is taken from Geoffrey Grigson's book *Places of the Mind*, a memoir of journeys to real places, many of which he made with John Piper.[1] While the artists' practices discussed in this book often resulted fortuitously in imagined landscapes, this final section is concerned with art that had less to do with the physical environment than with ideas about it. The individual world view, the 'personal *terra cognita*' or the private environment is always unique because 'all information is inspired, edited and distorted by feeling', which embraces prejudice, personality and experience.[2] This private world view is the creative terrain of the artist.[3] From it develops the treasured, richly symbolic personal place that may be a desert or an ice field, the 'cabin in the forest . . . the seashore, the valley and the island'.[4] Such sites of 'prelapsarian innocence and bliss' connect in turn with subjects as distinct from one another as tourism, philosophy and archaeology.[5]

In acknowledgement of the diversity of landscapes, interpretations of them range from analyses of cosmological systems to calculations of the financial benefits of World Heritage status. At its most obvious, landscape is the solid ground beneath our feet, though it may on occasion be ephemeral. Frequently recorded by artists, changeable landscapes are distinguished primarily by colour: the brilliant yellow of oilseed rape, for instance, or the scarlet of poppies that have evaded weedkillers.[6] Terry Frost was acutely conscious of landscapes altered by seasonal shifts; some of his paintings clearly refer to summer and harvest, whereas others evoke icy cold. For photographers who worked in monochrome, the articulation of landscape by the shifting shadows of clouds was a favoured subject that could not be replicated in colour. Many of Lanyon's gliding paintings are grounded in his pilot's observation of the transience of weather conditions, as was much of the work of Joan Eardley. However, by no means all of the artists whom I have discussed in this book were concerned with the visual qualities of weather or seasons: the flat, unmodulated

skies so familiar in the work of Clough and Lowry sustain a view that such natural phenomena were not their primary interest.

The visual mutability of landscape is balanced by physical remnants of history. Kitty Hauser argues that the evidence of archaeology in the mid-twentieth century resulted in the past being 'comfortingly' understood as 'essentially ineradicable, despite the destructive and alienating effects of modernity, and of war'.[7] Nevertheless, despite the truth of her assertion as regards physical traces, successive interpretations of ancient monuments reveal the rapid succession of developments in archaeological insight and, indeed, perceptions of the past in general. In the eighteenth century the antiquarian William Stukeley confidently identified Stonehenge as a stone 'temple erected in 460 BC by Egyptian "refugees"'.[8] In the late twentieth century its origins were more soberly described as a third-millennium BC '"Ur" henge – no stone in sight . . . a simple circular ditch and bank with wooden structures in the centre', which was eventually to become an 'ideological and physical battleground' where travellers and other free-minded folk regularly gathered to confront authority at the summer solstice (fig. 114).[9] All three statements reflect the perceptions of their periods.

## David Jones and the Landscape of the Mind

The painter and poet David Jones is frequently linked to Neo-Romanticism, though he was never part of the group of artists associated with Sutherland. At various times Jones painted and drew the landscapes of Wales, Sussex and Northumberland, while he also made numerous works in which landscape is grafted onto mythology, poetry and, notably, Christianity, since he was a convinced, if vexed Catholic.[10] Though Jones's work, predominantly in watercolour on paper, passed in and out of critical and commercial favour during the interwar years, by the early 1940s there was once again strong interest in his paintings. It has been plausibly suggested that this was because his literary, lyrical art was thought to articulate 'Britishness' at a time of national peril, a perception that extended into the post-war period when his work was frequently exhibited abroad by the British Council in group exhibitions.[11]

115   David Jones, *Vexilla Regis*, 1948

In 1948 Jones painted *Vexilla Regis* (fig. 115), a title appropriated from a hymn written by the sixth-century poet Venantius Fortunatus that became part of the Good Friday liturgy. The five verses of the text elaborate on the theme of a tree as a metaphor for the Crucifixion:

> Fulfilled are now the prophecies
> That David sang of, long ago,
> Saying, The nations of the earth
> God ruleth from a tree.[12]

*Vexilla Regis*, which belongs to a group of paintings in which trees are the principal motif, is a complex image that has been aptly described as conveying Jones's belief in the truth of his subject through 'direct equivalence and not by illusion'.[13] Three trees, serving as the crosses of Calvary, are its most prominent feature. The smallest, on the right, is 'partly tree and partly triumphal column and partly imperial standard', topped by an eagle.[14] A variety of birds and animals populate a fantasised landscape articulated by numerous structures that include a classical temple, a henge monument and a Renaissance fountain. Such references reach back to the Roman Empire and ancient Britain, and to the 'poetic landscape' common to Claude Lorrain and the English garden.[15] Jones himself equated *Vexilla Regis*, which he saw as a landscape of suffering and death transformed into one of regeneration and natural growth, with the end of the Roman Empire and the Christian Calvary.

Caroline Collier, comparing Jones with T. S. Eliot and Joyce, commented that he was a poet 'in the mainstream of Modernism' who was closer in his thinking to writers than to the 'British artists of the pastoral revival' or to the Neo-Romantics,[16] and concluded that for all their particularity 'the places that Jones painted became the landscape of his mind'.[17]

•

## Arcadia

The work of Paul Nash, Graham Sutherland and their associates in the 1940s reveals the compulsive attraction of a conceptual Arcadia as a counterbalance to the perils of the mid-twentieth century. An idealised perception of rural England as a fully evolved but timeless entity, Arcadia was characterised by melancholy and loss, typically rendered by Neo-Romantic artists as an unattainable, distant light across an extensive landscape. John Minton, Michael Ayrton, Keith Vaughan and John Craxton all for a time followed the lead of Sutherland and Nash in constructing versions of a modern romantic landscape. Acutely attuned to the emotional climate of the early 1940s, Arcadia had lost its potent nostalgic appeal with the end of the war, overtaken by the need to address the realities of the immediate future. As the rubble of bomb damage was gradually replaced by new urban landscapes, artists began to experiment with an approach to modernism that was distinct from pre-war models. Landscape, both rural and urban, was an ideal vehicle for visual experiment given that the human body remained a generally sensitive subject, notwithstanding its appropriation and intensive reformulation by Francis Bacon and Henry Moore.

For the general reader, Arcadia was factually formulated in the 113 books, in seven series, of 'countryside writing' published by B. T. Batsford Ltd, for the most part between 1930 and 1945.[18] The Batsford genre of specialised writing which explored the rural, and selective versions of the urban, landscape no doubt contributed to a heightened sense of national identity during the war. Two series, *The British Heritage* and *The Face of Britain* were particularly relevant in this context. The first detailed 'the man-made features of our heritage: the cathedrals, churches, castles, villages, cottages', while *The Face of Britain* described 'aspects of the countryside on a geographical basis'.[19]

During the early stages of the war, when paper stocks were still plentiful, Batsford printed 'thousands of copies' of *The British Heritage* and *The Face of Britain*.[20] The former included Ralph Dutton's *The English Country House*, with a foreword by Osbert Sitwell, the owner of Renishaw, a grand house in Derbyshire. He lamented:

'What country houses of any size, one wonders, can hope to survive the next forty years? . . . And indeed, as I sit writing these lines in an old house, I recall that two great houses in the neighbourhood have been dismantled and gutted within the last few years'.[21] The opening lines of Dutton's text speak still more eloquently of the desire, characteristic of the longing for Arcadia, to exclude the urban and implicitly the modern: 'No nation has the love of country life more firmly implanted in its character than the English, and it is an unfortunate chance that few, if any, European countries possess a larger proportion of urban population'.[22]

In so far as the Batsford books were concerned with towns, it was with their most obviously appealing features, notably cathedrals, market halls and Georgian houses. In W. G. Hoskins' *Midland England*, published in 1949, a few photographs of tileworks, brickworks and a quarry follow more picturesque images of cattle pastures and a horse fair. The author admitted that 'The midland sky is pierced by factory chimneys from north to south, even in the apparently purely rural parts', though he defiantly concluded: 'even in the largest towns the old country nucleus has not been lost'.[23] Yet six years later, when Hoskins published *The Making of the English Landscape* he conceded that his battle – a narrative that had begun with the Industrial Revolution – was over. A dream of Arcadia had sustained the nation through the war, after which it died, gently enough, to be replaced by the enthusiastic walkers, naturalists, photographers and tourists who would explore the new realities and freedoms of post-war Britain.

## Landscape Destabilised

After the war, the demonstrable fragility of the Edenic landscape, together with the pictorial freedoms offered by modernism, created a situation in which artists were encouraged to explore their terrors as well as their dreams. In their imagined spaces of the mid-century, certain painters developed and entered a conceptual arena where violence, mortality and sexuality were conjoined and expressed through narratives of brutality, betrayal and destruction. The most powerful and singular

manifestation of this mindset emerged in April 1945 when Francis Bacon showed *Three Studies for Figures at the Base of a Crucifixion* (*c.* 1944) at London's Lefevre Gallery, a triptych in which he explored death, bestiality and morality. Coincidentally, the exhibition opened in the same month as the British army liberated the German concentration camp Bergen-Belsen, an event that was widely reported in the British media. Bacon's painting, which has been associated with the atrocities discovered in the concentration camps, drew a line under all previous depictions of a living, possibly human body and set a benchmark for representations of brutality as a feature of everyday life.

A parallel, but less intense impulse informed the work of Sutherland and Hilton, and some of Scott's, causing Lawrence Alloway to write a decade later that 'many artists still believe in the constant, not of order, now, but of disorder – vitality, a sense of energy, the id' and, referring specifically to Scott, of his search for 'magic . . . another absolute, a dark instead of a bright one'.[24] As a war artist Sutherland had painted bomb damage in London and South Wales, open-cast mining in Derbyshire, Cornish tin miners huddled under great masses of rock, and steel workers in Cardiff and Swansea. Of the latter experience he remarked to his biographer, Roger Berthoud, that it took place in 'a Dantesque kind of atmosphere'.[25] Fire and flames became prominent in Sutherland's imagery; his paintings of steelworks, filled with apocalyptic reds, oranges and yellows, have been aligned with the late work of William Blake, for which he had a great enthusiasm.[26]

The 1945 exhibition in which Bacon's work was shown took place during the two years that have been identified as the point of his most intensive interaction with Sutherland. Whereas Sutherland was a committed landscape painter who contributed significantly to the reformulation of the genre after the war, Bacon's few landscapes were more or less incidental, suggesting that they were settings for events rather than events in themselves. In the early 1950s he visited his mother and sister who lived respectively in South Africa and Southern Rhodesia, now Zimbabwe. He was gripped by enthusiasm for the singular landscape of the African bush in

116    Francis Bacon, *Study of Figure in a Landscape*, 1952

the vicinity of the Limpopo River. Hot, arid, brilliantly lit and seemingly boundless, it stimulated his imagination, as did the wildlife.[27] After visiting the Kruger National Park in South Africa, Bacon became engrossed in the behaviour of animals and spent a considerable time photographing them as they moved 'through the mysterious screens of long grass'.[28] These experiences no doubt informed his *Study of Figure in a Landscape* (1952; fig. 116), a painting of a naked man seated under a deep blue sky among just such grasses, marked out in the bright yellows and browns characteristic of a southern African dry season. Bacon's landscape evokes no specific place; it refers, rather, to a private, undefinable mindset and, in general, to thousands of square miles of land. The human inhabitant of such a landscape is 'out of place'.

For Sutherland, conversely, the definition of place was habitual, as his pre-war images of Pembrokeshire demonstrated. Such places remained almost free of people until the late 1940s when he introduced disturbing hybrid beings. Adopting – or fortuitously reinventing – a theme explored by the sixteenth-century painter Giuseppe Arcimboldo when he painted human heads undergoing metamorphosis into vegetables, Sutherland developed creatures that were part animal, part plant. The concept of physical and mental transformation from a recognisably human, or even animal, condition to one that is unidentifiable, indeed unknowable, was powerful during the early post-war years when rumours abounded regarding the imminent, irreversible genetic damage to be suffered by humanity as a by-product of atomic warfare.[29] While sensationalist scaremongering was rife, such stories reflected a widespread belief in the inevitability of an annihilating conflict.

In 1944 the priest, artists' patron and collector Walter Hussey commissioned Sutherland to make a painting of the Crucifixion for St Matthew's Church, Northampton. Before starting work and while he was still considering how to set about it, Sutherland made some drawings of thorn bushes which, in his own, much-quoted words 'became . . . something else – a kind of "stand-in" for a Crucifixion and a crucified head'.[30] The bushes gave rise to various near-sculptural images; some took the form of a portal-like structure, whereas others were variations on

117 (LEFT)
Graham
Sutherland, *Thorn
Head*, 1947

118   Graham
Sutherland,
*The Origins of
the Land*, 1950–1

oval shapes on long stalks, encrusted with thorns. Sutherland set both groups in deep, dark spaces or on unnaturally green grass, signalling notional places within wider, if minimal landscapes. He wrote that the 'thorns sprang from the idea of potential cruelty . . . in benign circumstances: blue skies, green grass, Crucifixion

under warmth'; the contradictions echo the implausibility of his spaces.[31] Within its framework of metallic spikes, *Thorn Head* (1947; fig. 117) reveals a glimpse of blue sky and a small section of a golden cornfield, with a flower-like motif transposed from an earlier painting, as if this head laid out a tranche of the artist's imagination

for scrutiny. The picture's convoluted spatial arrangement suggests that both image and viewer are enclosed in the dark, tunnel-like spaces characteristic of the deep lanes that Sutherland had painted in Pembrokeshire and the subterranean mines that he had depicted during the war.

Between 1948 and 1951 he explored and elaborated on groups of organic entities related to trees, leaves, roots and insects, which evolved from one another as much as from what he saw around him. At the turn of the decade Sutherland began to paint vertical, sculptural forms, attributing the origins of at least one of them to a garden in the South of France, 'with old walls and hedges covered with creepers', which provoked in him a desire 'to place in an environment, things which were part figure, part a natural organic object'.[32] It was in such images that Kenneth Clark's 'landscape of fantasy' assumed a menacing nature, deeply embedded in fear of the unfamiliar. Such images contributed to a group which amount to formal variations on the theme of the Crucifixion, while bypassing its Christian content.

In April 1950 Sutherland was commissioned to paint a mural for the South Bank Exhibition on the theme of 'the origins of the land'. The phrase became the title of the work, though he initially called it 'Forces of Nature'.[33] *The Origins of the Land* (1950–1; fig. 118), which is often described as a mural but is in fact a large painting on canvas, was hung in the 'Land of Britain' pavilion in an installation that sought to demonstrate the continuity of the British Isles from their prehistoric origins to their dynamic present. Through geology and extending to the economic and technological wonders of the modern mining industry, the pavilion's narrative was presented as an incontrovertible truth.

Sutherland's painting offered a visual counterpart to Jacquetta Hawkes's book, *A Land* (1951). Hawkes was the archaeological adviser to the Festival of Britain and her book was published for it as a popular account of British geology. The painting, which purported to be a cross-section of the land and time, was essentially a rendering of the geological origins of the Earth imagined, as was Hawkes's text, as a sequential story. While it contains references to geology and evolution, in keeping

119    Reg Butler, photomontage of *Monument to an Unknown Political Prisoner*, 1956

with the general narratives of the South Bank Exhibition, its imagery of fantasised beings with bulbous bodies that culminate in single eyes reveals malign themes similar to those present in Bacon's work.

## Political Landscapes

Two years later, in 1953, the third year of the Korean war, during which an armistice was declared, Reg Butler's maquette for a *Monument to an Unknown Political Prisoner* won the first prize in an international competition. Organised from the Institute of Contemporary Arts, the purpose of the competition was to commemorate 'all those men and women who in our times have given their lives or their liberty to the cause of human freedom'.[34] As soon as the event was announced, it became embroiled in

international politics. Though it was shunned by the entire Eastern bloc, it proved hugely popular with artists across the rest of the world, attracting more than 2,000 entries. The favoured location for the winning work was West Berlin, which was then on the frontline of the Cold War and a perilously fractured Europe.

Butler's dramatically skeletal monument was to stand on the Humboldthöhe, a modest hill overlooking the city, where it would have transformed the adjacent landscape. Negotiations dragged on for several years, during which Butler revised the specification, originally conceived at almost 122 metres high, down to 70 metres, in order to reduce the cost. In 1957 it briefly seemed that the work might be erected but the process was again overtaken by insuperable problems, from antiquated legislation to international politics. In 1960 Butler's scheme was pronounced dead. A photomontage that he made in 1956 (fig. 119) is the only visual evidence for what might have been, the location signalled not so much by the hill itself as by a Volkswagen in the foreground. The image evokes an intensely politicised landscape, embracing the years of stand-off during which eastern Europe was an unknown and apparently unknowable territory, seemingly as far removed from the West in practical and cultural terms as was Korea.[35]

In January 1958, following almost a decade of protest against atomic weapons, the Campaign for Nuclear Disarmament (CND) was founded. It was chaired until 1964 by Canon John Collins of St Paul's Cathedral, whose ministry was directed to peaceful protest against nuclear weapons. Other founder members included the philosopher Bertrand Russell, the writer J. B. Priestley and the future leader of the Labour Party Michael Foot. Many artists and writers were among CND's early members, including the trio of old friends: Hepworth, Moore and Read. The first Good Friday march from Trafalgar Square in London to the Atomic Weapons Research Establishment at Aldermaston in Berkshire took place in April 1958. The four-day march started with 300 people and, despite snow, ended with 4,000. The following year, when the direction of the march was reversed, the equivalent figures were approximately 10,000 and 20,000.[36] As the protesters walked between Aldermaston and Trafalgar

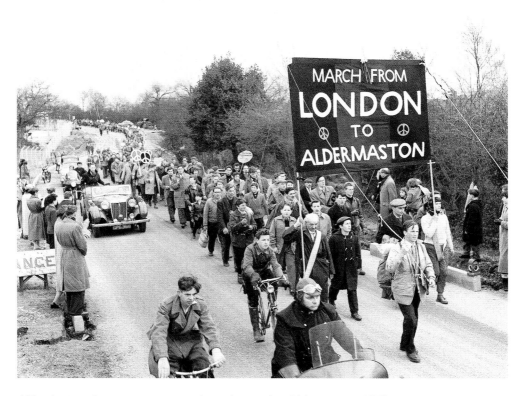

120   Anti-nuclear protestors march on the road to Aldermaston, 1958

Square, they marked out a political landscape, one that had only a transient material existence but that is nevertheless recorded in countless photographs of an event and a route that expressed a powerful communal will (fig. 120).

The painter Denis Bowen[37] was among the artists who made paintings on the theme of atomic energy, of which *Atomic Image* (1952; fig. 121), sold to Leicester County Council Artworks Collection in 1958, is a typical example.[38] Bowen was adamant that he was an abstract artist and that there was no question of representation in his work; nevertheless, his imagery and titles were devised to direct the thoughts of the viewer. In the context of the Aldermaston marches, walkers and artists addressed the same subject. The walkers created an enacted, or embodied landscape, the painter an imagined one.

121   Denis Bowen, *Atomic Image*, 1952

## Archigram: The Visionary Urban Landscape

Visionary architects are highly valued by their peers though they tend to be little understood outside the profession, not least because inevitably, they have few opportunities to build. In the 1960s the group known as Archigram offered an inspirational approach to the future. Its core members were Peter Cook, who trained at the Architectural Association, David Greene (Nottingham School of Architecture), Michael Webb (Regent Street Polytechnic) and Warren Chalk, Dennis Crompton and Ron Herron, who were working for the LCC. The group's perspective has been characterised as an anti-classicist reworking of early modernism.[39] They were interested in mass production and the concomitant systems that would provide standardised structures in kit form. Though Archigram produced few buildings, in 1960 Chalk, Crompton, Herron and fellow architect John Attenborough helped designed the South Bank Arts Centre. Finished in 1967, the complex, which has been described as 'the first serious attempt to build the Brutalist multi-level city',[40] remains a self-contained, specialised cultural precinct of great character, and a sophisticated counterpart to Clough's austere industrial landscape paintings.

Between 1961 and 1970 Archigram produced an eponymous magazine, one of many polemical publications of the period that vigorously promoted esoteric causes. Each issue of *Archigram* differed in format and appearance, though they were all distinguished by complex drawings of astonishing technical proficiency. Since Archigram's imaginative reach was beyond technological possibility, its drawings presented an equivalent to the landscapes of science fiction. Dismissing form, they emphasised circulation, process and ultimately 'the dissolution of the artefact . . . into a landscape of complex and indeterminate systems'.[41]

Archigram announced its presence in June 1963 with an exhibition at the ICA called *Living City*.[42] In his introduction, Cook set *Living City* in the lineage of the MARS Group's 1938 exhibition at the Burlington Galleries, which proposed a radical redevelopment of London to facilitate movement and communications, and the Festival of Britain.[43] For the display, the Institute's restricted space was divided into

122   Installation photograph, *Living City* exhibition, ICA Gallery, London, 1963

seven areas or 'gloops' titled: 'Man', 'Survival', 'Community', 'Communications', 'Movement', 'Place' and 'Situation'. These, it was claimed, were the primary pre-occupations of the 'living city'.[44] Monumental architecture was no longer viable; building itself was insignificant compared with 'the life and activity, the happenings within spaces in city [sic], the transient throw-away objects, the passing presence of cars and people' (fig. 122).[45] Visionary drawings were juxtaposed with assertions of the city's humanity revealed through its concern for 'health, housing, marriages,

123    Peter Cook, *Plug-In City, Overhead View (Axonometric Drawing)*, 1964

fertility rate, crime rate, journey to work, wages and salaries'.[46] Culturally, the 'Living City' was entirely expressive of its period: 'Man' was at its core and he was obsessed with the technology of space exploration.[47]

The 'Plug-In City' project (1962–4) supports Simon Sadler's contention that 'Biology and technology . . . were models for Archigram'.[48] Cook's axonometric drawing, reproduced in the group's magazine, shows a service structure with units attached wherever an extension might be required (fig. 123).[49] The image echoes Le Corbusier's *Ville Contemporaine*, necessarily updated to include 'a giant routeway for hovercraft' which were understood as components of mobile buildings, as were 'craneways'.[50] Cranes were the indispensable means of inserting units for living,

124   John Weeks, Northwick Park Hospital, Harrow, London, 1961–74, photographed in 1970

shops and offices. Above them a layer of 'environmental seal balloons' would provide protection from bad weather.[51]

By the mid-'60s it seemed that 'non-plan' or architecture in kit form might offer a practical, long-term alternative to conventional building.[52] John Weeks's Northwick Park Hospital (1961–74; fig. 124) in north London has been proposed as the built exemplar of the indeterminacy principle. Its design evolved within the context of biological growth patterns expounded by D'Arcy Wentworth Thompson and conceptually related to the music of Anton Webern and John Cage, the 'informel' in painting and Werner Heisenberg's indeterminacy principle.[53] The goal of non-plan was a 'conceptually endless' building based, after Heisenberg, 'on probability rather than certainty'.[54] Indeterminacy allowed for rapid structural alteration and

growth, according to medical or ecological demand, in buildings that were in theory infinitely extensible. They would need to respond through the addition of 'plug-in' units attached to a central stem.[55] The principle of indeterminacy applied to both the potential appearance and the actual purpose of non-plan, inevitably diminishing the possibility of its being built, given the existing context of a developer-led culture of construction. Nevertheless, non-plan echoed and expressed the political pragmatism and consumption-led ideology of the 1960s, relationships that were only retrospectively clarified by the ICA exhibition. Non-plan was embedded in its period, evoking comparison with Abstract Expressionism, a relationship sustained by the latter's emphasis on the painted mark without regard for a subject, just as non-plan rejected conventional formats and functions.

Every culture demands a visionary component, however fragile. It is paradoxical that it was only possible to conceive a visual landscape of indeterminacy – that is, a product of intellectual anarchy – within a flourishing capitalist economy. No doubt the members of Archigram relished the paradox as much as the intellectual liberty that enabled the group to function. Evidently, indeterminacy would have been unthinkable in the context of the consensual conformity of the immediate post-war years, suggesting that architecture is a more sensitive marker of historical shifts than painting or sculpture, just as it is the most active and immediate creator of actual landscapes.

## End Notes

The landscapes discussed in this book may be understood as predominantly those that resulted from or expressed a form of modernity, a nationwide cultural impulse that followed the end of the war. Modernity can be seen to have run through society, as a widespread, political and social imperative that encompassed general cultural renewal while engendering a somewhat sceptical sense of optimism that co-existed with black market racketeers, shoddy developers and the Cold War. The late 1940s was a time of paradox, dominated by episodes of international belligerence and a

deep fear of imminent nuclear annihilation, accompanied by a profound desire to return to a recollected normality. If this period was much harsher than today, it was also one imbued with a greater sense of social justice, which enabled the Attlee government to perform what amounted to a social revolution. Its most enduring result was the provision of universal healthcare, while war-damaged housing stock and schools were slowly repaired, and new estates and towns were constructed. Factories returned to normal production in a largely ad hoc process; the military presence was slowly cleared from the countryside, while agriculture resumed with an ever-increasing dependence on mechanisation and pesticides. Full employment brought unprecedented prosperity which was in turn accompanied by the development of 'leisure industries' and numerous schemes simultaneously to achieve full access to the countryside and to protect it.

All these factors came to bear on the already much-changed rural and urban landscapes of the early post-war period. A consideration of how these landscapes were understood and interpreted by artists brings a separate set of themes into play, involving critics, curators, the internal dynamic of the art world and, primarily, the recesses of individual creative minds. The work of artists and writers reminds us that landscape is an extraordinarily diverse subject, one that means something different to every observer. If landscape's appearance constitutes its first and most obvious identity, all those who use and inhabit it do so with different priorities. Farmers, walkers, tourists, climbers, gardeners and miners have made their individual places within it, but it is the perceptions of artists that tell us most about the nature of those diverse places. Lowry, Lanyon, Clough, Fell, Eardley, Auerbach, Kossoff, Piper and Brandt are among those who have imprinted their intensely personal visual insights on our minds. As a result, certain places and areas have become inseparable from the interpretation of a single artist, as is the case of Lanyon in Cornwall, Hitchens in Sussex and Eardley on the Scottish coast. Nevertheless, their work at times resists understanding and, though there are numerous pathways to interpreting the diversity of post-war landscape art, the impulses that led artists up mountains,

down mine shafts or into ferocious storms may remain incomprehensible without an acknowledgement of their phenomenological engagement with the landscapes that permeated their lives and art.

All the artists about whom I have written filtered their subject matter through personally specific habits of seeing, interpretation and painting. In doing so, they established what we might understand today as a composite, if extremely diverse visual image of large areas of the early post-war landscape. It was conceptual as much as it was material, as much urban as rural and defined largely, as Clark acknowledged, by its impetus to embrace the modern. He had noted 'a new sense of space', identifying the quality that Heron would identify as the primary goal for contemporary painters.[56] Heron's advocacy ensured that the interactions of space and colour would be prominent characteristics of innovatory post-war painting.

The modernisation of land and art after 1945 proceeded hand-in-hand, though art frequently proved contentious: in general, new commodities were welcomed with the same intensity as the more advanced manifestations of visual art were rejected. Nevertheless, contemporary art was to become a prominent, long-term signifier of renewal. The point was made most visibly in the flurry of commissions for public art – predominantly in the form of sculpture – that were set up in the later 1950s and '60s. The works that resulted did much to establish and articulate the character of New Towns, housing estates and public buildings across the country and to enhance their architecture and planning. During this time, just as artists developed unprecedented ways of constructing images, landscapes themselves were put to new uses. The works of art that emerged from and commented on these processes are testimony to a brief period of intense creativity that until recently has been passed over in favour of the Pop culture of the early 1960s.

Diverse routes to visual modernity were promoted by critics whose relationships with artists were variously close, edgy, trusting and suspicious, though virtually all those concerned were sustained by a recognition of mutual need. Lawrence Alloway's cogently expressed contempt for landscape painting sets him outside the scope of

this book, but his brief essay on Abstract Impressionism written as an introduction to the eponymous exhibition that he organised in 1959 amounted to an extension of Heron's precepts on space and colour.[57] In this way, perhaps coincidentally, Alloway confronted modern landscape painting and provided it with an historical pedigree. His wider, invaluable contribution in the late 1950s was to ensure that British artists became a part of international modernity.

Geoffrey Grigson and Patrick Heron were the most prominent critics to be deeply concerned with landscape art. Grigson was a maverick whose comments were invariably pertinent, whether to do with routes for motorists or the problems of preservation. Heron was one of the most original writers on art in the post-war period. He promoted an approach to painting that was simultaneously grounded in historical precedent, viable for a modern society and essential to contemporary artists. The priority that he gave to the relationship between colour and illusory space, which was a product of his own practice as an artist, influenced many of his colleagues as they moved towards the untested territory of abstraction. His message was not universally acknowledged: Clough is an outstanding example of a painter to whom pictorial space appears to have been subordinate to surface and texture, with which she constructed complete, multi-dimensional landscapes.

The peacetime landscape was as much conceptual as material; as much urban as rural; it was defined largely, as Kenneth Clark recognised, by the impetus among artists to embrace innovation. Many artists who opted for experimental practices were brought to despair by their lack of commercial success, though since the 1980s there has been a sustained renewal of interest in 'modern British' art which has brought a long overdue acknowledgement to the early post-war pioneers of modernity and, specifically, modern landscape painting.

With the end of the war, Arcadia lost its potent, nostalgic appeal, overtaken by the practicalities of the immediate future, and artists began to experiment with the landscape genre using the new ideas about imagery proposed by colleagues in France and the United States. If the work that resulted was not immediately popular

with a conservative public, it was enthusiastically acknowledged by the British Council, which adopted it as an effective, 'soft' weapon in its cultural armoury. During the Cold War the arts offered a potent and widely accepted means of disseminating knowledge of western culture, or of conducting a discreet form of propaganda. This also enabled British artists to exhibit internationally and to have their work assessed in relation to their peers abroad, a situation that they relished and from which they benefited greatly.

The post-war generation of artists – those whose names run through this book – are now recognised as pioneers of semi-abstract painting, an approach that combined realistic colour with sweeping marks across a canvas with the liberty to splatter areas of paint in drops or to turn a loaded brush in a celebratory circle. They chose landscape as their subject because it was spectacular, familiar and always new. It was a subject that came under much scrutiny after the war, as its many qualities were slowly recognised, acknowledged and put to use for unprecedented social purposes alongside updated perceptions of agriculture, tourism and disastrously unregulated industrial practices. Because 'before' and 'after the war' were periods so distinct that they might have existed in separate universes, the work of artists who belonged to either or both of them is particularly eloquent and period specific. Landscape, so frequently described as 'timeless', was itself revealed as an ultra-sensitive indicator of cultural change, whether the artist concerned was an architect, a photographer, a painter flying a glider, a sculptor or a man lying in a field, drawing compulsively. They have all contributed to our understanding of that irretrievably different landscape of seventy or so years ago.

# Notes

## Introduction

1   See Paul Farley and Michael Symmons Roberts, *Edgelands: Journeys into England's True Wilderness*, Jonathan Cape, London, 2011.

2   Stephen Kite, 'Landscapes of Negation; Landscapes of *Virtù*: Adrian Stokes and the Politico-ethical Landscapes of Hyde Park and Italy' in Mark Dorrian and Gillian Rose (eds), *Deterritorialisations . . . Revisioning Landscapes and Politics*, Black Dog Publishing, London and New York, 2003, pp. 130–41 (131).

3   Lord Keynes, 'The Arts Council: Its Policy and Hopes', *The Listener*, 12 July 1945, pp. 31–2.

4   Becky Conekin, Frank Mort, Chris Waters (eds), 'Introduction', *Moments of Modernity, Reconstructing Britain 1945–1964*, Rivers Oram Press, London, 1999, pp. 1–21 (2).

5   Many schools were embellished with murals by such painters as Kenneth Rowntree; Peggy Angus was a leading designer of tile murals; see James Russell, *Peggy Angus: Designer, Teacher, Painter*, Antique Collectors' Club with Towner Gallery, Eastbourne, 2014.

6   Elain Harwood, *Space, Hope and Brutalism: English Architecture 1945–1975*, Yale University Press, New Haven and London, with Historic England, 2015, p. 173.

7   See Victoria Perry, *Built for a Better Future: The Brynmawr Rubber Factory*, White Cockade Publishing, Oxford, 1994, pp. 35, 36.

8   Ibid., p. 56.

9   Jack Rose, *The Dynamics of Urban Property Development*, Routledge, London,1985, p. 153.

10   Robert Burstow, 'Modern Sculpture in the South Bank Townscape' in Elain Harwood and Alan Powers (eds), *Twentieth Century Architecture 5, Festival of Britain*, Twentieth Century Society, London, 2001, pp. 95–106.

11   See Michael Harrison, *Alan Reynolds: The Making of a Concretist Artist*, Lund Humphries, Farnham, 2011, pp. 13–15.

12   There are three near-identical versions of this picture, which was painted at Sandlands, Boar's Hill, the home of a friend of the artist. Nash also made 'twenty-six known paintings of the view from Sandlands'; see Ann Simpson, *Nash: Landscape of the Vernal Equinox*, Scottish National Gallery of Modern Art, Edinburgh, 1987, quoted in David Fraser Jenkins, *Paul Nash: The Elements*, exh. cat., Scala and Dulwich Picture Gallery, London, 2010, p. 162.

13   Roger Cardinal, *The Landscape Vision of Paul Nash*, Reaktion Books, London, 1989, p. 116.

14   Paul Nash, *Outline: An Autobiography* (Faber & Faber, 1949) Columbus Books, London, 1988, p. 122.

15   For earlier examples see Clarrie Wallis, 'Making Tracks', in *Richard Long: Heaven and Earth*, exh. cat., Tate Publishing, London, 2009, pp. 33–61.

16   See Farley and Symmons Roberts, *Edgelands*, passim.

17   Margaret Garlake, *New Art, New World: British Art in Postwar Society*, Yale University Press, New Haven and London, 1998, p. 151.

18   'People and environment are constitutive components of the same world . . . The landscape is an anonymous sculptural form always already fashioned by human agency, never completed, and constantly being added to, and the relationship between people and it is a constant dialectic . . . the landscape is both medium for and outcome of action', Christopher Tilley, *A Phenomenology of Landscape: Places, Paths and Monuments*, Berg, Oxford and Providence, 1994, p. 23.

19   Robert Macfarlane, *The Wild Places*, Granta, London, 2007, p. 127.

20   Edward Relph, 'Geographical Experiences and Being-in-the-world: The Phenomenological Origins of Geography' in D. Seamon and R. Mugerauer (eds), *Dwelling, Place and Environment: Towards a Phenomenology of Person and World*, Martinus Nijhoff, Dordrecht, Boston, Lancaster, 1985, pp. 15–31 (20).

21   Denis Cosgrove, 'Geography is Everywhere: Culture and Symbolism in Human Landscapes' in D. Gregory and R. Walford (eds), *Horizons in Human Geography*, Macmillan Education, Basingstoke, 1989, pp. 118–35 (126).

22   ' . . . the ways in which particular sets of practices are seen to generate particular ways of being in the landscape, which thereby becomes the occasion for an intellectual, spiritual and physical citizenship'; David Matless, *Landscape and Englishness*, Reaktion Books, London, 1998, p. 73.

23   Ibid., pp. 73–95. The Woodcraft Folk is a national organisation for children and young people that encourages interest in the environment and outdoor pursuits.

24   On the everyday nature of cultural landscapes, see John Wylie, *Landscape*, Routledge, London and New York, 2007, p. 109.

25   Richard Muir, 'On Change in the Landscape', *Landscape Research*, vol. 28, no. 4, October 2003, pp. 383–403 (385).

26   David Meinig, 'The Beholding Eye: Ten Versions of the Same Scene' in D. Meinig (ed.), *The Interpretation of Ordinary Landscapes*, Oxford University Press, 1979, pp. 33–48.

27  Kevin Lynch, *The Image of the City*, MIT Press, Cambridge, Mass., and London, 1960, p. 126.

28  David Fraser Jenkins, *Paul Nash: The Elements*, p. 29.

29  David Fraser Jenkins, 'Paul Nash, *Landscape of the Vernal Equinox (III)*, 1944', in R. Hoozee (ed.), *British Vision. Observation and Imagination in British Art 1750–1950*, exh. cat., Museum voor Schone Kunsten, Ghent, 2007, pp. 281–3 (282).

30  David Lowenthal, 'Living with and Looking at Landscape', *Landscape Research*, vol. 32, no. 5, October 2007, pp. 635–56 (640).

31  Geoffrey Grigson, *Places of the Mind*, Routledge & Kegan Paul, London, 1949, p. 98.

## 1  Landscape Painting in Post-war Culture

1  Frank Smythe, *Over Welsh Hills*, Adam & Charles Black, London, 1945, p. 58.

2  For Clark's role in the post-war art world see Garlake, *New Art, New World: British Art in Postwar Society*, pp. 11–12.

3  Brian Foss, *War Paint: Art, War, State and Identity in Britain 1939–1945*, Yale University Press, New Haven and London, 2007, p. 137.

4  'Neo-Romantic' as a description of a visual category was devised by the critic Raymond Mortimer in 1942.

5  Malcolm Yorke, *The Spirit of Place: Nine Neo-Romantic Artists and Their Times*, Constable, London, 1988.

6  Kitty Hauser, *Shadow Sites: Photography, Archaeology, and the British Landscape 1927–1955*, Oxford University Press, 2007, p. 6.

7  Ian Bowen, 'The Control of Building' in D. N. Chester (ed.), *Lessons of the British War Economy*, Cambridge University Press, 1951, pp. 122–43 (122).

8  'The "international" line may be more fruitful than the idea that British painters were by nature condemned to be romantic and lyrical, which seemed to be current in the immediate post-war years; at least it has broken the bars of that particular prison at the risk of becoming internationally packaged goods'. Robert Medley, 'Predicament', *London Magazine*, July 1961, pp. 79–80 (80).

9  The phrase was appropriated from the title of one of the artist's most desolate First World War battlefield paintings; see Paul Nash, *We are Making a New World*, 1918, Imperial War Museum, London.

10  Paul Nash, *Outline: An Autobiography*, Lund Humphries, 1949, p. 106.

11  Though the younger Neo-Romantics dispersed at the end of the war, an understanding of landscape as complex and romantic lived on in public perception and was vigorously – if incidentally – restated a decade later by the landscape historian W. G. Hoskins in *The Making of the English Landscape*, Hodder & Stoughton, London, 1955.

12  Kenneth Clark, *Landscape into Art* (Penguin Books, Harmondsworth, 1949) Pelican, London, 1956, p. 34.

13  Ibid., p. 97.

14  Ibid., p. 148. Unfortunately Clark did not define 'the more austere'.

15  Chris Stephens has memorably identified this trope as 'the modern-ish figuration of Moore's *Family Groups*'; see Chris Stephens, '"The Morrow We Left Behind": Landscape and the Rethinking of Modernism, 1939–53', in Lisa Tickner and David Peters Corbett (eds), *British Art in the Cultural Field, 1939–69*, Wiley-Blackwell, Chichester, 2012, p. 26.

16  Grigson, *Places of the Mind*, p. 118.

17  Ibid., pp. 119–20.

18  James Lees-Milne, *Midway on the Waves*, Faber & Faber, London, 1985, p. 65.

19  John Gaze, *Figures in a Landscape: A History of the National Trust*, Barrie & Jenkins with the National Trust, London, 1988, p. 71.

20  Ibid., p. 165.

21  James Lees-Milne, *People and Places: Country House Donors and the National Trust*, John Murray, London, 1992, p. 219.

22  Gaze, *Figures in a Landscape*, pp. 107, 270.

23  Ibid., p. 107.

24  See Barnaby Wright, *Shell Building Site: from the Festival Hall*, 1959, in Barnaby Wright (ed.), *Frank Auerbach, London Building Sites 1952–62*, exh. cat., Paul Holberton Publishing, with the Courtauld Gallery, London, 2009, p. 94.

25  Ibid.

26  Michael Ayrton, 'Fifty Years of Change in Art, II – The "Black Magic" of Picasso', *The Listener*, 5 April 1945, pp. 382–3.

27  Michael Ayrton, 'Art: William and Mary Scott at the Leger Galleries; Picasso and Matisse, the Victoria and Albert Museum', *The Spectator*, 14 December 1945, p. 567

28  The phrase 'abstract art' was applied to a much wider range of imagery than is the case today and often indicated hostility to any image that was not strictly conventional; see Garlake, *New Art, New World: British Art in Postwar Society*, pp. 36–8.

29  In 1989 the Central School merged with St Martin's to become Central St Martins College of Arts and Design.

30  See John McEwen, *William Gear*, Lund Humphries, Aldershot, 2003, pp. 30, 35.

31  For the ethos of COBRA, see Willemijn Stokvis, *COBRA: The History of a European Avant-garde Movement (1948–51)*, VAK Publishing, Netherlands, 1974, p. 314.

32  McEwen, *William Gear*, p. 39.

33  Garlake, *New Art, New World: British Art in Postwar Society*, p. 170.

34  Ibid., pp. 40–1.

35  Elaine de Kooning, 'Subject: What, How or Who?', *Art News*, New York, vol. 54, no. 2, 1956, pp. 26–9 and 61–2 (28).

36  James Hyman, *The Battle for Realism: Figurative Art in Britain during the Cold War 1945–1960*, Yale University Press, New Haven and London, 2001, p. 3.

37  Letter to Naum Gabo, February 1949, in Margaret Garlake, 'Peter Lanyon's Letters to Naum Gabo', *Burlington Magazine*, vol. CXXXVII, no. 1105, April 1995, pp. 233–41.

38  See Peter de Francia, *The Forgotten Fifties*, exh. cat., Graves Art Gallery, Sheffield, 1984, quoted in Michael Harrison, *Alan Reynolds: The Making of a Concretist Artist*, p. 18.

39  Uvedale Price, *An Essay on the Picturesque as Compared with the Sublime and the Beautiful* (London, 1794), Cambridge University Press, 2014.

40  Hubert de Cronin Hastings, 'EXTERIOR FURNISHING or Sharawaggi: The Art of Making Urban Landscape', *Architectural Review*, January 1944, pp. 3–8.

41  Ibid.

42  Nikolaus Pevsner, *The Englishness of English Art*, Architectural Press, London, 1956.

43  Ibid., p. 164.

44  The conditions for internal surprises were established when vistas down long rooms terminated in apses partly screened off by columns; ibid.

45  Price, *An Essay on the Picturesque as Compared with the Sublime and the Beautiful*, p. 28.

46  Jonathan Hughes, *The Brutal Hospital: Efficiency, Identity and Form in the National Health Service*, Ph.D. thesis, Courtauld Institute of Art, London, 1996.

47  ' . . . a post-colonial take on St Ives would properly see its entire artistic history as a matter not of outsider but of incomer art'; Michael Bird, *The St Ives Artists: A Biography of Place and Time*, Lund Humphries, Aldershot, 2008, p. 50.

48  Nina Lübbren, '"Toilers of the Sea": Fisherfolk and the Geographies of Tourism in England, 1880–1900' in D. Peters Corbett, Y. Holt, F. Russell (eds), *The Geographies of Englishness: Landscape and the National Past 1880–1940*, Yale University Press, New Haven and London, 2002, pp. 29–63 (29).

49  Roo Gunzi, *Amongst Heroes: The Artist in Working Cornwall*, exh. cat., Two Temple Place, London, 2013, pp. 6–44 (6).

50  On industry see Philip Payton, 'Paralysis and Revival: The Reconstruction of Celtic-Catholic Cornwall 1880–1945' in E. Westland (ed.), *Cornwall. The Cultural Construction of Place*, Patten Press, Penzance, 1997, pp. 25–39.

51  J. L. Martin, Ben Nicholson, N. Gabo (eds), *Circle: International Survey of Constructive Art*, Faber & Faber Ltd., London (1937), 1971.

52  Stephens, '"The Morrow We Left Behind": Landscape and the Rethinking of Modernism, 1939–53', pp. 22–3.

53  The second exhibition took place in August 1947 when Wilhelmina Barns-Graham replaced Wynter and the third in August 1948, when David Haughton and Patrick Heron were among the participants; see David Brown (ed.), *St Ives 1939–64: Twenty Five Years of Painting, Sculpture and Pottery*, exh. cat., Tate Gallery, London, 1985, pp. 104–5.

54  Diary, 18 May 1970. TGA 200511/5/25.

55  Diary, 6 May 1961. TGA 200511/5/16.

56  Andrew Causey, *Peter Lanyon: Modernism and the Land*, Reaktion Books, London, 2006, p. 37.

57  Ibid., p. 38.

58  Ibid.

59  Patrick Heron, 'St Ives and the Penwith', June 1977, p. 2. TGA 7925/26

60  Bird, *The St Ives Artists: A Biography of Place and Time*, p. 60.

61  *Porthleven* was commissioned by the Arts Council for the exhibition *60 Paintings for '51*. Though the Council provided free paint and canvas Lanyon destroyed the canvas by working on it too vigorously and had to repaint the whole image at a late stage.

62  C. Henry Warren, *Adam was a Ploughman*, Eyre & Spottiswoode, London, 1947, was illustrated by John Aldridge and dedicated to the memory of Thomas Hennell, an enthusiastic recorder of rural crafts; Noel Carrington, *Life in an English Village*, King Penguin, Harmondsworth, 1949, series editor Nikolaus Pevsner.

63  Malcolm Yorke, *Edward Bawden and His Circle*, ACC Art Books, Woodbridge, 2007, p. 169.

64  David Fraser Jenkins, *John Piper: The Forties*, exh. cat, Imperial War Museum and Philip Wilson, London, 2000, p. 45.

65  David Fraser Jenkins and Hugh Fowler-Wright, *The Art of John Piper*, Unicorn Publishing and Portland Gallery, London, 2015, p. 200.

66  David Solkin, *Richard Wilson: The Landscape of Reaction*, Tate Publishing, London, 1982, pp. 98, 100.

67  John Piper, 'Drawing N. Wales, and Wilson'; TGA 200410/3/1/19.

68  John Piper, 'Colour of the Rocks'; TGA 200410/3/1/19.

69  Frances Spalding, *John Piper, Myfanwy Piper: Lives in Art*, Oxford University Press, 2009, p. 269.

70  Joe Brown, *The Hard Years: An Autobiography* (Victor Gollancz, London, 1967), Penguin Books, Harmondsworth, 1975, p. 52; Jim Perrin, *The Villain: The Life of Don Whillans*, Hutchinson, London, 2005, p. 72, note 8. The name Clogwyn Du'r Arddu means 'the black cliff of the black height'; Perrin, ibid.

71  John Piper, *British Romantic Artists*, William Collins, London, 1942, p. 29.

72  Ibid., p. 7.

73  For the terminology and other details of their practice, see Alastair Grieve, *Constructed Abstract Art in England after the Second World War: A Neglected Avant-Garde*, Yale University Press, New Haven and London, 2005, p. 12.

74  Ibid., pp. 17–26.

75  See Margaret Garlake, 'Still Life 1945–58' in C. Stephens (ed.), *A Continuous Line: Ben Nicholson in England*, exh. cat., Tate Publishing, London, 2008, pp. 93–101.

76  Jeremy Lewison has interpreted the prominent oval shapes in this painting as suggestive of 'reproduction and birth' (*Ben Nicholson*, exh. cat., Tate Gallery, 1993, p. 88). The bottle that doubles as a steeple was a studio prop, painted as a still life a few years earlier. See *Feb. 14–49 (bottle)*, 1949, ibid., cat. no. 90, p. 169.

77  Those aware of the ideological furore aroused by Picasso's paintings of the body in 1945 may well have sought to avoid attracting similar critical outrage.

78  Organised by the Réunion des Musées Nationaux with the British Council.

79  Harrison, *Alan Reynolds*, p. 19.

80  Ibid., p. 23.

81  John Berger, 'Nicolas de Staël at Matthiesen's', *New States-man and Nation*, 1 March 1952.

82  John Russell, 'Risk All', *Sunday Times*, 24 February 1952.

83  De Staël's work was to be exhibited again, at the Whitechapel Gallery in 1956, the year after his death. Inevitably it caused less of a sensation than the first occasion, though Marco Livingstone has detected a 'pressure on those artists who had understood his language and expanded on it to continue the work he had started'; Catherine Kinley and Marco Livingstone, *Peter Kinley*, Lund Humphries, Farnham, 2010, p. 14.)

84  His ideas had previously been transmitted at secondhand to artist-tutors at the Bath Academy of Art by a French student, Marie-Christine Treinen; see Garlake, *New Art, New World: British Art in Postwar Society*, p. 176 and fig. 75, p. 176. For Dubuffet's status in England, see Alan Bowness, 'Dubuffet et l'Angleterre' in Françoise Bonnefoy (ed.), *Conférences et Colloques: Dubuffet*, Galerie Nationale du Jeu de Paume, Paris, 1992, pp. 56–61.

85  Frances Morris, *Paris Post War: Art and Existentialism 1945–55*, exh. cat., Tate Gallery, London, 1994, p. 80, citing Jean Dubuffet, 'Corps de Dames' in Georges Limbour, *Tableau bon Levain à vous de cuire la pâte*, 1953, p. 95.

86  Patrick Heron, *The Changing Forms of Art*, Routledge & Kegan Paul, London,1955, pp. 266–8.

87  This point was central to *Out There*, an exhibition of post-war public art mounted by Historic England at Somerset House, 2016. No catalogue was published but Historic England retained the copious wall texts and labels.

88  Ten extant pieces, many of them multipartite, have been identified on sites from primary schools to Loughborough University; see Terry Cavanagh and Alison Yarrington, *Public Sculpture of Leicestershire and Rutland*, Liverpool University Press, 2000. Peri also made work for schools in 'Derbyshire, Northants, Staffordshire, Warwickshire and Yorkshire'; see George Noszlopy, *The Public Sculpture of Warwickshire, Coventry and Solihull*, Liverpool University Press, 2003, pp. xviii, xxi, xxiv, xxviii, 221, 226

89  Andrew Forge, undated letter to Lawrence Alloway, quoted in Garlake, *New Art, New World: British Art in Postwar Society*, p. 150.

90  The exhibition originated from the Museum of Modern Art, New York.

## 2   Landscape in the Post-war Art World

1  Colour was 'the utterly indispensable means for realizing the various species of pictorial space', Patrick Heron, *The Changing Forms of Art*, p. 49.

2  Alister Warman, 'Foreword', *Ivon Hitchens: Forty-Five Paintings*, exh. cat., Serpentine Gallery, London, 1989, p. 5.

3  Patrick Heron, *Space in Colour*, exh. cat., Hanover Gallery, London, 1953, unpaginated.

4  Dated 24 May 1955. TGA 7919/3/4.

5  'Photostat' was the original name for what is now known as a photocopy. In the exhibition catalogue for *Victor Pasmore: Retrospective Exhibition 1925–65* at the Tate Gallery in 1965, the work was titled *Square Motif in Black, White and Brown* (1953), no. 110, and as *Abstract in Black, White and Umber*, 1953, no. 179, in Alan Bowness and Luigi Lambertini, *Victor Pasmore, with a Catalogue Raisonné of the Paintings, Constructions and Graphics 1926–1979*, Thames & Hudson, London, 1980.

6  *Victor Pasmore: Retrospective Exhibition 1925–65*, exh. cat., Tate Gallery, London, 1965, no. 110.

7  Heron, 'Space in Contemporary Painting and Architecture', *The Changing Forms of Art*, pp. 40–51 (50).

8  Grieve notes that *Nine Abstract Artists* was 'probably' published in November 1954; Grieve, *Constructed Abstract Art in England after the Second World War: A Neglected Avant-Garde*, Yale University Press, New Haven and London, 2005, p. 31.

9  With the constructive artists Robert Adams, Adrian Heath, Anthony Hill, Kenneth Martin, Mary Martin and Pasmore.

10  Anon., '"Radiant City" Lawsuit: Complaint of Brutal Realism', *The Times*, 4 December 1952.

11  Alison and Peter Smithson, 'House in Soho, London', *Architectural Design*, December 1953, p. 342.

12  Nikolaus Pevsner and Bill Wilson, *Norfolk 2: North-West and South*, Yale University Press, New Haven and London, 1999, p. 444.

13  Alison and Peter Smithson, 'The New Brutalism', *Architectural Design*, January, 1955, p. 1, cited in Nicholas Bullock, *Building the Post-war World: Modern Architecture and Reconstruction in Britain*, Routledge, London & New York, 2002, p. 95.

14  Tim Benton, 'Maisons Jaoul, Neuilly-sur-Seine' in M. Raeburn and V. Wilson (eds), Arts Council, *Le Corbusier: Architect of the Century*, exh. cat., Hayward Gallery, London, 1987, pp. 67–8 (68).

15  Reyner Banham, 'The New Brutalism', *Architectural Review*, December 1955, pp. 355–8, 361.

16  See Margaret Garlake, '"A War of Taste": The London County Council as Art Patron 1948–1965', *London Journal*, vol. 18, no. 1, 1993, pp. 45–65. See also Terry Cavanagh, *Public Sculpture of South London*, Liverpool University Press, 2007, pp. xix–xx.

17  Denny undertook mural commissions for the London County Council, Abbey Wood Primary School and Austin Reed, Regent Street.

18  Margaret Garlake, *Robyn Denny: Early Works 1955–1977*, exh. cat., Jonathan Clark/Delaye|Saltoun, London, 2008, p. 44.

19  Ibid., p. 22; Robyn Denny and Richard Smith, '"Evr'y Which Way": A Project for a Film', *Ark*, 24, 1959, pp. 39–40.

20  ' . . . a begetter of the abstract movement in painting on the basis of the broad brushwork and polyphonic use of colour which occur in his late works'; Douglas Cooper, 'Claude Monet' in *Monet*, exh. cat., Arts Council and Royal Scottish Academy, London and Edinburgh, 1957, p. 6.

21  Lawrence Alloway and Toni del Renzio, *Dimensions: British Abstract Art 1948–1957*, exh. cat., O'Hana Gallery, London, December 1957, unpaginated.

**22**  '. . . highly abstracted pictures contain allusions to landscape, still life, or figure'; ibid. In this context, Alloway named Bernard Cohen, Harold Cohen, Paul Feiler, Frost, Gear, Heron, Kinley, Lanyon, Rodrigo Moynihan and Scott.

**23**  Lawrence Alloway, *The Venice Biennale 1895–1968: From Salon to Goldfish Bowl*, New York Graphic Society Ltd, Greenwich, Conn., 1968, p. 144.

**24**  Emilio Vedova had exhibited in the 1950 Venice Biennale in a large group show, as had Tàpies in 1952.

**25**  Alloway, *The Venice Biennale 1895–1968: From Goldfish Bowl*, pp. 142–3.

**26**  David Carr and Alan Milburn were the other members of the consortium. Frances Spalding, *Prunella Clough: Regions Unmapped*, Lund Humphries, Farnham, 2012, p. 140

**27**  Ibid., p. 141.

**28**  First shown at the Department of Fine Art at Nottingham University where Cohen was a fellow in Fine Art 1956–59, it was exhibited in the Arts Council's London gallery, 11–28 June 1958; see *Abstract Impressionism*, exh. cat., Arts Council of Great Britain, London, 1958, unpaginated.

**29**  An exhibition titled *Nature in Abstraction: The Relation of Abstract Painting and Sculpture to Nature in Twentieth-Century American Art* at the Whitney Museum of American Art, New York, 14 January – 16 March 1958 explored this theme and may have stimulated 'Abstract Impressionism'.

**30**  'The exclusion or inclusion of nature is . . . not a matter of the individual artist's choice. For art, nature is unavoidable . . . Nature might be defined as anything which presents itself as fact . . . there is a point where any work stops being a human creation and becomes environment – or nature'; Elaine de Kooning, 'Subject: What, How or Who?', *Art News*, New York, vol. 54, no. 2, 1956, pp. 26–9; 61–2 (27–8).

**31**  Ibid., p. 28.

**32**  'these followers keep the Impressionist manner of looking at a scene but leave out the scene'; ibid., p. 62.

**33**  As a concomitant, light was 'the product of the paint and not merely the "time of the day" transfigured'; Alloway, 'Some Notes on Abstract Impressionism', *Abstract Impressionism*, Arts Council of Great Britain, 1958 unpaginated.

**34**  '. . . recasting abstraction into something much more concerned with the qualities of perception of light, space and air than the surface of the painting', Louis Finkelstein, 'New Look: Abstract-Impressionism', *Art News*, New York, vol. 55, no. 1, 1956, pp. 36–9, 66–8 (37). Alloway quoted the same extract in 'Some Notes on Abstract Impressionism', unpaginated.

**35**  Finkelstein, 'New Look: Abstract-Impressionism', p. 66.

**36**  Alloway attributed Mitchell's phrase to John I. H. Baur's catalogue, *Nature in Abstraction*, Whitney Museum of American Art, New York, 1958, although it is not quoted in Baur's long introductory essay. It may have been taken from the questionnaire that he issued to participating artists, on which his essay was based.

**37**  Irving Sandler, 'Mitchell Paints a Picture', *Art News*, New York, vol. 56, no. 6, October 1957, pp. 44–7, 69–70 (45); quoted in 'Some Notes on Abstract Impressionism'.

**38**  Sandler, 'Mitchell Paints a Picture', p. 47.

**39**  24 February – 22 March 1959.

**40**  James Faure Walker, 'Setting the Scene: British Abstract Painting in the Sixties' in *Sette Inglese a Milano*, exh. cat., Galleria Milano, Milan & Austin Desmond Fine Art Ltd, London, 2010, p. 3.

**41**  The minimal permissible size was thirty square feet.

**42**  Roger Coleman, *Situation: An Exhibition of British Art*, exh. cat., Arts Council, 1962, [p. 12].

**43**  For the LCC's commissions, see Garlake, '"A War of Taste": The London County Council as Art Patron 1948–1965', *London Journal*, vol. 18, no. 1, 1993, pp. 45–65.

**44**  See Harwood, *Space, Hope and Brutalism, English Architecture 1945–1975*, p. 517.

**45**  Now Central St Martins.

**46**  Frank Martin's course was designed to counter the orthodoxies of the National Diploma in Design (NDD).

**47**  Lawrence Alloway, introduction to 'New Sculptors and Painter-Sculptors', ICA, London, August–September 1955, quoted in Ian Barker, *Anthony Caro: Quest for the New Sculpture*, Lund Humphries, Aldershot, 2004, p. 67.

**48**  Anthony Caro quoted ibid., p. 94.

**49**  Kardia joined St Martin's in 1964, having been employed for his pedagogical skills after the School had failed to gain accreditation for the Diploma in Art and Design (DAD), i.e. degree-granting status. The students were dissatisfied with the old-style restrictions of the NDD and Martin had expected success; Kardia's primary task was to write a viable proposal for the DAD. His proposal was successful and became the basis of his teaching at St Martin's; Hester Westley, in R. Coyne, Peter Kardia, Malcolm LeGrice, Hester Westley, *From Floor to Sky: The Experience of the Art School Studio*, A. & C. Black, London, 2010, pp. 28–57 (32–3)

**50**  Peter Kardia, 'Art and Art Teaching' in Coyne et al., *From Floor to Sky: The Experience of the Art School Studio*, A. & C. Black, London, 2010, pp. 88–105 (92). Of Husserl, Kardia wrote that he was primarily interested in 'the focus . . . on the immediate perception of phenomena . . . the emphasis that if a person is to consciously experience the immediacy of phenomena, they must direct a continual effort towards enclosing and disregarding the presuppositions that determine what is commonly taken as constituting experience', ibid., p. 92.

**51**  Clarrie Wallis, 'Making Tracks', pp. 33–61 (53).

**52**  'Richard J. Long: Sculpture', Konrad Fischer Galerie, Düsseldorf, 21 September – 18 October 1968; see Wallis, 'Making Tracks', p. 54. Fischer, who supported minimalist and conceptual artists, had already shown Carl Andre and would soon exhibit Sol LeWitt and Lawrence Weiner.

**53**  Mary Warner Marien, *Photography: A Cultural History*, Lawrence King Publishing Ltd, London, 2002, pp. 23, 28. Links between early photography and painting were demonstrated in *Seduced by Art: Past and Present*, an exhibition at the National Gallery of Art, London, in 2012.

54  Wood's engraving after Salvator Rosa's *Landscape with Hermit* was exhibited in *Constable, Turner, Gainsborough and the Making of Landscape*, Royal Academy, London, 2012, no. 8D. The point was borne out throughout the exhibition.

55  Smythe, *Over Welsh Hills*, p. 98.

56  Ibid.

57  The Brownie came loaded with 100 exposures. When they were used up, the photographer returned the camera to the factory which sent it back reloaded, with the processed prints; Lucia Moholy, *A Hundred Years of Photography 1839–1939*, Pelican, London, 1939, pp. 148–50.

58  Robin Lehman (ed.), *The Oxford Companion to the Photograph*, Oxford University Press, Oxford, 2005, p. 97.

59  Moholy, *A Hundred Years of Photography 1839–1939*, pp. 151–2.

60  *Amateur Photographer* reveals the growth of a new leisure culture that was neither class determined nor age-limited; in 1956 a letter was published from a man who had been a reader since 1899; he had 'always preferred plates to roll films, and [had] never yet been bitten with the 35mm bug', *Amateur Photographer*, 11 November 1956, p. 68.

61  Lehman (ed.), *Oxford Companion to the Photograph*, p. 344.

62  L. A. Mannheim, 'Colour Pictorialism', *Amateur Photographer*, 17 January 1945, p. 37.

63  Marien, *Photography: A Cultural History*, p. 363.

64  Ian Leith, 'Bill Brandt: Topographical Record Photographer', paper for English Heritage, 2008; Kitty Hauser, *Shadow Sites: Photography, Archaeology, and the British Landscape 1927–1955*, p. 226–31. I am grateful to Ian Leith for making his paper available to me.

65  Mark Haworth-Booth, 'Portraits', *Bill Brandt Behind the Camera: Photographs 1928–1983*, Aperture with Philadelphia Museum of Art, 1985, pp. 40, 42 (42).

66  Hauser, *Shadow Sites: Photography, Archaeology, and the British Landscape 1927–1955*, p. 24.

67  It was used by the New York Police Department in the 1930s; see Haworth-Booth, 'Perspective of Nudes', *Bill Brandt Behind the Camera: Photographs 1928–1983*, p. 62.

68  Smythe, *Over Welsh Hills*, p. 98.

69  Ibid., p. 38.

70  Ibid., p. 98.

71  Lehman (ed.), *Oxford Companion to the Photograph*, pp. 348–9.

72  Smythe, *Over Welsh Hills*, plate XXXVI, p. 72.

73  Roly Smith, *A Camera in the Hills: The Life and Work of W. A. Poucher*, Frances Lincoln, London, 2008, p. 14.

74  Poucher's *Perfume & Cosmetics: With Especial Reference to Synthetics* (Chapman & Hall, London, 1923) is still considered a standard work.

75  W. A. Poucher, *Lakeland Through the Lens*, Chapman & Hall, London, 1940.

76  W. A. Poucher, Preface, *Escape to the Hills*, Country Life, London, 1943, p. v.

77  Ibid., p. 77.

78  Ibid., p. 4.

79  As opposed to being supported on a tripod. *The British Journal of Photography*, quoted in Smith, *A Camera in the Hills: The Life and Work of W. A. Poucher*, p. 128.

80  W. A. Poucher, *Climbing with a Camera: The Lake District*, Country Life, London, 1963. See Smith, *A Camera in the Hills: The Life and Work of W.A. Poucher*, p. 129.

81  Poucher, *Climbing with a Camera in the Lake District*, p. 11.

82  Alfred Wainwright, quoted in Smith, *A Camera in the Hills: The Life and Work of W. A. Poucher*, p. 183.

83  Mayne was a friend of Nigel Henderson, a technically experimental photographer whose best-known subjects were the people, streets and shops of Bethnal Green which he photographed between 1948 and 1952. See David Robbins (ed.), *The Independent Group and the Aesthetics of Plenty*, MIT Press, Cambridge, Mass. & London, 1990, pp. 76–7.

84  *Photography* was edited by Norman Hall, later picture editor of *The Times*; Mark Haworth-Booth, *The Street Photographs of Roger Mayne*, exh. cat., Victoria & Albert Museum, London, 1986, p. 68.

85  Roger Mayne, 'Children in the Streets', *Amateur Photographer*, 20 March 1957, pp. 546–9 (547).

86  On the fate of Southam Street, see Haworth-Booth, *The Street Photographs of Roger Mayne*, passim.

87  Roger Mayne, 'The Realist Position', *Uppercase: 5*, Whitefriars Press, Tonbridge, 1961, p. 64.

88  Naomi Rosenblum, *A World History of Photography*, Abbeville Press, New York, 5th edn, 2019, p. 548.

89  Quoted in Haworth-Booth, *The Street Photographs of Roger Mayne*, p. 67; Roger Mayne, letter to John Piper, 24 February 1955, TGA 200410/1/1.

90  Roger Mayne, letter to John Piper, 9 May 1955, TGA 200410/1/1.

91  Two heated letters from Ashton to Mayne are reproduced in Haworth-Booth, *The Street Photographs of Roger Mayne*, p. 6.

92  Roger Mayne, 'Pictorialism at a Dead End', *Amateur Photographer*, 24 October 1956, pp. 516–19.

93  A. L. M. Sowerby, 'Looking at Exhibition Pictures', *Amateur Photographer*, 21 September 1960, pp. 428–9 (428).

94  Roger Mayne, 'Combined Societies' Exhibition', *Amateur Photographer*, 20 March 1957, pp. 363–7 (365).

95  Ibid.

## 3   Engaging with Landscape

1  Robert Mcfarlane, *Mountains of the Mind: A History of a Fascination*, Granta, London, 2003, p. 74.

2  Ibid., p. 77.

3  Quoted in Chris Stephens, *Terry Frost*, Tate Publishing, London, 2000, p. 37.

4  Quoted in Monica Bohm-Duchen, *The Art and Life of Joseph Herman*, Lund Humphries, Farnham, 2009, p. 78.

5   Elizabeth Knowles (ed.), *Terry Frost*, Scolar Press, Aldershot, 1994, p. 30.

6   It is named for its designer, 'The notable engineer John Smeaton'; see A. C. Todd and Peter Laws, *The Industrial Archaeology of Cornwall*, David & Charles, Newton Abbott, 1972, p. 145.

7   Knowles (ed.), *Terry Frost*, p. 49.

8   Interview with David Lee, June 1993, quoted in Stephens, *Terry Frost*, p. 25.

9   The human body is 'the condition for experiencing the world'; see Yi-Fu Tuan, *Space and Place: The Perspective of Experience*, University of Minnesota Press, Minneapolis, 1977, p. 89.

10   Mary Warnock ' . . . to understand man's place in the world, we must understand perception, and . . . we cannot understand perception as long as we insist upon an absolute distinction between the perceiving subject and the object perceived'; Mary Warnock, *Existentialism*, Oxford University Press, 1970, p. 78. She comments: 'as is often true both of Merleau-Ponty and of Sartre, though the argument may be faulty, the meaning is clear'. (Ibid.)

11   Maurice Merleau-Ponty, *Phénoménologie de la perception*, Editions Gallimard, Paris, 1945; Maurice Merleau-Ponty (Colin Smith trans.), *Phenomenology of Perception*, Routledge & Kegan Paul, London & New York, 1962.

12   Stephens, *Terry Frost*, p. 21.

13   Roger Hilton, statement in Lawrence Alloway (ed.), *Nine Abstract Artists: Their Work and Theory*, Alec Tiranti Ltd, London, 1954, p. 30.

14   'Peter Lanyon, Alan Davie & William Scott Talking to David Sylvester of the BBC about Their Work', 19 June 1959, quoted in Margaret Garlake, *Peter Lanyon*, Tate Publishing, London, 1998, p. 11. This potentially terrifying sensation has been described as a 'fluid body boundary'; see Tony Hiss, *The Experience of Place*, Alfred A. Knopf, New York, 1991, p. 21.

15   John Wylie, *Landscape*, Routledge, Oxford & New York, 2007, p. 150.

16   Merleau-Ponty (Colin Smith trans.), *Phenomenology of Perception*, p. xviii.

17   See Edward Relph 'Geographical Experiences and Being-in-the-world: The Phenomenological Origins of Geography' in D. Seamon and R. Mugerauer (eds), *Dwelling, Place and Environment: Towards a Phenomenology of Person and World*, pp. 15–31.

18   Martin Heidegger, 'Building, Dwelling, Thinking', presented at Darmstadt symposium, 'Man and Space', 5 August 1951; published *Vorträge und Aufsätze*, Günther Neske Verlag, Pfullingen, 1954, pp. 145–62; Martin Heidegger (Albert Hofstaetler trans.), *Poetry, Language, Thought*, Harper Row, New York, 1971, pp. 143–61, in Neil Leach, *Rethinking Architecture: A Reader in Cultural History*, Routledge, London & New York, 1979, pp. 100–9.

19   Tim Creswell, 'Landscape and the Obliteration of Practice' in K. Anderson, M. Domosh, S. Pile, N. Thrift (eds), *Handbook of Cultural Geography*, Sage, London, 2003, pp. 269–81; Julian Thomas, 'The Politics of Vision and the Archaeologies of Landscape' in B. Bender (ed.), *Landscape: Politics and Perspectives*, Berg, Oxford & Providence, 1993, pp. 19–48 (28).

20   Hayden Lorimer, 'Herding Memories of Humans and Animals', *Environment and Planning D: Society and Space*, vol. 24, no. 4, 2006, pp. 497–518.

21   Ingold describes 'a "dwelling perspective"': a life system in which landscape 'is constituted as an enduring record of – and testimony to – the lives and work of past generations who have dwelt within it'; Tim Ingold, 'The Temporality of the Landscape', *World Archaeology*, vol. 25, no. 2, October 1993, pp. 152–72 (152).

22   Ibid., p. 156.

23   Ingold describes such activities and interactions as the 'taskscape'; ibid., pp. 153, 157.

24   Lorimer, 'Herding Memories of Humans and Animals', p. 505.

25   Fiona Pearson notes that Eardley's paintings of children were made when Peter and Iona Opie, with the film maker James Ritchie, were documenting children's songs and games; Fiona Pearson, *Joan Eardley*, exh. cat., National Galleries of Scotland, Edinburgh, 2007, p. 32.

26   Cordelia Oliver, *Joan Eardley RSA*, Mainstream Publishing, Edinburgh, 1988, p. 64.

27   Pearson, *Joan Eardley*, p. 54, citing Cordelia Oliver at the 'Writing Scottish Art' seminar, Dundee Contemporary Arts, 8 September 2006.

28   Pearson, *Joan Eardley*, p. 53.

29   Undated; quoted ibid., p. 55.

30   Ibid. p.53.

31   The Gregory Fellowships, devised by the publisher and Chair of Lund Humphries Eric Gregory, were offered for two years each to young modernists: ideally a painter, a sculptor and a poet together. They were provided with work spaces near the university and were asked to 'be readily available to students and staff' while being expected to carry on with their own work; see Marian Williams, 'A measure of leaven: the early Gregory Fellowships at the University of Leeds' in Margaret Garlake (ed.), *Artists and Patrons in Post-war Britain*, Courtauld Research Papers No. 2, Ashgate, Aldershot, 2001, pp. 55–93 (57).

32   Frost, undated letter to Alloway [1957], quoted in Stephens, *Terry Frost*, 2000, p. 37.

33   A. E. Trueman, *Geology and Scenery in England and Wales* (Victor Gollancz, 1938) Penguin, Harmondsworth, 1972, revised edition, p. 177.

34   Quoted in Ronnie Duncan, 'The Leeds connection', in Knowles (ed.), *Terry Frost*, pp. 62–6 (66). The painting was sold at Sotheby's, London, *20th Century British Art*, 13 December 2007, lot 86 as *Red, Black and White, Winter*, the title under which it was first exhibited in Arthur Tooth & Sons, 'Critic's Choice', 1956, no. 17. It has otherwise been known as *Red, Black and White*.

35   Transcript of Terry Frost talking with Adrian Heath and John Hoskin, July 1987, quoted in Stephens, *Terry Frost*, 2000, p. 38.

36   *Figure into Landscape* (1954) was reproduced in *Nine Abstract Artists*, no. 51, p. 39.

37   A 'life-process'; Tim Ingold, 'An anthropologist looks at biology', *Man*, vol. 25, no. 2, June 1990, pp. 208–29 (215).

38   John Wylie, 'Depths and Folds: On Landscape and the Gazing

Subject', *Environment and Planning D: Society and Space*, vol. 24, no.4, 2006, pp. 519–35 (526).

39   Maurice Merleau-Ponty, *The Visible and the Invisible*, ed Claude Lefort, trans. Alphonso Lingis, Northwestern University Press, Evanston, 1968, p. 84.

40   William Langewiesche, *Fly by Wire: The Geese, the Glide, the 'Miracle' on the Hudson*, Penguin, London, 2009, p. 177.

41   'Three Painters on Painting', *Third Programme*, BBC Radio, broadcast 19 June 1959 (a discussion between Peter Lanyon, Alan Davie and William Scott, chaired by David Sylvester), TAV 214 AB.

42   Yi-Fu Tuan, *Space and Place: The Perspective of Experience*, p. 86.

43   John Wylie, *Landscape*, p. 166; Hayden Lorimer, 'Cultural Geography: The Busyness of Being "More-than-representational"', *Progress in Human Geography*, vol. 29, no. 1, 2005, pp. 83–94 (84).

44   John Wylie, 'A Single Day's Walking: Narrating Self and Landscape on the South West Coast Path', *Transactions of the Institute of British Geographers*, vol. 30, no. 2, 2005, pp. 234–47 (236). He comments that landscape is 'neither something seen, nor a way of seeing, but rather the materialities and sensibilities *with which* we see' (ibid., p. 243).

45   'Identification with the passion or speed of a mark as an analogical trace of artistic embodiment is sustained within the domain that Merleau-Ponty describes as intercorporeity . . . a phenomenological binding of vision and touch'; Deanna Petherbridge, *The Primacy of Drawing: Histories and Theories of Practice*, Yale University Press, New Haven and London, 2010, p. 104.

46   Patrick Heron, 'Space in Contemporary Painting and Architecture', *The Architect's Yearbook: V*, 1953, pp. 19–26; reproduced in Heron, *The Changing Forms of Art*, pp. 40–51 (45).

47   He subsequently destroyed all but about twenty.

48   David Batchelor, 'Bob Law 1999/2009' in David Batchelor et al., *Bob Law: A Retrospective*, Ridinghouse, London, 2009, pp. 228–34 (233).

49   'Bob Law in conversation with Richard Cork' (1974), in David Batchelor et al., *Bob Law: A Retrospective*, pp. 32–9 (33).

50   ' . . . one's own body is the third term, always tacitly understood, in the figure–background structure'; Merleau-Ponty (trans. Smith), *Phenomenology of Perception*, p. 115.

51   Christopher Tilley, *A Phenomenology of Landscape: Places, Paths and Monuments*, Berg Publishers, London, 1994, p. 16.

52   Yi-Fu Tuan, *Space and Place: The Perspective of Experience*, p. 129.

53   Tilley, *A Phenomenology of Landscape*, p. 17.

54   Edward Relph, *Place and Placelessness*, Pion Ltd, London, 1976, p. 22.

55   Tilley, *A Phenomenology of Landscape*, p. 14.

56   See Rob Shields, *Places on the Margin: Alternative Geographies of Modernity*, Routledge, London & New York, (1991) 1992, p. 52.

57   Ibid., p. 60.

58   See Farley and Symmons Roberts, *Edgelands*.

59   Patrick Heron, 'Space in Contemporary Painting and Architecture', *The Changing Forms of Art*, pp. 40–51 (41).

60   Ibid, p. 47.

61   Florence Ingleby (ed.), *Sean Scully. Resistance and Persistence: Selected Writings*, Merrell, London & New York, 2006, p. 175.

62   John Agnew, 'Representing Space: Space, Scale and Culture in Social Science' in James Duncan & David Ley (eds), *Place/Culture/Representation*, Routledge, London & New York, 1993, pp. 251–71 (263).

63   Madeleine Bunting, *The Plot: A Biography of an English Acre*, Granta, London, 2009, p. 5.

64   'From the sculptor's point of view one can be either the spectator of the object or the object itself'; Herbert Read, *Barbara Hepworth: Carvings and Drawings*, Lund Humphries, London, 1952, unpaginated.

65   Ibid.

66   Barbara Hepworth, *Drawings from a Sculptor's Landscape*, Cory Adams & Mackay, London, 1966, p. 11. Her words fortuitously echo Law's account of his own work.

67   Chris Stephens, 'Landscape Sculpture' in Penelope Curtis and Chris Stephens (eds), *Barbara Hepworth Centenary*, exh. cat., Tate Publishing, London, 2003, p. 65.

68   Relph, *Place and Placelessness*, Preface, unpaginated.

69   Ibid., pp.49–62.

70   Ibid., p. 55.

71   J. Douglas Porteous, 'Home: The Territorial Core', *Geographical Review*, vol. 66, 1976, pp. 383–90 (389).

72   Relph, *Place and Placelessness*, p. 142.

73   'The transformation of sensuous reality is . . . to exert an existential freedom: for *how we choose to make sense of the world significantly constitutes its reality*'; Neil Lewis, 'The Climbing Body, Nature and the Experience of Modernity', *Body & Society*, vol. 6, nos 3–4, 2000, pp. 58–80 (58–9).

74   Ibid.

75   *Cornishman and Cornish Telegraph*, 22 October 1919

76   Ibid.

77   'Peter Lanyon Talking to Lionel Miskin about his Early Life, etc', also known as 'An Unfamiliar Land: Interview with Lionel Miskin', audio recording, 1962. Copy with transcript in Tate Archive, TAV 211 AB.

78   David Haughton, letter to Norman Levine quoted in Norman Levine, 'David Haughton's St. Just', *Painter & Sculptor*, vol. 4, no. 2, 1961, pp. 18–24 (22).

79   Todd and Laws, *Industrial Archaeology of Cornwall*, p. 62.

80   The plans of the mine were inaccurate and consequently the miners tunnelled into a section of the flooded mine. Cyril Noall, *Botallack*, Truro 1999, pp. 59–60.

81   Andrew Lanyon, *Peter Lanyon*, Newlyn, 1990, p. 195.

82   'The Subject in Painting', *Horizons*, BBC Radio Home Service West, broadcast 22 May 1963 (a discussion between Peter Lanyon and Paul Feiler, chaired by Michael Canney and introduced by Lawrence Ogilvie). Copy with transcript in Tate Archive, TAV 212 AB; Andrew Lanyon, *Peter Lanyon*, p. 192.

83  Ann and Lorne Welch, *The Story of Gliding*, John Murray, London, 1965, p. 147.

84  C. E. Wallington, *Meteorology for Pilots*, John Murray, London, (1961) 1977, p. ix.

85  Toby Treves and Barnaby Wright, 'Peter Lanyon's Gliding Paintings: An Introduction', Toby Treves and Barnaby Wright (eds), *Soaring Flight: Peter Lanyon's Gliding Paintings*, exh. cat., The Courtauld Gallery with Paul Holberton Publishing, London, 2016, pp. 11–29 (14).

86  See Toby Treves 'Catalogue', in Treves and Wright (eds), *Soaring Flight: Peter Lanyon's Gliding Paintings*, cat. 10, pp. 122–3 and *North East*, cat. 18, pp. 140–1.

87  Toby Treves, 'Flight', in Treves and Wright (eds), *Soaring Flight: Peter Lanyon's Gliding Paintings*, pp. 31–9 (36).

88  Peter Lanyon, recorded talk for British Council, 1963, quoted in Treves 'Catalogue', in Treves and Wright (eds), *Soaring Flight: Peter Lanyon's Gliding Paintings*, p. 130.

89  Treves, 'Flight', p. 58.

## 4  Reshaping Rural Britain

1  Relph, *Place and Placelessness*, p. 122.

2  See James J. Gibson, *Perception of the Visual World*, Riverside Press, Boston, Mass., 1950. The source of Hamilton's thinking, James J. Gibson was an American scientist, commissioned during the war to investigate human visual perception, presumably in connection with pilots and reconnaissance.

3  Jacqueline Darby, in Richard Morphet (ed.), *Richard Hamilton*, exh. cat., Tate Gallery Publications, London, 1992, cat. 10, p. 146.

4  Gordon E. Cherry, *Cities and Plans: The Shaping of Urban Britain in the Nineteenth and Twentieth Centuries*, Edward Arnold, London, (1988) 1993, p. 143.

5  Ibid.

6  Ian Nairn, 'Outrage', *Architectural Review*, vol. 117, no. 702, June 1955, p. 363.

7  W. G. Hoskins, *The Making of the English Landscape*, (Hodder & Stoughton, 1955), Penguin, Harmondsworth, 1985, p. 299.

8  Angus Calder, *The People's War: Britain 1939–45*, (Jonathan Cape, 1969), Granada Publishing, St Albans, (1969) 1971, p. 485.

9  Matless, *Landscape and Englishness*, p. 27.

10  Ibid., pp. 276–7; B. A. Holderness, *British Agriculture Since 1945*, Manchester University Press, 1985, p. 149. The pre-war preservationist position is summarised by Jemima Montagu in *Paul Nash: Modern Artist, Ancient Landscape*, exh. cat., Tate Publishing, London, 2003, pp. 12–13.

11  Hugh Prince, 'Art and Agrarian Change, 1710–1815' in Denis Cosgrove and Stephen Daniels (eds), *The Iconography of Landscape: Essays On The Symbolic Representation, Design And Use Of Past Environments*, Cambridge University Press, 1988, pp. 98–118 (114).

12  Peter Hennessy, *Never Again: Britain 1945–1951*, Jonathan Cape, London, 1992, p. 111.

13  Calder, *The People's War: Britain 1939–45*, p. 483.

14  Hennessy, *Never Again: Britain 1945–1951*, p. 112.

15  Holderness, *British Agriculture Since 1945*, pp. 8–9.

16  Calder, *The People's War: Britain 1939–45*, pp. 484, 489; Holderness, *British Agriculture Since 1945*, p. 9; David Kynaston, *Austerity Britain: 1945–51*, Bloomsbury, London, (2007) 2008, p. 169.

17  Hennessy, *Never Again: Britain 1945–1951*, p. 112.

18  Ibid., p. 300.

19  Holderness, *British Agriculture Since 1945*, p. 15.

20  Kynaston, *Austerity Britain: 1945–51*, p. 169.

21  Ian Nairn, 'Outrage', *Architectural Review*, p. 365.

22  Andrew O'Hagan, 'On the End of British Farming' in *The Atlantic Ocean: Essays on Britain and America*, Faber & Faber, London, 2008, pp. 88–124 (114).

23  Kynaston, *Austerity Britain: 1945–51*, p. 584.

24  'The Politics of the Archers', BBC Radio 4, broadcast 31 December 2010. Baseley did not wish the actors to be members of Equity (or any union) and is said to have written out a character early in the series because she was allegedly touting for Equity.

25  On nationalisation, see Matless, *Landscape and Englishness*, pp. 218–19.

26  Ibid., pp. 226–30.

27  Hennessy, *Never Again: Britain 1945–1951*, p. 111; Calder, *The People's War: Britain 1939–45*, p. 488.

28  Anon. (Laurie Lee), *Land at War*, Ministry of Information, London, 1945; see Matless, *Landscape and Englishness*, pp. 173–4.

29  Morphet (ed.), *Richard Hamilton*, p. 143; see also Mark Godfrey, Paul Schimmel, Vicente Todoli (eds), *Richard Hamilton*, exh. cat., Tate Publishing, London, 2014, pp. 18–21.

30  Morphet notes: 'Art, for Hamilton, is not just transmission but, more importantly, transformation'; Morphet (ed.), *Richard Hamilton*, p. 18.

31  See Richard Hamilton, *Richard Hamilton Prints: A Complete Catalogue of Graphic Works. 1939–83*, Edition Hansjörg Mayer, Stuttgart & London, with Waddington Graphics, London, 1984, p. 23, note 21; Sigfried Giedion, *Mechanization Takes Command: A Contribution to Anonymous History*, Oxford University Press, New York, 1948.

32  Hamilton, *Richard Hamilton Prints*, p. 23, note 21. Hamilton used and combined hard-ground etching, drypoint, roulette, punches, dry-stipple, engraving, and lift-ground and colour aquatint.

33  John Stewart Collis, *The Worm Forgives the Plough*, (C. Knight, London, 1973), Vintage, London, 2009, p. 26. Collis provides an inimitable personal account of wartime farming.

34  A small housing development on the edge of Aspatria, at the end of the street where her parents' house still stands, is called Sheila Fell Close.

35  Sheila Fell, 'Notes', *Painter & Sculptor*, vol. 4, no. 2, Summer 1961, pp. 12–15 (12).

36  R. Goldman (ed.), *Breakthrough: Autobiographical Accounts of the Education of Some Socially Disadvantaged Children*,

Routledge & Kegan Paul, London, 1968, p. 69, quoted in Caroline Collier and Helen Lessore, *Sheila Fell*, exh. cat., South Bank Centre, London, 1990, p. 4.

37  Sheila Fell quoted by Frank Haley in *Cumbria Lakeland Life and Literature*, September 1960, p. 206; copied in Anna Fell Archive.

38  Undated statement, after the mid-70s; ibid.

39  He made a memorable portrait drawing of her in 1954, reproduced in Cate Haste, *Sheila Fell: A Passion for Paint*, Lund Humphries, Farnham, 2010, p. 27.

40  Ibid., p. 25.

41  John Russell Taylor, 'A Vision of Cumbria that Scorns the Picturesque', *The Times*, 8 September 1981; copied in Anna Fell Archive.

42  Ibid.

43  Letter to Kathleen and Tony Dalzell, Dalzell Archive, 11 September 1966.

44  Prunella Clough's diary entry of 16 February 1947 refers to 'rudder' and 'carpentry for rudder'. TGA 201215/1/1.

45  Malcolm White, *A Century of Fishing: Fishing from Great Yarmouth and Lowestoft 1899–1999*, Malcolm. R. White, Lowestoft, 1999, p. 11.

46  David Smart, *The Cornish Fishing Industry: A Brief History*, Tor Mark Press, Penryn, 1992, p. 32.

47  Quoted in Norbert Lynton, *William Scott*, Thames & Hudson, London, (2004) 2007, p. 123.

48  Ibid., p. 377.

49  Andrew Lambirth, *Roger Hilton: The Figured Language of Thought*, Thames & Hudson, London, 2007, p. 77.

50  G. S. Whittet, 'Painting Industrial Britain', *The Studio*, vol. 151, no. 757, April 1956, pp. 106–11.

51  Hennessy, *Never Again: Britain 1945–1951*, p. 204.

52  Ibid., p. 103.

53  Ian Cox, *The South Bank Exhibition: A Guide to the Story it Tells*, HMSO, London, 1951, p. 22.

54  Hennessy, *Never Again: Britain 1945–1951*, p. 204.

55  Tim Barringer, '"Our English Thames" and "America's River": Landscape Painting and Narratives of National Identity', in Mark Dorrian and Gillian Rose (eds), *Deterritorialisations . . . Revisioning: Landscapes and Politics*, Black Dog Publishing Ltd, London and New York, 2003, p. 32.

56  John Brunsdon printed the *Rhondda Suite* at the Etching Studio in Welwyn Garden City.

57  Robert Meyrick, 'George Chapman 1908–93: Painter and Printmaker', *Printmaking Today*, vol. 4, no. 1, 1995, pp. 11–12 (12).

58  Quoted in Alistair Crawford, 'George Chapman and the Road to the Rhondda Valley' in *George Chapman*, exh. cat., Aberystwyth Arts Centre, 1989, pp. 8–22 (14).

59  'Landscaping' has introduced a startling greenness to the modern Rhondda; the houses and almost continuous villages have changed less, though they are brighter for the lack of coal dust. Chapman would have been startled by the relative prosperity that has brought cars and forests of satellite dishes to every street.

60  Monica Bohm-Duchen, *The Art and Life of Josef Herman*, pp. 18, 26.

61  Ibid. p. 50.

62  Ibid. p. 81.

63  Josef Herman, *Notes from a Welsh Diary* (Free Association Books, London, 1988, p. xi) quoted in Bohm-Duchen, *The Art and Life of Josef Herman*, p. 78.

64  Bohm-Duchen, *The Art and Life of Josef Herman*, p. 79.

65  Tim Ingold first used the phrase in 'The Temporality of Landscape', *World Archaeology*, vol. 25 no. 2, October 1993, to describe a view of landscape as 'an enduring record of – and testimony to – the lives and works of past generations who have dwelt within it, and in so doing, have left there something of themselves.'

66  T. Curtis (ed.), *Josef Herman: Related Twilights – Notes from an Artist's Diary*, Seren, Bridgend, 2002, p. 73, quoted in Bohm-Duchen, *The Art and Life of Josef Herman*, p. 77.

67  Haste, *Sheila Fell: A Passion for Paint*, p. 13.

68  Sheila Fell, 'Notes', p. 13.

69  Shelley Rohde, *A Private View of L. S. Lowry*, Collins, London, 1979, p. 59.

70  Ibid., p. 179.

71  Angus J. L. Winchester, 'Humphrey Senhouse (1705–1770)', *Oxford Dictionary of National Biography*, 2004.

72  The Settlement was built as a private house in 1786 by a shipbuilder, Henry Curry; the Society of Friends used the building as an educational institution from the 1930s to 2002; it was restored and reopened on 21 April 2010 as a community arts and education centre.

73  Haste, *Sheila Fell: A Passion for Paint*, p. 80.

74  Letter David Carr to Lowry, 5 December 1943, quoted in Rohde, *A Private View of L. S. Lowry*, p. 210.

75  David Carr, unpublished MS, quoted in Ronald Alley, 'David Carr' in Rohde, *A Private View of L. S. Lowry*, p. 9.

76  It is likely that Clough and Fell encountered one another regularly, as they both taught at Chelsea School of Art. Fell's name first appears in Clough's diaries in December 1955 in connection with life drawing. Subsequently, between March 1960 and December 1966, Clough noted intermittent social meetings which included two with Fell's parents. Clough admired her work and in 1961 bought a 'snowscape'. Clough knew Lowry and visited him on her occasional trips north. See Frances Spalding, *Prunella Clough: Regions Unmapped*, Lund Humphries, Farnham, 2012, p. 106.

77  Spalding, *Prunella Clough: Regions Unmapped*, p. 106.

78  Bryan Robertson, 'Introduction', *Prunella Clough: New Paintings 1979–82*, exh. cat., Warwick Arts Trust, London, 1982, unpaginated.

79  Diary entry, 6 June 1952. TGA 200511/5/7.

80  Clough's visit to the works was recorded in her diary. TGA 200511/5/8.

81  Bryan Robertson, 'Introduction', *Prunella Clough: New Paintings 1979–82*, unpaginated.

82  Diary entry, 4 September 1958. TGA 200511/5/13.

83 Marion Shoard, 'Edgelands' in Jennifer Jenkins (ed.), Re-making the Landscape: The Changing Face of Britain, Profile Books, London, 2002, pp. 117–46, 267–8.

84 Farley and Symmons Roberts, Edgelands, p. 185; Nick Gallent and Johan Andersson, 'Representing England's Rural–urban Fringe', Landscape Research, vol. 32, no. 1, February 2007, pp. 1–21 (13).

85 Farley and Symmons Roberts, Edgelands, p. 10.

86 Shoard, 'Edgelands', p. 122.

87 Grigson, Places of the Mind, pp. 115–16.

## 5   Cities Reimagined

1   David Kynaston, Austerity Britain 1945–51, p. 122.

2   See Margaret Garlake, '"A War of Taste": The London County Council as Art Patron', London Journal, vol. 18, no. 1, 1993, pp. 45–65.

3   Alison Smithson, broadcast with Peter Smithson, 10 July 1970, BBC2, in Alan Powers (ed.), Robin Hood Gardens: Re-visions, Twentieth Century Society, London, 2010, p. 71.

4   Gordon E. Cherry, Cities and Plans: The Shaping of Urban Britain in the Nineteenth and Twentieth Centuries, pp. 5, 152.

5   Robert Hoozee, 'Observation of Landscape' in R. Hoozee (ed.), British Vision. Observation and Imagination in British Art 1750–1950, exh. cat., Museum voor Schone Kunsten, Ghent, 2007, pp. 180–5 (185).

6   Ibid., p. 124.

7   Paul Moorhouse, Leon Kossoff, exh. cat., Tate Gallery, London, 1996, pp. 11, 12–13.

8   'Address by the Minister of Works', RIBA Journal, 52, 1945, p. 215, quoted in Anthony Jackson, The Politics of Architecture: A History of Modern Architecture in Britain, Architectural Press, London, 1970, pp. 161, 162. The Minister was Duncan Sandys.

9   Elain Harwood, 'White Light/White Heat: Rebuilding England's Provincial Towns and Cities in the Sixties' in Elain Harwood and Alan Powers (eds), The Sixties: Life, Style, Architecture, Twentieth Century Architecture 6, Twentieth Century Society, London, 2002, pp. 55–70 (58).

10   'The LCC allowed 1.7 million square feet of new office space in 1951, but 5.9 million in 1955', ibid., p. 58. The 'Brown Ban' was imposed by George Brown, Minister of Economic Affairs, on 4 November 1964 (Elain Harwood, Space, Hope and Brutalism, English Architecture 1945–1975, p. 402.)

11   Cherry, Cities and Plans: The Shaping of Urban Britain in the Nineteenth and Twentieth Centuries, p. 169.

12   Quoted in Steve Humphries and John Taylor, The Making of Modern London: 1945–1985, Sidgwick & Jackson, London, 1986, p. 62.

13   For categories released from restrictions in 1950 see Ian Nairn, 'Counter-Attack', Architectural Review, vol. 120, no. 719, 1956, p. 432; for photographs see ibid., and Ian Nairn, 'Outrage', Architectural Review, vol. 117, p. 702, June 1955.

14   Cherry, Cities and Plans: The Shaping of Urban Britain in the Nineteenth and Twentieth Centuries, p. 176.

15   John Partridge, 'Roehampton Housing' in Harwood and Powers (eds), Housing the Twentieth Century Nation, Twentieth Century Architecture 9, Twentieth Century Society, London, 2008, pp. 113–30 (115).

16   Rodney Gordon, 'Modern Architecture for the Masses: The Owen Luder Partnership 1960–67' in Harwood and Powers (eds), The Sixties: Life, Style, Architecture, pp. 71–80 (73).

17   Partridge, 'Roehampton Housing', p. 117.

18   One of the figures was stolen on 10 January 2006 but the group was re-sited in 2016.

19   Terry Cavanagh, Public Sculpture of South London, p. 370.

20   B. Campbell (ed.), 'Concrete Play Sculpture: A Fast Developing Art', Concrete Quarterly, no. 54, July 1962, pp. 6–11

21   Nairn, 'Counter-Attack', p. 378. Nairn was right; railed off and treated like a 'monument', the denatured Gulliver is now a forgotten irrelevance.

22   The Editors, 'The Cover', Architectural Review, vol. 110, no. 656, August 1951, p. 71.

23   The Editors, 'Foreword', Architectural Review, vol. 110, no. 656, August 1951, pp. 73–79 (74).

24   Ibid.

25   Ibid., pp. 73–4.

26   Peter Cook, 'Introduction', Living Arts, 2, 1963, p. 69.

27   See Mary Banham and Bevis Hiller (eds), A Tonic to the Nation: The Festival of Britain 1951, Thames & Hudson, London, 1976, caption, p. 49; embroidery reproduced pl. VIII, p. 45.

28   Philip Powell, '"No Visible Means of Support": Skylon and the South Bank' in Elain Harwood and Alan Powers (eds), Festival of Britain, Twentieth Century Architecture, 5, Twentieth Century Society, London, 2001, pp. 81–6 (83).

29   It had a successor in the Arcelor Mittal Orbit (2012) designed by Anish Kapoor for London's Olympic Park.

30   J. M. Richards, 'The Exhibition Buildings', Architectural Review, vol. 110, no. 656, August 1951, pp. 123–34 (128).

31   Ibid.

32   The Editors, 'The Exhibition as Landscape', Architectural Review, vol. 110, no. 656, August 1951, pp. 80–105 (85).

33   The Editors, 'The Exhibition as a Town Builder's Pattern Book', Architectural Review, vol. 110, no. 656, August 1951, pp. 107–22 (108).

34   Ibid.; 'The Exhibition as Landscape', p. 103

35   'The Exhibition as Landscape', p. 104; 'Foreword', p. 78.

36   See Robert Burstow, 'Modern Sculpture in the South Bank Townscape' in Harwood and Powers (eds), Festival of Britain, pp. 95–106.

37   See Elain Harwood, 'Lansbury' in Harwood and Powers (eds), Festival of Britain, pp. 139–60.

38   The Editors, 'Preview of Lansbury', Architectural Review, vol. 109, no. 651, March 1951, pp. 177–80.

39   Harwood, 'Lansbury', p. 154.

40   Kevin Lynch, The Image of the City, p. 102.

41  Nairn, 'Counter-Attack', p. 378.

42  Participants were Gregor Paulsson, University of Uppsala; Henry-Russell Hitchcock, MIT; William Holford, University of London; Walter Gropius, Harvard; Lucio Costa, Director of Artistic & Historical Monuments, Brazil and Alfred Roth, editor of *Werk*, with Sigfried Giedion (University of Zurich).

43  Sigfried Giedion, 'In Search of a New Monumentality', *Architectural Review*, vol. 104, no. 62, September 1948, pp. 117–28. (126).

44  The property of the Borough of Tower Hamlets, the work is on long loan to the Yorkshire Sculpture Park.

45  Elizabeth Williamson and Nikolaus Pevsner with Malcolm Tucker, *London: Docklands*, Penguin, London, 1998, p. 170.

46  Nairn and Cullen deplored the low population densities of the New Towns, maintaining that 'except for rather better house plans, [they] have advanced but little on the old housing estates; Gordon Cullen, *The Concise Townscape*, (Architectural Press, London, 1966), Butterworth-Heinemann, Oxford, 1971, p. 138.

47  In 2011 the Public Monuments & Sculpture Association made a special award of commendation to Harlow as a 'Sculpture Town'.

48  Patricia Gibberd, 'Harlow Art Trust', *Landscape Design*, April 1982, pp. 20–2 (21).

49  Cited by Ruth Walton, 'The Meat Porters' in Dennis Farr, Ruth Walton, Adam White, *Ralph Brown Sculpture and Drawings*, exh. cat., Henry Moore Centre for the Study of Sculpture/ Leeds City Art Galleries, 1988, pp. 14–20. The square has since been described as displaying 'the humane, rational and lively atmosphere of the best of 1950s urban architecture' (Neil Bingham, 'Harlow Brave New Town', notes for a Twentieth Century Society visit, 18 July 1992.)

50  Harlow Art Trust, minutes, 11 January 1960.

51  T. R. Fyvel, 'The Stones of Harlow. Reflections on Subtopia', *Encounter*, 6, June 1956, pp. 11–17.

52  Mike Ricketts, 'Harlow', *Inventory*, vol. 2, no. 1, 1997, pp. 41–70 (51, 62). I am grateful to Jonathan Hughes for this reference.

53  Harlow Art Trust, minutes, 17 December 1956.

54  'Peterlee New Town' in Peter Coe and Malcolm Reading, *Lubetkin and Tecton: Architecture and Social Commitment*, University of Bristol/Arts Council of Great Britain, 1981, pp. 181–7; David Boyes, *An Exercise in Gracious Living: The North-East New Towns 1947–1988*, Ph.D. thesis, Durham University, 2007, p. 82.

55  Pasmore was then Master of Painting at King's College, Durham, which was located in Newcastle. It became part of Newcastle University in 1964.

56  Lawrence Alloway, 'Pasmore Constructs a Relief', *Art News*, vol. 55, no. 4, 1956, p. 32.

57  J. M. Richards, 'Housing at Peterlee', *Architectural Review*, vol. 129, no. 768, February 1961, pp. 88–97 (88).

58  'Peterlee: a symposium' in Alan Bowness and Luigi Lambertini, *Victor Pasmore, with a Catalogue Raisonné of the Paintings, Constructions and Graphics 1926–1979*, Thames & Hudson, London, 1980, pp. 255–62 (259). The symposium took place on 22 January 1967; participants were J. M. Richards, A. V. Williams, A. T. W. Marsden and Pasmore.

59  Pasmore, in 'Peterlee: a symposium', p. 262.

60  J. M. Richards, 'Housing at Peterlee', p. 92.

61  Elain Harwood, 'Neurath, Riley and Bilston, Pasmore and Peterlee' in Harwood and Powers (eds), *Housing the Twentieth Century Nation*, pp. 83–96 (93).

62  Victor Pasmore, 'Peterlee. The South West Area. Urban Design as a Function of Multi-dimension', unpublished, undated article, Jon Pasmore archive; Harwood, 'Neurath, Riley and Bilston' in Harwood and Powers (eds), *Housing the Twentieth Century Nation*, p. 95.

63  It was developed from an unrealised competition design for a monument to the physicist Enrico Fermi and was intended to take the form of a Museum of Science and Art in Chicago; see Alan Powers, 'New Town Artistry', *Architects' Journal*, 11 October 2001, pp. 44–8.

64  'Draft Description. Pasmore Pavilion (GD3488), Register of Parks and Gardens of Special Historic Interest', 25 April 2002, John Pasmore Archive.

65  For its later history see Paul Usherwood, 'Victor Pasmore's Peterlee Pavilion and the "Publicness" of Public Sculpture', *Sculpture Journal*, 8, 2002, pp. 62–72. The Pavilion was listed Grade II* in December 2011.

66  Simon Sadler, 'British Architecture in the Sixties' in Chris Stephens and Katherine Stout (eds), *Art and the Sixties: This was Tomorrow*, exh. cat., Tate Gallery, London, 2004, pp. 116–33 (125).

67  The building was renamed Smithson Plaza in 2018.

68  Peter Smithson attributed its success to its 'spatial energy field', where 'the space is a combination of the energy of what is existing and what you're putting in it'; Peter Smithson, 'The Space Between' in Elain Harwood and Alan Powers (eds), *The Sixties: Life, Style, Architecture*, Twentieth Century Society, London, 2002, pp. 49–54 (51).

69  Between October 1951 and October 1963 wages rose approximately 72 per cent while retail prices rose by 45 per cent. By 1965 88 per cent of households had a television set; see David Childs, *Britain since 1945: A Political History*, Routledge, London & New York, 2001, pp. 79, 80.

70  Nairn wrote most if not all of 'Outrage' himself; 'Counter-Attack' included articles by colleagues.

71  Nairn, 'Outrage', p. 363. He commented: 'Subtopia is the annihilation of the difference', ibid, p. 451.

72  Ibid., pp. 363, 366.

73  Nairn, 'Counter-Attack', p. 356.

74  Ibid., pp. 378, 379.

75  Cullen, *Concise Townscape*, pp. 133–5.

76  Harwood, 'White Light/White Heat: Rebuilding England's Provincial Towns and Cities in the Sixties', p. 66.

77  Ibid., p. 62.

78  T. J. Clark and Anne M. Wagner, *Lowry and the Painting of Modern Life*, exh. cat., Tate Publishing, 2013.

79  T. J. Clark, 'Lowry's Other England' in *Lowry and the Painting of Modern Life*, pp. 63–4.

80  The group was perhaps prompted by his invitation to

contribute to the Arts Council's Festival of Britain exhibition *60 Paintings for '51*, for which the stipulated minimum size was 45 × 60 inches. His contribution was the *Industrial Landscape: River Scene*, 1950, Leicester City Art Gallery.

81  Shields, *Places on the Margin*, pp. 60–1.

82  Clark, 'Lowry's Other England', p. 61.

83  Ibid., p. 35.

84  Quoted in Rohde, *A Private View of L. S. Lowry*, p. 99.

85  Barnaby Wright, interview with Frank Auerbach, 15 January 2009 in the artist's studio; unpublished transcript, Courtauld Gallery and Marlborough Fine Art, London.

86  Judith Bumpus, 'Frank Auerbach', interview, *Art & Artists*, June 1986, quoted in Catherine Lampert, Norman Rosenthal and Isabel Carlisle, *Frank Auerbach: Paintings and Drawings 1954–2001*, Royal Academy of Arts, 2001, p. 100.

87  Ibid.

88  Paul Moorhouse, *The Transformation of Appearance*, exh. cat., Sainsbury Centre for Visual Arts, Tate Gallery Publications, London, 1991, unpaginated.

89  Frances Spalding notes that the human figure became less prominent and more generic after Clough's exhibition in 1953 at the Leicester Galleries; *Prunella Clough: Regions Unmapped*, p. 119.

90  Letter to David Carr, TGA, postmarked 1955. TGA 200511/1/1/23/22.

91  Farley and Symmons Roberts, *Edgelands*, p. 93; Nairn, 'Outrage', 1955, p. 379.

92  Diary entry, 2 September 1957. TGA 200511/5/12.

93  Letter to David Carr, undated, 1956. TGA 200511/1/1/23/54.

## 6   Landscapes for People

1   See Brian Cook, *The Britain of Brian Cook*, B. T. Batsford Ltd, London, 1987; David Mellor, Gill Saunders and Patrick Wright, *Recording Britain: A Pictorial Domesday of Pre-war Britain*, David & Charles with the Victoria & Albert Museum, Newton Abbot & London, 1990.

2   See James Lees-Milne, *People and Places: Country House Donors and the National Trust*, John Murray, London, 1992

3   Ibid.

4   National parks were established in the Lake District, Snowdonia and Dartmoor in 1951; on the North Yorkshire Moors and along the Pembrokeshire coast in 1952; on Exmoor and in the Yorkshire Dales in 1954; Northumberland in 1956; the Brecon Beacons in 1957; see Trevor Rowley, *The English Landscape in the Twentieth Century*, Hambledon Continuum, London & New York, 2006, p. 302.

5   Martin Postle, '"Happy England": The Artist and the Garden from Allingham to Spencer', in Steven Parissien (ed.), *Stanley Spencer and the English Garden*, exh. cat., Compton Verney, Paul Holberton Publishing, London, with Compton Verney, 2011, pp. 38–53 (44).

6   David Crouch and Colin Ward, *The Allotment: Its Landscape and Culture*, Faber & Faber, London, 1988, p. 62; Postle, '"Happy England"', p. 44.

7   Crouch and Ward, *The Allotment: Its Landscape and Culture*, pp. 75–6.

8   Ibid., p. 35.

9   Farley and Symmons Roberts, *Edgelands*, p. 107.

10  Ibid., pp. 106–7.

11  Charles Quest-Ritson, *The English Garden: A Social History*, Viking, London, 2001, p. 253.

12  Postle, '"Happy England": The Artist and the Garden from Allingham to Spencer', p. 45.

13  Gilbert Spencer, *Stanley Spencer*, Victor Gollancz, London, 1961, p. 90, cited in Jane Alison (ed.), *Stanley Spencer: The Apotheosis of Love*, exh. cat., Barbican Art Gallery, London, 1991, p. 13.

14  Keith Bell, 'Stanley Spencer's Gardens' in Parissien (ed.), *Stanley Spencer and the English Garden*, exh. cat., Compton Verney, Paul Holberton Publishing, London, with Compton Verney, 2011, pp. 18–37 (30).

15  Postle maintains that it was commissioned by Plymouth City Council and painted in 1954; '"Happy England"': The Artist and the Garden from Allingham to Spencer', p. 45. Bell dates the painting to 1955 and states that it was purchased by the Friends of Plymouth City Museum & Art Gallery in that year; see cat. no. 404 in *Stanley Spencer: A Complete Catalogue of the Paintings*, Phaidon, London, 1992, p. 506.

16  Peter Shepheard, *Modern Gardens*, Architectural Press, London, 1953, p. 17.

17  Ibid., pp. 15, 17. Shepheard was chief architect for Stevenage Development Corporation, 1947–8.

18  Postle, '"Happy England": The Artist and the Garden from Allingham to Spencer', p. 53.

19  'a most carefully considered system for spatial recession . . . flat screens of scribbled tone-colour . . . arranged in depth, one behind the other' Patrick Heron, 'Ivon Hitchens, Introduction' *The British Pavilion: Exhibition of works by Ivon Hitchens, Lynn Chadwick and John Bratby, Derrick Greaves, Edward Middleditch*, exhibition catalogue for the XXVIII Biennale, British Council, 1956, p. 8.

20  Ibid.

21  Andrew Wilson, 'Looking and Painting: Patrick Heron's Garden Paintings of 1956 and the 1980s' in *Patrick Heron: Early and Late Garden Paintings*, exh. cat., Tate Gallery, St Ives, 2001, pp. 8–19.

22  Ibid., pp. 11–12.

23  Peter Clarke, *Hope and Glory: Britain 1900–2000*, (Allen Lane, 1996), Penguin, Harmondsworth, 1997, pp. 254–5.

24  F. E. Smythe, *Over Welsh Hills*, p. 61.

25  Joe Moran, *On Roads: A Hidden History*, Profile Books, London, (2009), 2010, p. 4.

26  Ibid., p. 21.

27  See Karolina Szynalska, 'Hyper Pioneer', *C20*, 2, 2013, pp. 38–41.

28 Quoted in Frances Carey and Antony Griffiths, *Avant-Garde British Printmaking 1914–1960*, exh. cat., British Museum Publications, London, 1990, p. 177.

29 Derek H. Aldcroft and P. J. Bernard, 'The Changing Pattern of Demand for Passenger Transport in Post-war Britain', in Derek H. Aldcroft, *Studies in British Transport History 1870–1970*, David & Charles, Newton Abbot ,1974, pp. 263–74.

30 Ibid., pp. 243–53.

31 Quoted ibid., p. 41.

32 A new television film aired in 2000. E. Nesbit's book was serialised in *The London Magazine*, 1905 and published as a book in 1906.

33 See Paul Moorhouse, *Leon Kossoff*, p. 24.

34 W. H. Auden, *Collected Shorter Poems 1927–1957*, Faber & Faber, London, 1966, pp. 83–4.

35 David Kynaston, *Austerity Britain: 1945–51*, p. 511.

36 Kitty Hauser, *Bloody Old Britain: O. G. S. Crawford and the Archaeology of Modern Life*, Granta Books London, 2008, p. 40. The proposed provinces were analogous to wartime civil defence regions and were later appropriated by the Arts Council for logistic reasons.

37 Geoffrey Grigson, *West Country*, Collins, London, 1951, p. 37.

38 W. J. Gruffydd, *North Wales and the Marches*, Collins, London, 1951, pp. 17, 19.

39 R. S. R. Fitter, *Home Counties*, Collins, London, 1951, p. 33; Sid Chaplin, *The Lakes to Tyneside*, Collins, London, 1951, p. 24.

40 Initiated in 1940; see David Mellor, Gill Saunders and Patrick Wright, *Recording Britain: A Pictorial Domesday of Pre-war Britain*.

41 W. A. Poucher, *The Welsh Peaks: A Pictorial Guide*, Constable, London, 1962, p. 9.

42 David Matless, *Landscape and Englishness*, pp. 227–30.

43 John Urry, *The Tourist Gaze*, Sage, London, (1990) 2002, p. 3.

44 Diary entries 15–21 September 1954. TGA 200511/5/9.

45 Ben Nicholson, letter to Herbert Read, 5 December [1939]; TGA, 8717.1.3.31.

46 A sense of being foreign coincides with the way that railway advertising promoted Cornwall as a holiday destination in the 1920s when the exotic 'Cornish Riviera' was explicitly compared with Italy, concluding that it continued to feel 'comfortable' because it was not actually abroad; Chris Thomas, 'See your own country first: the geography of a railway landscape' in E. Westland ed., *Cornwall: The Cultural Construction of Place*, Patten Press, Penzance, with the Institute of Cornish Studies, University of Exeter, 1997, pp. 107–28.

47 Ben Nicholson, letter to Herbert Read, 2 October [1944]; TGA 8717.1.3.52.

48 Ben Nicholson, letter to Herbert Read, 3 October [1956]; TGA 8717. 1. 91.

49 Ben Nicholson, letter to Herbert Read, 28 September [1966]; TGA 8717.1.3.167.

50 Ibid.

51 In 1957 Nicholson and Felicitas Vogler visited Fountains Abbey and Rievaulx, as well as Read, during their honeymoon; see Peter Khoroche, *Ben Nicholson: Drawings and Painted Reliefs*, Lund Humphries, Aldershot, 2002, p. 79.

52 Peter Fergusson, *Rievaulx Abbey: Community, Architecture, Memory*, Yale University Press, New Haven and London, 1999, p. 211.

53 National Archive, Works 14/787 quoted ibid., p. 211.

54 Ibid.

55 Ben Nicholson, letter to Herbert Read, 15 April [1958]; TGA 8717.2.3.99. Ben Nicholson, letter to Herbert Read, 2 December [1959]; TGA 8717.2.3.109.

56 See Christopher Green and Barnaby Wright (eds), *Mondrian || Nicholson in Parallel*, exh. cat., Courtauld Gallery, London with Paul Holberton Publishing, 2012.

57 Khoroche, *Ben Nicholson*, p. 87.

58 Ben Nicholson, letter to Herbert Read, 16 March [1961]; TGA 8717.2.3.116. The link is explicit in *1967 (Pisa as intended)*, which is drawn on the back of an intaglio etching and is therefore slightly in relief.

59 Yi-Fu Tuan, *Place and Space: The Perspective of Experience*, p. 138.

60 Nicholson, quoted in Norbert Lynton, *Ben Nicholson*, Phaidon Press, London, 1993, p. 313. For home as a physical site see J. Douglas Porteous, 'Home: The Territorial Core', *Geographical Review*, pp. 383–90.

61 See Rebecca Solnit, *Wanderlust: A History of Walking*, Verso, London & New York, (2001), 2002, pp. 16–22.

62 See Tim Edensor, 'Walking in the British Countryside: Reflexivity, Embodied Practices and Ways to Escape', *Body & Society*, vol. 6, nos 3–4, November 2000, pp. 81–106 (82; 102).

63 Alfred Wainwright, *Memoirs of a Fell Wanderer*, (Michael Joseph, 1993) Frances Lincoln, London, 2003, p. 79.

64 Ibid., p. 61.

65 Ibid., p. 8.

66 Ibid., pp. 26, 28.

67 Alfred Wainwright, *A Pictorial Guide to the Lakeland Fells: 1 – The Eastern Fells*, Henry Marshall, Kentmere, 1955; Wainwright, *Memoirs of a Fell Wanderer*, p. 86.
Grigson held a contrary view, waspishly commenting: 'the Lake district was enjoyed so early because the mountains were in miniature', requiring none of the specialised equipment of the serious rock climber. Geoffrey Grigson, *Places of the Mind*, p. 109.

68 Clare Palmer and Emily Brady, 'Landscape and Value in the Work of Alfred Wainwright (1907–1991)', *Landscape Research*, vol. 32, no. 4, August 2007, pp. 397–421 (405, 407).

69 Kenneth R. Olwig, 'Liminality, Seasonality and Landscape', *Landscape Research*, vol. 30, no. 2, April 2000, pp. 259–71 (266).

70 Tim Edensor maintains that justifications for solitary walking are 'explicitly status-oriented . . . in contrast to collective walking practices', sustaining a view of Wainwright's walking as an elite pastime. Edensor, 'Walking', p. 89.

71 Wainwright, *Memoirs of a Fell Wanderer*, p. 176; Hoskins, *The Making of the English Landscape*, p. 299.

72 Reproduced in Wallis, 'Making Tracks', p. 44.

73  Ibid., p. 35.

74  Katrín Lund, 'Landscapes and Narratives: Compositions and the Walking Body', *Landscape Research*, vol. 37, no. 2, March 2012, pp. 225–37

75  Yi-Fu Tuan, *Landscapes of Fear*, Basil Blackwell, Oxford, 1980, p. 6.

76  Robert Mcfarlane, *Mountains of the Mind*, p. 71.

77  Lewis, 'The Climbing Body, Nature and the Experience of Modernity', pp. 58–80 (65).

78  Ibid., p. 65.

79  Douglas A. Brown, 'The Modern Romance of Mountaineering: Photography, Aesthetics and Embodiment', *The International Journal of the History of Sport*, vol. 24, no. 1, January 2007, pp. 1–34 (6), citing *Alpine Journal*, vol. 12, no. 185, 1885, p. 216.

80  Ibid., p. 7, citing *Alpine Journal*, vol. 15, no. 189, 1891, pp. 472–9.

81  Ibid., p. 6, citing *Alpine Journal*, vol. 4, no. 187, 1870, p. 402.

82  Brown, 'The Modern Romance of Mountaineering: Photography, Aesthetics and Embodiment', p. 29.

83  Sam Turner, 'Landscape Archaeology for the Past and Future: The Place of Historic Landscape Characterisation', *Landscapes*, vol. 8, no. 2, 2007, pp. 40–9 (42).

## 7   Places of the Mind

1  Piper's frequent presence is acknowledged in the opening note in Geoffrey Grigson, *Places of the Mind*, p. v.

2  The private environment is an 'inchoate, diffuse, irrational' terrain where 'Non-terrestrial geometries, topographical monsters, and abstract models of every kind in turn lend insight to views of reality'; see David Lowenthal, 'Geography, Experience, and Imagination: Towards a Geographical Epistemology', *Annals of the Association of American Geographers*, vol. 51, no. 5, September 1961, pp. 241–60 (257).

3  Ibid., pp. 248, 249, 257.

4  Yi Fu Tuan, *Topophilia: A Study of Environmental Perception, Attitudes and Values*, Columbia University Press, 1974, pp. 93, 118.

5  Ibid.

6  See Paul Brassley, 'On the Unrecognized Significance of the Ephemeral Landscape', *Landscape Research*, vol. 23, no. 2, July 1998, pp. 119–32.

7  Kitty Hauser, *Shadow Sites: Photography, Archaeology and the British Landscape 1927–1955*, pp. 55–6.

8  Barbara Bender, 'Stonehenge – Contested Landscapes (Medieval to Present-day)' in B. Bender (ed.), *Landscape: Politics and Perspectives*, Berg, Providence & Oxford, 1993, pp. 245–79 (263).

9  Ibid., pp. 249, 266

10  When he visited Salles-de-Béarn in south-west France with Eric Gill in 1928, Jones is said to have been seeking a 'holiness in landscape' similar to an ethos that he recognised in the work of Stanley Spencer, who was then engaged in portraying Cookham as the site of the New Testament. See Jonathan Miles and Derek Shiel, *David Jones: The Maker Unmade*, Seren, Bridgend, 1995, p. 112.

11  Ibid., p. 188

12  Felicitas Corrigan (ed.), Helen Waddell (trans.), *More Latin Lyrics from Virgil to Milton*, Victor Gollancz, London, 1976, pp. 122–3.

13  David Fraser Jenkins, 'An Interpretation', *David Jones*, exh. cat., South Bank Centre, London, 1989, p. 12.

14  Miles and Shiel, *David Jones*, p. 196. Helen Waddell translated the first line of the text of the hymn, Vexilla Regis as 'The standards of the king go forth'.

15  Miles and Shiel, ibid., p. 193.

16  Caroline Collier, '"Under the Form of Paint . . . "', *David Jones*, South Bank Centre, London, 1989, pp. 36–7.

17  Ibid., p. 33.

18  Half of the books were published before 1940 and a few in the early 1950s. See Catherine Brace, 'Envisioning England: The Visual in Countryside Writing in the 1930s and 1940s', *Landscape Research*, vol. 28, no. 4, October 2003, pp. 365–82 (366).

19  Cook, *The Britain of Brian Cook*, p. 24.

20  Ibid., p. 43

21  Osbert Sitwell, 'Foreword', Ralph Dutton, *The English Country House*, B. T. Batsford, London, (1935) 1949, p. vi.

22  Ibid., p. 1.

23  W. G. Hoskins, *Midland England: A Survey of the Country between the Chilterns and the Trent*, B. T. Batsford, London, 1949, p. 103.

24  Lawrence Alloway (ed.), *Nine Abstract Artists*, Tiranti, London, 1954, p. 5.

25  Roger Berthoud, *Graham Sutherland: A Biography*, Faber & Faber, London, 1982, p. 105.

26  Martin Hammer, *Graham Sutherland: Landscapes, War Scenes, Portraits 1924–1950*, exh. cat., Scala Publishers & Dulwich Picture Gallery, London, 2005, p. 24. Hammer also notes the impact of the work of J. M. W. Turner and John Martin; ibid., p. 25.

27  Ibid., p. 18. Bacon had long been fascinated by wildlife photographs; Martin Hammer has cited Marius Maxwell's *Stalking Big Game with a Camera in Equatorial Africa* (1924) as especially important to him. Hammer notes that a plate in Maxwell's book was the model for the background of Bacon's *Figure in a Landscape* (1945) (see Martin Hammer, *Bacon and Sutherland*, Yale University Press, New Haven and London, 2005, p. 24).

28  Michael Peppiatt, *Francis Bacon: Anatomy of an Enigma*, Weidenfeld & Nicolson, London, 1996, p. 137.

29  Margaret Garlake, *New Art, New World: British Art in Post-war Society*, p. 189.

30  Graham Sutherland, 'Thoughts on Painting', *The Listener*, 6 September 1951, pp. 37–68, reproduced in Hammer, *Graham Sutherland: Landscapes, War Scenes, Portraits 1924–1950*, pp. 142–5 (143).

31  Ibid., p. 145.

32  Berthoud, *Graham Sutherland*, p. 143; Sutherland, interview with Andrew Forge, *The Listener*, 26 July 1962, quoted ibid.

33  Berthoud, *Graham Sutherland*, p. 146.

34  Prospectus for the International Sculpture Competition, quoted in Robert Burstow, 'The Limits of Modernist Art as "Weapon of the Cold War": Reassessing the Unknown Patron of the Monument to the Unknown Political Prisoner', *Oxford Art Journal*, vol. 20, no. 1, 1997, pp. 68–80 (70); Margaret Garlake, *The Sculpture of Reg Butler*, Henry Moore Foundation with Lund Humphries, Aldershot, 2006, pp. 89–90.

35  See Robert Burstow, 'Butler's Competition Project for a Monument to "The Unknown Political Prisoner"; Abstraction and Cold War Politics', *Art History*, vol. 12, no. 4, December 1989, pp. 472–96.

36  See Chris Stephens, 'Henry Moore's *Atom Piece*: the 1930s Generation Comes of Age' in Jane Beckett and Fiona Russell (eds), *Henry Moore: Critical Essays*, Ashgate Publishing, Aldershot, 2003, pp. 243–56; John Minnion and Philip Bolsover (eds), *The CND Story: The First 25 Years of CND in the Words of the People Involved*, Allison & Busby, London, London, 1983, pp. 42–7.

37  Bowen was one of the founders of the New Vision Centre Gallery in London, which he directed for ten years from 1956.

38  It is dated 1952 by the Leicester curators but it is unlikely that Bowen could have made an abstract painting of this sophistication at such an early date.

39  Simon Sadler, 'The Brutal Birth of Archigram', in Elain Harwood and Alan Powers (eds), *The Sixties: Life, Style, Architecture*, Twentieth Century Architecture 6, The Twentieth Century Society, 2002, pp. 119–28.

40  Ibid., p. 127.

41  Hadas Steiner, 'Off the Map', in Jonathan Hughes and Simon Sadler (eds), *Non-Plan*: *Essays on Freedom Participation and Change in Modern Architecture and Urbanism*, Architectural Press, Oxford, 2000, pp. 126–37 (136).

42  Peter Cook (ed.), *Archigram*, (Studio Vista, London, 1972) reprinted Birkhäuser, Basel, 1991, pp. 20–2. The catalogue was published as a single issue of the ICA's magazine, *Living Arts*.

43  Peter Cook, 'Introduction', *Living Arts*, 2, 1963, p. 69.

44  Ibid., p. 71.

45  'Gloop 7 Situation', ibid., p. 112.

46  Dennis Crompton, 'City Synthesis', *Living Arts*, 2, 1963, p. 86.

47  Ibid.

48  Sadler, 'The Brutal Birth of Archigram', p. 124.

49  Cook's axonometric is reproduced in Cook (ed.), *Archigram*, pp. 36–7.

50  Ibid., p. 36.

51  Ibid., p. 41. It recalls an optimistic rumour floated in 1945 that a gigantic atomic umbrella would shortly be installed to protect Britain from its natural climate; see Garlake, *New Art, New World: British Art in Post-war Society*, note 48, p. 266.

52  Simon Sadler, 'Open Ends: The Social Visions of 1960s Non-planning', in Jonathan Hughes and Simon Sadler, *Non-Plan: Essays on Freedom, Participation and Change in Modern Architecture and Urbanism*, Routledge, London, 1999, pp. 138–54 (140–1).

53  Jonathan Hughes, 'The Indeterminate Building', in Jonathan Hughes and Simon Sadler, *Non-Plan: Essays on Freedom, Participation and Change in Modern Architecture and Urbanism*, Routledge, London, 1999, pp. 94–5; 98.

54  Ibid., p. 97.

55  Ibid.

56  Clark, *Landscape into Art*, p. 34; Patrick Heron, 'Space in contemporary painting and architecture', *The Changing Forms of Art*, Routledge & Kegan Paul, London, 1955, pp. 40–51.

57  Alloway, 'Some Notes on Abstract Impressionism', *Abstract Impressionism*, unpaginated.

# Illustrations

1 Aerial photograph of Corfe Castle, 1947. Reproduced with permission of the Cambridge University Collection of Aerial Photography © Copyright reserved

2 Prunella Clough, canal and gasworks, 1950s. Black and white photograph, 6.2 × 8.7 cm. Tate. © Estate of Prunella Clough / Robin Banks. All rights reserved, DACS 2021. Photo © Tate Images

3 Kenneth Rowntree, mural at Barclay School, Stevenage, 1949. Photo: John Maltby / RIBA Collections

4 Architects' Co-Partnership with Ove Arup, factory for Brynmawr Rubber Company, 1946–51, photographed in 1951. Photo: Architectural Press Archive / RIBA Collections

5 Paul Nash, *Landscape of the Vernal Equinox*, 1943. Oil on canvas, 71.8 × 91.6 cm. The Royal Collection. Royal Collection Trust. All rights reserved

6 Richard Long, *A Line Made by Walking*, 1967. Gelatin silver print on paper and graphite on board, 37.5 × 32.4 cm. Tate. © Richard Long. All rights reserved, DACS 2021. Photo © Tate Images

7 Frank Smythe, *Nearing Sundown: from Lliwedd*, 1940. © Frank Smythe. Photo: Modern Art Press

8 Michael Ayrton, *Entrance to a Wood*, 1945. Oil on canvas, 72.4 × 91.4 cm. Arts Council Collection, Southbank Centre. Arts Council Collection, Southbank Centre, London © The Estate of Michael Ayrton

9 Henry Moore, *Family Group*, 1948–9. Bronze, 152 × 113 × 72 cm. Shown installed at Barclay School, Stevenage in 1949. © The Henry Moore Foundation. All rights reserved. Photo: Michael Furze, Henry Moore Foundation Archive. Reproduced by permission of The Henry Moore Foundation

10 Peter Lanyon, *Turnaround*, 1963–4. Oil on board with polystyrene, plastic, glass, wood and metal screws, 66.5 × 61 × 11 cm. Tate. © Estate of Peter Lanyon. All rights reserved, DACS 2021. Photo © Tate Images

11 William Gear, *Summer Garden*, 1951. Oil on canvas, 122 × 81.2 cm. Glasgow Museums © CSG CIC Glasgow Museums Collection

12 Patrick Heron, *St Ives Window with Sand Bar*, 1952. Oil on canvas, 91.4 × 45.7 cm. Private collection. © The Estate of Patrick Heron. All rights reserved, DACS 2021. Photo: Courtesy the Estate of Patrick Heron

13 Peter Lanyon, *Porthleven*, 1951. Oil on board, 244 × 122 cm, Tate. © Estate of Peter Lanyon. All rights reserved, DACS 2021. Photo © Tate Images

14 John Aldridge, *Builders at Work, Brick House, Great Bardfield*, c. 1946. Oil on canvas, 62.1 × 74.3 cm, Fry Art Gallery, Saffron Walden. © the artist's estate / Fry Art Gallery, Saffron Walden, Essex, UK / Purchased with assistance from the V&A Museum Purchase Fund / Bridgeman Images

15 Michael Rothenstein, *Untitled (Farm Scene)*, 1945. Watercolour on paper, c. 28 × 42 cm. Private collection. © Estate of Michael Rothenstein. Photo: Modern Art Press, photography by Matthew Hollow

16 Ivon Hitchens, *Garden*, 1957. Oil on canvas, 52 × 106 cm. Private collection. © The Estate of Ivon Hitchens. All rights reserved, DACS 2021. Photo: Modern Art Press

17 Richard Wilson, *Cader Idris, Llyn-y-Cau*, c. 1765–7. Oil on canvas, 51.1 × 73 cm. Tate. Photo © Tate Images

18 John Piper, *Llyn Du'r Arddu – A Lake under Snowdon*, 1946–7. Pen and ink, watercolour, charcoal and pastel, 56 × 68.5 cm. Private collection. © The Piper Estate / DACS 2021. Photo: Sotheby's London

19 Victor Pasmore, *Square Motif, Blue and Gold: The Eclipse*, 1950. Oil on canvas, 45.7 × 61 cm. Tate. © The Tate. Photo © Tate Images

20 Alan Reynolds, *Kent Summer*, 1953. Oil on board, 48 × 58.5 cm. Private collection. © Estate of the Artist. Photo © Agnew's, London / Bridgeman Images

21 Paul Feiler, *Black Rocks with Blue Harbour*, 1953. Oil on board, 45.7 × 30.2 cm. © Estate of Paul Feiler, Bridgeman Images. Photo: Bonhams, London

22 Jean Dubuffet, *Table de forme indécise*, 1951. Oil on canvas, 73 × 91 cm. Private collection. © Fondation Dubuffet, Paris, ADAGP, Paris and DACS, London 2021

23 Pierre Soulages, *Untitled*, 1951. Oil on canvas, 194.3 × 128.9 cm. Herbert F. Johnson Museum of Art, Cornell University. © ADAGP, Paris and DACS, London 2021. Photo: Cornell Museum, USA

24 Peter Peri, *Man's Mastery of the Atom = Self Mastery*, 1957, sited at Longslade Community College, Leicestershire. Concrete on glass, 209 × 147 cm. © The Estate of Peter Laszlo Peri. All rights reserved, DACS 2021. Photo: The Estate of Peter Laszlo Peri.

25 Jackson Pollock, *One: Number 31*, 1950. Oil and enamel paint on canvas, 269.5 × 530.8 cm. Museum of Modern Art, New York. © The Pollock-Krasner Foundation ARS, NY and DACS, London 2021. Image copyright The Metropolitan Museum of Art/Art Resource/Scala, Florence

26 Jean-Paul Riopelle, *Le Printemps*, 1952. Oil on canvas, 96.5 × 130.2 cm. Private collection. Estate of Jean Paul Riopelle /© SOCAN, Montreal and DACS, London 2021.

27 Patrick Heron, *Square Leaves (Abstract): July 1952*, 1952. Oil on canvas, 76.2 × 50.8 cm. The Estate of Patrick Heron. © The Estate of Patrick Heron. All rights reserved, DACS 2021. Photo: Courtesy the Estate of Patrick Heron

28 Ivon Hitchens, *Winter Walk 3*, 1948. Oil on canvas, 43 × 109 cm. Private collection. © The Estate of Ivon Hitchens. All rights reserved. DACS/Artimage 2021. Photo: Jonathan Clark & Co.

29 William Scott, *Figure into Landscape*, 1954. Oil on canvas, 50.6 × 60.7 cm. Private collection. © William Scott Foundation

30 Robyn Denny, *Untitled*, 1956–7. Oil and bitumen on board, 48 × 96 inches. Private collection. © The Estate of Robyn Denny. All rights reserved, DACS 2021. Photo: private collection

31 Robyn Denny and Richard Smith, *Ev'ry-Which-Way*. Reproduction of collage, published in *Ark*, issue 24, 1959. Royal College of Art Archive and Special Collections © The Estate of Robyn Denny. All rights reserved, DACS 2021 / © Richard Smith Foundation. All rights reserved, DACS 2021.

32 Claude Monet, *Nymphéas*, after 1916. Oil on canvas, 200.7 × 426.7. National Gallery. Photo © Tate Images

33 Emilio Vedova, *Dal ciclo della protesta '53 – 6*, 1953. Egg tempera and pastel on canvas, 138 × 190 cm. Private collection, EU. Photo: Giorgio Cacco, Venezia, Fondazione Emilio e Annabianca Vedova

34 Prunella Clough, *Brown Wall*, 1964. Oil on canvas, 131.7 × 121.6 cm. Pallant House Gallery, Chichester. © Estate of Prunella Clough. All rights reserved, DACS 2021. Photo: Pallant House Gallery, Chichester

35 Joan Mitchell, *Hudson River Day Line*, 1955. Oil on canvas, 200.66 × 210.82 cm. Collection of the McNay Art Museum, Museum purchase from the Tobin Foundation © Estate of Joan Mitchell

36 Willi Soukop, *Donkey*, 1935, shown sited at Harlow in 1955. Bronze. Harlow Museum & Walled Garden

37 Installation photograph of *The New Generation* exhibition at Whitechapel Gallery, 1965, with Phillip King's sculpture *Genghis Khan* 1963 in the foreground. © Estate of Philip King. All Rights Reserved, DACS 2021. Photo © Whitechapel Gallery Archive

38 Installation shot of Richard Long's exhibition at Konrad Fischer Galerie, 1968. © Richard Long. All Rights Reserved, DACS 2021. Photo: Bernd & Hilla Becher, courtesy Konrad Fischer Galerie.

39 Bill Brandt, *Barbary Castle, Marlborough Downs, Wiltshire*, 1948. © Bill Brandt Archive

40 Bill Brandt, *Nude, East Sussex Coast*, 1959. © Bill Brandt Archive

41 Frank Smythe, *Cynicht from the South-West*, 1945. Photo: Modern Art Press

42 Cover of *Lakeland Through the Lens* by W. A. Poucher, 1940. © Estate of W. A. Poucher. Photo: Modern Art Press

43 Roger Mayne, *Footballer and Shadow*, 1956. © Roger Mayne Archive / Mary Evans Picture Library

44 Philip de Loutherbourg, *An Avalanche in the Alps*, 1803 (detail). Oil on canvas, 109.9 × 160 cm. Tate. Photo © Tate Images.

45 Terry Frost, *Walk Along the Quay*, 1950. Oil on canvas, 152 × 156 cm. Private collection © Estate of Terry Frost. All Rights Reserved, DACS 2021. Photo: Sotheby's, London

46 Sheila Fell, *Cumberland*, 1959–60. Oil on canvas, 124.5 × 203 cm. Private collection. © Estate of Sheila Fell. Photo: Professor J. A. Bradley

47 Joan Eardley, *Glasgow Street, Rottenrow*, c. 1955–6. Oil on board, 22.3 × 64.5 cm. Private collection. © Estate of Joan Eardley. All Rights Reserved, DACS 2021.

48 Joan Eardley, *Flood Tide*, 1962. Oil on board, 120 × 183 cm. Lillie Art Gallery, East Dumbartonshire. © Estate of Joan Eardley. All rights reserved, DACS 2021. Photo: East Dunbartonshire Leisure and Culture Trust

49 Terry Frost, *Blue Winter*, 1956. Oil on board, 121 × 190.5 cm. British Council Collection © Estate of Terry Frost. All Rights Reserved, DACS 2021.

50 William Scott, *Figure into Landscape*, 1953. Oil on canvas, 114.3 × 152.4 cm. Private collection © William Scott Foundation 2019.

51 John Piper, *Nant Ffrancon Pass*, 1947. Ink, wash and gouache, 55.5 × 69.8 cm. Private collection. © The Piper Estate / DACS 2021. Photo: Bonhams, London

52 Bob Law, *Drawing 25.5.59*, 1959. Pencil on paper, 25.4 × 35.4 cm. Richard Saltoun Gallery © Estate of Bob Law. Photo: Richard Saltoun Gallery

53 Prunella Clough, *Rockery*, 1963. Oil on canvas, 66 × 50.8 cm. Tate. © Estate of Prunella Clough. All Rights Reserved, DACS 2021. Photo © Tate Images

54 William Scott, *Table Still Life*, 1951. Oil on canvas, 143.3 × 183.8 cm. British Council Collection. © William Scott Foundation

55 Peter Lanyon, *St Just*, 1951–3. © Estate of Peter Lanyon. All Rights Reserved, DACS 2021. Photo: © Modern Art Press

56 David Haughton, *Queen Street*, 1960. Etching, 47 × 45 cm. Private collection. © David Haughton Estate. Photography: Jonathan Bassett

57 Peter Lanyon, *Wheal Owles*, 1958. Oil on board, 122 × 183 cm. Moore Danowski Trust. © Estate of Peter Lanyon. All Rights Reserved, DACS 2021. Photo: © Modern Art Press

58 Peter Lanyon, *North East*, 1963. Oil on canvas, 183 × 122 cm. Richard Green Ltd. © Estate of Peter Lanyon. All Rights Reserved, DACS 2021. Photo: Modern Art Press

59 Peter Lanyon, *Airscape*, 1961. Oil on canvas, 122 × 183 cm. Museum of Art, Rhode Island School of Design, Providence. © Estate of Peter Lanyon. All Rights Reserved, DACS 2021. Photo: Museum of Art, Rhode Island School of Design

60 Bryan Wynter, *Cornish Farm*, 1948. Monotype and gouache on paper, 33.7 × 53.7 cm. Tate. © Estate of Bryan Wynter. All rights reserved, DACS 2021. Photo © Tate Images

61 Richard Hamilton, *Trainsition IIII*, 1954. Oil on board, 91.4 × 121.9 cm. Tate. © R. Hamilton. All Rights Reserved, DACS 2021. Photo © Tate Images

62  Gordon Cullen, cover illustration of Ian Nairn's 'Outrage', *Architectural Review*, 1955. © Estate of Gordon Cullen. Photo: Modern Art Press

63  Edward Burra, *English Countryside*, 1965–7. Watercolour on paper, 79.4 × 132.1 cm. The Donlea Collection. © Estate of the Artist, c/o Lefevre Fine Art Ltd, London. Photo: Modern Art Press

64  Richard Hamilton, *Reaper (p)*, 1949. Drypoint and roulette on paper, 17.9 × 17.2 cm. Museo Nacional Centro de Arte Reina Sofia. Long-term loan of Rita Donagh Hamilton, 2014. © R. Hamilton. All Rights Reserved, DACS 2021. Photo: Museo Nacional Centro de Arte Reina Sofia

65  Diagram of a nineteenth-century reaper from Siegfried Giedion's *Mechanization Takes Command*. © Estate of Siegfried Giedion. Photo: Modern Art Press.

66  Sheila Fell, *Aspatria*, 1959. Oil on canvas, 71 × 91.5 cm. Private collection. © Estate of Sheila Fell. Photo: Professor J. A. Bradley

67  Sheila Fell, *Skiddaw*, 1963–4. Oil on canvas, 71 × 91.5 cm. Private collection. © Estate of Sheila Fell. Photo: Professor J. A. Bradley

68  Edward Burra, *The Harbour, Hastings*, 1947. Watercolour on paper, 73.7 × 110.5 cm. Pallant House Gallery, Chichester (on long-term loan from a private collection) © Estate of the Artist, c/o Lefevre Fine Art Ltd, London. Photo: Bridgeman Images.

69  Prunella Clough, *Lowestoft Harbour*, 1951. Oil on canvas, 162.6 × 106.7 cm. Arts Council Collection © Estate of Prunella Clough. All Rights Reserved, DACS/Artimage. Photo: © Arts Council Collection, Southbank Centre 2021

70  William Scott, *The Harbour*, 1952. Oil on canvas, 61.3 × 91.7 cm. Tate. © William Scott Foundation

71  Prunella Clough, *Sunset in Mining Area*, 1959. Oil on canvas, 41 × 51 cm. Private collection. © Estate of Prunella Clough. All Rights Reserved, DACS 2021. Photo: Modern Art Press

72  George Chapman, *The Valley Gets Deeper*, c. 1959. Etching, 67.8 × 46.5 cm. National Museums of Wales © Estate of the Artist. Photo: National Museums of Wales

73  Josef Herman, *Evening, Ystradgynlais*, 1948. Oil on canvas, 63.5 × 85.1 cm. Tate. © Estate of Josef Herman. All Rights Reserved, DACS 2021. Photo © Tate Images

74  Sheila Fell, *Maryport*, 1964. Oil on canvas, 101.5 × 127cm. Private collection. © Estate of Sheila Fell. Photo: Professor J. A. Bradley

75  Prunella Clough, *Cranes*, 1952. Lithograph on paper, 43 × 36.8 cm. Tate. © Estate of Prunella Clough. All Rights Reserved, DACS 2021. Photo © Tate Images

76  Prunella Clough, *Slag Heap*, 1958. Mixed media on board, 27.7 × 31.3 cm. Private collection. © Estate of Prunella Clough. All Rights Reserved, DACS 2021. Photo: Private collection, courtesy Annely Juda Fine Art, London

77  St Giles-without-Cripplegate, City of London, after bombing during the Blitz, December 1940. Detail of photo by William Vandivert/The LIFE Picture Collection via Getty Images

78  Siegfried Charoux, *Neighbours*, 1959. Cemented iron. Photo © London Picture Archive, London Metropolitan Archives, City of London

79  Construction site of the Shell Building, London, 1959. With kind permission Sir Robert McAlpine Ltd

80  Frank Auerbach, *Shell Building Site from the Thames*, 1959. Oil on board, 153 × 122.5 cm. Museo Nacional Thyssen-Bornemisza, Madrid. © Frank Auerbach, courtesy of Marlborough Fine Art. Photo: Museo Nacional Thyssen-Bornemisza, Madrid

81  Gollins, Melvin, Ward & Partners, Castrol House, Marylebone Road, London, 1957–60, shown nearing completion in 1959. Photo: Henk Snoek / RIBA Collections

82  Lynn Chadwick, *The Watchers*, 1960, shown sited in Roehampton in 1963. Photo: John Donat / RIBA Collections

83  Bryan Kneale, *Sculpture*, 1962, shown sited in Lambeth in 1965. Photo: © London Picture Archive, London Metropolitan Archives, City of London

84  Trevor Tennant, *Gulliver*, c. 1959. Photo by Harry Todd/Fox Photos/Hulton Archive/Getty Images

85  Dome of Discovery and Skylon – South Bank Exhibition, 1951. Photo: The National Archives, Kew

86  Poster advertising the Lansbury Estate, Poplar, as part of the *Living Architecture* exhibition. © Museum of London

87  Henry Moore, *Draped Seated Woman*, 1957–8, shown sited in Stepney in 1962. Bronze, 164 cm high. © London Picture Archive. London Metropolitan Archives, City of London. Reproduced by permission of the Henry Moore Foundation

88  Sydney Harpley, *The Dockers*, 1962. Ciment fondu. © Estate of the artist. Photo: London Metropolitan Archives (LMA/4218/01/025), City of London

89  Edward Wyon, *Richard Green*, 1865–6, shown in 2006. Photo: Dennis Gilbert, agefotostock.

90  Ralph Brown, *Meat Porters*, 1960. Photo: Harlow Museum and Walled Garden

91  Henry Moore, *Family Group*, 1954–5. Bronze, 185.5 cm high. Shown sited in its original position, Old Harlow, c. 1968. © The Henry Moore Foundation. All rights reserved. Photo: John Hedgecoe. Reproduced by permission of The Henry Moore Foundation

92  Victor Pasmore, *Apollo Pavilion*, 1963, photographed in the 1970s © Estate of Victor Pasmore. All Rights Reserved, DACS/Artimage 2021. Photo: John Pasmore

93  Birmingham City Architect's Department, Bull Ring shopping centre and market, 1961–4, photographed in 1969. Photo: Architectural Press Archive / RIBA Collections

94a  Sheffield Corporation City Architect's Department, Park Hill Estate, Sheffield, 1957–61, photographed nearing completion in 1961. Photo: RIBA Collections

94b  Sheffield Corporation City Architect's Department, Park Hill Estate, Sheffield, 1957–61, photographed nearing completion in 1961. Photo: John Donat / RIBA Collections

95  L. S. Lowry, *Industrial Landscape*, 1955. Oil on canvas, 114.3 × 152.4 cm. Tate. © The Estate of L. S. Lowry. All rights reserved, DACS 2021. Photo © Tate Images

96  Frank Auerbach, *The Origin of the Great Bear*, 1967–8. Oil on board, 114.6 × 140.2 cm. Tate. © Frank Auerbach, courtesy Marlborough Fine Art, London. Photo © Tate Images

97    MPs Hugh Dalton and Barbara Castle with Tom Stephenson talking to hikers on the Pennine Way, June 1952. Photo by Mirrorpix via Getty Images

98    Roger de Grey, *Allotments*, 1947. Oil on canvas, 49.1 × 59.5 cm. Tullie House Museum and Art Gallery, Carlisle. © Estate of the Artist. Photo: Tullie House Museum and Art Gallery/Bridgeman Images

99    Stanley Spencer, *Goose Run, Cookham Rise*, 1949. Oil on canvas, 76.2 × 50.8 cm. Private collection. © The Estate of Stanley Spencer. All rights reserved. Photo: Bridgeman Images

100    Stanley Spencer, *The Hoe Garden Nursery*, 1955. Oil on canvas, 67.8 × 108.2 cm. The Box Plymouth City Council. © The Estate of Stanley Spencer. All rights reserved. Bridgeman Images. Photo credit: The Box Plymouth City Council

101    Patrick Heron, *Camellia Garden: March 1956*, 1956. Oil on canvas, 182.8 × 91.5 cm. Private collection. © The Estate of Patrick Heron. All rights reserved, DACS 2021. Photo: Courtesy the Estate of Patrick Heron

102    View of the model of the town centre of Geoffrey Jellicoe's Motopia, 1961. © Estate of Geoffrey Jellicoe. Photo: Modern Art Press

103    Hugh Segar Scorer, Markham Moor service station, 1960, photographed in 1960s. Photographer unknown

104    John Carter, *On the Road*, 1964. Mixed media and collage on paper, 42 × 64cm. Redfern Gallery. © John Carter, courtesy of the Redfern Gallery, London

105    Michael Rothenstein, *Guard and Lamp*, 1950. Monotype on paper, 57 × 39.3 cm. British Museum. Reproduced by permission of the artist's estate. Photo © The Trustees of the British Museum

106    Leon Kossoff, *Railway Landscape near King's Cross, Summer*, 1967. Oil on board, 122 × 168.5 cm. Private collection © Leon Kossoff Estate

107    Strip map from *About Britain No. 1: West Country*, 1951, by Geoffrey Grigson, published by Collins. Reproduced by permission David Higham Associates

108    Kenneth Rowntree, title page of *About Britain No. 2: Wessex*, 1951. © Estate of Kenneth Rowntree. Photo: Modern Art Press

109    Ben Nicholson, *1951, December (St Ives – Oval and Steeple)*, 1951. Oil and pencil on board, 50 × 66 cm. City of Bristol Museum and Art Gallery © Angela Verren Taunt. All rights reserved, DACS 2021. Photo: Bristol Museums, Galleries & Archives

110    Ben Nicholson, *1969 (Rievaulx No. 1)*, 1969. Pencil and wash on paper, 59.3 × 49 cm. Private collection, on loan to the Middlesborough Institute of Modern Art. © Angela Verren Taunt. All rights reserved, DACS 2021. Photo: private collection

111    Ben Nicholson, *Feb 1960 (ice-off-blue)*, 1960. Oil on carved board, 122 × 184 cm. Tate. © Angela Verren Taunt. All rights reserved, DACS 2021. Photo © Tate Images

112    Alfred Wainwright, *Bowfell from Lingmoor Fell*. © Estate of A. Wainwright.

113    John Piper, *Slopes of Glyder Fawr, Llyn Idwal*, 1947. Watercolour and ink on paper, 55.7 × 71.2 cm. The Whitworth Art Gallery, Manchester © The Piper Estate / DACS 2021. The Whitworth, The University of Manchester / Bridgeman Images

114    Stonehenge Free Festival, 1970s. Detail of photograph by Homer Sykes © Homer Sykes

115    David Jones, *Vexilla Regis*, 1948. Graphite and watercolour on paper, 75 × 55.2 cm. Kettle's Yard, Cambridge © Estate of the artist. All rights reserved 2021. Kettle's Yard, University of Cambridge /Bridgeman images

116    Francis Bacon, *Study of Figure in a Landscape*, 1952. Oil on canvas, 198 × 137 cm. The Phillips Collection, Washington DC. © The Estate of Francis Bacon. All rights reserved, DACS/Artimage 2021. Photo: Prudence Cuming Associates Ltd

117    Graham Sutherland, *Thorn Head*, 1947. Oil on canvas, 113 × 80 cm. Private collection. © Estate of Graham Sutherland. Photo: Sotheby's London

118    Graham Sutherland, *The Origins of the Land*, 1950–1. Oil on canvas, 425.5 × 327.7 cm. Tate. © Estate of Graham Sutherland. Photo © Tate Images

119    Photomontage of Reg Butler's winning entry to the International Sculpture Competition, *Monument to an Unknown Political Prisoner*, 1956. © Estate of Reg Butler. Photo © Tate Images

120    Anti-nuclear protestors march on the road to Aldermaston, 1958. © Henry Grant Collection/Museum of London

121    Denis Bowen, *Atomic Image*, 1952. Oil on board, 137 × 76 cm. Leicestershire County Council Artworks Collection © Estate of Denis A. Bowen. Photo: Leicestershire County Council Artworks Collection, photography by Kerem Cetindamar

122    Installation photograph, *Living City* exhibition, ICA Gallery, London, 1963. © Archigram 1963

123    Peter Cook, *Plug-In City, Overhead View, (Axonometric)*, 1964. Collage, ink, pencil and polymer on board, 69.5 × 75.9 cm. MoMA, New York © Archigram 1964.

124    John Weeks, Northwick Park Hospital, Harrow, London, 1961–74, photographed in 1970. Photo: Architectural Press Archive / RIBA Collections

# Index